
The Painting
and Politics of
George Caleb
Bingham

The Painting and Politics of

GEORGE CALEB

Bingham

NANCY RASH

Yale University Press *New Haven & London*

Designed by Richard Hendel.
Set in Basilia Haas type by
G & S Typesetters, Inc., Austin, Texas.
Printed in the United States of America by
Hamilton Printing Company, Castleton,
New York.

Library of Congress
Cataloging-in-Publication Data

Rash, Nancy, 1940–
 The painting and politics of George Caleb
Bingham / Nancy Rash.
 p. cm.
 Includes bibliographical references and index.
 ISBN 0-300-04731-2 (alk. paper)
 1. Bingham, George Caleb, 1811–1879—
Criticism and interpretation. 2. Bingham,
George Caleb, 1811–1879—Political and social
views. I. Title.
ND237.B59R37 1991
759.13—dc20 90-36010
 CIP

The paper in this book meets the guidelines for
permanence and durability of the Committee on
Production Guidelines for Book Longevity of the
Council on Library Resources.

10 9 8 7 6 5 4 3 2 1

TO FRANK

Contents

Acknowledgments / ix

Introduction / 1

1 Portrait of the Artist as a Young Whig / 9

2 Bingham's Early Vision of the West / 40

3 Of Snags and Whigs: Bingham's *Lighter Relieving a Steamboat Aground* and Other Riverboat Paintings / 66

4 From Snags to Slavery: Bingham and Benton, 1847–1850 / 94

5 Free People and Free Institutions: The Election Series / 120

6 Bingham and Union: Governmental Commissions and State Portraits / 155

7 Bingham and Liberty: *Order No. 11* / 184

Epilogue. The Empty Studio / 216

Notes / 229

Bibliography / 269

Index / 279

Acknowledgments

My inquiry into the work of George Caleb Bingham has led me on a journey to study Bingham's paintings in museums across the country. It has taken me to historical societies and libraries to peruse manuscripts and printed material, newspapers and governmental records. The journey also led to the banks of the Mississippi and the Missouri, to the places Bingham knew—the smaller towns like Arrow Rock, Rocheport, Fayette, and Boonville that preserve many of their nineteenth century structures and the larger cities like Columbia, Independence, Kansas City, and St. Louis, where the traces of Bingham's world are less in evidence.

In the course of my research, I have followed two paths. One has led me to study closely and repeatedly almost all of Bingham's major genre and history paintings in museums and in corporate and private collections. The other path has put me in touch with Bingham's world, leading me to work intensely with primary manuscript and printed sources. I have traced Bingham's correspondence beyond that with his close friend James Sidney Rollins and have uncovered numerous unpublished letters written about him. Bingham's publications have been of great use, especially a series of articles on slavery hitherto unattributed to him. But I have gone beyond Bingham's own writings to immerse myself in the political and cultural life of Missouri. From the eastern to the western borders of the state, daily and weekly newspapers have taught me about Whig and Democratic views on local and national issues. Of particular interest were two newspapers that, it is clear, Bingham read regularly and even contributed to—the Columbia *Missouri Statesman,* edited by his good friend William Franklin Switzler, and the St. Louis *Missouri Republican.* The Missouri legislative journals and archives were indispensable, with daily accounts of the debates and votes in both senate and house. Finally, I have plumbed the records, both published and unpublished, of the cultural organizations that patronized Bingham, especially the American Art-Union in New York and the Mercantile Library Association in St. Louis.

As I worked on Bingham's art and politics, I found much support from Connecticut College and my colleagues there. Early versions of the riverboat chapter first saw the light of day in an American Studies class and a seminar on American landscape painting, and a later draft was part of the Faculty at Work series. For interesting queries and substantial suggestions I am grateful to my colleagues: Professors Robert Baldwin, John Knowlton, Alasdair

MacPhail, Charles Price, and Barbara Zabel. The R. Francis Johnson Travel, Study and Research Fund supported trips to Missouri and the purchase of innumerable photographs.

In the course of my studies many institutions and people have warmly offered help of many sorts, and I want to thank them all. James Burke of the St. Louis Art Museum and Henry Adams of the Nelson-Atkins Museum of Art in Kansas City were generous in making their collections available to me. Others who opened doors to storage areas and private collections include Joanne Tuckwood and Sidney Larson at the State Historical Society of Missouri in Columbia; Judy Weiss Levy and Laura Meyer at the St. Louis Art Museum; Barbara Jedda at Washington University; Lisa Wangerin at the Boatmen's Bank in St. Louis; and Karen Goering at the Missouri Historical Society in St. Louis. Richard Forry and Kathy Borgman have welcomed me often at the Arrow Rock State Historic Site, sharing their insights about the town where Bingham grew up and generously offering me tours of points of interest in Saline County. In Columbia, the director and staff of the State Historical Society of Missouri have been exceedingly helpful on my many visits there, and I particularly want to thank James Goodrich, director, Elizabeth Bailey and Fae Sotham in the library, Nancy Sandleback in the manuscript collection, and again Joanne Tuckwood and Sidney Larson. At the St. Louis Mercantile Library, the director Charles Bryan and his staff members, Charles Brown and John Hoover, went out of their way to unearth dusty volumes from the basement and to provide suggestions about other resources I might explore. Also in St. Louis, Eric P. Newman of the Eric P. Newman Numismatic Education Society and the library staff of the Missouri Historical Society have been helpful. Across the river, E. Louisa Bowen guided me through the intricacies of the McDermott Archive at Southern Illinois University at Edwardsville. George Miles, curator of the Western Americana Collection at Beinecke Library, Yale University, steered me to innumerable sources. Howard Lamar and Jules Prown of Yale University were kind enough to read the manuscript and offer valuable suggestions. Thanks go as well to Dillman Rash, Marianne Rash Rowe, Elizabeth Rash Brown, and Gian-Dillman Rash Fabbri for their enthusiasm; to Bruce Lundberg and Barbara Campel for keeping me here to finish it; and to Judy Metro and Stacey Mandelbaum for their editorial expertise. Finally, I thank my husband, Frank M. Turner, who has patiently and constantly encouraged me in this project as he read and criticized more drafts of this text than even the most devoted editor would be willing to plough through. To him I dedicate this book, with gratitude and affection.

Introduction

Throughout his adult life George Caleb Bingham was closely identified with Missouri. As early as 1840, the *Boon's Lick Times* designated him as "the Missouri Artist," and the title has remained with him to this day.[1] Not only did the original designation tie him to the place where he had lived since he was an eight-year-old boy, it also suggested that he was a painter who took Missouri as his subject. In the course of his career as an artist he left a memorable panorama of his adopted state. As a portraitist, he created a veritable pictorial roster of the distinguished citizenry of Missouri. Beyond the scores of portraits he painted, he also vividly composed scenes of life on the western rivers and moments of the political process in the newly developing state. Still later, paintings he proposed and executed chronicled significant moments in the history of Missouri. Recording the face, as well as the faces, of the West, the Missouri Artist bequeathed to posterity a penetrating picture of his fellow citizens—solid, sober, thoughtful, and committed people staring out unflinchingly from their portraits, hardy boatmen engaging their audience as they enjoyed leisure earned by diligent labor, citizens and politicians participating in the democratic process and later beset by the trials of the Civil War that threatened to disrupt that process. From the beginning to the end of his career, the people and institutions of Missouri provided the subjects for his paintings.

But Bingham's association with Missouri went far beyond that of a mere visual chronicler. He also served the state in elective and appointed offices. When asked, toward the end of his life, to provide biographical information for a history of the state, he characterized himself "as a public officer, as a writer and even as an artist."[2] Deliberately giving precedence to his work in government, he set forth an image of himself as a man of many talents.

Bingham was, after all, as much a Missouri politician as he was a Missouri artist. Ferociously committed to political principles, he was active in partisan politics throughout his life. His fifteen year association with the Whig party, from the late 1830s to the mid-1850s, shaped his ideology and colored his views on the nature of government, on economic and commercial development, and on the interconnectedness of all the states within the Union. Whig, too, were his views on liberty and property. After the dissolution of that party, he brought his Whig ideas to the Constitutional Union party during the Civil War and finally to the Democrats in the last decade of his life. In all but one decade of his adult life he held elected or appointed

office in state government—as representative in the state General Assembly in the late 1840s, as treasurer of the state during the Civil War, as president of the Kansas City Board of Police Commissioners and then adjutant general of Missouri in the 1870s. Beyond this actual service his name came up on more than one occasion as a possible candidate for other offices—for governor in the late 1840s and again in the 1870s and for congressman in the 1860s and 1870s.[3]

Just as he justifiably thought of himself as a public servant, so too he considered himself a writer. But his writings, both formal and informal, focused more on politics than on art, revealing "him often more as politician and statesman than as artist."[4] In addition to his massive correspondence with his friend James Sidney Rollins, he left essays written for newspapers, pamphlets published privately, and speeches recorded in newspapers and in legislative journals.

In every decade of his adult life, Bingham's political involvement proceeded alongside his artistic career. In the 1840s, as he undertook his river paintings, he painted banners and gave speeches for the Whig party, ran for office twice, and served in the state legislature, giving his name to an important series of pro-Union resolutions. In the 1850s, when he painted his election series and state portraits, he was active in the Whig party in the state, and he continued to write and speak out on the issue of slavery and union. In the 1860s, when he painted even more polemical pictures, he put his views into action as he served with the provisional state government and later helped to shape Democratic party platforms in the state after the Civil War. Finally, in the 1870s, as he saw to the sale of his prints of *Order No. 11* and considered a final commission from the state, he was active as adjutant general pressing war claims in Washington.

The conjoining of Bingham's activities in painting and politics did not go unnoticed in certain circles in Missouri. In the 1840s, the Whig press in St. Louis, Liberty, and the central part of the state covered his work as an artist and as a politician more often than the Democratic press did. His good friend William F. Switzler saw to it that Bingham appeared often in the pages of the paper he edited in Columbia, the *Missouri Statesman*. Switzler was convinced of the close link between his friend's two careers, and he even thought of asking Bingham for woodcuts to illustrate certain political issues in the paper.[5] Other Whigs before Switzler had asked Bingham for political images, paintings on banners carried at Whig rallies for William Henry Harrison and Henry Clay. The Democrats, in contrast, sometimes sought portraits from Bingham, but they so disliked his political banners that they went so far as to damage one of them. In the late 1840s the Democratic press tersely covered his campaigns for the legislature but only rarely noted his

art. When the Jefferson City *Metropolitan* ran a piece on Bingham's art from the New York *Express,* the local Democratic editor could not resist adding an editorial comment that the artist "ought to give up politics, about which he knows but little, and for which his peculiar temperament wholly unfits him."[6] If the Democratic press was for the most part lukewarm about Bingham's dual interests, the Whig press in Columbia and St. Louis continued to follow it closely. When Bingham painted his first election scene, at least one reviewer for a Whig paper in St. Louis connected the subject with the artist's own experiences in politics.[7] Finally, in the late 1850s and early 1860s those who took note of the connection between Bingham's two careers were legislators, then charged with commissioning portraits for the state capitol. Bingham prompted this attention by making overtly political speeches in favor of the Union when he delivered the portraits to the legislature. Partisan feelings then erupted in the General Assembly on such matters as Bingham's fees and the wisdom of assigning him another commission, and political opponents waxed eloquent in their criticisms of his art.

For all these contemporaneous and local commentaries on Bingham as artist and politician, critical reviews focused more single-mindedly on his art, and in particular on its distinctive character. In 1847 a local reporter in St. Louis voiced pride that Bingham had chosen to paint Missourians in western settings, thereby establishing "a whole new field of historical painting" and sending a clear image of the West to the East, where the artist exhibited.[8] In the early days of his success in New York, critics there went beyond the local chauvinism of the Missouri journalist and remarked on the national character of Bingham's paintings. Only a few acknowledged his career in politics, and then only to exalt his achievement as an artist. One critic asserted in 1847 that Bingham's work was "truly American (we always award this compliment with pleasure) and decidedly original; and when we remember that the painter therof is a statesman by profession, we think it a remarkable production."[9] Two years later a correspondent for the American Art-Union made no mention at all of Bingham's political career and instead took up the theme of the distinctly American quality of his work. The New York writer found the paintings "thoroughly American in their subjects" possessing a "striking nationality of character."[10] Missourians were proud of the picture that Bingham painted of their local world, while Easterners welcomed subjects so different from the European tradition and, in their view, so unmistakably American.[11]

This view of Bingham as a quintessential American artist, based on the subjects he chose, originated in the critical reception of the earliest works he sent to the East. It is a view that has come down to the present and has informed every later evaluation of his art. Art historical appreciation of Bing-

ham's work and serious efforts to place it in the chronicles of American art began soon after the major exhibition of his paintings at the Museum of Modern Art in 1935.[12] In broader histories of American art, Bingham's works rapidly took their place among the best examples of midnineteenth century genre painting.[13] His apparently accurate records of the America of his day impressed scholars, but so too did his formal affinities with Renaissance and baroque art. Monographs on the artist also appeared, expanding and illuminating the early biography that Fern Rusk had written in 1917. The first was by Albert Christ-Janer in 1940. In 1959 John F. McDermott, who devoted his life to studying the art and culture of Missouri, set out to chronicle Bingham's life and work. Then, from 1967 to 1986, the art historian E. Maurice Bloch produced a series of works that cataloged the artist's paintings and drawings and studied much more fully and magisterially the form and content of Bingham's oeuvre.[14] Bloch paid particular attention to the formal sources of the artist's style as he analyzed Bingham's production from decade to decade. His excellent book and extensive catalogs have become the standard reference works on the artist, the necessary starting point for any serious inquiry.

What is most remarkable about many discussions of Bingham's work in larger studies of American art is the almost mythic quality their authors discern in the artist's picture of America. In 1956 E. P. Richardson wrote: "over all there is a mood of grandeur and solemnity in his work, as if he would say to his fellows: This is a heroic age." A little more than a decade later, Alan Gowans went on: "Bingham moulded great symbolic images of a new kind of life—unprecedented in security and scope for individual self-realization—which American democracy had made possible. A new Eden inhabited by new Adams!" A decade later, in the late 1970s, Joshua C. Taylor noted: "the legends existed in the public mind, giving a special, sometimes mythic overtone to literally rendered scenes of the West. The man who profited most from this belief in a special western character was George Caleb Bingham."[15] Most recently Theodore Stebbins added his own encomium, praising Bingham's art as a major force in shaping America's vision of itself. "In painting the heady, masculine flavor of the frontier, in depicting these rugged Westerners relaxing, dancing, and celebrating America in clean, bare feet and unsoiled clothing, Bingham paints the nation's mythic view of itself. If the artist could be believed, this *was* a golden land, one of beautiful, hazy summer days when men could simply drift with the current, where labor and hardship and hate were unknown."[16] Including Bingham's work in the exhibition of American Masterpieces at Boston in 1983, Stebbins acknowledged his major role as one of the major American genre painters of the nineteenth century and designated him as "an archetypal American painter."

In their enthusiasm for his paintings, all of these writers ascribe to Bingham an intention that rarely if ever appears in the documentary evidence of his life. It is true that Bingham sought to portray the America—or part of the America—of his day, but he was not attempting to set forth myths or archetypes. His intentions, as pronounced on two different occasions, were much more down-to-earth. His riverboat scenes and election pictures, he stated, assured "us that our social and political characteristics as daily and annually exhibited will not be lost in the lapse of time for want of an Art record rendering them full justice."[17] His goal then was to capture the social and political, cultural and ideological character of his world. *Fur Traders* and *Concealed Enemy* did look back in time, but the rest of his works of the 1840s and 1850s portrayed a West that was shaping itself through economic development, through the establishment of educational and cultural institutions, and above all through political debate and political processes. Time and again reporters in the Missouri press remarked on how lifelike his pictures were and on how ably he captured the character of boatmen or politicians. In his river subjects he left a picture of the society and economy of the West, the labors and leisure of the boatmen, and the lives of the woodcutters who served the steamboats. His election scenes provided an image of the activities of western citizens as they engaged in and listened to political arguments, as they participated in the democratic process. He rooted these images in the Missouri he knew, yet as he gained a national reputation he began to consider the election pictures in particular as national in character. Later in his life his intentions in some of his post–Civil War paintings became more overtly polemical, "to perpetuate a record of events [and to] . . . give due warning to posterity."[18] His later paintings, he felt, were as valuable as history itself, painted to provide lessons about the past that could help citizens and statesmen make decisions in the future. Both of his pronouncements about his paintings, then, clearly indicated that he thought of his art not simply as a mirror of what the West and westerners looked like but as a record of social and political characteristics and of contemporaneous events. In all his major figurative paintings he was more interested in what his vision of the West *was* when he painted it than in what it might have been in its mythical past. The mythic or archetypal qualities that scholars have found in Bingham's pictures have existed more in their own minds than in the mind and work of the artist.

Of course, the West that Bingham recorded was the particular West that he inhabited and that he wanted to see develop. His West was a settled world that had grown out of the commerce of the early fur traders and out of the settlements of the early pioneers. It was a place of families with ties to the land, of cultivated fields, of domestic animals, of towns. It was a place of

commerce, where men labored hard to carry on trade on the river, to sustain the steamboats that plied the waterways of Missouri. It was a place where the political process was taken seriously, where men gathered to hear political arguments and to express their opinions at the polls. It was a place that fostered educational and cultural institutions that later would become his patrons, places such as the University of Missouri and the Mercantile Library in St. Louis. Bingham did not turn to the Far West, as Catlin and Bodmer did, to record the life of the native American or the face of the untamed wilderness. Instead his riverboatmen headed for port, his citizens and politicians argued issues of national import, and his state capitol garnered portraits of national heroes like those in Washington. His Missouri had its own sectional interests, but it was firmly a part of the established Union. And when that Union was threatened, he recorded the splintering of his vision in the hope that posterity could learn and recover the principles and ideals that had been temporarily lost.

Most of the scholars writing about Bingham have acknowledged his interest in politics, but only a few have explored his political career in relation to all of his art. The monographs by Rusk, McDermott, and Bloch treated Bingham's political career as a fact of his life, and they provided valuable information drawn from nineteenth-century newspapers and letters. All three scholars also connected Bingham's political activity with certain of his works, quite obviously with the political banners he had painted in the 1840s, with his election series of the early 1850s, and later with his polemical *Order No. 11.* In the wake of their books, scholars like Barbara Groseclose, Robert Westervelt, and Gail Husch undertook more specialized studies, looking into Bingham's political affiliations with the Whig party in an attempt to read the Whig message in those same works.[19] All of these authors provided valuable readings of a handful of Bingham's paintings, those that dealt overtly with political or polemical subjects.

In this book I propose to push this approach still further. All of Bingham's figurative paintings were embedded in an active and ongoing political life, and it seems unlikely that he was able to forget his political concerns when he took up the paintbrush. However much he protested at times that he wanted to be nothing more than a painter, he was unable to do so in Missouri. He was not an artist, who sat on the sidelines and occasionally used political symbols like log cabins, coonskins, or cider barrels. When viewed in context, his paintings take on far richer, associative meanings. At different levels—sometimes latently, sometimes patently—his major figurative paintings express a profoundly political sense of his particular world.

A close reading of Bingham's political activities and views illuminates and gives deeper meaning to the major figurative works that occupied him in

each decade of his life. His riverboat paintings of the 1840s presented a haunting picture of life in the days of westward expansion, to be sure, but they also testified to Whig economic and cultural goals in Missouri, particularly to the importance of commerce on cleared rivers carrying civilization into the wilderness. His election paintings of the early 1850s mirrored the democratic process in the West, true, but they also spoke of fundamental beliefs in the open expression of the will of the people, at a time when major political decisions that affected Bingham and his fellow Missourians were made behind the closed doors of the legislature. His proposed series of the border ruffians of the late 1850s would have illustrated local history, yes, but would also have captured Bingham's outrage at the travesty of the election process in Kansas and the conflict he felt would lead to civil war. Just on the eve of that conflict, his portraits for the Missouri capitol championed national statesmen who had revered the Union, and the pictures themselves became spokesmen for the preservation of the Union. And after the war his portrait of Nathaniel Lyon, his *Order No. 11,* and *Major Dean in Jail* transformed events of Missouri history into deeply felt expressions of the artist's beliefs in liberty, property, and the duty of every governmental official to guarantee those rights.

The associations that Bingham's works evoke, the overt and covert messages that one can read in them, seem clear today as one surveys the written record he has left and the whole of his oeuvre. But it should be stressed that, apart from the early political banners, the political content of his other works moved from latent and associative messages early in his career to overt statements corroborated by his own writings later on. This is hardly surprising, as the audience for his work also changed in the course of his lifetime. When he first branched out from portraiture to figurative paintings, he exhibited them in Missouri, but his market was an eastern one. Whatever connections there were between the subjects of his riverboat paintings and imagery he had used on Whig banners—that may have been recognizable to his small and predominantly Whig audience in Missouri—went unnoticed in the East. In New York the Art-Union and eastern critics responded positively to his American subject matter, and for a time he enjoyed a certain success there. After the publication of one of his compositions as a print, he rose to national attention and began to sell a few works outside New York, in St. Louis and at the Cincinnati Art-Union. In the early 1850s, however, he decided to seek a larger audience. Publishing prints of his major works, he felt he could sell them across the nation and turn a profit that was more substantial than what he could earn on the sale of a single painting. As he moved into this new realm he took pains to assure that his local scenes had details that made them national in character. With engravings of his election pic-

tures in particular he wished his portrayal of free people and free institutions to reach across the land. Throughout the 1850s his quest for a national audience paralled his desire for patronage from the federal or state government. When Washington failed to award him a commission, Missouri recognized her adopted son and in the second half of the 1850s offered him major commissions for state portraits. As the nation began to splinter, Bingham had to draw back from a national audience and address a more local one, the legislators in the Missouri General Assembly, who heard a speech stating quite clearly what Bingham's political intentions had been in those portraits. In the 1860s he went even further and provided a full written account of the meaning of *Order No. 11,* a work that circulated widely as a print in Missouri but failed to reach the national audience Bingham had hoped for. Latent and associative meanings in his earlier works for the general eastern market yielded to quite specific and acknowledged meanings directed to particular audiences in his later works.

All the writers, from 1847 to the present, then, are correct in their assertions that Bingham is an utterly American painter. But he is an American painter not solely because he chose American rather than European subjects, not solely because he recorded what western America looked like or what Westerners did. He is American—and Tocqueville would have found him so—because he embued his scenes with the essence and concerns of the particular American political culture in which he lived, an American political culture of a particular time and place, within the rules and confines of particular laws and institutions that he and many of his fellow citizens cherished. His works were embedded in the particular American cultural character of his day—in region, in partisan political ideas, in a certain view of race and gender. As an official in Missouri state government, as a writer published in the Missouri press, as a citizen active in Missouri partisan politics, Bingham brought to his paintings a broad understanding of his particular regional culture. And it is the particularity of the message of his art that this book sets out to explore. In the end, Bingham was a quintessentially American artist precisely because he was "The Missouri Artist."

1

Portrait of the Artist as a Young Whig

Down, down with the rulers who've
ruined the land,
Who have crushed all our hopes with a
merciless hand;
The men who would make our loved
country the same
As serf-peopled Russia, or tyrannized
Spain,
Who would rule our loved land with
imperial sway,
And give for our labour but sixpence per
day, —
VAN BUREN, BUCHANAN, and Benton, the
knaves—
Such are but fit to be rulers of slaves.

Arouse, then, ye freemen, at Liberty's
call!
Arouse, in your glory, and out with them
all!
Already they falter, altready they reel;
The signs of defeat they're beginning to
feel;
One blow from your hands lays them low
in the dust,
Arise in your ardour, and conquer you
must;
Then be true to your country, to principle
true,
And bold Harry Clay will be faithful to
you!

—"The People's Rally," Whig Campaign
Song for Henry Clay, 1844

In 1846 George Caleb Bingham, widely known as the Missouri Artist, chose to run as a Whig to represent Saline County in the Missouri General Assembly (fig. 1). His friend, Whig editor William Franklin Switzler,[1] took note of

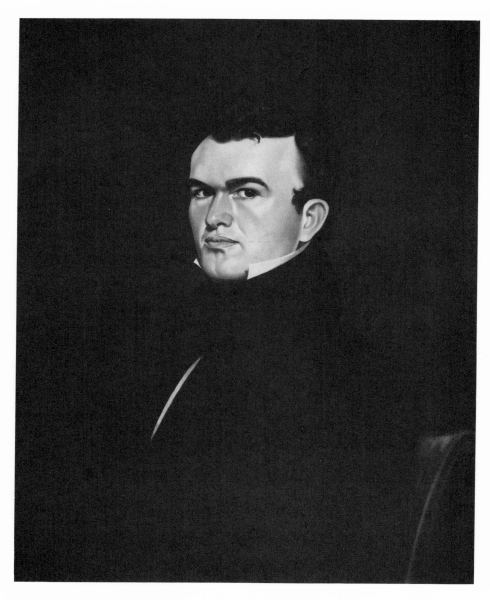

1 Self Portrait, *1834–35, oil on canvas, 28 × 22½ in. St. Louis Art Museum, St. Louis. Purchase: Eliza McMillan Fund.*

both vocations in announcing Bingham's candidacy on the pages of his Columbia *Missouri Statesman* (fig. 2): "Geo. C. Bingham, Esq., the Missouri Artist, is a candidate for the Legislature in Saline County. Mr. B. is not only a faithful painter of 'the human face divine,' but he also has powers of exposing on the stump and canvass the monstrosities of Loco-focoism. He is a whig

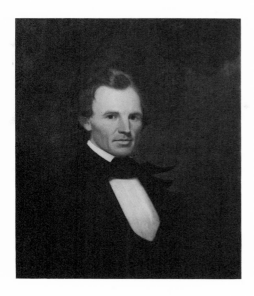

2 William Franklin Switzler, *1849, oil on canvas, 30 × 25 in. Missouri Historical Society, St. Louis.*

'dyed in the wool.'"[2] Switzler was simply telling central Missourians what they already knew—Bingham was both an artist and a politician, just as adept at making images as at lambasting the Democrats, who were commonly known in Whig circles as Locofocos. The editor of the *Boonville Observer* echoed Switzler when he declared that Bingham was "*as true* to nature, too, in his portraitures of Locofocoism, as of the human face divine."[3] In the opinion of his fellow Whigs, the Missouri Artist knew as much about the political fabric of his state as he did about the faces of his fellow citizens.

At age thirty-five Bingham was well on his way to success as an artist. In the preceding year the American Art-Union in New York had purchased and exhibited six of his paintings, figurative works and landscapes that were different from the portraits that earned him a living in Missouri. He had begun his career as a portraitist, plying his trade at first among the gentry of central Missouri, where he lived, and then by 1835 in St. Louis, where he set up a studio. With his marriage to Sarah Elizabeth Hutchison in 1836 and the birth of their first son, Newton, in 1837, family responsibilities spurred him to develop his career. In the winter of 1836–37 he even ventured outside of Missouri, traveling south with his wife to Natchez in search of commissions. But as his world broadened, so did his ambitions. He encountered other artists and artworks in St. Louis and began to experiment with subjects other than portraits. When he was in St. Louis in 1835, he painted copies after other works. One of these was a picture of Thomas Sully's Fanny Kemble as Beatrice, which Bingham took after a print in *The Gift* for 1836.[4] Two others were landscapes with "bufaloe hunts of our western praris—they are

thought by those who see them to be superior to the original paintings from which I coppied them."[5] Bingham was clearly impatient to break out of the mold of provincial portraitist.

To do so, however, he knew he had to go east. "The greater facilities there, for improvement in my profession, would be the principle induce-ment," he wrote in 1837. "There is no honourable sacrifice which I would not make to attain emminence in the art to which I have devoted myself."[6] The East had academies of art where one could study, museums where one could view great works of the past, galleries where contemporary artists could exhibit their works, and even building projects that promised commis-sions to talented painters. There he could continue training his eye by copy-ing other works of art. There, too, he might find different markets for his works. So in 1838 he journeyed to Philadelphia, where he "obtained a little knowledge of color by looking at pictures which before he had no oppor-tunity of studying," as he told the interviewer who wrote up the earliest sketch of his life.[7] While in the East he collected "a lot of drawings and en-gravings, and also a lot of casts from antique sculpture which will give me nearly the same advantages in my drawing studies at home that are at present enjoyed here."[8] The trip east, then, opened his eyes to artists' pal-ettes, to the methods of the academy, and to the great works of the past, but it did not secure him a market. The one work he exhibited at the Apollo As-sociation in New York, *Western Boatmen Ashore,* failed to receive any criti-cal notice.[9] Armed with his prints and casts, the artist returned home in 1838 to his wife and child in Boonville, to immerse himself once more in the cultural and political life of the central part of Missouri.

It was then that Bingham's involvement in Missouri politics began in ear-nest. Through his close friend James Sidney Rollins, Bingham was first drawn into the Whig circle then beginning to pull together a party in the state (fig. 3).[10] The two men had met in the spring of 1834, and since then their friendship had blossomed with Rollins at the outset helping Bingham obtain commissions for portraits.[11] Rollins was in an ideal position to do so, for he had a wide circle of acquaintances in Columbia. Not only was he the editor of an anti-Democratic newspaper there from 1835 to 1840, he also took an active role in pursuing matters of interest to fellow Missourians. His commitment to economic progress and internal improvements made him a leading member of the first railroad convention in St. Louis in April 1836. A few years later he ran for the state legislature on an anti-Democratic plat-form but failed to obtain a seat. Just a year after Bingham's return from the East, Rollins joined with others in the autumn of 1839 to form a state Whig party. In the elections of 1840, he finally succeeded in capturing a seat in the state General Assembly and began a life in state and national government.[12]

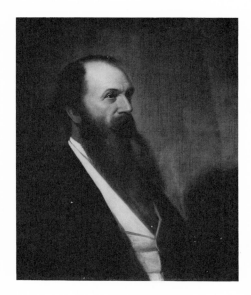

3 James Sidney Rollins, *1871, oil on canvas, 33 × 30 in. State Historical Society of Missouri, Columbia.*

The surviving correspondence between Bingham and Rollins bears witness to a tie between the two based firmly on a commitment to Whig principles. "Yours in the bonds of Whiggery" closed one of Bingham's letters to his friend, but it was a salutation implicit in every other one.[13] There is nothing to document the exact date of Bingham's entry into the Whig party in the state, but it is clear that his involvement began soon after his return from the East in 1838, as the party began to consolidate.[14] Through Rollins, Bingham met Switzler, who bought Rollins' Columbia newspaper and transformed it into the voice of Whiggery in central Missouri. By 1840 Bingham had earned the respect of the leaders of the party and spoke often at party gatherings.

That Bingham became fascinated with politics at the end of the 1830s was hardly surprising. The whole political sphere in America had come to life in that decade with the reestablishment of the two-party system. Andrew Jackson's imperial presidency had sparked the formation of the Whig party, whose very name cried out opposition to a tyrannical executive. Whigs also decried the tightly disciplined organization of Martin Van Buren's newly forged Democratic party. In Missouri Whigs opposed Jackson and Van Buren at the national level but more importantly joined battle at the local level against the monolithic presence of Senator Thomas Hart Benton.[15] Benton had represented Missouri in the Senate since statehood and, as an avowed and devoted follower of Jackson, had formed a powerful Democratic party that dominated the state for decades. A lawyer and former newspaper editor, Benton was well connected with the professional classes in St. Louis yet also able to reach out to the common people that Jackson had cham-

pioned. Against such adversaries the Whigs of Missouri faced an uphill battle. Never numerous enough to dominate politics in Missouri, they nonetheless formed a small and vociferous group that sparked discussion and in some cases action on issues that concerned them, specifically internal improvements and public education. They also formed a tightly knit group who knew each other and supported fellow party members throughout the state.

To formulate their ideas, the Missouri Whigs looked toward the programs and the rhetoric of the great national Whig leader, Henry Clay.[16] Clay's American System, which promised economic growth throughout the country, was of particular interest to them.[17] Arguing the interconnectedness of all interests in the United States, Clay advocated a balance between agriculture and commerce, support to home industry through protective tariffs, and federal funding of internal improvements—roads, canals, rivers, and railroads—that would link all parts of the nation together. As vociferously as Clay advocated the American System, he strongly opposed the hard-money policy of the Democrats and the Independent Treasury Bill that decentralized the banks. Always longing for the rechartering of the National Bank, Clay pushed for a credit system that he felt would favor commerce. It is hardly surprising that Clay's views should have appealed to Missouri Whigs. Most of them were landholders, businessmen, and professionals who were drawn to his program of economic development.[18] Living predominantly in the counties along the rivers, they were also concerned with commerce. They approved of Clay's American System and joined him in criticizing the tyrannical executive power first embodied in Andrew Jackson and the strict party control that Martin Van Buren had perfected and that Thomas Hart Benton exerted in their own state. Along with his fellow Whigs in Missouri, Bingham looked to Clay's speeches for a rhetoric and an articulation of his own political ideas. The artist-politician's later pronouncements about political issues were to ring with Clay's style, even as they appropriated the substance of Clay's ideas—on the bank, on economic development, on opposition to excess power lodged in the hands of the president. But this is jumping ahead in his career.

Toward the end of the 1830s, Bingham turned to Whiggery for personal as well as ideological reasons. He had felt the effects of Van Buren's fiscal policies in 1837, when he had been unable to redeem the bank notes he had received in payment for portraits in Natchez. Writing to Rollins he had blamed the current financial crisis on "the interferance of the government with the established currency of the country, and to the Treasury circular."[19] Resenting the impact of Democratic policies on his own income, Bingham began to move toward the Whig party.

A Banner, a Speech, and a Letter, 1840–41

About a year after his return from Philadelphia, Bingham had the op-
portunity to conjoin his interests in art and politics. Whig leaders invited
him to speak at the major Whig rally to be held at Rocheport. There he
shared a platform with Rollins and other central Missourian notables, like
the lawyer Abiel Leonard, who had challenged long-term Democratic Sen.
Thomas Hart Benton for the Senate in 1838, and A. W. Doniphan, also a law-
yer whose distinguished military career in the Mexican War later catapulted
him into prominence.[20] The massive gathering brought to Missouri the fever-
ish Log Cabin Campaign for William Henry Harrison then spreading across
America (fig. 4).[21] At Rocheport, Whigs from all parts of the state gathered
for parades, speeches, and feasts. In blistering heat relieved by only a few
showers, close to a thousand of them demonstrated support for their candi-
date for president, marching in procession with distinctive banners pro-
claiming their allegiance. The banner committees of the Tippecanoe Clubs
from both Boone and Saline counties had requested paintings from Bingham,
but he had been able to satisfy only the Whigs of his own county.[22] Among
the multitude of banners displayed at Rocheport, newspapers reported that
Bingham's for Saline County "appeared to excite the most interest."[23]

The banner was a hefty one, apparently carried on four poles by several
men, with different scenes related to Harrison and the Whig party on no less
than four sides. Newspapermen praised it, providing the only descriptions
known of this work that has long since vanished.[24] On the front appeared a
monumental representation of Harrison on a marble pedestal "at the base of
which lies the contribution [Constitution], mechanical and artists' instru-
ments. On the right of the pedestal, a farm in the distance, with agricultural
implements in front. On the left, a vessel discharging freight with others sail-
ing in the distance."[25] Inscribed on the pedestal was a summation of the
Whigs' national goals: "Commerce, Agriculture and the Arts, in union we
will cherish them." American flags and another inscription identifying Har-
rison as "One of the People" completed this image. The sides of the banner
showed scenes tied to the candidate—the battle of the Thames and the log
cabin on a farm that had become the hallmark of his campaign.[26] In the ban-
ner Bingham touched on many of the issues that interested Whigs in this
fervid campaign that attempted to rival the Democrats' appeal to masses of
people. The log cabin and the inscription "One of the People" were calcu-
lated attempts to out-Jackson the Democrats and to create the impression
that Harrison sprang from humble origins. On the front the inscription on
the pedestal and the images of commerce and agriculture around it were al-

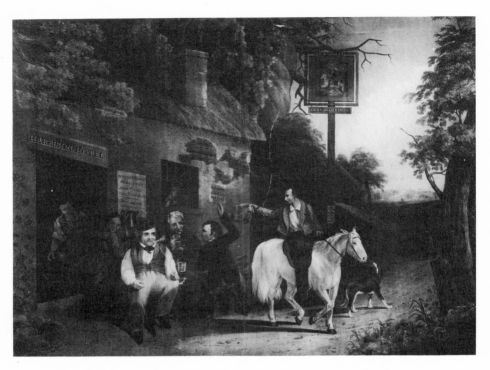

4 *J. T. Bowen,* Log Cabin Politicans, *after a painting by William Hall, 1841, lithograph. Museum of History and Technology, Peters Collection, Washington, D.C. Smithsonian Institution Photograph, No. 60400A.*

lusions not only to Whig economic goals but also to the national unity they hoped their policies would foster.

On the fourth side of the banner Bingham deliberately placed an image he intended to contrast with the picture of economic prosperity presented on the front. The reverse showed "a river scene, with a canoe—the sun breaking forth from the clouds in the distance, diffusing a warm and mellow light over the scene." Creating images appropriate for a Whig audience in Missouri, Bingham must have intended the canoe to represent the early days of trade on the western rivers as an anticipation of the crowded and prosperous shipping scene promoted by Harrison and the Whigs on the front of the banner. In the whole banner, then, Bingham praised the particular candidate as he also asserted the party's beliefs.[27] Moreover, he gave a specifically western accent to the message by including a river scene familiar to all Missourians.

The artist knew just what points to stress in the political banner, and the Whigs of Saline County who patronized him recognized his expertise, as did other central Missourians. Bingham's reputation as an adept in Whig imag-

ery was such that Thomas Miller of the Boone County Tippecanoe Club not only sought the artist's services in painting a banner but also asked for advice about appropriate content. Unable to provide Miller with a banner, Bingham nonetheless proffered advice, stating that his own imagery for Harrison's campaign depended on "the inspiration of the cause, to furnish appropriate devices and inscriptions."[28] A few years later, when Bingham campaigned for himself, the Whig press in the central part of the state continued to laud him as a committed party member, "intimately acquainted with the political history of his country."[29]

What Bingham set forth on the banner then was not simply a visual eulogy of the particular candidate but a well-informed picture of the promise of the American System. Especially in the inscription on the front of the banner he emphasized aspects of Clay's program, with its balance between agriculture and commerce and its stress on union. In alluding to the place of the arts and by extension of civilization in the Whig vision, furthermore, Bingham picked up a theme adumbrated by other Whigs. His visual point was a subtle reminder of views like those expressed by Reverend Horace Bushnell of Connecticut: "The sooner we have railroads and telegraphs spinning into the wilderness, and setting the remotest hamlets in connexion and close proximity to the east, the more certain it is that light, good manners, and christian refinement will become universally diffused."[30] In a similar vein, but with more subtlety, Bingham's banner set forth the nexus between economic progress and civilization. Speaking at the Rocheport rally where his banner was carried, Bingham undoubtedly expounded on the principles he had illustrated.

Though there is no record of Bingham's Rocheport speech, there is a published record of a political speech he gave just a few months later in the heated campaign for Harrison. That speech demonstrates just how closely Bingham modeled his views on those of party leader Henry Clay.[31] In August back on the stump Bingham presented Whig principles to his fellow citizens in Arrow Rock. Arguing specifically against the Independent Treasury Bill that President Van Buren was then pushing through Congress, Bingham not only presented his views on that matter but also launched a broad attack against Van Buren's tyrannical and iron grip on the Democratic party. Bingham salted his harangue with topical allusions of interest to Missourians, but he took the principal line of his argument and even some of his wording from a speech Clay had given on the Sub-Treasury Bill earlier in the year.[32]

The Independent Treasury Bill, also known as the Sub-Treasury Bill, was designed to bring fiscal stability to a shaken economy. By removing governmental funds from pet banks and placing them instead in government sub-treasuries located in major cities throughout the country, Van Buren

hoped to safeguard those funds and to assure that that money would be used only for public purposes and not as the working capital of private banks. With greater governmental control over the funds, government officials were to be paid in specie. The Whigs were skeptical, and Bingham voiced his party's doubts as he drew upon Clay's speech on the bill. Bingham paraphrased Clay when he argued that the Independent Treasury "increases to an almost indefinite extent, the already overgrown patronage of the executive, and lodges in the same hands, both the purse and the sword of the nation."[33] Developing this theme, Bingham reminded his audience of the lessons of history, as Clay so often did. Other republics had fallen because tyrants had abrogated the rights of the people and had invaded the treasuries. Bingham brought forth Clay's favorite specters—Philip of Macedon, Caesar, Cromwell, and Napoleon—to prove his point.[34]

For Bingham and his fellow Whigs, Van Buren and the Democrats were likely to join the ranks of these tyrants in history. Bingham argued that the Democratic Independent Treasury Bill threatened one of the basic tenets of Whiggery—the responsibility of government to guarantee a citizen's property. Boldly espousing a principle that he would cling to throughout his life, he stated: "it is the existence of [free rather than tyrannical] government alone which gives security in the possession of property."[35]

At the end of his speech, Bingham broadened his argument to attack the executive power of Van Buren, as Clay had done in his speech on the Sub-Treasury Bill earlier that year. According to Bingham, Van Buren had appointed to high office only those people who would carry out his own wishes, thus "exhibiting his *innate* contempt for the people." Moreover, Van Buren had removed from office those who had the independence of mind to vote as their constituencies desired and against him—"And we charge him with exercising his questionable authority, as becomes only a tyrant, by punishing honest public servants . . . for presuming to exercise the rights of freemen."[36] Contrasting freemen with those who had to kowtow to party discipline, Bingham also criticized the tyranny of a party that substituted the will of the party for the will of the people. In a sweeping conclusion to his attack on Van Buren, Bingham voiced for the first time a principle that would remain dear to him throughout his life. "Gentlemen," he said, "strict obedience to the will of the people, is by all acknowledged to constitute the vital principle of a republic."[37]

Bingham's speech in August 1840 then was not only a critique of the Independent Treasury Bill but also a Whig attack on Van Buren's control over the Democratic party. Moreover, two of the ideas that Bingham would cherish through his life—the independence of free men and the sanctity of the will of the people—surfaced for the first time there. Once Harrison was elec-

ted later that fall, Bingham would expatiate on these ideas in a letter to his good friend and fellow Whig James Rollins.

After the excitement of the Harrison campaign ended, Bingham decided to take advantage of the Whig victory and move to Washington, where he hoped to make a name for himself. He yearned for a success larger than that which he enjoyed in central Missouri, particularly among the local gentry. At age 29, responsible for a young wife and child, he began to realize that he could not forge a profitable career in Arrow Rock, where he had bought property and built a house in 1837. However much he was interested in the political life of Missouri, however eagerly he had participated in the Rocheport convention, he knew that his art was what would pay the bills. In December then, Bingham set off with his family for the nation's capital, where he remained for almost four years.

Bingham undoubtedly hoped that the city dominated by a Whig administration would look with with favor on the works of a Whig artist. He set up a studio in the Capitol and undertook portraits of some of the nation's notables, hoping to establish a national reputation. On at least one occasion, he exhibited a work in another genre, a copy after John Vanderlyn's *Ariadne,* surely a sign that he wanted more important commissions like the one Vanderlyn himself had received to fill one of the coveted spaces in the Rotunda of the Capitol.[38] This ambition for official patronage—and that it was apparently not forthcoming in Washington—led him to write to Rollins in December 1840 about obtaining a commission from the Missouri legislature for portraits of Washington, Jefferson, and Lafayette modeled after those on view in the nation's capital.[39] His request came to naught, but it did reveal something of the artist's circumstances. However firm his resolve to succeed as an artist in the East, it was easier to revert, for commissions, to the people who knew him in Missouri.

In fact, Bingham in Washington was somewhat out of place away from his circle of Whig friends in Missouri. He and his wife, as she wrote a friend back home, were the only Whigs in their boarding house.[40] Yet despite his lack of partisan contacts in Washington, Bingham could not disengage from the political scene in Missouri.

Nothing better reveals this ambivalence than a letter Bingham wrote to Rollins in February 1841.[41] In the body of the letter, Bingham made statements that, on the surface, seemed to show him signing off from politics— and they have been interpreted as such. He had been once to the Senate "only to hear Mr. Clay and was prompted more by a desire to hear the great orator, than by any interest which his subject itself afforded." He avowed to Rollins that he knew "less of the proceedings of Congress than if I were in Missouri, the fact is I am no politician here," he confessed. "I am a painter

and desire to be nothing else." Scholars have often cited these passages as evidence of the artist's lack of interest in politics. In fact, the letter, taken in its entirety, shows just the opposite.

When Bingham wrote Rollins from Washington that he was "no politician here," he clearly made the point that *there* in Missouri he *was* in fact a politician. His three-page letter, in fact, burst with commentary on the Missouri political scene. Although he was distant and removed when he discussed political activities in Washington, he was feisty, sarcastic, peppery, and involved when he turned to Missouri politics. He bemoaned Rollins' "nauseating report of the doings of our *sage* patriotic Jeffersonian Democratic Locofoco legislature," and he baldly labeled the lawmakers' activity as "tyrany" and intolerable "Locofoco impudence." Later in the letter he took uncommon delight in an appointment that he knew would discomfit Missouri's longtime Democratic senator and state party leader, Thomas Hart Benton. Bingham ended with a gleeful query: "How do the Locos generaly stand their using up in Missouri? they are as raw all over here as if they had been blistered from the crown of the head to the sole of the foot." His statement that he wanted to be nothing but an artist was qualified in the clearest terms: "*unless* another corrupt dynasty, like the one that has just been overthrown, shall again arouse the energy of the whole people in behalf of a suffering Country, I shall be content to pursue the quiet tenor of a painters life" (emphasis added). One of the most remarkable aspects of this early letter, and the most anticipatory of his later attitudes, is that Bingham embedded this statement of his desire to be only a painter in the thickest of political discourse. As he denied political involvement in one breath, he embraced it in the next. Bingham made clear to Rollins in 1841 that, to combat the Locofocos he so detested with their corruption, tyranny, and threats to liberty, he would leave his quiet painter's life and enter the political fray.

The letter is remarkable for another reason. It contains the fullest statement of Bingham's Whig principles. Ironically, this declaration appeared immediately after his protest that he was no politician in Washington. Pleased with the election of a Whig president and discounting the Democratic view that there was dissension in the Whig ranks, he went on to offer his definition of his party's principles. In so doing he echoed the speech he had given just a few months earlier in Arrow Rock, though in this letter to Rollins he was unequivocal that it was Whigs that he considered freemen. The Democrats, he said, "seem to forget that the whigs are freemen, and not like themselves bound to model their thoughts to correspond with the wishes of a master. We differ, as men ever will differ who enjoy the consciousness of freedom, but are a unit in opposition to the men who would dare deprive us of the *right* to do so, and I trust we shall never fear to exercise this privilege

for which we have been so long contending against the dictation and pro-scription of an unscrupulous party." In this assertion of individual freedom,[42] Bingham spoke directly against Van Buren's advocacy of "substituting *party principles* for *personal preferences.*"[43] Instead he echoed the words of William Henry Harrison: "'Freemen! Remember! That, to maintain your lib-erties, you must do your own voting, and your own fighting.'"[44] Bingham had seen the tight party system that had evolved under Van Buren, a system that he himself had openly criticized in his Arrow Rock speech the preceding Au-gust, modeling his stance on the ideas of Henry Clay. Here Whig ideology became the personal credo that would last him a lifetime. He condemned tyranny and corruption of any sort. He decried the arbitrary use of power to coerce, whether the coercion was intended to establish a firm party line or to push through decisions or bills within a legislature controled by one party. In his concern with fair and open discussion, with differences of opinion, he also spoke for the free expression of the will of the people. Above all Bing-ham cherished liberty that, together with life and property, stood at the very foundation of American life.

The banner of June 1840, the speech of August 1840, and the letter of February 1841 stood at the beginning of a lifetime of political involvement. Yet even as all three demonstrated Bingham's utter familiarity with Whig ideology and his affirmed commitment to the party, they also suggested subtle differences in the ways he would conjoin art and politics in his life. In the East, the letter of 1841 suggested, Bingham tried to pursue his career as an artist without actively entering politics. In Missouri, the Harrison banner and speech at Rocheport demonstrated, Bingham found an easier coexis-tence of his two interests. At home he could count on the support of friends and patrons who understood him.

Surely it was this pull that drew Bingham back to Missouri in the sum-mer of 1844. His four years in Washington had yielded disappointingly few commissions. They had also been hard for his family. After the death of his son Newton in the winter of 1841 in Washington, his wife and their second son Horace spent at least one winter in Arrow Rock.[45] She longed to return permanently to Missouri, and even Bingham wrote nostalgically of Arrow Rock. His son Newton, he wrote in 1841, "would rather have fallen asleep in a little corner of his little garden at Arrow Rock, about which I can almost fancy his spirit now lingers."[46] For her part, Sarah Bingham took pleasure in writing about her "acquaintances and friends, and . . . all the news of Boon-ville and Arrow Rock."[47] Later in 1843 she even asked her husband about living in Arrow Rock: "It would be hard for me to tell now," he responded, "when we shall want our house to dwell in ourselves, I fear it will be many years first, unless a great change should take place in my pursuits and feel-

even proposed a fourth banner, which he explicated, providing some insight into his choice of imagery. For the content of these works he drew on his earlier banner for Harrison, as well as on Clay's speeches and current campaign literature. For his portraits of Clay he took into account the state portraits he had seen in the east, as well as those reproduced in books or single engravings. As in the Harrison banner, he consciously contrasted—on the obverse and reverse of two of the banners—scenes illustrative of the civilizing progress envisioned by the Whigs with scenes before the coming of that civilization.

That Bingham thought quite carefully about intended meanings is obvious in a proposal he made to Rollins. The artist's good friend was then on the banner committee of the Boone County Clay Club, thus in a position to offer him a commission.[58] Having shared the platform at Whig conventions with Rollins, Bingham wrote to him quite directly about the political implications of the imagery he proposed. "I would suggest for the design as peculiarly applicable to your county, old Daniel Boone himself engaged in one of his death struggles with an Indian, painted as large as life, it would make a picture that would take with the multitude, and also be in accordance with historical truth. It might be emblimatical also of the early state of the west, while on the other side I might paint a landscape with 'peaceful fields and lowing herds' indicative of his present advancement in civilization."[59] Bingham's opposition of the early state of the west, represented by Boone fighting with an Indian,[60] with man's present advancement in civilization, represented by a landscape with cattle, recalled the contrast he had made in the Harrison banner—the early days on the river on one side with prosperous shipping scenes on the other. Here, too, he clearly implied that it was the Whigs who would bring about the present advancement in civilization.

His choice of Daniel Boone, though not directly related to Whig ideals, was appropriate for Boone County. For his image of the renowned pioneer he undoubtedly would have conjured up the portraits of Boone he had seen when he worked as a boy with Chester Harding,[61] or possibly even the tavern signboard of "Boone in a buckskin dress" some say Bingham painted early in his career.[62]

The artist's concern with appropriate subject matter also surfaced in a banner he actually executed for the members of the Juvenile Clay Club of Boonville. This one was by far the simplest of the three he painted, and it is the only one that has survived. On the obverse, Bingham painted Henry Clay as a boy, returning from the mill with a full sack of ground grain (fig. 5). On the reverse, now lost, he painted "a little fellow carving the name of Henry Clay," according to a contemporary newspaper account.[63] In the surviving portion of the banner, a winsome lad astride a roan horse rides boldly for-

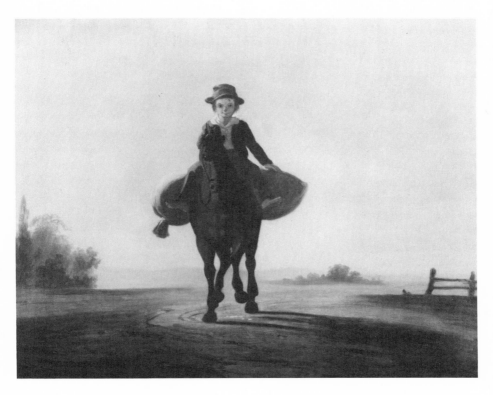

5 Henry Clay as the Mill Boy, *1844, oil on canvas, 37½ × 46¾ in. Private collection.*

ward out of the picture. He looms above a flat nondescript landscape, broken only by two copses and an insignificant fence. Warm sunlight bathes the scene from the left. In its central composition, warm color, and raking light, the work stands in the closest relation to an earlier genre work that Bingham had submitted to the National Academy in 1842, *Going to Market* (fig. 6).[64] Yet, if he drew formal inspiration from his own earlier work, he drew the subject matter from contemporary Whig literature.

In that campaign year of 1844 Clay's humble origins and ties to the soil were common themes, calculated to rival the Democrats in their appeal to the common man as carefully as had been the tie between Harrison and the log cabin in 1840. Biographies painted a picture of Clay's modest origins in Hanover County, Virginia, and described the circumstances that left the boy and his brother with few resources at an early age. A typical account appeared in *The Clay Minstrel, or National Songster,* dedicated to "The Clay Clubs throughout the United States." John Littell, the author, wrote: "Frequently, has HENRY CLAY, clad in the coarsest apparel, and with bare feet, ploughed the live-long summer day. . . . In the performance of his multi-

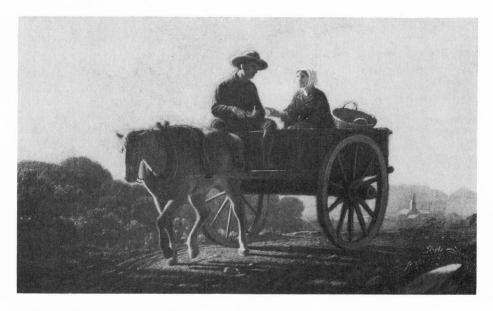

6 Market Day *or* Going to Market, *ca. 1842, oil on canvas, 14⅝ × 23¼ in.*
Virginia Museum, Richmond. Museum purchase: The Williams Fund, 1979.

farious labors as a farmer's boy, he has often ridden to the mill with grain,
his sole equipment in harmony with his own humble appearance, being a
rope bridle, and his seat, in lieu of a saddle, the bag containing the grist of
the flour, which he brought upon his return."[65] As Littell had described him,
so Bingham painted the mill boy using a grain bag for a saddle. The artist
emphasized the boy's straitened circumstances, showing him with worn
clothes, bare feet, and a tattered hat.[66] If Bingham had not seen *The Clay
Minstrel* that Clay Clubs received throughout America, he must have known
other similar material engendered by the campaign.

Indeed, his painting seems a slight variation on the painting by J. G.
Chapman of Henry Clay as the Mill Boy. Chapman's painting, widely diffused
as an engraving (fig. 7), showed the youthful Clay in a broad-brimmed hat
using a grain sack as his saddle. Looking directly out of the picture, Chap-
man's Clay rode across a bridge to the right with a mill visible in the dis-
tance. Bingham's banner shares the direct outward gaze and the oversized
grain sack, but the Missouri artist turned the horse and rider toward the
viewer and eliminated the mill in the background, thus focusing attention
on the youthful Clay. Nonetheless, his work does have undeniable affinities
with Chapman's work, which was circulating during Clay's campaign for
the presidency.

Yet another banner, for the Whigs of Cooper County, emphasized Clay's

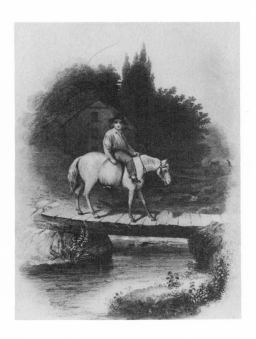

7 *Anonymous,* Henry Clay as the Mill
Boy, *engraving after painting by J. G.
Chapman. Collection author.*

attachments to the soil, showing "him as the plain farmer of Ashland," as
Bingham reported in the letter to Rollins. Given the size of the banner that
Bingham recorded, seven by eight feet, one must imagine a full-length por-
trait of Clay in front of his home near Lexington, a building widely re-
produced in contemporary books on Clay like the *Clay Minstrel* or in edi-
tions of his speeches. If the obverse presented Clay as a simple farmer, the
reverse symbolically captured his aspirations. It showed "an Eagle perched
on a high, immovable rock," recalling similar images on campaign banners
and medals.[67]

The third banner Bingham executed, for the Howard County Clay Club,
carried the most explicit political meaning, presenting the promise of the
American System, as had the earlier Harrison banner. Bearing a full-length
portrait of Clay on the obverse, it demonstrated the artist's utter familiarity
with Clay's program and his speeches. The *Boonville Observer* thus de-
scribed the banner:

> On one side . . . our noble champion is represented advocating the
> "American System." "All the great interests" of America are here repre-
> sented. On one hand is a fortress with our National flag waving above it;
> on the other, and to the rearward is the ocean, crowded with shipping,
> and farther in the front is a farmer with his plough, a railroad, a number
> of [. . .] manufacturing establishments, the capital and other national

buildings, while Mr. Clay, with his hands extended toward them, exclaims in his own impressive manner, "All these great interests are confided to the protection and care of government!" . . . On the reverse side of the banner is represented a prairie, in its uncultivated state, with a herd of buffalo racing across it.[68]

Here again, as in the banner proposed for Boone County and the one for Harrison, the artist contrasted the earlier "uncultivated" state of the West with the prosperity and progress Clay's American System promised to bring.

Demonstrating his utter familiarity with Clay's rhetoric, Bingham deliberately chose to quote almost verbatim from one of the great Whig leader's earliest speeches on the American System—"All these great interests are confided to the protection and care of government!" Clay delivered that line in his speech "On American Industry" in 1824, arguing in favor of a protective tariff to encourage American business. In that early formulation of his American System, Clay urged the necessity of his program in order to preserve harmony within the nation. Toward the end of his speech he summed up: "Mr. Chairman, our confederacy comprehends, within its vast limits, great diversity of interests; agricultural, planting, farming, commercial, navigating, fishing, manufacturing. No one of these interests is felt in the same degree, and cherished with the same solicitude, throughout all parts of the union. . . . But *all these great interests are confided to the protection of one government*—to the fate of one ship; and a most gallant ship it is, with a noble crew" (emphasis added).[69] The entire Howard County banner, obverse and reverse, suggested that the American System advocated by Clay and the Whigs would extend economic progress to the whole of the nation and thereby unite the country. In quoting that particular speech, Bingham was surely acknowledging to his fellow Missourians the urgency of certain sectional needs that the American System would address. In Bingham's imagery, Clay's program would transform what had formerly been prairie filled with buffalo, seen on one side of the banner, into a landscape dotted with prosperous farms and factories, traversed by railroads, and bounded by waterways crowded with shipping, seen on the other.

The Howard County banner had formal ties to Bingham's own earlier works, as well as to the work of others. The reverse must have recalled the artist's earliest forays into western landscape, the paintings of buffalo hunts he had made in St. Louis in 1835. On the other hand, the crowded formal portrait on the obverse surely reflected Bingham's knowledge of earlier portraits of the great statesman as much as it did the artist's awareness of Whig ideology. The association of Clay with ships and ploughs was commonplace, appearing in such campaign promotions as the *National Clay Almanac* pub-

lished in Philadelphia in 1844.[70] But Bingham's composition of a figure towering over buildings, landscapes, and seascapes apparently was quite a specific elaboration of a major portrait of Clay painted just two years earlier by John Neagle (fig. 8).[71] The original that went to the Union League in Philadelphia had spawned progeny, ranging from skilled engravings by John Sartain to needlepoint banners by unnamed artisans, any one of which Bingham could have known.[72] Neagle's majestic Clay stood within a neoclassical building surrounded by scenes and objects, among them a globe draped with an American flag, an anvil, and a vista of a landscape with plough and cattle giving way to a seaworthy ship silhouetted against the sky. To the flag, ocean, and farm of Neagle's painting Bingham added railroads, factories, government buildings, and even Clay's own words. In Bingham's hands, the restrained message of the Neagle portrait became a specific plea for the statesman's American System.[73]

In this instance there is clear evidence that Bingham's patrons intended just such a message, with a stress on commerce and internal improvements. In fact, A. J. Herndon, active in the Howard County Clay Club, wrote quite specific instructions that Whig leader Abiel Leonard was to pass on to Bingham. "We have been thinking of having one 6 ft by 8, 'Old Hal' on one side with something representing internal improvements, commerce &c &c. On the other side, an Eagle and Howard County."[74] Not wishing to tie the artist's hands, however, Herndon suggested: "Perhaps it may be best to give Mr. Bingham authority to make just such a banner as he may think best."

In the end Bingham clearly collaborated with his patrons but at the same time made his own contributions to the imagery. The obverse of the Howard County banner with its reworking of Neagle's portrait of Clay clearly spoke to the issues of development that Herndon and the banner committee wanted. But since Bingham had already used an eagle on the Cooper County banner, he made a much more telling image for the reverse of the Howard County one. He deliberately contrasted the commercial and economic prosperity fostered by the American System under Clay with what had preceded it in the West, an untamed prairie filled with buffaloes.

The banners certainly brought Bingham to the attention of Missouri politicians of both parties. Accounts of the Boonville convention in the Whig press singled out his works as noteworthy features of the elaborate procession. Yet the Howard County image, on view with the others in the courthouse after the rally, so stirred the Democrats that someone defaced it. "Our opponents must be very much pushed for some method of venting their spleen against Mr. Clay and the Whigs when they resort to such meanness," wrote a reporter for the Whig *Boonville Observer.* "Mr. Clay was presented as delivering one of his most eloquent and patriotic speeches in behalf of the

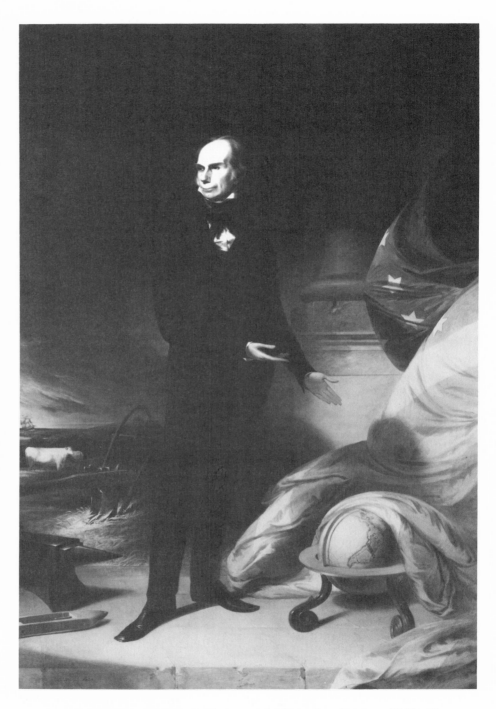

8 *John Neagle,* Henry Clay as the Father of the American System, *1843, oil on canvas, 108 × 71 in. U.S. Capitol Collection, Architect of the Capitol, Washington, D.C.*

American interests; and while so doing he is now represented as being as-sassinated!"[75] It can be no accident that the Democrats chose to attack the banner that carried the most explicit political meaning with its clear refer-ence to Clay's speech, "On American Industry."

In his illustrations of Clay's policies Bingham stressed the positive goals of the Whig campaign and deliberately omitted certain other pressing issues. Nowhere did he attack James K. Polk, nor did he even paint the poke stalks that alluded to the Democratic candidate on other banners. Nowhere did he refer to the expansionist policies of the Democrats that were a part of their platform, as some of the other Whig banners did. For example, the Boone County banner committee, that had turned down Bingham's sugges-tion for a banner showing Daniel Boone, opted for a direct reference to Polk's desire to annex Texas. One side of that banner showed Polk in a wagon under a banderole bearing the inscription "Bound for Texas," and be-neath the words "The enemies of the Union within the Union—may they an-nex themselves to Texas, the sooner, the better."[76] In contrast Bingham chose not to belabor Whig opposition to the annexation of Texas and stressed instead the development of lands already settled. In this emphasis he stood firm with the party and with such views as those voiced by Horace Greeley: "Opposed to the instinct of boundless acquisition stands that of In-ternal Improvement. A nation cannot simultaneously devote its energies to the absorption of others' territories and the improvement of its own. . . . Vainly should we hope to clear, and drain, and fence, and fertilize, our useless millions of acres, at the same time that we are intent on bringing the whole vast continent under our exclusive domain."[77] For Bingham and for fellow Whigs in 1844, development of settled lands far outweighed the need to expand.

On his return to Missouri from Washington, then, the banners gave Bingham the opportunity to demonstrate to a large group of central Mis-sourians his knowledge of partisan politics. In these banners he poured out his Whig concerns in an effort to carry Missouri for Henry Clay. In 1824 a substantial majority of the popular vote in the state had gone to Clay. What a disappointment twenty years later when Polk easily took the state on his ex-pansionist platform. Expansion had triumphed over development, and Bing-ham and his fellow Whigs in central Missouri had to wait another two years before they could mount another campaign for Whig principles. They could take some satisfaction, however, that the election of 1844 had brought about a small rift in the Missouri Democratic party. Thomas Hart Benton's opposi-tion to annexation had split the party, making it possible for a certain num-ber of expansionist anti-Benton Democrats to enter the General Assembly. The end result was a three-factioned legislature—with Whigs, Benton

Democrats, and anti-Bentonites participating. It was this legislature that would consider a commission for Bingham later in the session.

For the moment, however, the painter had to hope that his banners had demonstrated his artistic skills. The quality of the surviving banner shows what care Bingham must have taken with all of them. They were a form of advertising for the Missouri artist just returned from the East. Potential commissions might well hang on their success. Here was an artist who could handle monumental portraits of statesmen on the order of those by Easterners like John Neagle and on the order of those Bingham had proposed to Rollins in 1840 for the Missouri State House. Here was an artist who could venture beyond portraiture to paint charming and sentimental scenes like the *Mill Boy,* evocative western landscapes filled with buffalo and panoramic views of farms, factories, and notable buildings. And the banner committee of Boone County also knew about his proposal for a historical portrait of Daniel Boone. Bingham still seemed determined to break out of the mold of simple bust portraitist. A few months later he made a move that would help him to pursue that goal.

State Portraiture and History Painting in Jefferson City

When the legislature convened in mid-November 1844, Bingham moved to the state capital, his artistic career apparently unaffected by Clay's defeat. Earlier in his life, when the artist had wanted more clients, he had gone to seek them among St. Louis gentry. This move to Jefferson City put him, instead, in close contact with legislators. Before the legislative session was over, Bingham had painted impressive portraits of some of the governmental officials and, more importantly, had come within a hair of obtaining a commission for a history painting from the state. His proximity to the lawmakers had almost paid off.

Of the many portraits that a Jefferson City reporter saw in Bingham's studio in December 1844, one seemed to him "most perfect indeed." [78] It was a full-length portrait of the newly elected Democratic governor of Missouri, John C. Edwards (fig. 9). Though less than three feet high, the portrait is impressively monumental. [79] Edwards faces forward, clad in a voluminous dark cape that is entirely silhouetted against the brightness of sky. High above the horizon, he stands on a bluff above the Missouri River, the newly completed statehouse visible behind him to the left against the evening sky.

Bingham here departed from his usual bust portraits of Missouri gentry to create a striking full-length portrait of a statesman, bound to tradition in its heroizing association of figure with sky and in its significant choice of setting. The general composition of figure towering over landscape recalled

9 John C. Edwards, *1844, oil on canvas, 36 × 29 in. Missouri Historical Society, St. Louis. (neg: Por E–23)*

Bingham's own Howard County banner of Clay. But the artist undoubtedly also intended to evoke those portraits in Washington he had offered to copy for the Missouri statehouse in 1840. One of these was Ary Sheffer's portrait of the Marquis de Lafayette, which had been on view in the Capitol since 1824 (fig. 10).[80] The Revolutionary War hero, clad as a simple citizen, stood

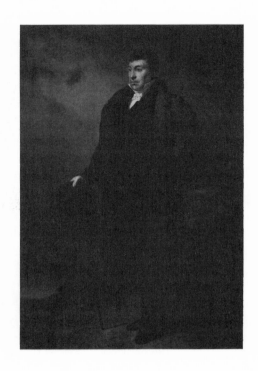

10 *Ary Sheffer,* Marquis de Lafayette,
*1823, oil on canvas, 92 × 62 in. U.S.
Capitol Collection, Architect of the
Capitol, Washington, D.C.*

bold against the sky yet at the same time graciously doffed his hat for the
viewer—in these two ways a precedent for Bingham's figure. But Edwards
stared straight out at the viewer, in this respect closer to the slightly more
frontal *Lafayette* by Samuel F. B. Morse for the city of New York, as Bloch
and Gerdts have suggested.[81]

A pentimento enlarging the dome and substructure of the capitol in-
dicates that Bingham considered this building an important part of his
composition. In its close association with Edwards, it was more than a mere
indication of locale in Jefferson City. Indeed, in 1844, the capitol had be-
come something of a political problem.[82] Begun in 1837 after a design by
A. Stephen Hills, the structure was functional in 1840 but hardly finished. In
that year the Ways and Means Committee of the General Assembly declared
it was "imposing on the outside but a rough skeleton inside." Efforts to allo-
cate funds for its completion in 1842 came to naught, and by 1843 the state
had defaulted on its payments to contractors. One of the tasks facing
Edwards when he took office in the fall of 1844, then, was to see to the build-
ing. Otherwise critics might succeed in their efforts to change the location of
the state capital.[83] Surely Edwards—and probably Bingham, too—intended
the building in the portrait to assert the imposing character of the neo-
classical edifice, as well as to support the rightness of the choice of Jefferson
City as the capital.

With this impressive portrait, Bingham made a persuasive argument that he could produce an admirable series of state portraits for the state-house like the one he had proposed to Rollins in 1840. Even better would be a commission for a history painting on the order of those that had been commissioned for the Rotunda in Washington not long before Bingham moved there in 1840.

Within two months of the opening of the state legislature, the matter of just such a commission for the Missouri artist came up in the senate. If Bingham had hoped his stay in Jefferson City would win him further work, he must have been more than satisfied. The proposed commission raised him to the rank of history painter.

The joint resolution, introduced to the senate by William Fort of Randolph County, authorized "the Governor to contract with G. C. Bingham to paint a historical picture," specifically an image of Andrew Jackson submitting to the court in New Orleans.[84] First brought before the senate on 21 January 1845, the resolution was tabled and then resubmitted in mid-February:

> Be it resolved by the General Assembly of the State of Missouri, that the Governor of the State be authorized to contract with Geo. C. Bingham for a historical picture, representing the arraignment of General Andrew Jackson before Judge Hill of the district Court of Louisiana.
>
> Said picture to embrace the portraits, life Size, of the principle actors of the Scene, to be executed upon a scale of magnitude sufficient to extend over one of the large spaces, now vacant, upon the right or left of the Chair of the Speaker of the house of representatives, and to cost, when completed, a sum not exceeding one thousand dollars: which sum, or any part thereof, shall not be considered due, until the picture shall have been approved and accepted by a future legislature.[85]

A thousand dollars for a painting must have seemed an astronomical sum to Bingham, who just a few months earlier had received only $50 for the Howard County banner of Clay. Late in March the bill arrived in the house and passed on Saturday, March 22. Among those voting in favor were all the representatives from Rollins' county, including Democrat Sinclair Kirtley, who had served on the Boone County banner committee, and two legislators that would play an important part in Bingham's life, the Democratic speaker of the house, Claiborne Fox Jackson, with whom Bingham would lock horns in the legislative session of 1848–49 and later during the Civil War and a Whig from St. Louis named Hamilton Gamble, who would appoint Bingham as state treasurer during the Civil War.[86] Among the Democrats supporting the motion were anti-Bentonites who had defected from Benton's tight-knit party ranks during the campaign of 1844. Claiborne Jackson was one of

these anti-Bentonites, and he joined Representatives Gamble and Finch in speaking "of Mr. Bingham as a highly honorable gentleman, and a native artist of great excellence. It was giving encouragement to a gentleman who had been raised among us, and would do the subject great credit."[87] Through the weekend, then, Bingham must have been riding high, only to crash on Tuesday, March 25, when the senate narrowly defeated the bill, 15 to 11.[88]

The commission was a significant one for Bingham. Not only would it have raised him to the rank of history painter and fully demonstrated the esteem in which he was held by fellow Missourians of both parties, it would also have provided him the opportunity to tackle a compelling subject, to use his art to teach a lesson. As an advocate of Whig liberty and freedom, Bingham must have been delighted to compose a scene of the triumph of civil over military authority, a scene of restraint imposed on General Jackson, whom most Whigs had long considered a despotic tyrant.

The incident to be represented had occurred near the closing days of the War of 1812, when Andrew Jackson confronted Judge Dominick Hall in the District Court of New Orleans. In the tense days when peace was pending in Europe, Jackson had declared martial law and had arrested a local journalist on charges of inciting American troops to desertion. When a local judge issued a writ of habeas corpus, Jackson refused to comply and had the gall to detain the judge and remove him from the city limits. Charged with contempt of court, Jackson had to appear before Judge Hall and pay a fine of $1,000, which he funded out of his own pocket, refusing to let the people of New Orleans pay the fine for him. Judge Hall thus clearly defended the rights and liberties of the individual, and in particular the principles of habeas corpus and of freedom of the press.[89] The incident became the paradigm of the supremacy of civil authority over the military. And it was Jackson's appearance before the judge to pay the fine that was chosen as a subject by the General Assembly.

It was not surprising that this scene was on the minds of lawmakers early in 1845. From 1842 on Congress had thrice debated a bill to repay Jackson's fine. It was a Missouri senator and staunch supporter of Jackson, Lewis Linn, who first introduced the bill. The issue, of course, was not remuneration but exoneration, as Jackson made clear in a letter to Linn. A battle between Whigs and Democrats ensued not over the fine itself but over issues of civil versus military authority, individual liberties versus the public good. Defeated in the twenty-sixth and twenty-seventh sessions of Congress (1842–43 and 1843–44), the bill to repay Jackson finally passed in the twenty-eighth, early in 1844.[90]

Late in the debate a senator from Louisiana had made the suggestion that a painting of Jackson in the court at New Orleans be commissioned for

the Rotunda. Showing "the warrior fresh from the field of battle, in his military dress, bowing in submission to the decree of the Court," the image could stand for the Democrats as an example of the humility of their revered leader. Not so for the Whigs. Whig Representative David W. Dickinson from Jackson's own state gave his interpretation of the message of the scene: "Thus teaching posterity by his example, that great truth—which they should not fail to learn, which should be deeply impressed upon their hearts, and which lies at the basis of our institutions—'*that the military should always be subordinate to the civil authority.*'"[91] Even if the fine were repaid, the Whigs did not want to exonerate Jackson; instead they wanted to find a great civic lesson in his submission to civil authority.

It was not quite a year later when the Missouri legislature took up the issue of a painting of this scene. Since Bingham had been in Washington during the debate about refunding the fine, he may even have been the one to suggest the subject. Democrats could hardly refuse an image of their great leader. One of their number, James Morrow, thought the whole incident was "one of the sublimest moral spectacles of the times."[92] And Whigs could find the subject a compelling illustration of the triumph of civilian over military authority, as Senator Dickinson had. As it turned out, there was bipartisan support for the commission in the Missouri house, but some of the Democratic votes came from anti-Benton men. The followers of Benton whose admiration for Jackson was unbounded probably joined together in the senate to defeat the bill. Bingham would have to wait more than three decades to receive a commission for this very same subject from the state government.[93]

Implications of This Year for the Future

In December 1844, when Bingham completed his portrait of Edwards standing above the statehouse and the Missouri River, little did the artist know how much of his future was contained in that painting. Bingham would for a time descend the hill to examine life on the river. He would climb back up the hill and take a seat in the statehouse, and later he would record the political processes that elected the representatives of the people who sat there. Eventually he would receive commissions for full-length state portraits to hang in that building. And ultimately in 1877, he would receive the commission from the legislature for the same history painting that was denied him there in March 1845.

Far from being unproductive time between Bingham's Washington years and his first riverboat painting, the fall and winter of 1844–45 were busy and had profound implications for his careers both as an artist and as a politician. In those months he was a Missouri artist in close association with the

Missouri political scene—with the Whigs for whom he painted banners and with the legislators of both parties, both those who sat for him and those who almost gave him a commission for a history painting. Living for much of that time in Jefferson City Bingham was in daily contact with Missouri politics. If he had felt himself "no politician" in Washington, he certainly was more at home politically in the state capital. Surely he was confident and forthright enough to lobby for votes for the state commission. Given his firmly established political convictions, it is easy to imagine him discussing the moral lessons that the Jackson painting would teach. In those months, he forged bonds with politicians that would carry into the future, either in solidarity with such fellow Whigs as Rollins and Hamilton Gamble or in interlocked opposition to such Locofocos as Claiborne Fox Jackson.

Those months were crucial, too, for his development as an artist. He became accustomed to a way of thinking about art. He endowed the simple vignettes on the Clay banners with charged political meaning, he incorporated symbols into his full-length portraits of Clay and Edwards, and he undoubtedly contemplated the moral lesson inherent in the projected Jackson painting. This way of thinking in symbols and moral messages became second nature to Bingham and filled some of his later, apparently simple works with latent meaning.

The specific works Bingham proposed or executed in those months also had implications for the future. Some of the images on the Clay banners— the mill boy, the farmer of Ashland, the landscapes and seascapes—were essays for his later forays into genre and landscape. The full-length portraits of Clay and Edwards demonstrated the artist's abilities as a state portraitist even as they anticipated the works he would later paint for the state capitol, the Mercantile Library in St. Louis, and the University of Missouri. The proposed Daniel Boone with the Indian manifested Bingham's interest in historically accurate images of the West, even as it prepared for his *Concealed Enemy* of 1845 (fig. 12) and *Daniel Boone Escorting Settlers through the Cumberland Gap* of 1851 (fig. 21). Finally the defeat of the commission for a historical painting strengthened Bingham's convictions to prove himself as a history painter. The Jackson painting anticipated the future in another way, too. The theme of the defeated commission—the triumph of civil over military authority and the defense of citizens' rights—became one that would haunt Bingham and would return overtly much later in his life in his attack on arbitrary military authority in *Order No. 11* of 1865–68 (figs. 57, 58, 64) and still later in a state commission for another painting of Jackson before the court in New Orleans.

Yet as important as all these works were for Bingham's future, his immediate career took a different tack. The Edwards portrait had not resulted in

commissions for major state portraits. The proposal for a historical painting had failed. At the close of the legislative session in the spring of 1845, Bingham turned his back on Jefferson City and sought other markets. His family had grown with the birth of his daughter Clara in March of that year, and he had to continue to think of earning a living. By June he had set up a studio in the major metropolis of St. Louis, first on Main Street and then on Chestnut.[94] There he sought commissions for portraits, the mainstay of his income,[95] but he also undertook works in a different vein, which he hoped would sell in different markets. An article in the St. Louis *Missouri Republican* announced Bingham's presence in the city and urged St. Louisans "who would have a faithful likeness and a fine painting, to call at Mr. B's studio, over the store of Mr. Forbes on Main street."[96] The author of the article went on to note that Bingham had also brought other works with him—"fancy sketches, and some paintings which demonstrate the possession of a high order of talent in another line, but to which we believe he has not devoted a large share of time." A portfolio of drawings and a few new paintings showed Bingham experimenting "in another line," creating the works he would send later that year to the American Art-Union. In those pictures Bingham picked up some of the themes set forth in his banners for Henry Clay and began to develop his own vision of the West.

2

Bingham's Early Vision of the West

We see a numerous generation of painters rising up around us, in every part of the country. . . . Cincinnati is now swarming with artists. We have painters beyond the Mississippi; some of their works, which any of us might be glad to possess, will be distributed this evening. The canvass is stretched and the pencil dipped amid the solitude of the prairies.

—William Cullen Bryant, Proceedings at the Annual Meeting of the American Art-Union, 1845

By December 1845 Bingham had found a market for his new works, selling four paintings to the American Art-Union in New York. They may well have been the pictures "in another line" that the St. Louis reporter had seen in his studio the preceding June. The paintings that went on view in New York were *Fur Traders Descending the Missouri* (fig. 11), *Concealed Enemy* (fig. 12), *Cottage Scenery* (fig. 17), and another landscape, probably identical with *Landscape: Rural Scenery* (fig. 18).[1] In selecting these subjects Bingham quite calculatedly chose what he thought would please the eastern audience. Indeed the two landscapes would appear to be almost a direct response to the kinds of works that the Art-Union had called for in its annual report of the preceding year. Yet at the same time all four works presented a decided and quite particular view of the West that grew out of the vision Bingham had presented on the political banners he had earlier painted for Missouri Whig audiences. It was a vision that stressed the early history of the West, the beginnings of commerce there and the development of civilization. It was a vision that Bingham would continue to explore and to expand in later years.

At the most basic level, the quartet signaled the artist's serious attempt to reenter the eastern art scene. Bingham had tried his luck before in New York with a variety of subjects sent between 1838 and 1842, but without much success. At the time of his first trip east in 1838, when he was living in Philadelphia, he had exhibited his first painting at the Apollo Gallery, *Western Boatmen Ashore,* now lost. Failing to attract any attention with his scene of western boatmen on the banks of a river, he must have decided two

11 Fur Traders Descending the Missouri, *1845, oil on canvas, 29¼ × 36¼ in. Metropolitan Museum of Art, New York. Morris K. Jesup Fund, 1933. (33.61)*

years later to try other subjects that might be more appealing to the eastern audience. In the spring of 1840, before he moved to Washington, he sent several different works from St. Louis to the National Academy of Design. Among them were *Pennsylvania Farmer,* a landscape, two illustrations of *Tam O'Shanter,* and two pictures of children, one of them a sleeping child. Another rural scene followed in 1842, *Going to Market* (fig. 6), the only one known today.[2] Yet, if Bingham had hoped to attain recognition, he must have been disappointed. Reviewers of the New York exhibitions remained silent on his works. Three years later, in 1845, Bingham must have felt that it was important for him to select subjects that would capture the attention of eastern audiences.

Scrupulously avoiding narrative scenes like *Tam O'Shanter,* sentimental scenes like *Sleeping Child,* and rural scenes like *Going to Market,* he chose instead to send two pairs of loosely related works, one safer, the other more daring. The safer pair—*Cottage Scenery* and a landscape—were rustic pictures with small figures, perhaps recalling the landscape Bingham had submitted to the National Academy in 1840. The more daring pair—*Fur*

Traders and *Concealed Enemy*—took western scenes as their subjects. Formally more adventuresome than the landscapes, these two pictures focused on large figures in the foreground, the fur traders dominating a placid river, the Osage Indian commanding a craggy bluff.

In December 1845 the Art-Union purchased all four paintings.[3] Though the prices the board chose to pay did not come close to the fee mentioned in the failed commission for the history painting in Jefferson City, Bingham must have been pleased with his sale. The board decided on $35 for *Cottage Scenery* and $40 for *Concealed Enemy.* They awarded the highest price, $75, to *Fur Traders,* showing their preference for that work.

His success must have demonstrated to Bingham that he had hit upon the right subjects for his paintings. There were many reasons for his choices. Not the least was the encouragement the American Art-Union gave to scenes that "distinguished this country from all others," scenes of American landscape, scenes of the daily lives of Americans, regional scenes of the South and West.[4] The Art-Union was an outgrowth of the Apollo Gallery, but it had expanded considerably from the exhibition area where Bingham had put on view his first genre work, *Western Boatmen Ashore,* in 1838. Now renamed the American Art-Union, it was an organization that, in 1844, had more than two thousand members spread across the nation. Its purposes reflected its new name. The American Art-Union was determined to purchase and to promote American art and to distribute it throughout the country. The association guaranteed its members an engraving a year and the chance to win one of the works of art in the annual exhibition, awarded by lottery. Through speeches at the annual meetings and later through the pages of their publications, officers and members such as William Cullen Bryant, John Jay, and others, advocated a national art.[5] All four of Bingham's paintings, then, were American subjects ideally suited for the goals of the Art-Union.

Just the year before Bingham sent his works, the Art-Union had practically issued a call for works like the cottage scenery and landscape that Bingham submitted. In the annual report Charles F. Briggs of the Committee of Management had interjected some remarks on the Art-Union's goals to distribute art across the land.

It is the aim of the Art-Union . . . to convey to the abodes of common life works of intrinsic merit. . . . To the inhabitants of cities, as nearly all of the subscribers to the Art-Union are, a painted landscape is almost essential to preserve a healthy tone to the spirits, lest they forget in the wilderness of bricks which surrounds them the pure delights of nature and a country life. Those who cannot afford a seat in the country to re-

fresh their wearied spirits, may at least have a country seat in their par-
lors; a bit of landscape with a green tree, a distant hill, or low-roofed
cottage;—some of those simple objects, which all men find so refreshing
to their spirits after being long pent up in dismal streets and in the
haunts of business.[6]

What could better answer this concern than the two landscapes Bingham
submitted, reminiscent as they were of earlier rustic cottage scenes by the
Dutch or British?[7]

The success of the two western subjects at the Art-Union also cannot
have come as a surprise to Bingham. Just the year before, his fellow St. Louis
artist Charles Deas had sent *Long Jakes—The Rocky Mountain Man*
there.[8] The rugged protagonist of that picture had won acclaim in New York,
described as coming "'to us from the outer verge of our civilization; . . .
[and] as wild and romantic as any of the characters in Froissart's pages or
Salvator Rosa's pictures.'"[9] Deas, educated in the East, had turned to west-
ern subjects in the early 1840s, traveling to the upper Mississippi in 1840
and again in 1841. His portraits of American Indians and pictures of their
life had hung annually at the Mechanics Fair in St. Louis since 1841. In 1845,
he had a studio on Chestnut Street not far from Bingham's, and it is thus
likely that the two artists knew each other. In that year Deas was preparing a
couple of canvases for exhibit at the Art-Union, one for distribution to mem-
bers entitled *The Indian Guide: One of the Shawnee Tribe* and the other
purchased by the Art-Union treasurer George W. Austen entitled *Death
Struggle.*[10] Bingham's Osage thus found a comfortable ally in Deas' work,
which would also hang in the Gallery of the Art-Union in December.

Even before the Art-Union hung these two paintings of American Indians
in their exhibit of 1845, the East had been receptive to such subjects. The
success of George Catlin's Indian gallery in New York had paved the way for
both Deas and Bingham. Between 1837 and 1839 Catlin had exhibited por-
traits of Indians and scenes of their life and had also lectured on his experi-
ences in the Far West.[11] Even if Bingham had not actually visited Catlin's gal-
lery, he might well have heard about its success during his trip east in 1838.

Along with the paintings by Deas and Catlin, there were also publica-
tions that chronicled Indian life and lore. One such example was the work
Scenes in Indian Life, published in 1843 by the illustrator F. O. C. Darley.[12]
Works such as Darley's carried pictorial information about the Indians
throughout the country.

If Bingham expected a favorable reaction in the East to his painting of
the Osage, he had reason to think that his river scene would also be wel-

come. This was the period when moving panoramas of the great western rivers were coming into vogue.[13] Many of them were painted by artists in St. Louis and then sent on tours to the East and even to Europe. John Rowson Smith's remarkable panorama of the Mississippi River had been the first. It was exhibited in Boston and Louisville in 1839–40 and later went on to London. Unrolling before the eyes of paying customers were "views . . . from the Falls of St. Anthony to the Gulf of Mexico, representing 4000 miles of scenery and running through nine States and sixteen degrees of latitude."[14] Such was the popularity of Smith's panorama that other artists followed suit. John Banvard had begun his sketches of the Missouri and the Mississippi in the early 1830s, but he must have been inspired by Smith's success in 1839–40. Visiting St. Louis in 1841, Banvard continued his preparatory sketches and even exhibited a panorama of the city.[15] Samuel Stockwell claimed to have started thinking about his panorama in 1842. By the end of the decade several artists had completed panoramas of the western rivers and sent them touring in the United States and Europe: John Banvard in 1846; Samuel Stockwell, Leon Pomarede, and Henry Lewis in 1849; and M. W. Dickeson in 1850.[16] With the exception of Dickeson, all these artists spent time sketching in St. Louis and on the rivers in the 1830s and early 1840s, and notices of their activities appeared in the local newspapers. The panoramas enjoyed a wide popularity, and Barbara Novak has argued quite persuasively that they affected American landscape painting from the sweeping landscapes of Frederic Church to the quieter horizontal compositions of the Luminists.[17] Surely the horizontal format of *Fur Traders,* moving so smoothly from right to left, also reflects the panoramas. In any event, aware of the popularity of the panoramas in the East, Bingham must have hoped that his *Fur Traders,* like a vignette out of one of them, would satisfy the same curiosity that prompted so many people to visit the exhibition in Boston and Louisville of the earliest of these great moving pictures.

Beyond his desire to satisfy the Art-Union and eastern taste, Bingham may well have chosen these subjects because they were popular as well in St. Louis. In addition to Deas' work and the panoramas issuing forth from St. Louis were local periodicals and books recording the face of the West and its rivers. One of these, *The Valley of the Mississippi Illustrated,* had appeared in monthly numbers beginning in 1841, with illustrations by J. C. Wild and descriptions by Lewis F. Thomas.[18] Bingham's paintings belonged to the same impulse that produced these books, and his *Concealed Enemy* even owed a debt to one of Wild's illustrations.

Inherent in Bingham's choice of two scenes from Missouri's early history may also have been a defiant desire to prove to the doubting legislators his

abilities at rendering "historic truth." Bingham had already manifested this concern in the proposal he made for the Boone County banner for Henry Clay's campaign, an image of Daniel Boone fighting with an Indian. Now he focused that concern on images of the early days of Missouri's history—the French fur traders who had settled the territory, the Osages who had once claimed land south of the Missouri River in the central part of the state. Though he did not choose specific heroic moments in the settlement of the state, he may have had in mind the general category of "settlement of the United States" that Congress had established for one of the paintings in the Rotunda of the Capitol, well underway during Bingham's four year stay in Washington.[19] He may even have dreamed that these works would land him a governmental commission in Washington or elsewhere.[20]

As much as these pictures grew out of Bingham's desire to satisfy the Art-Union, as much as they shared certain affinities with art produced in St. Louis, they also portrayed a particular vision of the West, a vision that the artist developed as he grew to adulthood in Missouri. It was a vision nurtured on the frontier, but never venturing beyond the frontier. It was a vision that grew quite decidedly out of the artist's Whig ideas about development, economic growth, and civilization. Bingham had not traveled to the upper reaches of the Missouri River to record the faces of native Americans living in the wilderness, as had Charles Deas and George Catlin. His pictures were not images of a yet untamed Far West. Instead Missouri was his subject. If an Osage, a half-breed, and a French trapper appeared in two of his paintings, it was because they were part of Missouri history. The Osage had lived in Missouri but had ceded title to their land in the 1820s. The French settlers had intermarried and mined the riches of the land. Bingham did not show the trappers encountering the wilderness but rather presented them heading back to port to sell their goods. The trappers, then, were forerunners of the great fur companies that had spurred the economy of St. Louis. They were the necessary precursors of the civilization that had grown up in Missouri. Even the two landscapes fleshed out Bingham's vision of the West. They showed houses, cattle at pasture, roads cleared, a family scene. In sum, they represented the kind of settlement that Bingham had known in his early days in Missouri and that he felt was essential for the establishment of civilization.

Concealed Enemy

Bingham's painting sets an Osage Indian high on a rocky bluff beneath a vast cloud-filled sky (fig. 12). The spectator shares the aerie, looking down

12 The Concealed Enemy, *1845, oil on canvas, 29¼ × 36½ in. Stark Museum of Art, Orange, Texas.*

with the brave over a river that ultimately flows between bluffs to hazy tree-lined banks in the distance. Highlit from the right by sunrise or sunset, the brave's red body stands out against the dun-colored crag. Yet he is but one small part of the scene and is allied with the landscape as well. The rise of the crag behind him echoes his posture, and the dead tree branch atop the rock even mimics his headdress. His frozen pose, the intensity of his concentration, the tenseness of his legs and arms make him as much a part of the landscape as the blasted stump in the center of the picture. The lush foliage in the foreground and the forest growth in the distance speak of summer, yet two branches of dried leaves among the green ones near the brave hint at autumn and perhaps at the passing of time. Bingham's original title, *Indian Figure * Concealed Enemy,* stresses the figure's action. The brave has abandoned the bow and arrow in favor of the white man's rifle. He lies in wait on the bluff to attack those who are plying the river below.

This was not the first time Bingham had thought of painting Indian scenes. In his proposal for the Boone County banner in 1844, he suggested

Daniel Boone "in one of his death struggles with an Indian . . . [as] a picture that would . . . be in accordance with historical truth." [21] Here he made every attempt at accuracy as he recorded the unmistakable headdress and body paint of an Osage Indian. [22] Bingham's knowledge of Indian lore might well have derived from talks with his father. On his first trip west, Henry Vest Bingham had visited William Clark's collection of Indian objects in St. Louis. [23] The diary he kept also contains descriptions of the various tribes he saw on his journey. [24] Young George might even have had first-hand experience of the Osages—around 1827–28 several hundred of them lived in a village near Malta Bend in Saline County, not far from Arrow Rock. [25] But he could also have drawn inspiration from books then being published on American Indians. In the 1830s and 1840s, Thomas McKenney and James Hall had published accurate portraits of many tribes, including the Osage. [26] What is significant here is that Bingham did not paint a picture that purported to show contemporary Indian habits or ways. He did not journey west as Catlin, McKenney, and Hall had done to record the appearance and dress of the Indians. His work was a historical one that had required historical research.

The picture, after all, looked back in time to the early days of Missouri's history. By 1832 the state General Assembly working with the national government had seen to the removal of all Indians from Missouri. Negating the Indians' land claims, the government had offered them land in the Indian Territory in Kansas, and most of the Osage had left Missouri in the 1820s. The Osage War in 1837 marked the end of their presence in Missouri. [27] A few years later *Concealed Enemy* of 1845 evoked Missouri's past.

For all its historical accuracy, Bingham's picture of the preparation for an attack bears a decided resemblance to narrative scenes produced in this period in St. Louis. In fact, its composition is remarkably similar to the frontispiece of *The Valley of the Mississippi Illustrated,* published in monthly editions from 1841 on. That image (fig. 13), drawn and lithographed by J. C. Wild and perhaps based on a painting by Deas, [28] also evoked the early days of settlement, showing an Indian about to attack a group of settlers. In both images, the brave is on the left behind a blasted tree trunk that juts out toward the right. In both images he is bald with a feathered topknot, and he looks down from his perch at his quarry. In both images dry angular branches reach heavenward out of soft beds of foliage. For all these basic similarities, Bingham made some changes that heightened the psychological drama of the piece. In spite of the title he gave the work, *Concealed Enemy,* what Bingham hides here is the target. His Osage perches high on a bluff like those visible in the distance in Wild's print. He lunges inward toward the tree stump holding a rifle that hints at past dealings with the white settlers.

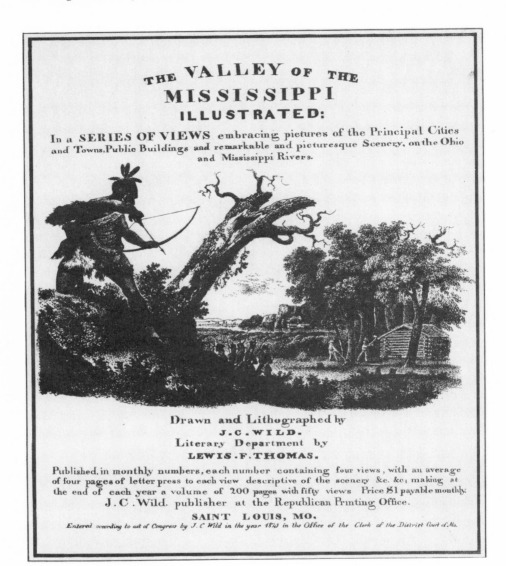

13 *J. C. Wild,* Cover of "The Valley of the Mississippi Illustrated," *1841, lithograph. The Library of Congress, Washington, D.C.*

Given Bingham's propensity for copying after prints, it is not hard to see him taking some elements from Wild and then adapting them to his own purposes. In this instance he may have made changes in this painting in order to complement the other western scene he was painting. *Fur Traders* (fig. 11) may well be the completion or pendant of *Concealed Enemy,* as Henry Adams has suggested.[29] Of exactly the same dimensions and of similar color-

ation, it shows fur traders on a river, perhaps the prey that Bingham so skill-fully concealed in this painting.

Fur Traders Descending the Missouri

In contrast to the craggy rocks, dominant diagonals, and implicit danger in *Concealed Enemy* are the placid river, insistent horizontals, and peaceful commerce in *Fur Traders* (fig. 11). Almost every form in *Fur Traders* suggests calm, in contrast to the tension of the jagged trees and diagonal thrusts in *Concealed Enemy*. The dominant horizontal of the boat finds parallels in the calm currents of the river, in the line of silvery green trees on the banks, and even in the lower layer of clouds scudding above the horizon. Breaking this horizontal insistence are the figures, close to the picture plane, their presence enlarged by the soft form of the island behind them, as well as by their magical reflections in the surface of the water. Though they seem frozen in their communication with the spectator, their movement down-stream toward port is emphasized by the snags, the current, and the flight of birds in the distance. The viewer, like them also on the river, shares the calm of their journey for one brief moment.

Like *Concealed Enemy,* this work is also nostalgic, capturing the early days of trade in the Missouri territory.[30] The French voyageurs had opened up the fur trade in the late eighteenth century and continued into the early nineteenth, plying the rivers in their canoes and pirogues. However, with the advent of larger craft like keelboats, flatboats, and finally steamboats, the fur trade changed, taken over by larger companies who used the new craft to streamline their operations.[31] According to commentators like St. Louisan Wilson Primm, the steamboat, now the symbol of a new era, had earlier aroused "execrations and foreboding of the nervous and hardy *voyageurs,* who felt and knew that the days of the *warp* and *cordelle* and of the *red feather in the cap* were to pass away."[32] In *Fur Traders* Bingham looked back to the days before the change in the fur trade.

Bingham's original title, *French Trader and His Half-Breed Son,* also suggested something very different from the subject of *Concealed Enemy.* Instead of ambush Bingham here presented the early taming of the West by French voyageurs. Here the old world has literally embraced the new. The half-breed son leans toward his father, and both stare out of the picture, as if making a statement.[33] The son's posture and rifle mimic the Osage's in the other work, just as the markings on the blanket echo the Indian's body paint. But these similarities only underline the manifold differences in the two works. The half-breed has adopted the clothes of his French father, his dark

hair hangs loosely over his forehead. He has clearly abandoned the cere-
monial body paint and headdress of his mother's tribe. Moreover, he does
not lie in wait to attack invaders, he uses his rifle for other purposes. To-
gether with his French father, he has conquered the abundance of the land,
and they carry it there in the center of the boat, a duck for sustenance and
furs to trade downriver. Snags behind the boat, almost covered by the flow
of the river, point downstream like signposts, and in the distance a flock of
birds also curves off in the same direction. Just beneath their free flight, a
dark animal sits still, chained in the prow of the boat, as if to symbolize na-
ture tamed. In the background, nature seems to smile. There are no jagged
blasted tree stumps as in *Concealed Enemy.* Instead, clouds of soft green
foliage behind the boat, on the island and on the more distant bank, speak of
early summer as clearly as the haze and relatively high water do. In contrast
with the other picture, there is no hint of autumn here. With light coming in
from the left in *Fur Traders,* one might also wonder if Bingham wanted to
distinguish times of day in the two, showing early morning in this picture and
sunset in the other. Although the winding course of the Missouri makes it
nearly impossible to be sure of this point, the other differences in the two
works would support a reading of contrast.

 Henry Adams was right to stress the ways these two works point toward
each other and yet at the same time contrast with each other. The most no-
table difference he found was in the landscape modes chosen by Bingham—
for *Fur Traders,* a calm, atmospheric Claudian mode, for *Concealed En-
emy,* a more rugged and blasted Salvatoran mode. Not content with mere
formal observation, Adams went on to query why Bingham had chosen these
types of landscape. The Salvatoran mode of the one suggested "the end of
American savagery," Adams asserted, while the Claudian mode of the other
alluded to "the coming of civilization."[34] Citing the contrasts Bingham had
made in the obverse and reverse of his political banners, Adams offered a
reading of the two pictures that was close to the mark, and a more extended
analysis of sources only confirms his conclusions.

 As with the *Concealed Enemy,* it may have been Charles Deas that ini-
tially inspired Bingham's decision to paint the voyageurs. Deas' *Fur Trader
and His Family* of 1845, known in a watercolor sketch and in an oil, has gen-
eral affinities with Bingham's work, as Charles Collins has suggested (fig.
14).[35] Yet the changes Bingham made raised his own work far above the par-
ticularity of Deas'. Bingham chose to show a father and son heading down-
stream to market rather than a large family battling the current in an ascent
of the river. He reduced the number of figures and brought them close to the
picture plane, turning them outward to engage the spectator. Gone are the

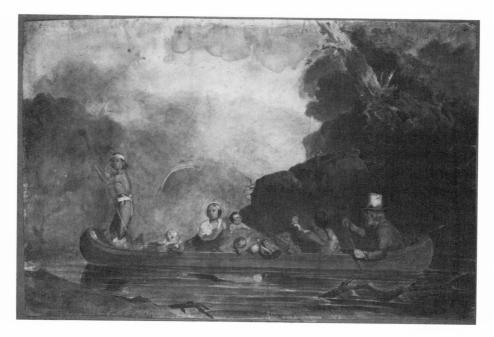

14 *Charles Deas,* The Trapper and His Family, *watercolor on paper, 13⅜ × 19½ in. Courtesy, Museum of Fine Arts, Boston. M. and M. Karolik Collection of American Watercolors and Drawings, 1800–1875.*

craggy cliffs in the background, the numerous threatening snags in a rushing river, the slew of half-breed children, the disordered cargo.

Bingham's calm riverscape suffused with atmospheric haze also differs from Deas' wild landscape, another Claudian-Salvatoran contrast on the order of the one posited by Adams between *Fur Traders* and *Concealed Enemy.* Whether Bingham knew works by Claude or by other artists such as Vernet, his sultry haze and slightly rosy sky create an undeniably luminous riverscape that provides an atmosphere of calm for the trappers who quietly glide toward port.

The monumentality of the figures, their dignity, and straightforward gazes make them very different from Deas' figures and suggest other antecedents, ancestors in the art of the past. After all Bingham had brought back from the East prints, drawings, and casts after the antique to help him in his drawing studies, and his later works show clearly the use he made of these earlier models. In *Fur Traders,* Bloch noted that the figures' insistent outward stares were "somewhat reminiscent of Marcantonio's best known engravings after Raphael," notably the river gods in the *Judgment of Paris* (fig. 27).[36] There does indeed seem to be something of an echo here. But the trap-

15 *Engraving after Raphael,* The Miraculous Draught of Fishes, *detail, published in R. Cattermole,* The Book of the Cartoons, *(London: Rickerby, 1837). Yale University Library.*

pers' postures are quite different from those of the river gods. The juxtaposition of seated and kneeling figures in a low boat recalls more nearly another work by Raphael, his Christ and Peter in the *Miraculous Draught of Fishes* (fig. 15).[37] Not only does Bingham take over these two postures, he also borrows Raphael's simple design for a boat, with curved ends low in the water. This feature of the boat makes it notably different from the square-sterned pirogue actually used by the French trappers, and argues that Bingham was recalling Raphael's boat in his *Fur Traders*. In a later version of the painting, *Trappers' Return* of 1851, Bingham seemed conscious of his mistake and more accurately and less poetically recorded the correct form of the boat (fig. 16).[38] There were reasons that Bingham looked back to specific figures in the art of the past, and these had to do with the latent message he intended his picture to convey.

In this evocation of summer light and haze, Bingham's *Fur Traders* would seem a development of one of his own earlier works—not the painting of boatmen on the banks of the river that he had sent to the Apollo Gallery in 1838 but rather the reverse of the Harrison banner. Indeed, the description of that image could almost double as a description of *Fur Traders*: "A river scene, with a canoe—the sun breaking forth from the clouds in the distance, diffusing a warm and mellow light over the scene."[39] Like the image on the Harrison banner, this painting did not present a current scene on the river but rather looked back to the early days of Missouri history.[40]

The clear association with the image on the Harrison banner provides a

16 The Trappers' Return, *1851, oil on canvas, 26¼ × 36¼ in. Detroit Institute of Arts, Detroit. Gift of Dexter M. Ferry, Jr.*

clue to a broader reading of *Fur Traders.* On that early Whig banner, Bingham intended the canoe on the reverse to stand for early trade on the river as an anticipation of prosperous shipping promised by the Whigs on the obverse. Like the Indian on the proposed Boone County banner, the canoe would have been "emblimatical of the early state of the west" anticipating the "present advancement in civilization" on the obverse. Bingham was not the only voice in Missouri suggesting that the fur traders were the forerunners of commerce and civilization. This is exactly as another Whig, Thomas Allen, described them the following year in a speech on the fur trade. In his conclusion, he praised the benefits of "Commerce, the civilizer, of which the fur trader was the forerunner."[41] Clearly, in Missouri, the French voyageurs who opened up the West with their fur trade anticipated not only the full-blown commerce of the West but also looked toward the establishment of civilization. Bingham's audience in St. Louis would have understood the message of *Fur Traders.* Like the traders eulogized in near contemporary speeches, these men represented the early days of commerce in the West even as they heralded civilization.

 If Bingham's message thus chimed with contemporaneous rhetoric, his formal vocabulary also carried a similar message. His reflections of the art of

the past echoed and reechoed other great civilizations. Marcantonio's insistent outward staring figures in his *Judgment of Paris* after Raphael were, after all, the river gods of classical antiquity. In the Christian era Raphael's tapestry design celebrated the miraculous abundance of fish in Lake Tiberias. Even the mysterious animal in the prow, on whose species critics still cannot agree,[42] may allude to a river of another ancient civilization. It sits like a jackal in the prow of the Egyptian boat of the dead, evoking the Nile, to which the Missouri River was often compared—among others, by Bingham's own relatives, as well as by Lewis F. Thomas, whose *Valley of the Mississippi Illustrated* Bingham may well have known.[43] Bingham's classical composition and monumental calm then convey much more than a record of the early French voyageurs. As the fur traders head toward port, they are forerunners of commerce, they are civilizers related to figures of earlier civilizations. And their river has associations with the major bodies of water of past civilizations.

The forerunners of civilization and commerce in *Fur Traders* and the Osage in *Concealed Enemy* turn out to have far more specific roots than those suggested by Adams. Bingham must have associated the two images with those he had conceived for earlier Whig banners. The Indian brave was a variation of the image on the reverse of the proposed Boone County banner, while *Fur Traders* was a reworking of the reverse of the Harrison banner. Both stood as reminders of early days in the West—the Osage representing the wilderness, the fur traders shown as tamers of the wilderness and forerunners of civilization. In addition to the Whig associations in his choice of subjects, Bingham may also have alluded in subtle details to the history of his adopted state. The name of the state, according to some, derived from an Indian word, *missouri,* meaning "the people who use wooden canoes," and a figure in a canoe had appeared on early currency in the state. The bear, given such a prominent role in *Fur Traders,* was also an important symbol of the state, emblazoned on the state seal since its creation in 1822.[44] The dense associations in *Fur Traders*—with Bingham's earlier Whig banner, with local views about the fur traders as forerunners of civilization, and with well-known symbols of the state—would have seemed obvious to the artist's coterie of friends in central Missouri. In New York it was the quiet beauty of the work and its distinctly American subject that appealed to the board of the Art-Union.

Two Landscapes

The two landscapes that Bingham submitted were not nearly so innovative or distinctive as the other two works, but he may have seen them simi-

17 Cottage Scenery, *1845, oil on canvas, 29 × 36 in. In the Collection of The Corcoran Gallery of Art, Washington, D.C. Museum Purchase: Gallery Fund and gifts of Charles C. Glover, Jr., Orme Wilson, and Mr. and Mrs. Lansdell K. Christie.*

larly as complements of one another (figs. 17, 18). They both had exactly the same dimensions. In both light streamed in from the left, illuminating the foregrounds and calling attention to the central image within the picture— an inhabited thatched cottage in the one and a clearing near a stream where a mother quietly did her washing in the other. Clouds scudded by in a pastel sky over feathery trees that rose to fill in the compositions. The thatched cottage in a landscape recalled similar scenes in both English and Dutch paintings and prints, while the figures in the doorway were reminiscent of Dutch cottage scenes, like those by Adrian von Ostade reproduced in handbooks of art like John Burnet's.[45] Both landscapes also had American antecedents, such as Washington Allston's *Landscape with Rustic Festival* of 1798 and other earlier submissions to the Art-Union.[46] Here Bingham was clearly creating the kind of image that the Art-Union board had called for the preceding December. But *Landscape: Rural Scenery* with its snug cottage

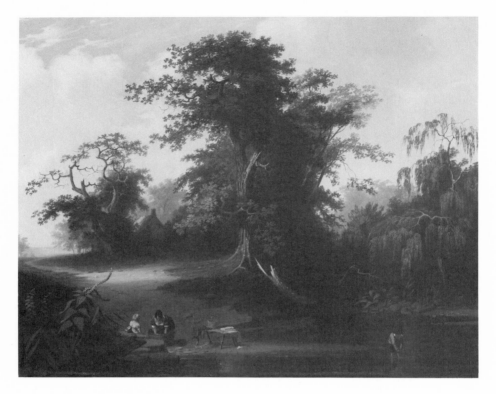

18 Landscape: Rural Scenery, *1845, oil on canvas, 29 × 36 in. Private collection.*

nestled beneath trees was less obviously tied to English or Dutch anteced-
ents. It suggested more nearly a scene in central Missouri. Indeed it may also
have expressed the artist's own nostalgia for the simple life, the life in Arrow
Rock that he was unable to live. The family group with mother and two chil-
dren near a stream undoubtedly evoked thoughts of his wife Sarah and their
children, Horace, then four, and newborn Clara. In 1845 when he painted
this rustic scene, Bingham had made the hard decision to sell some of his
property in Arrow Rock, almost in fulfillment of what he had written his wife
in 1843—"I can be nothing else but a painter, and as a painter, how much
soever I might desire it, I cannot live in Arrow Rock." [47] If these personal as-
sociations were there in Bingham's rustic landscape, they were latent. On
the surface both works seemed tailor-made for the Art-Union.

A close look at the two, however, suggests that they were congruent with
Bingham's own views about development and settlement in the West. In
both, Bingham clearly departed from the buffalo-filled landscapes of the far
West that he had copied in St. Louis in 1835 and that he had placed on the
reverse of the Howard County banner for Henry Clay. He even departed

from the moments of early Missouri history he had painted in *Concealed Enemy* and *Fur Traders.* Instead he created quiet landscapes more on the order of the one he had suggested for the reverse of the Boone County banner. There, to contrast with the image of Daniel Boone representing "the early state of the west" on the obverse, he had proposed "a landscape with 'peaceful fields and lowing herds' indicative of his [man's] present advancement in civilization" on the reverse.[48] In an echo of this idea, Bingham included a view of cattle calmly grazing in the background of *Cottage Scenery.* But that picture illustrated an intermediate step toward the realization of Whig hopes for civilization. The thatched cottage, more a descendant of Dutch and English antecedents, needed repairs, the blasted tree in the foreground stood as a reminder that new trees needed planting. In contrast *Landscape: Rural Scenery* offered signs of earnest settlement. There lush vegetation surrounded a snug and neat home nestled in a grove, forming the background for a mother and her children. Certainly the domestic tranquility of the mother washing clothes while her children played in the stream nearby argued for the kind of quiet industry that supported and nurtured the establishment of settlements and by extension of civilization.

This image chimed with Whig views about progress and the settlement of America, most succinctly summarized by Henry Clay in his speech *On the Public Lands:* Settlers who have been given the opportunity to purchase land, he said, "apply the axe to the forest, which falls before them, or the plough to the prairie. . . . They build houses, plant orchards, enclose fields, cultivate the earth, and rear up families around them. In this way thousands, and tens of thousands, are daily improving their circumstances, and bettering their condition."[49] Clay was here advocating the sale of public lands, arguing that purchasers investing in such lands would settle there with their families, build houses, develop the land, and reap a profit from what they had cultivated before moving on. Bingham here presented a scene of such a settlement, emphasizing the family that had grown up in that place. As much as both landscapes were what the Art-Union had called for, *Landscape: Rural Scenery* also latently set forth a view of the West congruent with Whig views about settlement and family.

Another work, which Bloch attributed to Bingham and dated some time before 1845, also dealt with the importance of families in establishing settlements in the West. *Family Life on the Frontier* was an interior pendant to *Landscape: Rural Scenery.*[50] In a dark room lit only by candle and firelight, a family gathered together around the table. The father read, the mother nursed a baby, while others cleared the table or sat warm by the fireplace. A clock on the mantel and a picture hanging nearby tied the family to time and place, to a world outside the confines of their home. All of the elements

here—family, hearth, book, picture, clock—pointed to the kind of civilized world of settlement, education, and culture that Bingham had known in his youth in Missouri.

Five or six years later Bingham returned to the theme of the settlement and development of the West in works he sent East to New York, *The Squatters* of 1850 (fig. 19) and the painting Bingham referred to as *The Emigration of Daniel Boone* of 1851 (fig. 21). These two works were thematic interlopers in his repertoire of the late 1840s and early 1850s, which focused instead on other aspects of life in the West—commerce in the riverboat scenes and political life in a few scenes of the political process. Instead these two pictures projected ideas about settlement and development that linked them to the works of 1845.

The Squatters, 1850

In this painting, two men and their dog pause—and pose—before their log cabin as they stare out at the viewer (fig. 19).[51] Behind them a woman works at a wash tub outside the cabin, while further in the distance two more men loll beside an open fire, where a cauldron sends forth a cloud of steam indicative of a full boil. From the men in the foreground a diagonal recession sweeps back to the cauldron and then continues over a hill and down toward the river gleaming in the background, that sweep reinforced by a bank of clouds scudding from left into the distance at the right. Two tree stumps at the right stand boldly silhouetted against the distant landscape of green trees, reminders that trees have been felled to create the log cabin. They also act as sign posts that there are other trees waiting to be felled. Though the squatters stand firm before their cabin in poses reminiscent of those used for some of Bingham's riverboat men, the strongly recessional space, the pull of the clouds, and the gleam of the distant river suggest future migration.

Recognizing how different the subject of this work was from others he had sent to the Art-Union, Bingham felt obliged to explain to the board just what he intended in this picture. "The Squatters as a class, are not fond of the toil of agriculture, but erect their rude Cabins upon those remote portions of the National domain, where the abundant game supplies their phisical wants. When this source of subsistence becomes diminished, in consequence of increasing settlements around, they usually sell out their slight improvement, with their '*presentation title*' to the land, and again follow the receding footsteps of the Savage."[52] Bingham here made clear that these people had no intention of engaging in agriculture. Instead of laboring to

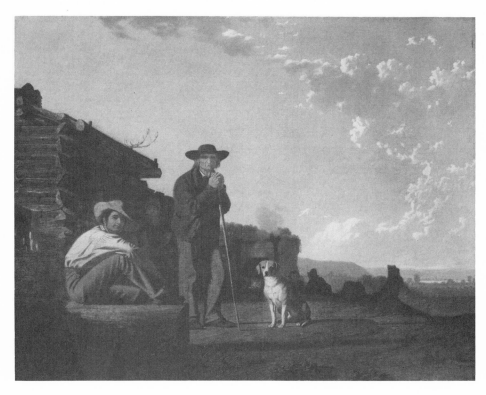

19 The Squatters, *1850, oil on canvas 23 × 30 in. Courtesy, Museum of Fine Arts, Boston. Bequest of Henry L. Shattuck in memory of the late Ralph W. Gray.*

cultivate the land, the squatters lived off its abundance, as the antlers on the cabin make clear. Instead of building permanent dwellings, they made do with hastily built log cabins. Their entire existence depended on the expectation that they would move on westward, following "the receding footsteps of the Savage," leaving only the slightest of improvements behind. These were not the settlers in Henry Clay's speech on the public lands who cleared forests and cultivated land, who built houses and raised families. Bingham showed no children in this painting. Indeed, what a contrast his squatters made with the tranquil family scene in *Landscape: Rural Scenery* (fig. 18), with its well built house and its suggestion of permanent settlement, or with *Family Life on the Frontier,* where the hearth was inside with meals served at table, with a picture hanging on the wall.[53]

They also differed from the protagonists of *The Woodboat* that Bingham submitted at the same time to the Art-Union (fig. 20). He may well have considered the two as pendants, contrasting with each other as *Fur Traders* and *Concealed Enemy* had. In his letter to the board of the Art-Union de-

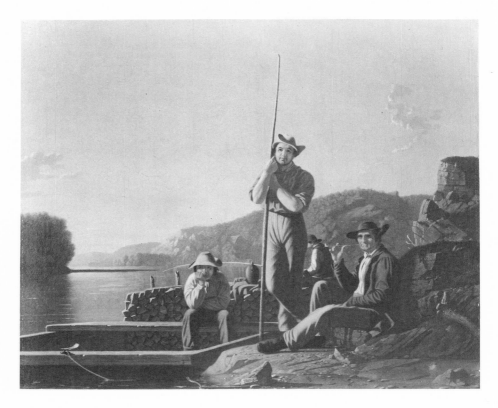

20 The Woodboat, *1850, oil on canvas, 24¾ × 29⅝ in. St. Louis Art Museum, St. Louis. Museum purchase.*

scribing *The Squatters,* he made the point that his woodboatmen were "hardy *choppers* [who] await a purchaser in some approaching Steamer."[54] For Bingham these woodsmen were an integral part of commerce in the West, the first link in a chain of economic connections that bound all Missourians together. He had described that chain in his speech on the Independent Treasury Bill in 1840, linking the woodboatmen with the steamboat captains, the steamboat captains with the merchants, and the merchants with the townspeople he was then addressing.[55] In this painting he celebrated these woodsmen. They had worked hard to cut and stack the wood to fuel the steamboats that forged commerce in Missouri. They were not about to "follow the receding footsteps of the Savage" but were as tied to the river bank as their boat was. The presence of the boy alongside an adult and an old man indicated that this was a generational enterprise, likely to continue into the future. As similar as their poses were to those of the squatters, these men were cut of a different cloth, part of the fabric of commercial civilization making an essential contribution to commerce on the western rivers. In con-

trast with the squatters, they were settled members of the stable and inter-connected society that populated the banks of the rivers in Missouri.[56]

Daniel Boone Escorting Settlers through the Cumberland Gap or *The Emigration of Boone,* 1851

Permanent settlement was also a message that lay beneath the surface of another atypical work that Bingham submitted to the Art-Union board just a year after they purchased and exhibited *The Squatters* and *The Woodboat. Daniel Boone Escorting Settlers through the Cumberland Gap* was Bingham's first history painting, and it is clear he had high hopes for it (fig. 21).[57] He considered "the subject . . . a popular one in the West," and he boasted to Rollins that it had "never yet been painted." [58] He planned to have the painting lithographed and thus diffused to a wide audience. He may even have hoped that the work would one day win him a public commission. Years later, he mentioned to Rollins on more than one occasion the possibility of painting an "emigration of Boone" for the state capitol in Jefferson City or better yet for the Capitol in Washington.[59] Yet, despite his high expectations, the work of 1851 did not have a great success. The Art-Union, up to that time Bingham's most reliable patron, rejected it in April 1851. A contract with Goupil somewhat softened the blow, and local papers, ever loyal to their Missouri Artist, touted the publication of the print as "a high compliment." [60] Nonetheless, Bingham retreated to Missouri to lick his wounds, repainting part of the background in the fall of 1852, when he conceived the idea of raffling off the painting.[61] But the raffle was not a success, and when Goupil finally published the print, the artist felt that it did not embody "the style first contemplated by me." [62] Indeed, the print lacked the dramatic contrast between the highlit band of settlers and the dark threatening landscape sur-rounding them on both sides (fig. 22).

In its conception as a history painting, the work was a dramatic recre-ation of Boone's passage through the Cumberland Gap to settle in Kentucky. The pioneers shone in the darkness of a threatening wilderness, its gloom recalling the dark and bloody ground that would become the very name of the area they were entering. Mountains rose up on both sides, while jagged, lightening-blasted trees appeared like ominous stanchions on either side of them. Through this terrifying pass, the group, bathed in a shaft of light, moved forward toward the viewer. Contrasting with the horrific Salvatoran setting, the figures embodied a classical calm: Boone and his foremost male companion modeled after the classical statues of the *Doryphoros* and the *Jason,*[63] Mrs. Boone in her shawl resembling a Madonna by Raphael. The allusions to quest—for the Golden Fleece or for safety after the Flight into

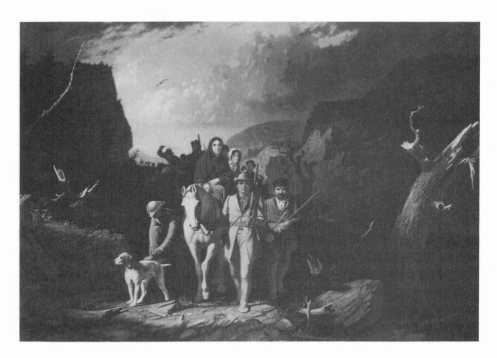

21 Daniel Boone Escorting Settlers through the Cumberland Gap *or* The Emigration of Daniel Boone, *1851, oil on canvas, 36½ × 50 in. Washington University Gallery of Art, St. Louis.*

Egypt—added subtle meaning to the composition. Bingham here represented the pioneers and their families on pilgrimage to the promise of a new life. And their classical poses—contrasting with the Salvatoran setting—bespoke civilization in the midst of wilderness.

The artist was right to characterize his subject as one that had never before been attempted. He chose to treat the moment of settlement when women and children entered the West. His theme was thus entirely different from the painting by William Ranney that Bloch felt Bingham must have seen at the Art-Union in December 1850.[64] Ranney had chosen *Boone's First View of the Kentucky Valley* as his subject, placing six large male figures in the foreground, gazing and gesturing toward the left, toward Kentucky. Bingham instead let it be known that he had drawn on Humphry Marshall's *History of Kentucky,* which recounted the emigration of Boone with five other families.[65]

Settlement was Bingham's theme in this painting, and the title and dedication of his print made this absolutely clear. Entitled *The Emigration of Daniel Boone with His Family from North Carolina to Kentucky,* it assertively bore the inscription, "To the Mothers and Daughters of the West." Not

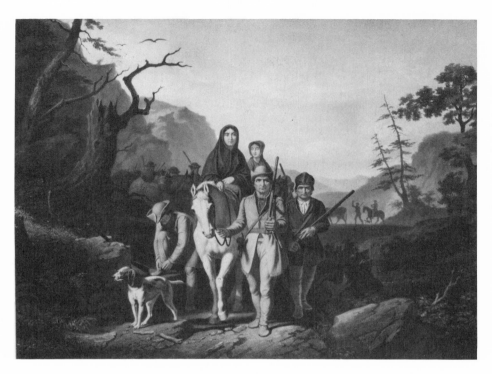

22 *Claude Régnier, after Bingham,* The Emigration of Daniel Boone with His Family, *lithograph, 18¾ × 23¾ in. Missouri Historical Society, St. Louis.*

only did Bingham use the inscriptions to stress the importance of family in settlement, he also used the composition to make the same point, placing the two women at the apex of the compositional pyramid. This particular emphasis on the role of women in the settlement of the West is remarkable, since women appeared only rarely in Bingham's figurative paintings. There were none in his river scenes nor in his election pictures, with the exception of *Verdict of the People.* When they did appear in other paintings of the 1840s and early 1850s, they played traditional domestic roles, breastfeeding or comforting children, serving food, going to market, or washing clothes.[66] In the painting of Daniel Boone, however, Bingham showed women facing the same hardships that their men encountered. In the central role that women played in the composition and especially in the dedication of the print, the artist left no doubt about his view of their significance.

It was not surprising in 1851 that Bingham should have thought of emphasizing the importance of women and families in settling and taming the West. He had subtly done so in the rural scenes he had submitted to the Art-Union in 1845. Now in the Boone painting his message was more overt. He had personal as well as public reasons for emphasizing family and settle-

ment. At the simplest level, his choice reflected his own life. In December 1849 he had married once again, choosing Eliza Thomas as the new mother for his motherless children. Reconstituting a family for Bingham, Eliza would later bear him one son. But beyond the immediately personal, there was another, possibly subliminal reason. The period when he executed the painting also witnessed new emigration—to California—with its promise of new lands, development, even riches. Among the settlers heading west were citizens from Boone County, touted in the newspapers of central Missouri as the "Boone Emigration."[67] If these two are specific personal and local reasons that Bingham might have chosen his theme, there were also more general ones.

For a Whig like Bingham, the mere discovery of new land, as shown in Ranney's painting, was not the major goal of expansion. New territories had to be settled in order to develop as areas of commerce and of civilization. The brazen explorers, like Boone, could not establish these new pockets of civilization by themselves. They needed wives and families to realize this dream. Settlements meant homes, clustered together in self-sustaining communities. With the establishment of towns, the Whigs believed, commerce and civilization would follow, sustained and supported by federal funding of the roads and canals that would bind all Americans together.[68] The painting of *Daniel Boone* then was a paean to the beginnings of familial settlement, from which civilization would follow.

In the inscriptions on the print of *Daniel Boone* and in his comments about *The Squatters,* Bingham spelled out quite specifically some of his own views about settlement in the West. In their specificity these comments went beyond the tentative and latent messages in his four paintings of 1845. It is well to remember, however, that the two works of 1850 and 1851 came after a slew of riverboat paintings, in which Bingham set forth latent messages about the commercial development of the West as well. All of these works then were the outgrowth of the issues he touched on so subtly in the first four paintings for the Art-Union—the history of Missouri, commerce, civilization, and even family.

Conclusion

The story of Bingham's emergence as a western artist, then, varies somewhat from the account published in the *Bulletin of the American Art-Union* in 1849 and quoted in the preceding chapter. Contrary to what the New York reporter wrote, Bingham's new line of western subjects was not the immediate result of his romantic reencounter with his home state after four years in Washington. Nor was it solely due to the Art-Union's encour-

agement of American art. The works he chose to paint had much in common with others produced at the time in St. Louis. Yet, as much as these works found a comfortable niche there, they were also rooted in the artist's own oeuvre. However much he consciously sought to please eastern audiences, he did not forget the projects he had undertaken or proposed in the fall and winter of 1844–45. The iconographic links between the paintings of 1845 and earlier scenes on Whig banners, whether proposed or actually executed, suggest that the experience of inventing those symbolic political images remained in Bingham's mind. And the associations he had with certain images—the Indian, the canoe, even the grazing cattle—lay beneath the surface of his paintings.

In just nine months, Bingham moved from disappointment at the failed commission in March 1845 to the sale of four paintings to the Art-Union in December. The price he received for *Fur Traders* probably encouraged him to continue his paintings of riverboats. The next spring, when *Boatmen on the Missouri* fetched $100, his decision was cemented (fig. 26). In the next several years, Bingham painted several more riverboat scenes, thus firmly establishing the reputation he had when his first biographical sketch appeared in 1849—as a "painter of boatmen and pioneers." Those riverboat paintings, however, were more than just simple genre scenes. When viewed in the context of Bingham's political milieu in Missouri, they had other associations and deeper levels of meaning.

3

Of Snags and Whigs

Bingham's *Lighter Relieving a Steamboat Aground* and Other Riverboat Paintings

The face of the water, in time, became a wonderful book. . . . There never was so wonderful a book written by man; never one whose interest was so absorbing, so unflagging, so sparklingly renewed with every re-perusal. The passenger who could not read it was charmed with a peculiar sort of faint dimple on its surface . . . ; but to the pilot that was an italicized passage; indeed, it was more than that, it was a legend of the largest capitals, with a string of shouting exclamation points at the end of it; for it meant that a wreck or a rock was buried there that could tear the life out of the strongest vessel that ever floated. It is the faintest and simplest expression the water ever makes, and the most hideous to a pilot's eye. In truth, the passenger who could not read this book saw nothing but all manner of pretty pictures in it, painted by the sun and shaded by the clouds, whereas to the trained eye these were not pictures at all, but the grimmest and most dead-earnest of reading matter.

—*Mark Twain*, Life on the Mississippi

Fur Traders Descending the Missouri (fig. 11) marked the beginning of a remarkable series of riverboat scenes that brought Bingham to national attention and underscored the aptness of his nickname, the Missouri Artist.[1] The eighteen months following the exhibition of *Fur Traders* in New York saw the production of four other riverboat paintings. These four, however, did not look back to the early days of trade on the river but rather recorded contemporaneous shipping on Missouri's waterways. Just five months after his first success at the Art-Union, Bingham sent along *Boatmen on the Missouri* in May 1846 (fig. 26).[2] Since the board of management paid more for

66

Boatmen than it had for *Fur Traders,* the artist had good reason to concentrate thereafter on river scenes. The next painting he sent east was just such a scene, *Dance on the Flat Boat,* which fetched almost three times what *Boatmen* had just five months earlier (fig. 25).[3] Still later in 1846, when the Board selected *Dance* as one of two compositions to be engraved for the membership and changed its name to *The Jolly Flatboatman,* they assured Bingham's national reputation.[4] Two more river scenes quickly followed in the spring of 1847: *Lighter Relieving a Steamboat Aground* (fig. 23) and *Raftsmen Playing Cards* (fig. 24).[5] Before sending these two paintings on to New York, Bingham exhibited them first in St. Louis. Their success in Missouri made it clear that the Missouri Artist had come home.

Bingham's river scenes clearly struck a responsive chord at the Art-Union. They were like vignettes from the newly popular panoramas of the western rivers, as noted in the preceding chapter. But they also were clear illustrations of the river life that writers had been chronicling for at least a decade. Works like Timothy Flint's *The History and Geography of the Mississippi Valley* of 1832 and Washington Irving's *Astoria* of 1836 had whetted an appetite for more information about western life and landscape.[6] Fictional tales like *The Big Bear of Arkansas and Other Sketches* of 1845 presented lively pictures of steamboat captains and other Missouri characters.[7] Even popular music like "De Boatman's Dance" of 1843, "The Jolly Raftsmen" of 1844, and "Dance, Boatman, Dance" called attention to the waterways of America.[8] Surely the interest in these artistic, literary, and musical paeans to life on the western rivers cannot have escaped Bingham. Their popularity may even have played a role in his decision to produce such an abundance of riverboat scenes.

At the same time, the intensity with which Bingham concentrated on these pictures and the specific subjects he chose to paint suggest that there were other reasons for the path he took. After *Fur Traders* (fig. 11) and *Concealed Enemy* (fig. 12), Bingham's works took on a different character. No longer did the artist look back in time to the early days of settlement in Missouri. Instead, the paintings of 1846 and 1847 presented contemporaneous life on the river. Steamboats, shown in both *Boatmen on the Missouri* and *Lighter,* had been a presence on the western rivers since 1816. Flatboats, portrayed in the other two paintings, were also much in evidence on the Missouri and Mississippi Rivers, with some four thousand keel and flatboats reported in 1847 by the St. Louis Chamber of Commerce.[9]

In representing these contemporaneous scenes, Bingham was flying in the face of those critics who urged artists to preserve the image of a primordial America, an Edenic wilderness. The same year that Bingham exhibited *Lighter* and *Raftsmen* in New York, an article by a St. Louis correspondent

appeared in *The Literary World* praising Charles Deas for "delineating scenes and characters of this wild region [the Far West]." Referring to one of Deas' pictures of Indians, the author went on: "The rapidity of civilization and emigration is fast driving from our country a race of men which the pencil of Deas will preserve to posterity with truth and fidelity."[10] A few weeks later, in a review of the exhibition at the National Academy of Design, a local critic for *The Literary World* in New York took up the same theme: "The axe of civilization is busy with our old forests, and artisan ingenuity is fast sweeping away the relics of our national infancy. What were once the wild and picturesque haunts of the Red Man, and where the wild deer roamed in freedom, are becoming the abodes of commerce and the seats of manufactures. Our inland lakes, once sheltered and secluded in the midst of noble forests, are now laid bare and covered with busy craft. . . . Yankee enterprise has little sympathy with the picturesque, and it behooves our artists to rescue from its grasp the little that is left, before it is for ever too late."[11] The mood among art critics in 1847, then, was that artists should preserve on canvas the face of America that development was destroying. To a degree Bingham had done this with *Fur Traders* and *Concealed Enemy.*

But in 1846 and 1847 the Missouri Artist took a different tack and instead chose to show just what the critic for *The Literary World* decried— waterways plied by "busy craft." Having looked back to the early days of trade on the river in his picture of French trappers, he chose in 1846 to move on to pictures of his own modern world. For him the rivers in Missouri were ripe subjects for beautiful landscapes. But they were more than that. They were the setting for boatmen supporting and engaged in commerce. They were also conduits for travel and the life-blood of Missouri's economy. If *Fur Traders* and the rustic landscapes of 1845 had presented a clear image of Bingham's view of the West—those who had begun the development of the fur trade, the families that had settled, built houses, and tamed the wilderness, the people who had brought trade and civilization to Missouri—then the riverboat paintings of 1846–47 fleshed out that vision of development in the West. Rather than showing explorers setting out to brave the unknown reaches of the upper Missouri, these pictures presented men engaged in commerce and trade, men on their way to port with their cargo, men who were part of the commercial development that Whigs envisioned across the nation. In all of these paintings the crew loomed large in the foreground, asserting that without human labor none of the Whig dreams of commercial development could be realized.

Indeed Bingham's was a particularly Whig vision. If *Fur Traders Descending the Missouri,* illustrating as it did the forerunners of commerce in the state, had latent associations for him with the Whig ideas about trade

he had presented on political banners, surely the other fluvial images did too. Nothing better demonstrates this than the fourth riverboat scene Bingham painted.

Lighter Relieving a Steamboat Aground

Of all four paintings no work better captures Mark Twain's observations about the western rivers than this one (fig. 23). At first glance, it seems one of Twain's "pretty pictures . . . painted by the sun and shaded by the clouds," but on closer examination it becomes the "most dead-earnest of reading matter." In this river painting, in contrast to the earlier ones, a steamboat has run aground. A motley crew in the foreground has haphazardly stacked some of its cargo in their boat. Idly they listen to a tale or drink from a jug. Why did Bingham choose to depict an accident on the river that damaged property and interrupted labor? In unraveling the answer to this question, it becomes clear that Bingham the artist was here painting a work that spoke to issues of grave importance for Bingham the Whig politician. Just six months before he exhibited it, the artist had run for the state house of representatives as a Whig, had won, and had taken his seat before the Democratically controlled legislature decided a contested election against him. *Lighter* was one of the first works he painted after his ouster at the end of 1846. It clearly reveals bitterness not only about his own defeat but also about Democratic views on commerce and internal improvements. Ironically, given its present location on the walls of the White House, the painting carries a subtly veiled criticism of the presidential veto in the late 1840s.

Lighter was one of the two works that Bingham exhibited in April 1847 in St. Louis. The other was his *Raftsmen Playing Cards* (fig. 24). He intended to send the two paintings on to New York for sale to the American Art-Union. When they went on view, a local reporter for the leading Whig paper in St. Louis wrote enthusiastically about them: "Mr. Bingham has struck out for himself an entire new field of historic painting, if we may so term it. He has taken our western rivers, our boats and boatmen, and the banks of our streams for his subjects. The field is as interesting as it is novel. . . . He has taken the simplest, most frequent and common occurrences on our rivers—such as every boatman will encounter in a season— such as would seem even to the casual and careless observer, of very ordinary moment, but what are precisely those in which the full and undisguised character of the boatmen is displayed."[12] The local writer clearly delighted in Bingham's choice of the western rivers as the subject for a "new field of historic painting," and he also lauded the truthfulness of the artist's portrayal of the boatmen.

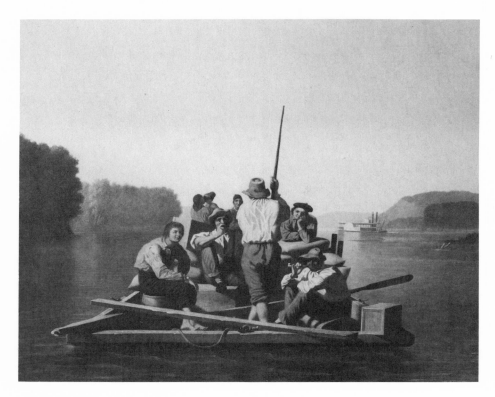

23 Lighter Relieving a Steamboat Aground, *1847, oil on canvas, 30¼ × 36 in. The White House Collection, Washington, D.C.*

Both pictures presented crews of boatmen on the river, the one listening to a story, the other playing cards. Both works had similar compositions with a centrally placed pyramidal group of figures balanced on either side by the banks of the river. Yet in each, hints of instability undermined the harmonious composition with diagonal planks or oars disrupting the horizontal base of the picture. In each, the deck was in disarray, with remains of kindling scattered about, a frying pan overturned, and shoes tossed casually aside in *Raftsmen,* with drooping rope and a crate poised precariously on the corner of the craft in *Lighter.* In each, the figures seemed self-absorbed, turned inward, not directing their gazes confidently out of the picture at the viewer, as they had in Bingham's earlier river scenes. In *Lighter* a man drank from a jug; in *Raftsmen* a glazed man sat in a stupor. Even more tellingly, each contained signs of the dangers of the river—a snag and sand bar in *Raftsmen,* a wrecked steamboat, snag, and sandbar in *Lighter.*

As he continued his commentary, the St. Louis reviewer made it clear that he understood the significance of the details of the snag, the sandbar,

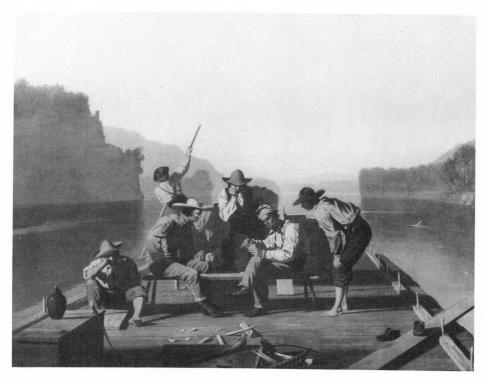

24 Raftsmen Playing Cards, *1847, oil on canvas, 28 × 38 in. St. Louis Art Museum, St. Louis. Purchase: Ezra H. Linley Fund.*

and the wrecked steamboat. He pointed first to the hardy character of the boatmen in both works. The western boatmen, he wrote, "constitute a large, interesting, and peculiar class, and in their labors they are surrounded by natural scenery, or accidental occurrences, which *lend* to their own peculiarities a yet deeper interest. Their employment, the dangers, fatigues and privations they endure—the river—its incidents and obstacles—its wild beautiful scenery—its banks of rocks, or its snags, sawyers and sand bars, draw out, as it were, the *points* of these hardy, daring and often reckless men."[13] Clearly he understood that the raftsmen in both pictures had to contend with dangers on the river. In *Lighter,* however, the reviewer read a more direct narrative of life on the water. "Mr. BINGHAM, gives a view of a steamboat, in the distance, aground on a sand bar. A portion of her cargo has been put upon a lighter or flatboat, to be conveyed to a point lower down the river. The moment seized upon by the artist is, when the lighter floats with the current, requiring neither the use of oar nor rudder, and the hands collect together around the freight, to rest from their severe toil." The sub-

ject of this picture resonated forcefully with the daily newspaper accounts of
steamboat accidents on the river. The message was not lost on the local jour-
nalist, nor on the Missourians who saw the work.

One St. Louisan, enthusiastic about Bingham's art, purchased *Lighter*
for $250. This was James E. Yeatman, a civic leader then serving as the first
president of the St. Louis Mercantile Library.[14] A reporter for the *Weekly
Reveille* was "gratified to hear that one of these masterly efforts of our tal-
ented Missouri artist has been retained in the city" saved "from the *grasp-
ing* fingers of the eastern connoisseurs."[15] It was time, the reporter seemed
to say, for westerners to appreciate Bingham's "western" scenes. With the
picture assured a permanent place in his St. Louis collection, Yeatman
agreed to have it exhibited in New York along with *Raftsmen Playing Cards.*

Nothing could offer a greater contrast to the reception of the two works
in St. Louis than the criticism they received several months later when ex-
hibited at the Art-Union in New York. A reporter for the *New York Express*
was intrigued by the distinctively American subject matter of *Raftsmen,* and
he noted how accurately Bingham had captured "the monotonous shores of
the Mississippi, . . . the rapid and muddy water, the characteristic snags and
sand bars."[16] But he went on at length about the artist's disagreeable color-
ing. "The flesh tints are all too heavy, and not in keeping with the surround-
ing effects of sunlight; the lights of the picture are too heavy and dead-like;
and all the deeper shadows are nearly of one hue. . . . The sky of the picture
is tame and uninteresting. . . . Mr. Bingham is the only man in this country
who has it in his power to rival Mr. Mount [William Sidney], but he must
change the tone of his pictures." A few months later a reporter for *The Lit-
erary World* set forth a full-scale attack on the Missouri artist's paintings.
He began by lambasting *The Jolly Flatboatmen* (fig. 25) he had seen the
year before as "a vulgar subject, vulgarly treated . . . altogether a most un-
worthy and unfortunate selection [as an engraving for the membership.]"[17]
The Knickerbocker writer was equally critical of the two pictures on view:

Of Mr. Bingham's qualities as a painter, however, No. 91 [*Raftsmen*]
and another subject yet unpurchased [*Lighter*], are a sufficient ex-
ample. In color they are disagreeable, a monotonous, dull dirty pink
pervades every part; and in texture there is the same monotony. Flesh,
logs, earthen jugs have the same quality of substance, the same want of
handling. . . . In composition, Mr. B. should be aware that the regularity
of the pyramid is only suitable to scenes of the utmost beauty and re-
pose; that when motion and action are to be represented, where expres-
sion and picturesqueness are objects sought for, proportionate depar-
tures must be made from this formal symmetry.

These were caustic comments that focused on formal qualities and dismissed the subject matter in one word, "vulgar." New Yorkers clearly could not read the meaning in *Lighter* that Missourians did.

In this very critical review of Bingham's works, the eastern journalist for *The Literary World* recapitulated the general discontent occasioned by the choice of Bingham's *Jolly Flatboatmen* as the engraving for the membership of the Art-Union in 1846.[18] That picture, he wrote quite acerbically, "has by some fatuity been selected by the committee, to be engraved for distribution to the members of the present year." [19] Even earlier that year, in April, *The Literary World's* account of the Art-Union's annual meeting bristled at the choice. Reporting on a resolution offered that the Art-Union should disseminate among its members an appreciation of "High Art," the author went on to say: "we regret that in accordance with the spirit of the resolution, and the comments of the gentleman who offered them, the Committee did not select some other subject for engraving than the 'Jolly Flat Boatman'—the very name of which gives a death blow to all one's preconceived notions of 'HIGH ART.' The picture is tolerably well in its way; but it is by no means what a student in art would select as a standard of taste, and it contains no redeeming sentiment of patriotism." [20] The following month a letter from Providence echoed the disgruntlement of the staff of *The Literary World,* providing a vivid record of the discontent of an Art-Union member with the choice of *The Jolly Flatboatmen.*[21] Despite the Art-Union's endorsement of Bingham's scenes of life on the western rivers, eastern critics and connoisseurs were not drawn to the Missouri artist's paintings nor did they see in them the merits that the St. Louis audience had seen.

Whether one praises or damns them, *The Jolly Flatboatmen* of mid-1846 and *Lighter* of early 1847 at first glance seem to resemble each other. In both, boatmen pause on the river in a moment of apparent leisure—to make music and dance or to listen to a story. Assertively pyramidal groupings of figures loom large in the foreground, the edges of their boats parallel to the picture plane and echoing the horizon. The river flows quietly in a hazy landscape, both banks visible beyond the boats in an uneven balance.

For all their similarities, however, the pictures are profoundly different. In the earlier work, there is a solid compositional base in the boat, with stable horizontals bound together by repeated verticals. The oars, pulled up for the moment, form another insistent horizontal, stretching beyond the frame of the picture, almost as if to connect the boat with the land itself. This stability disappears in the later work, where the edge of the lighter rests close to the water, its narrow horizontal overpowered by the diagonals of planks and oars that point outward. A crate rests precariously on the corner of the boat while a bit of rope droops carelessly over the water, unlike the

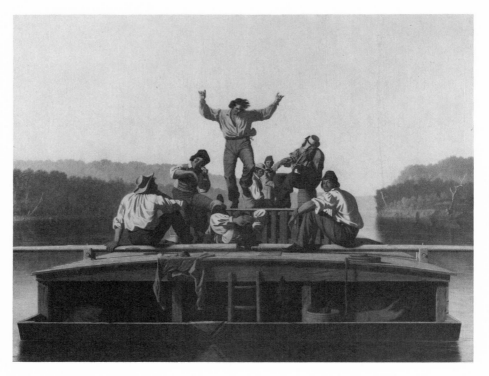

25 The Jolly Flatboatmen *(1), 1846, oil on canvas, 38⅛ × 48½ in. Private collection, on loan to the National Gallery of Art, Washington, D.C.*

neat coil of rope in the earlier work. Indeed, the cargo in *Lighter* is in notable disarray with sacks and boxes piled haphazardly among the crew. This contrasts markedly with the pristine, almost gridded order of the pelts and barrels in *Jolly Flatboatmen.* In that picture even the live wild turkey, a topical and local detail, is penned in a wooden cage.

The crews in the two works also differ, despite their similar pyramidal grouping. Many of the jolly flatboatmen turn out of the picture, and one even makes eye contact with the viewer. If they dance and make merry, they are able to do so because they have worked hard to put their cargo in order. They glide downriver, on their way to port, where they may realize a profit on their goods. The crew in *Lighter,* in contrast, ignores the viewer, concentrating instead on the central storyteller, who makes a point of turning his back to the spectator, as does the toper in the background. Many of the boatmen sit among the bales and boxes. They have no vested interest in their freight, they simply must wait until the steamboat is once more afloat. While waiting, they listen to a story, and one of them drinks. The St. Louis reporter noted these details. He called attention to those "seeking more con-

genial enjoyment in the jug," and he surmised that the yarn had to do with "adventures at *Natchez under the hill*," a port noted for its disreputable rowdiness.²² The drinker appears for the first time in Bingham's river scenes, surely an allusion to the dangers of intemperance. No one drinks in *Jolly Flatboatmen,* and the caged turkey may even refer to temperance, since "having a turkey on" was a slang term in the 1840s for a fit of intoxication.²³

The most striking change in the painting of 1847 is the wrecked steamboat in the distance. This is Bingham's first portrayal of an accident on the river, of the kind so frequently reported in the contemporary Missouri press. The steamboat, promoter of commerce and symbol of economic progress, has run aground, caught on a sandbar. Immobile and helpless, it waits to be freed of its trap. Though the steamboat is well in the background, its plight is what has occasioned the painting. Even if the New York reporter saw in it only a vulgar subject, improper color, and clumsy composition, the contemporaneous reviewer in St. Louis immediately recognized that this was a painting about more than picturesque life on the river. It spoke to him of "dangers, fatigues and privations—the river—its incidents and obstacles—. . . its snags, sawyers and sand bars." It spoke to him of an interruption of commerce.

To understand the picture as some contemporaneous Missourians did, and as Bingham must have at some level, one must look beyond the work itself to its broader context. What did the river mean to Missourians in 1847? What was the danger of snags and sand bars? What did Bingham think about these issues? What did Yeatman, the purchaser of the painting, think?

In the middle of the nineteenth century, St. Louis was the major trading center in the West. Its situation at the confluence of the Mississippi and Missouri rivers made it a logical gateway to the far west, as well as a conduit to New Orleans, the Gulf of Mexico, and beyond. Just two months before Bingham exhibited *Lighter* and *Raftsmen* in St. Louis, the city had put on a major celebration of its founding, a celebration that stressed its preeminence in the West as well as its dependence on the river. After a procession featuring models of the earliest steamboat on the Mississippi and the latest modern example, there came a sumptuous banquet with numerous toasts. In addition to drinking to the founders of the city, to the state, to the union, and to St. Louis itself, those assembled raised their glasses to the unsung heroes of Missouri—to the fur traders and trappers of the early days and to the present-day western boatmen. Accompanied by the tune "Dance, Boatman, Dance," this toast saluted the boatmen: "The right arm of Commerce— every sweep of the wave wakes some echo of their triumphs. Commencing with the broad-*horn,* who can wonder at their attachment for steam?" In remarks following the toast, Captain Nathaniel Eaton, foremost among the

city's steamboat pilots, gave the boatmen a distinguished ancestry, observing "that there had been a great struggle through the evening for the honors of the occasion, among the hunters, boatmen, &c., &c., but that Noah was ahead of all of them, having been the first to navigate in a—*flat boat!*"[24] Here the Missouri denizens of the river took their place with the legendary boatmen of the venerable biblical past.

If the city's anniversary committee festively celebrated the steamboat and the western boatmen, it was because the city and the Chamber of Commerce in particular took trade on the river dead seriously. It was, after all, a mainstay of the economy. Any threat to commerce on the river was a threat to St. Louis, as well as to the state. In 1842, the St. Louis Chamber of Commerce had published a detailed study to demonstrate to Congress "the great and pressing necessity of their taking action to cause the navigation of the Mississippi river and its principal tributaries, as well as the harbor of St. Louis to be improved."[25] In 1844 a group of St. Louis citizens sent a memorial to Congress asking for "an appropriation for removing the obstruction to the navigation of the western rivers, for the improvement of the St. Louis harbor and for other purposes."[26] And in early 1847 yet another report on the rivers appeared, "prepared by authority of the Delegates from the City of St. Louis for the use of the Chicago Convention of July 5, 1847."[27]

The major obstructions on the rivers were snags and sawyers, those twisted uprooted trees that slid into the rivers whenever the unstable sandy banks shifted. Snags jammed into the river bottom, while sawyers bobbed loose with the current. These obstructions not only disrupted, or even halted, traffic for extended periods of the year but, far more gravely, damaged property and caused the loss of human life. The St. Louis reports argued with statistics and with rhetoric the disastrous economic and human consequences of failure to tend to the snags and sawyers.[28] The federal government, they concluded, should fund improvements.

If the reports painted the dark side of trade on the river, the anniversary celebration painted the bright side. Not surprisingly, several of the men who organized and took part in the gala of 1847 were involved in the preparation of the various river reports. Among the members of the organizing committee of the anniversary celebration were: the author of the 1842 report, A. B. Chambers; three signers of the memorial of 1844, Chambers, Thornton Grimsley, and Samuel Treat; and three delegates to the Chicago Convention in 1847, Chambers, Wilson Primm, and Henry Geyer. One of the orators at the celebration, Thomas Allen, was author of the 1847 report and another of the delegates to the Chicago Convention.[29]

Like Bingham, all these men were Whigs—which helps explain their commitment to economic progress and internal improvements. Grimsley,

Primm, Geyer, and Allen had run for or served in the state legislature as Whigs. Chambers was editor of the Whig newspaper, the *Missouri Republican.* As committed party men, all of them must have espoused Henry Clay's American System, with its emphasis on tariffs for the protection of home industry and internal improvements to develop waterways and railroads. For the Whigs economic progress was important because it would bring unity and even civilization to the entire country.

James Yeatman, who bought Bingham's *Lighter,* was not one of the planners of the anniversary celebration, but he was an active Whig, committed both to internal improvements and to close connections between commerce and civilization. As founder and first president of the St. Louis Mercantile Library, he promoted an institution where trade and knowledge went hand in hand.[30] Even more important, just a few months after he purchased Bingham's painting, Yeatman joined fellow Whigs—Allen, Chambers, Geyer, and Primm—as a delegate to the Chicago Convention. He was thus fully capable of reading the deeper meaning in *Lighter,* aware as he was of concerns about commerce and navigation on the western rivers in 1847.

Worry about the snags and about federal funding for internal improvements on the rivers was not new to the Whigs, nor was it confined to St. Louisans. Internal improvements had been a theme of Henry Clay's presidential campaign of 1844, as the Howard County banner with its deliberate stress on commerce made clear.[31] Even after Clay's defeat, the need to improve the rivers in order to sustain trade remained an issue among Westerners. Indeed from 1845 on the state of the Missouri River made such issues of paramount importance. Writing in 1847, John Wilson recapitulated earlier problems, notably "'the low stage of the Missouri river for two years, the high freight, not to say impossibility of sending produce to market at all.'"[32] So pressing were the problems that, late in 1845, the Great Southwestern Convention convened at Memphis to discuss internal improvements. Among the delegates was a strong contingent of Missourians. A reporter from the Whig *New York Tribune* captured the fervor of that convention: "It is the general opinion here that we are on the eve of great changes in the matter of Internal Improvements; that the rising of the West and South to this work is the prelude to a more liberal policy, or the dismemberment of the Democratic party. No public man can resist the will of the Western people on this question but at the price of his place and position. . . . What a gratification is this for Mr. Clay and his friends!"[33] Before the end of the year, the River and Harbor Bill, which dealt with internal improvements, was introduced into the House in Washington.[34] With the beginning of the Mexican War in the spring of 1846, the cry for cleared rivers became an issue of national de-

fense. Although the Whigs opposed the war, they were not above using it, when it served their interests, as yet another pressing reason to clear the rivers. By mid-summer 1846 optimism ran high as the bill passed both House and Senate.[35]

In August, however, President Polk vetoed the River and Harbor Bill, inflaming many in Washington and across the country.[36] Whigs in Missouri almost immediately raised their voices against Polk's stand. In the Whig press articles ranging from the satirical to the serious lambasted Polk. Snags soon came to be known locally as poke stalks or "Polk stalks" in a punning reference to the president's name.[37] Early in October the St. Louis *Weekly Reveille* published an irate letter to the editor, from one Augustus Snag, Esq., on the need for improving the St. Louis harbor.[38] A few weeks later, the Liberty *Weekly Tribune* carried a front-page article from the *National Intelligencer* entitled "The Difference," which laid out Whig and Democrat views on the funding and rationale of internal improvements. The Whigs favored federal funding of improvements "national in their character and general in their effects, being necessary connecting links to important lines of national defence or of foreign and domestic trade and commerce." In contrast, the Democrats were reluctant to support federal funding.[39]

Not surprisingly, internal improvements became a hot issue in the fall election, when Bingham was running for the state house of representatives.[40] One Whig candidate for Congress, William Kincaid, may well have spoken for all his Whig cronies: "I am one of those who believe that Congress . . . has the right to make internal improvements of whatever kind or character it may deem necessary to increase, facilitate or render more safe the Commerce between the states as well as with foreign nations. . . . I would consequently be in favor of the River and Harbor Bill . . . or any appropriation having for its object the improvement of our Western Rivers or Harbors."[41] Campaigning at the same time Kincaid did, in the late summer and early fall 1846, Bingham cannot have failed to harangue the Democrats about the same issue. Indeed, when he took his seat in November 1846, he heard Governor John Edwards join the cry for improvements on the rivers—though Edwards took the Democratic position that the state should be responsible for funding.[42] Bingham must have shared a laugh about this with his fellow Whigs. The editor of the *Liberty Tribune* published a letter in his Whig newspaper ridiculing Edwards' venal motivations: "and those snags—all have agreed that his Excellency shall have that contract—the accomplishment will win him immortal honors—*green*, unfading honors."[43] The Whigs in Missouri clearly advocated federal, not state, funding for clearing the rivers.

Bingham, however, was not able to devote his full attention to the mat-

ter. While forces were marshaling in Washington to set a second internal improvements bill before Congress, he was waging a fight to retain his contested seat in the legislature. The day after the second River and Harbor Bill was introduced in the Senate in Washington, Bingham was voted out of the General Assembly in Jefferson City. Switzler, who wrote the minority report of the committee investigating the contested election, vented his anger on the pages of the *Missouri Statesman:* "Thus by a majority of eighteen was the greatest outrage against truth and justice perpetrated which ever disgraced Locofoco legislation."[44] For the moment Bingham's circle of Whig friends focused on the Democrats' ouster of their colleague.

Late in February 1847, however, the Whigs in the central part of Missouri convened in Jefferson City to discuss pressing political issues, chief among them internal improvements. There they heard an address by Switzler and also voted on resolutions drafted by a committee including Bingham's friend, Rollins, then serving as state senator. The very first resolution, apparently the most pressing to the delegates, dealt with internal improvements on the rivers: "*Resolved,* That the people of the State of Missouri, have a deep and permanent interest, in the construction of works of National Improvement, by the General Government, and *an especial interest in procuring liberal appropriations of land and money, for the purpose of improving the navigation of the Mississippi, Missouri and Osage rivers"*[45] (emphasis added). The issue of improvements of the rivers was as important in central Missouri as it was in St. Louis.

Bingham did not attend the meeting, but he did comment on the Whig resolutions. He thus joined his voice to those of his political colleagues calling for internal improvement of the rivers. In a letter to Rollins soon after the meeting, he wrote: "Judging from the resolutions adopted by the meeting, I think we will either conquer in the next campaign or *split our breeches.*"[46] In approving the work of his fellow Whigs, Bingham came out strongly on the side of clearing the rivers, a message that also inheres, if only latently, in *Lighter,* a work he was presumably painting in this very period. But in alluding to the next campaign, he also showed his anger at the Democrats in the state legislature who had unseated him. Later in the same letter he went on to express his general rancor against the Democrats, both local and national. The meeting at Jefferson City, he wrote Rollins, must have been a "glorious" one, "showing that there is still spirit enough left in our ranks, diminished as they are, to hurl defiance upon the foe, and fight for truth, justice, and our Country." Further on he attacked the Democrats in Washington: "Uncle Sam seems to be getting terribly out of sorts every way—and if the old fellow don't get out of the hands of the quacks [Polk et al.] I am afraid he will go to

old Nick some of these days." Early in 1847 then Bingham's anti-Democratic sentiments clearly surfaced at the same time that he decided to move away from scenes of prosperous commerce on the river to a scene of an accident.

The subtly veiled anti-Democratic undercurrents in *Lighter* become more understandable if one remembers that Bingham's first scenes of boats on water appeared on partisan political banners for the Missouri Whig supporters of William Henry Harrison in 1840 and Henry Clay in 1844, discussed in the first chapter. In 1840, on the Harrison banner, Bingham had contrasted a scene where "a vessel discharged freight, with other ships seen in the distance" with "a river scene, with a canoe—the sun breaking forth from the clouds in the distance, diffusing a warm and mellow light over the scene."[47] Four years later Bingham again painted shipping scenes on the Howard County banner for Henry Clay as part of his illustration of Clay's American System. This image was in direct response to the request of his Whig patrons for subjects having to do with "internal improvements, commerce &c &c."[48] Bingham's boat scenes in the banners of 1844 and 1840, then, spoke to the particular interests of Missourians, even as they may have also alluded obliquely to the ship of state.

Understanding the politically charged images on the banners and the subtly allusive *Lighter,* one must look afresh at the works they bracket chronologically, the three other scenes of boats on the rivers that Bingham sent to the Art-Union in 1845 and 1846—*Fur Traders, Boatmen on the Missouri,* and *The Jolly Flatboatmen.* At the national level, all three fulfilled the organization's desire for paintings of American subjects. Yet, at the local level and particularly in the chronological context of his oeuvre from 1840 to 1847, the three paintings carried other, latent associations. As a group, they reminded the knowledgeable Whig viewer in Missouri of the images and even of some of the concerns expressed in the banners that preceded them.

Fur Traders Descending the Missouri (fig. 11), as noted in the preceding chapter, had the closest ties to the Harrison banner, echoing the canoe on the reverse of that banner that served as a prologue to the prosperous shipping scene on the obverse. Bingham's painting, too, was a painting of promise. It presented the early French traders as the "forerunners" of commerce and by extension of civilization.[49] The references Bingham made to earlier art conjoined these trappers to the river gods of antiquity, to figures from the Christian era enjoying the blessings of abundance. As they plied the Missouri, they carried with them the heritage of great waterways of other civilizations. In their light craft they were easily able to maneuver around the snags. Only the dead duck whose reflection was obliterated by a snag hinted at possible dangers.

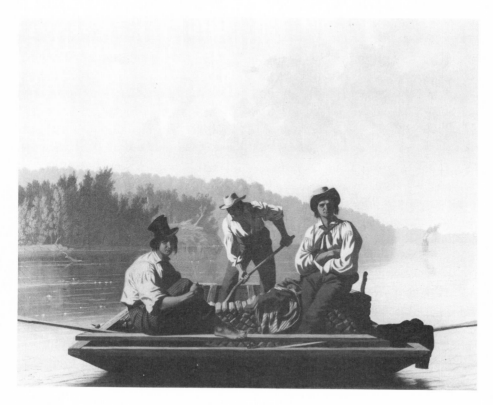

26 Boatmen on the Missouri, *1846, oil on canvas, 25 × 30 in. The Fine Arts Museums of San Francisco, San Francisco. Gift of Mr. and Mrs. John D. Rockefeller 3d.*

If Bingham's first riverboat painting recalled the reverse of the Harrison banner, his second one with its steamboat in the background alluded to the obverse of that banner that showed a scene of maritime trade with "ships seen in the distance." *Boatmen on the Missouri* (fig. 26), submitted to the Art-Union in the spring of 1846, presented a scene common enough in the 1840s: a trio of boatmen waiting to sell the wood they have cut and stacked to a steamboat visible in the background. These men were crucial to river trade, supplying the essential fuel to the great steamboats. Without them the steamboats could not function. These were the woodboatmen whose key role in commerce Bingham had noted in his political speech on the Independent Treasury in 1840. "We have heard the owners of wood yards told, that they have but to refuse paper [currency], and the masters of boats will be compelled to buy their wood, and pay them in specie. Well, now, admitting that by a general concert, between the proprietors of wood lands all along

the river, from the mouth to the source, that such a result might be accomplished!"[50] In his painting, as if to make the same assertion about the central importance of these men in the economic life of Missouri, Bingham focused on the three dignified figures. The calm patience of the men pervades the poised composition of the work. The resolute horizontals of the boat and oars serve as a stable base for the loose pyramidal arrangement of the figures. Two men engage the viewer, one standing to the right, the other seated to the left. In between, a third concentrates on his work, as he leans over the handle he so firmly holds in both hands. In this painting, trade has shifted from the voyageurs' canoes to the craft of the men who sold wood to fuel the steamboats. Like the scene on the front of the Harrison banner, *Boatmen on the Missouri* bore witness to prosperous commerce on the rivers. Yet it is important to keep in mind that Bingham did not fill his canvas with the numerous vessels that overtly referred to commerce in the partisan banner. Instead he distilled a lovely image of a hazy river with only one steamboat in the distance. And in that quiet world he stressed the importance of the boatmen in the life of the river. Playing a key role in fueling the steamboat, they made possible the trade that Missouri Whigs wanted to encourage, the commerce that Whigs felt brought civilization in its wake.

Focusing on these men, Bingham ennobled them by turning them outward to engage the viewer and by adapting their poses from the art of the past. The seated figure to the left in *Boatmen on the Missouri* is surely a descendant of Raphael's seated river god in the *Judgment of Paris* (fig. 27). The figure at work in the center of the boat recalls and reverses Michelangelo's digging Noah in the Sistine Ceiling (fig. 28).[51] As in *Fur Trader,* Bingham's choice of sources seems deliberate. In this painting he likened his Missouri boatmen to the river gods of classical antiquity or to Noah, whom contemporary Missourians touted as the "first to have navigated in a—*flat boat!*"[52] In associating his hardy boatmen with river gods and patriarchs, Bingham dignified them and suggested, however subliminally, their links with other civilizations. If the French fur traders were the forerunners of civilization, these men carried civilization into the present.

The third painting, *The Jolly Flatboatmen* of mid-1846 (fig. 25), went beyond mere illustration to overt celebration of trade on the rivers. Bingham broke the quiet beauty of the riverscape with the sounds of tapping feet and music on the flatboat. As in *Boatmen on the Missouri,* the boat and boatmen are the principal focus of the picture. Building on the stability and order of the earlier painting, Bingham amplified the horizontal base of the larger flatboat, even as he expanded the pyramidal group of figures. With equal force, he increased the overt evidence of hard work by placing the carefully stowed cargo prominently in the foreground.

27 *Marcantonio Raimondi, after Raphael,* The Judgment of Paris, *engraving, detail. Yale University Art Gallery. Gift of Edward B. Greene, Yale 1900.*

For all the beauty of its hazy river banks and the charm of its relaxed scene, this picture is not a nostalgic evocation of carefree life on the river before the dominance of the steamboat. In 1847 the St. Louis Chamber of Commerce reported that keel and flatboats still plied the Missouri and Mississippi Rivers in great numbers.[53] And contemporaneous accounts of life on the river, such as Timothy Flint's, stressed the rigors of the life of the flatboatman:

> This boat, in the form of a parallelogram, lying flat and dead in the water, and with square timbers below its bottom planks, and carrying such great weight, runs on a sandbar with a strong headway, and ploughs its timbers into the sand; and it is, of course, a work of extreme labor to get the boat afloat again. . . . [Yet] all the toil and danger, and exposure, and moving incidents of this long and perilous voyage, are hidden. . . . At this time there is no visible danger, or call for labor. The boat takes care of itself; and little do the beholders imagine, how different a scene may be presented in half an hour. Meantime one of the hands scrapes a violin, and the others dance."[54]

Flint's account of the picturesqueness of the scene did not overlook the dangers encountered by the boatmen nor the challenge of their work. Such was

28 *Michelangelo,* The Drunkenness of Noah, *fresco, detail. The Sistine Chapel, Vatican City. (Photo: Alinari/Art Resource)*

also the case in Bingham's painting. Beneath the dancing and tapping feet, the carefully stowed cargo reminded the viewer that hard work had preceded relaxation.[55]

Like *Fur Traders* and *Boatmen on the Missouri,* Bingham's third riverboat painting formally promised that the men who worked the rivers could bring civilization as well as commerce in their wake. There is a descendant of Marcantonio's seated river god in this painting as well, in the figure seated to the right. Even the dancing flatboatman has a Renaissance source. His posture is almost an exact copy of Raphael's Christ in the *Transfiguration*

29 *Raphael,* The Transfiguration, *oil on canvas, detail. Vatican Pinacoteca, Vatican City. (Photo: Alinari/Art Resource)*

(fig. 29).[56] And although their postures are varied, the other figures in Bingham's painting recall the general disposition of two flanking figures and three recumbent figures in the Renaissance work. Even the two onlookers in the Italian painting are present, though moved from the margin to the center of the composition. These quotations gave an extraordinary dignity to the river boatmen, who usually were described as rough characters. Bingham's boatmen in his first three works were not raucous but rather were descendants of the art of earlier civilizations. Subliminally, then, Bingham suggested the civilization that he and fellow Whigs hoped commerce would bring to the American West.

All three early riverboat paintings, then, seemed to carry latent messages about commerce and civilization as optimistic, though not as overt, as the images on Bingham's political banners—and well they might have. They all dated from those years when Westerners were demanding internal improvements, first at the Memphis Convention in 1845 and then on the floors of the House and Senate in Washington in 1846. As the three pictures chronicled trade on the river, they also praised the men who labored hard to trap and hunt, to stow wood to serve the steamboat, to pack cargo to trade downriver. They thus not only reflected contemporaneous Whig sentiments about

economic progress but also echoed Whig rhetoric about the morality of labor. In the summer of 1846 the Whig paper in Liberty carried an article extolling the rewards of honest work and praising biblical laborers as exemplars. Among these was "Noah himself, who was God's instrument to save the world, [and who] was a master ship-builder." [57]

The last and most celebratory of the three paintings, *The Jolly Flatboatmen,* omitted the snags present in the earlier two and, as if to allude to the latent Whig content, even included a coonskin, long a symbol of the Whig party.[58] Around the time this painting was finished, all seemed to augur well for the supporters of internal improvements. In the spring and summer of 1846 the House and Senate had passed the River and Harbor Bill in what seemed a victory for Henry Clay and the Whigs. Even if Bingham painted these as American scenes for the New York market, he conceived them in Missouri, and they incorporated, however latently, local concerns that Missouri Whigs would have understood.

Against the optimism of the earlier works, the veiled pessimism of *Lighter*—and even of *Raftsmen*—stands out. In *Lighter* the chief subject speaks quite obviously of the danger of snags and sawyers. But, in both works, the crew's idleness and the cargo's disarray also hint subtly at a world gone awry. The jug and nodding boatman in *Raftsmen,* the drinker in *Lighter* speak too of the dangers of intemperance, a concern of some members of the Whig party.[59] Particularly in *Lighter,* the Whig values of labor and morality, of commerce and civilization, have, like the steamboat, run aground.

Yeatman and others in Missouri must have sensed the latent meaning in the work. Yeatman, ready to depart for the Chicago Convention on internal improvements, purchased it. The St. Louis reviewer saw in it "dangers, fatigues and privations . . .—the river—its incidents and obstacles—. . . its snags, sawyers and sand bars." For other Missourians, the painting must have chimed with the statistics in the St. Louis river reports, as well as with the almost daily newspaper reports of disasters on the river. One such piece in the Whig *Weekly Tribune,* published a few months after Polk's veto, made clear its antiadministration stand: "This is the second steamer that has sunk with government stores in the Missouri river, since the veto of the River and Harbor bill. So much for the economy of our Locofoco President." [60] Even beyond recognizing the currency of accidents on the river, Whigs who knew Bingham may have understood the subtle partisan criticisms in his work. The same month his pictures were on view in St. Louis, his good friend Switzler, who was editor of the Columbia *Missouri Statesman,* proposed to go after a certain Democratic editor he had attacked the pre-

ceding winter: "with this difference, that we may call on *Bingham,* the Missouri Artist, to furnish us with a drawing or wood cut illustrative of that operation!"[61] Even though Switzler's argument had to do with opposition to the Mexican War, his first thought was that Bingham was the man to give visual form to the issue, just as the artist seems to have done, quite subtly, in the subject matter of *Lighter.*

In the months after Yeatman purchased *Lighter,* clearing the rivers continued to be an important issue. Yeatman and others from St. Louis went to the Chicago Convention of the Friends of Western Improvement, armed with Thomas Allen's report on the urgent need for improvements on the Mississippi and the Missouri.[62] The delegates surely felt that they could make a difference, since President Polk had not yet acted on the second River and Harbor Bill, which had passed both the House and the Senate by March. The Missouri Whig press recognized that the state contingent had to argue persuasively for the pressing need for improvement of the western lakes and rivers. *The Weekly Tribune* noted that "men of both political parties are being made aware by the united voice of the people, of the importance of doing something to protect this vast trade from the numerous losses it has hitherto experienced. . . . It is to be hoped that the distinguished eastern delegates expected at the proposed convention, will fully possess themselves of the importance of the subject, and by their influence aid in giving full consequence to it."[63] If the delegation as a whole carried the force of Allen's report with them, Yeatman must also have borne with him the memory of the painting he had purchased from Bingham just a few months earlier. Indeed, his own convictions about the importance of clearing the rivers may have had something to do with his decision to send *Lighter* east.

However, if he, or Bingham for that matter, hoped the painting would persuade the Easterners of the need for internal improvements, they were wrong. Those who saw *Lighter* in New York in the fall failed to understand the painting's local meaning, as noted earlier in the chapter. The Chicago Convention also had no lasting impact. In December 1847, Polk once more vetoed the River and Harbor Bill.[64] But this action did not put an end to the cry for clearing the rivers. As the fervor of an election year began to build in Missouri, the Whig press asserted its party's goals. In February 1848 a Whig signing himself "Vigilance" lamented: "When will the system of internal improvements be commenced? Never until the Whigs gain the ascendancy."[65]

By 1848, Bingham had made a name for himself as the painter of riverboat scenes. Exhibition of the five paintings had called him to the attention of Easterners, and the Art-Union's publication of his *Jolly Flatboatmen* in 1847 carried his reputation throughout the country. In the years that fol-

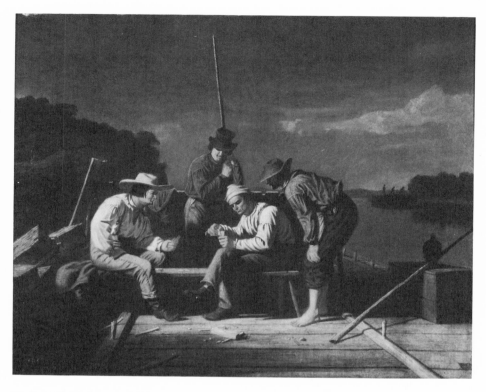

30 In a Quandary *or* Mississippi Raftsmen at Cards, *1851, oil on canvas, 17¼ ×
21 in. The Henry E. Huntington Library and Art Collections, San Marino,
California. The Virginia Steele Scott Collection.*

lowed, the Missouri artist capitalized on his success and painted other river
scenes. In two instances, he reiterated earlier successful compositions.
Trappers' Return of 1851 (fig. 16) looked back to his scene of French fur
traders on the Missouri (fig. 11). *In a Quandary* of the same year (fig. 30),
painted for Goupil to publish as a lithograph, was a reprise of his card-play-
ing boatmen (fig. 24).[66]

 In other cases Bingham developed new compositions for his river
scenes, but his emphasis in these new works was decidedly different. Rather
than recording boatmen in craft *on* the river, he quite often chose to place
them on shore. Indeed, almost all his river scenes of the early 1850s stuck
close to land. In a few pictures Bingham showed figures sitting patiently
waiting to sell their wood or watching cargo. In still others fishermen sat im-
mobile waiting for a nibble. And in two works of 1854, night descended on
the boatmen who quietly guarded freight in the darkness.[67]

One of the paintings that focused on the shore turned out to be an elegy for a particular steamboat. Although Bingham's *St. Louis Wharf* is now lost, a description in the *Bulletin of the American Art-Union* outlined its principal features: "On the wharf are piles of merchandise, upon which are seated boatmen and travellers; behind them are teamsters, and beside the levee is a steam-boat, the 'Kit Carson.'"[68] Bingham exhibited this work in Cincinnati in June 1849, the month after fire swept the St. Louis pier and destroyed many steamers including the *Kit Carson*.[69] That he sent it on to the East after the conflagration, with the steamboat's name unchanged, suggests that he intended it as a mournful reminder of the dangers besetting commercial traffic on the river.

On at least two occasions Bingham showed accidents on the river caused by snags or sand bars, as if haunted by the memory of *Lighter* and Democratic opposition to internal improvements. The earlier of these came in 1849. *Watching the Cargo* placed men on the banks of a river attending the freight of a steamship run aground (fig. 31).[70] In the background a series of snags alongside the steamboat informed the viewer just what had caused the wreck. Abandoning a central focus, Bingham here balanced three men and cargo on the left with a menacing log in the right foreground and the clear silhouette of a grounded steamer in the distance, from which men continued to unload cargo. His picture exudes the melancholy of decline. The steam engines have grown still, the day has begun to wane. With the power of steam defeated by snags in the distance, one figure, ironically, has paused to blow on an ember to light a fire that will warm the men as they watch the cargo through the night.

In this work, as subtly and as latently as he had done in *Lighter,* Bingham alluded to the need for clearing the rivers. It was an issue that had played a role, at both the state and national levels, in the election campaigns of 1848. Indeed, internal improvements had been at the forefront of Rollins' gubernatorial campaign in that year.[71] Rollins made numerous campaign speeches on the issue, and Missouri Whigs echoed his cries for federal funding for clearing the rivers. For them, it was a western issue that President Polk had beaten down. "The time has arrived, *we* think, when the west should *demand* of its public servants, a due regard to its interests. But if the doctrine, for the first time advanced by President POLK [that the federal government had no constitutional right to fund such improvements], and endorsed by the Democratic Convention in Missouri, is to prevail, then our rivers are to remain filled with snags, and impeded with sand-bars, our boats are to be sunk, our property destroyed, our commerce crippled, and our lives endangered for an indefinite time to come."[72] Once the elections

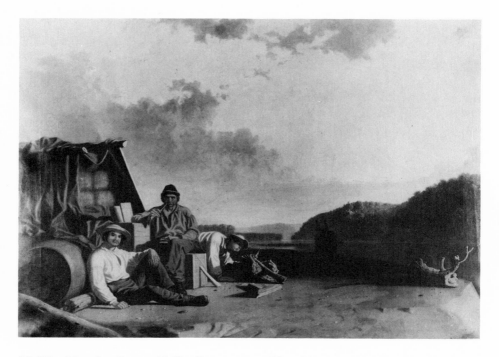

31 Watching the Cargo, *1849, oil on canvas, 26 × 36 in. State Historical Society of Missouri, Columbia.*

took place in the fall of 1848, Whigs looked to Zachary Taylor, elected president in November, to implement federal funding for such improvements. On Taylor's victory St. Louis Whigs celebrated with a torchlight procession featuring "a transparency of river and harbor improvement, with a view of Salt River on the back." [73] In the short term of Taylor's presidency, however, slavery dominated politics, even as it did in Missouri. Nonetheless, internal improvements remained on the minds of Whigs well into the 1850s. [74]

If Bingham's *Watching the Cargo* suggested that the sun was setting on commercial ventures on the river, his second image of a wrecked steamboat confirmed this. [75] *Watching the Cargo by Night* of 1854 is a nocturne, presenting a triangular group of figures on shore guarding the cargo unloaded from a wrecked boat just visible in the distance (fig. 32). [76] A small work, it was quite different from the larger election paintings that occupied Bingham at this time. But it picked up the theme of accidents on the rivers that Bingham had explored in *Lighter* of 1847 and *Watching the Cargo* of 1849, even as it may have subtly alluded to the Whigs' continuing concern with internal improvements. That issue had been a plank in the national Whig platform in 1852. [77] And in the year Bingham painted *Watching the Cargo by Night,* an-

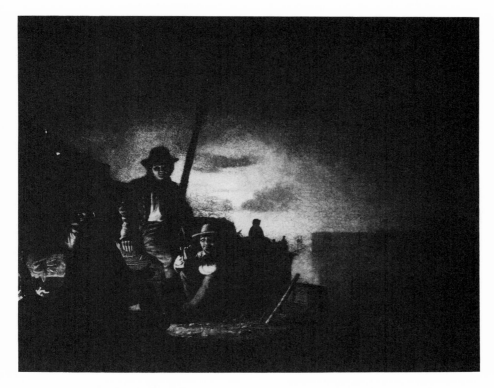

32 Watching the Cargo by Night, *1854, oil on canvas, 24 × 29 in. Museum of Western Art, Denver.*

other River and Harbor Bill went before Congress. It was passed only to suffer at the hands of another presidential veto in August.[78]

For a few years Bingham gave up river scenes in favor of other subjects. Only when he distanced himself from America in 1857 did he take up a river scene again. In Düsseldorf he created a painting that clearly was his farewell to the genre. He originally called his *Jolly Flatboatmen in Port* by another name, *Life on the Mississippi,* a title that clearly indicates the general content of the scene he portrayed (fig. 33). Painting in Germany at some remove from America, his river scene was an American subject that he may have hoped to publish as a print.[79] In this large multifigured composition Bingham summarized his earlier riverboat paintings. The principal figures of *The Jolly Flatboatmen* were there along with the drinker and the man leaning on a pole from *Lighter,* the poling figure with his back to the viewer and the seated glazed figure from *Raftsmen,* and the smoker from *Lighter* and *The Wood Boat.* In the distance on the river Bingham presented the craft that plied the river, that he himself had shown earlier in *Fur Traders* and

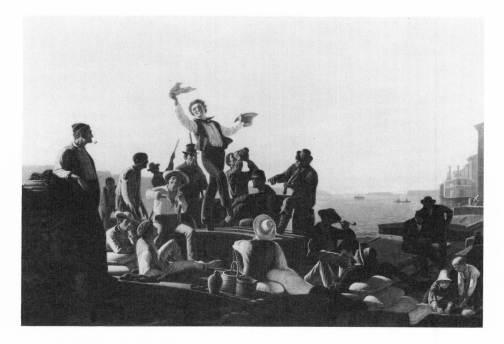

33 The Jolly Flatboatmen in Port, *1857, oil on canvas, 46¼ × 68¹⁵/₁₆ in. St. Louis Art Museum, St. Louis. Museum purchase.*

Boatmen on the Missouri. A canoe or pirogue with two figures in it appeared between a steamboat at anchor and a flatboat on the river. Bingham here eliminated any hint of danger. He did not include any snags or sandbars, and he brought the steamboat safe to port. Safe, too, were all his river denizens, whom he rounded up for the last time. The whole assembly had the character of a tableau vivant posing for the man sketching in the middle ground. The only newcomer to Bingham's river pictures was the black man. He smiled as he joined the group, but his extremely tattered clothes suggested a difficult past and surely interjected the issue of slavery into this otherwise riant picture. Indeed, at the time Bingham painted this work, he was deeply concerned with this issue and its threat to the Union. With these matters on his mind, then, Bingham signed off from paintings of life on the river.[80]

As much as Bingham continued to exhibit and sell river scenes in the early 1850s, his principal interest lay elsewhere. As early as 1847, he had turned to other subjects. The only painting he submitted to the Art-Union in 1848 was *The Stump Orator,* a painting now lost that quite probably reflected the loss of his seat in the legislature (fig. 34).[81] The next year, in 1849, he submit-

ted another picture of the political process, *The Country Politician* (fig. 35). Bingham's turn in this direction undoubtedly had to do with his own active participation in government. After a false start in a contested election in 1846, his political career had taken off, in earnest, with his election to the Missouri General Assembly in the fall of 1848. Then he threw himself into politics and became concerned with the issue of slavery. By the early 1850s, his major paintings had to do with elections and the electoral process.

4

From Snags to Slavery

Bingham and Benton, 1847–1850

The [Jackson] resolutions, taken altogether, are false in their facts, incendiary in their temper, disunion in their object, nullification in their essence, high treason in their remedy, and usurpation in their character. . . . The resolutions should be repudiated as a disgrace to the state. They should be disavowed as any injury to her.

—*Thomas Hart Benton, Speech at Fayette, Missouri, 1 September 1849*

Bingham's loss of the legislative seat at the end of 1846 initiated a three-year period in which his activities swung, like a pendulum, between art and politics. At the height of his battle to retain his seat, he had vowed to Rollins: "As soon as I get through with this affair, and its consequences, I intend to strip off my clothes and bury them, scour my body all over with sand and water, put on a clean suit, and keep out of the mire of politics *forever*." [1] Yet, despite his immediate return to painting with the exhibition of *Lighter* and *Raftsmen* in April 1847, he did not forget the political scene. He remained bitter about his ouster from the house and soon took up in his paintings the theme of politics. Two works addressing this new subject bracket this period, *The Stump Orator* (fig. 34) of 1847 and *The Country Politician* (fig. 35) of 1849. Between the two, Bingham the artist painted only a handful of works, but Bingham the politician was once more active.

Early in 1848 Bingham returned to the fray. His good friend Rollins was running as a Whig candidate for governor, and Bingham made speeches in April in support of his friend. [2] A few months later the artist himself agreed to run for the state house of representatives, and he conducted his campaign during the summer. Then, having won a seat in the legislative session of 1848–49, he assumed a prominent role in the house as spokesman for the Committee on Federal Relations. During the gubernatorial and legislative campaigns, internal improvements of the rivers continued to be an issue. The Whigs took uncommon delight in an accident on the river that prevented certain prominent Democrats from reaching their convention on time. "The steamer Missouri," Switzler wrote, "not unlike a certain most un-

fortunate State bearing the same name, groaning under a superincumbent mass of Locofocoism, [was] wrecked on a *Polk stalk* in the river, to the terror, confusion and imminent peril of all on board."[3] On a more serious note, Missouri Whigs made clearing the rivers and support for public education the key planks in their platform.[4] Again and again, Rollins, who cared deeply about both matters, addressed them in his campaign speeches.[5] Presumably Bingham echoed his friend as he stumped. Yet, once the state legislature opened in December, the issue that overrode all others and that occupied Bingham in particular was the formulation of Missouri's position on slavery.[6]

In the course of the legislative session, Bingham held fast to his most prized definition of Whiggery, even if it meant abandoning some of his fellow party members. "The whigs are freemen," he had written in 1841, "and not like them [the Democrats] bound to model their thoughts to correspond with the wishes of a master."[7] Brashly exercising a Whig independence of mind, Bingham felt no compunction in 1848 about speaking out on matters of principle. In so doing he assumed a preeminent position in the General Assembly as a pro-Union spokesman. If politics make strange bedfellows, then such was the case here. Bingham's views on the issue of slavery cut across party lines and ultimately linked him—and like-minded Whigs, such as Rollins and Switzler—with the man who had been the central figure in the Missouri Democratic party and senator for almost thirty years, Thomas Hart Benton (fig. 38). The artist's former ferocious opposition to Missouri's senior senator melted as Benton himself took a stand on principle.[8]

Various stages of Bingham's political thought and the surprising shift in his allegiances made themselves felt in his political paintings of 1847 and 1849: *The Stump Orator* and *The Country Politician*. Each work reflected particular moments in his political thinking. The earlier painting was an immediate and quite personal response to his loss of the legislative seat, intended at the outset to satirize the Democrats. The later one, in contrast, carried a latent message about his political thinking on the slavery issue in the spring of 1849. Even beyond this two-year period, Bingham's belated admiration for Benton ultimately led him, in 1853, to conceive a historical painting with Old Bullion Benton as its chief protagonist. Even before that time, he had used a portrait of Benton to make a sharp political point in the legislature.

The Stump Orator, 1847

The Stump Orator, known only through a daguerreotype, was Bingham's first painting of the political process in action (fig. 34).[9] The candidate on a stump to the left gesticulates as he makes a point to the crowd arrayed

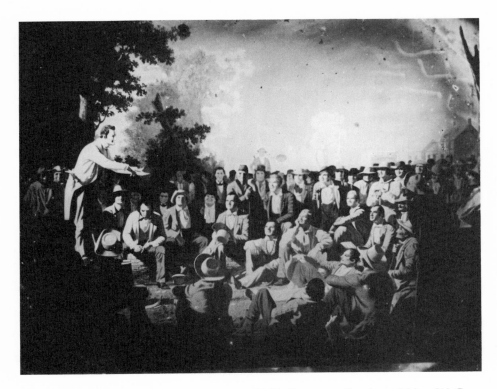

34 *Daguerreotype of* The Stump Orator, *1847. Former collection of Mrs. W. C. Roberts. (Photo: State Historical Society of Missouri, Columbia)*

before him in a semicircle. Below him, almost at his feet, sits a man intent on whittling, possibly the opponent awaiting his turn. The figures in the immediate foreground loll or sit, their backs to the viewer, as repoussoirs for the seated figures that complete the semicircle in front of a standing teeming crowd. A tree bows over the speaker on the left, echoed by floating clouds, and a row of buildings closes the composition to the right.

Formally, the painting loosely recalls any number of earlier oration scenes. The outdoor setting is particularly reminiscent of Renaissance and baroque representations of St. John the Baptist preaching in the wilderness. But Bingham need not have resorted solely to precedents in Grand Manner art. Even on the western frontier of America, artists had already begun to record political gatherings, as in the anonymous *J. K. Polk, 1840/Knoxville, Tennessee,* which offers a parallel for Bingham's lolling postures and awkwardly gesticulating figures.[10]

A St. Louis reporter was just as enthusiastic about the contemporaneity of the picture as he was about its artistic quality:

It is not an attempt to carricature, but an effort to draw an unexagger-
ated representation of an assemblage which is familiar to every one in
the west. The postures—the dress, as clean and neat as the humble
means of western life will justify—the little knot of busy politicians
around the finely dressed Demagogue, in the back ground—the idiotic
expression of an unfortunate inebriate behind the speaker—the joy of
the zealous partizan—the cool, calculating aspect of the more reflecting
citizen—the half stare and half incredulity of another—the man with
his coon skin cap and rifle—the side bar dialogue at the end of the
circle—the tavern, and unfinished log house in the distance—the
mellowed landscape and autumnal evening scene—give to the whole a
merit, a richness and a beauty to which ordinary language cannot do
justice.[11]

On the surface, the scene would seem to be simply a record of American
political life, familiar to Bingham from his years of political involvement. But
was it only that? This commonplace scene of a candidate appealing to the
people had another level of meaning for Bingham that was clear in his mind
when he first conceived the work.

The artist's first ideas for this painting arose late in the spring of 1847,
just a few months after his loss of his seat in the legislature. Early in May
1847, just after the exhibition of his two riverboat paintings in St. Louis, he
told S. W. Bailey, a Whig friend there, that he would "immortalize some of
his legislative and Saline friends in a painting he projects."[12] Bailey was
quick to pass the news on to Abiel Leonard, a major Whig leader in central
Missouri. "I suppose," he concluded, "the effect will be equal to Popes Dun-
ciad." If Bailey likened Bingham's project to the great satire by Alexander
Pope, he must have heard an earful of the artist's bitterness and anger over
the Democratic legislature that had unseated him. Yet one can construe only
the barest hint of criticism in the picture—a few members of the audience
are not entirely attentive. But that is not enough to transform *The Stump
Orator* into a ruthless satire like Hogarth's scenes of the election process.[13]
The reviewer in St. Louis was adamant that he saw no hint of caricature in it.
What message then did Bingham convey in the painting?

In the artist's oeuvre up to 1847, the painting is notable for its crowd of
people. In contrast with the riverboat scenes, which had at the most seven or
eight figures, this one virtually teems with citizens, more than forty-five of
them. With a few exceptions, almost all of them appear to listen intently to
what the speaker has to say, their faces turned toward him. The St. Louis
reporter's characterization of the audience—"some pleased, some dis-
pleased, and some without any idea at all of what he is saying"—does not

suggest a satirical criticism of the electorate as a whole or of the political process.[14] Rather, this painting would seem to record an appeal to the people. Contemporaries and scholars have long recognized the autobiographical nature of the painting, but without noting how keenly that particular theme touched Bingham at this time.

Indeed, the preceding fall Bingham himself had suggested just such an appeal to the people in order to settle his own contested election. In August he had won a seat in the state legislature by the slim margin of three votes. When his opponent, Erasmus Darwin Sappington, announced in September that he was contesting the election, Bingham's immediate response was to suggest that the contest go back to the electorate, "leaving the people, according to the genuine republican method, to determine for themselves who shall be their representative."[15] Sappington refused, preferring to place the decision in the hands of the predominantly Democratic house, which he knew would find in his favor.

Throughout the fall and early winter, as he defended his seat, Bingham returned again and again to the issue of the sanctity of the voice of the people. The most complete expression of his views on the matter—indeed of his views on the whole electoral process—came in the final speech he gave in the legislature in his own defense.[16] That tour-de-force not only sheds light on the thinking behind his *Stump Orator* of 1847 but also illuminates his later election pictures of the early 1850s. In a stirring moment of that speech, Bingham described the difficulties of his campaign against the Democratic machine:

> Upon the stump I had to contend with the abilities of others besides my competitor. Against me was arrayed, not only a large portion of the concentrated wealth of the county in which I reside, but I found, meeting me regularly at my own appointments, the *great* champion of our opponents from the other end of our Senatorial district. Opposed by such a combination; assailed both in front and flank, with an *Ex-Governor* whenever an occasion offered bearing down on my rear, I still found myself sustained by the consciousness of a good cause. The people rallied to my rescue, and notwithstanding the fearful odds against me, I conquered in their strength and came off victorious.

Sappington was well connected in the Democratic party. His counsel during the contest in the General Assembly was the attorney general, B. F. Stringfellow. Sappington's brother-in-law, Meredith Miles Marmaduke, had been governor of the state, and he took an active role in the fight.[17] Just a few days after the election, in August 1846, Marmaduke was already gathering information on voters that could challenge Bingham's victory.[18] Bingham was

aware of the Democratic power arrayed against him, but he insisted that the people had chosen him.

It was the people who had supported Bingham and to them he wanted to turn to decide the contested election. "I would to God that the people of our county, who are well acquainted with all the facts and circumstances of the case, could be permitted to judge between us! But my opponent . . . changes the venue from what I conceive to be the most proper tribunal in such cases, the sovereign people themselves, and comes here to this Hall [House of Representatives], where, calculating upon the force of political bias, he expects to find a jury already packed and empanneled in his favor." Bingham could scarcely have made clearer here his faith in the will of the people and his concomitant distrust of party machinations within the Democratically controlled legislature.

Using the most Jacksonian arguments, he went on jabbing at his Democratic colleagues in the legislature. "I am, sir, a Republican, a Democrat, in the true and legitimate sense of those terms, being governed by that principle which urges us to submit with due deference to the omnipotence of the popular will." But he was also a Whig, he confessed, "a title that blends with the rallying cry of freedom throughout the world!" Here he picked up the theme that Whigs are free men because they can vote their consciences and not defer to the will of the party. He then concluded, "For sir, I value a seat in this House . . . because it is the free and unbought gift of the people, worthy as such to be prized as a pledge of their confidence and esteem." Once again Bingham returned to the theme of the will of the people, who, he felt, would have kept him in office.

Manipulations in the General Assembly were so blatant that Missourians recognized that the cards were stacked against Bingham. One letter to the editor of the Liberty *Weekly Tribune* summed up the artist's difficulties: "I am beginning to believe contrary to my first impression, that Bingham is doomed. He is contending with too much wealth and too great a family, in addition I have been informed, the abilities of the Attorney General [Stringfellow] are to be in the scale against him, powerful odds, not to mention the large party majority, which will unconsciously, lend a better ear to Sappington's side of the case."[19] The Committee on Elections came in with a split vote, with William F. Switzler writing the minority report and decrying the decision.

Given the timing of *The Stump Orator*—it was planned in May and finished by November—the painting testifies to Bingham's faith in the popular vote and, by extension, criticizes the partisan intrigue that had unseated him.[20] Out in the open, the candidate appeals directly to the people. This is a scene of the democratic process in action, quite a contrast to the partisan

milieu behind the closed doors of the legislature. For Bingham the Whig, a seat in that body should be "the free and unbought gift of the people," not the result of partisan juggling and intrigue. After concentrating for two years on riverboat scenes, Bingham's decision to paint a political scene of an appeal to the people seems intimately connected with his own experiences in politics. The coonskin hat and the partially built log cabin in the distance, still highly charged Whig symbols, might subtly mark the message as a particularly Whig one.

The autobiographical element did not go unnoticed by Bingham's contemporaries, even though the artist himself demurred. The St. Louis reporter who raved about the work in November wrote: "The artist, himself, has been on the stump, and gone through a hot and exciting canvass. Whilst he disclaims every thing personal—and we know he is above anything of the sort—we think we can recognize in the group many well known political characters."[21] Although the reporter claimed to believe the artist's denial of any personal meaning in the work, he did notice portraits, on the order of those the artist had earlier promised to Bailey.[22] The identification of particular figures, however, is difficult, if not impossible, given the blurred daguerreotype and the absence of accurate portraits with which to compare the heads. Nonetheless, the work would seem to be topical, local, and, despite the artist's public protestations, quite personal.

As had occurred with *Lighter* and *Raftsmen, The Stump Orator* received high praise in St. Louis, only to be castigated in New York, undoubtedly discouraging Bingham from proceeding immediately with other political genre scenes. The enthusiasm of the St. Louis reporter had been unbounded: "For vitality, freshness, grouping, shade and light, and costume, we have never seen anything equal to it. . . . No description could do justice to the talent, skill and study, which it displays. It is a painting which may be studied by the hour."[23] From St. Louis the work went on to New York, where it was exhibited first at the National Academy of Design in June 1848 and then as Bingham's only work at the American Art-Union in December. After the success of St. Louis, imagine then Bingham's reaction when the work was reviewed unfavorably in New York. Said one critic: "Mr. Bingham's picture, *The Stump Orator* . . . makes one's eyes ache to look at it. All the laws of chiar'oscuro are set at defiance so that the eye is distressed and carried all over the canvas, without a single resting place. He has evidently no idea of the value of light. . . . In color it is unmistakably bad."[24] Another, only slightly more generous, found the work a "highly wrought and multitudinous picture . . . full of both merits and faults."[25] Nonetheless the Art-Union bought the painting and distributed it in December of 1848. By this time, however, Bingham's mind was on other matters. The death of his first wife

late in November had saddened him. His only solace was to plunge himself into his work as a newly elected legislator.[26]

In the spring of 1848, after completing his painting of a stump speaker, Bingham's life had imitated his art as he had taken once more to the campaign trail, first to support Rollins' campaign for governor, then to push for his own election to the house. At first reluctant to run as a Whig from Saline County, Bingham changed his mind late in June.[27] When an anonymous letter writer informed Switzler's *Missouri Statesman* that Bingham had decided to run, he enclosed a "graphic pencil sketch of the Locos during the speech delivered in this place [Marshall], on the 27th instant in reply to Judge King by Major Rollins."[28] Even if the sketch were not by Bingham, it may well have reflected his *Stump Orator* and certainly indicated that art and politics went hand in hand in Saline County.

The latent message of *The Stump Orator* in 1847—that the *people* should decide issues like Bingham's contested election—was fulfilled in the summer of 1848, when the artist asked them to decide once more between him and Sappington. This time he emerged triumphant. The unfavorable reviews of *The Stump Orator* from New York may have seemed minor in December 1848 in the face of the important issues facing him as a legislator.

Bingham, Benton, and the Slavery Question in Missouri, 1848–1853

Elected as a representative in August 1848, Bingham entered a legislature geared up to deal with the questions of internal improvements and education that had dominated the campaign. Though Rollins had lost his bid for governor, he had forced the Democrats at last to confront these important issues, and Gov. Austin King's inaugural speech addressed both of them.[29] Nonetheless, almost as soon as the legislative session opened, two more pressing issues surfaced to dominate discussion—first, partisan debate over the legality of the Mexican War and, second, the formulation of Missouri's position on slavery.

It was the second issue that most engaged Bingham during the latter half of the legislative session. In fact, the one item from that session to bear his name was a series of pro-Union resolutions in regard to slavery formulated to counter the pro-South Jackson Resolutions. Bingham's position on slavery joined him to Benton on this key issue and made him a state spokesman for the Union. Even before he drafted the Bingham Resolutions, the artist's hankering admiration for Benton surfaced.

Indeed, in the debate on the Mexican War, Bingham publicly espoused a position close to Senator Benton. Throughout the month of January, acri-

monious exchanges had occurred on the floor of the house over the justness of the Mexican War. Ostensibly discussing approval of the Annual Report of the State Penitentiary, Democrats and Whigs had each offered amendments that prompted a full-scale debate on the war. Democrats defended Polk's war as a just and honorable one. Whigs decried it as unwise and unnecessary, its chief virtue having been to bring about the election of a Whig President. On January 21, Bingham took the floor. According to Switzler's *Missouri Statesman:* "Mr. B. said he had declared openly from the stump, before his constituents, his opinion in regard to the war, and he feared no responsibility; he took the same ground which Mr. Benton had taken in his speech in St. Louis—that the war might have been honorably avoided. [But] he held it his duty to obey the will of a majority, and to go to the rescue of and defence of our flag whenever necessary." [30] The speech rang with Bingham's love of country and his political principles: his faith in stump speaking, his belief in direct appeal to the people, and his reverence for the will of the majority. But more particularly, it showed his independence of mind. With great good sense, Bingham took the position of the renowned Missouri Democrat in order to attack his Democratic colleagues in the house. In this move he echoed the Whig who had just preceded him, his good friend Switzler, who had quoted Benton's pronouncements on the illegality of the war. Having publically declared his political alliance with Benton over the Mexican War, Bingham moved, just a little more than two weeks later, to demonstrate his admiration still further.

On 8 February Bingham introduced a resolution into the house having to do with Thomas Hart Benton. So brief as to have gone unnoticed in the literature on Bingham, his motion proposed: "That the door keeper be and he is hereby directed to remove the portrait of the honorable Thomas H. Benton, from its present exposed situation in the State Library, and to place it in an elevated position in this Hall, either to the right or the left of the chair of the Speaker." [31] The work, painted by an unnamed "german artest," had hung in the capitol since 1844, at first on loan, then purchased by the state during the fourteenth General Assembly. [32] A full-length state portrait, it showed Benton "standing wrapt in a black cloak, with a scroll in the left hand," a work that later inspired images of Benton on Missouri bank notes. [33] Surviving into the twentieth century, the portrait is barely visible over the speaker's chair in the interior view of the house chamber taken around 1900 (fig. 55), before fire destroyed the state capitol in 1911. Clearly an impressive work, it caught Bingham's eye and prompted his resolution.

It was curious that a Whig should have introduced such a resolution, since Senator Benton had led the Democratic party in the state for more than a quarter of a century. On the surface, the language of the resolution

would seem simply to indicate that Bingham was here acting as an artist concerned with the preservation of a work of art. But the mind of the politician was also at work. In this tumultuous legislative session devoted to controversial issues, the Whig Bingham had good reason to want the debates overseen, as it were, by the image of the eminent and outspoken Democratic senator whose views on the great issues of the day were closer to those of many state Whigs than to those of the state Democrats. Bingham thus used his position as an artist to bring Benton, with whom he now found himself allied on the issue of the Mexican War, literally into the legislative chamber to act as a conscience for his Democratic colleagues and surely to remind them that they were breaking with the leading state Democrat of the day. Benton's presence surely might help in the debate on slavery that Bingham— and others in the house—knew was coming.

Several resolutions on slavery, already passed in the Democratically controlled state senate, were on their way to the house and to the Committee on Federal Relations, on which the artist sat. These resolutions, written by Judge William Napton and sponsored by Claiborne Fox Jackson, were to serve as Missouri's official response to the Wilmot Proviso.[34] Known thereafter as the Jackson Resolutions, they defined Missouri's position on the issue of slavery in the nation.[35] They came in response to the Wilmot Proviso, hotly debated but never passed in Congress, which would have forbidden the introduction of slavery into the territories. The Jackson Resolutions, in contrast, argued that Congress had no power to legislate on slavery in the territories. Proslavery in intent, they stated that "in the event of the passage of any act of Congress conflicting with the principles herein expressed," Missouri should stand with the southern states on all congressional votes. The final clause of the Jackson Resolutions was a binding instruction to Missouri's Senators Benton and Atchison to vote accordingly.[36] Many Missourians, including Rollins, Bingham, and Benton himself, would later regard these resolutions as a deliberate attempt to defeat the senator in the upcoming Senate race.[37] Some regarded them as a mean-minded retaliation for Benton's opposition to Jackson's bid for governor the preceding fall. Whatever their genesis, the resolutions presented a position that Benton would have difficulty accepting, and most Missourians knew this. When the state senate considered the resolutions in January, James Rollins voted with other Whigs against them. Surely he discussed them with his friend Bingham, whose House Federal Relations Committee had to deal with them in February.[38] Bingham's move to place Benton's portrait so prominently in the house may well have anticipated the position that he and other Whigs would take, in alliance with Benton, on the issue of slavery.

Bingham, delivering his report in the house on 26 February, wanted,

above all, to defeat the Jackson Resolutions with their staunch proslavery position and their binding instructions to Missouri legislators. Though modern scholars have described Bingham's resolutions as conciliatory, in the context of the times they were bold.[39] Contemporaries like A. B. Chambers, the editor of the St. Louis *Missouri Republican,* felt that his report against the Jackson Resolutions was "not surpassed in force & ability by any thing that has been written or spoken on this subject."[40] The position that the majority of the House Committee on Federal Relations took on the Wilmot Proviso was essentially this: they acknowledged that Congress had the authority to prohibit slavery in the territories, yet they recommended that Congress exercise that power "with due regard to the rights and interests of every section of the Union."[41] Conceding that Congress could not make laws affecting slavery where it already existed, the majority of the committee trusted that Congress "in all its acts, which may in any manner be calculated to effect the institutions of Slavery . . . will be guided alike, by the principles of justice, and the letter and spirit of the Constitution of the United States." Bingham and the committee felt, presciently and rightly, that the gravest threat that the Jackson Resolutions posed was the threat to the Union.

His report then was more than a judgment about the legality of the Wilmot Proviso. It was a heartfelt and farsighted plea for the preservation of the Union. Bingham opened the report forcefully, despite a double negative: "We are not prepared to say, that we would not prefer this glorious Union, even with the Wilmot Proviso, to its dissolution without it." Bingham went on to make an impassioned entreaty using the words of Washington's *Farewell Address:* "Having before us the warning voice of the Father of His Country, we deem it our most sacred duty, to cherish an immovable attachment to the National Union; to watch for its preservation with jealous anxiety, to discountenance even the suggestion, that it could in any event be abandoned, and indignantly to frown upon the first dawning of every attempt to alienate any portion of the country from the rest." At the end, after asserting that the present prosperity of the nation derived from the union of the states, the committee resolved: "That inheriting with our sister States a common legacy, we desire also to be united with them in a common destiny; and regardless of the railings of fanaticism, either in the north or South we pledge ourselves, come what may, whether prosperity or adversity, weal or wo, still to stand by the Union."

Firm on the preservation of the Union, Bingham once again voiced his faith in the will of the people. Writing for the majority of the committee, he was "disposed to leave, for the present at least, this grave and important question, to the wisdom, intelligence and patriotism of the people of the entire Union." In leaving the issue to the "people of the entire Union," Bing-

ham was not adopting the stance of Lewis Cass, who in 1847 advocated leaving the decision to the people of the territories, thereby opting for the solution of popular sovereignty.[42] Instead Bingham here called for widespread discussion of the issue that would carry the will of the people to their representatives in Washington. And it would then be Congress that would make its decision. In a vague and undefined way, Bingham wanted all the people of the Union to decide through their elected representatives. He may have had some intuition that popular sovereignty would ultimately lead to a travesty of the election process, when the federal government adopted that principle in Kansas. In the prologue to the Bingham Resolutions he was advocating—perhaps overly naively and overly optimistically—the free expression of the people in legally conducted elections and the honest representation of the will of the people by elected representatives in Congress.

However forceful they were, the Bingham Resolutions were doomed to die a partisan death. When the vote came on March 7, the house split along party lines, defeating the Bingham Resolutions by a vote of 53 to 29 and passing the Jackson Resolutions by almost the same majority. Throughout the debate in the house Thomas Hart Benton's portrait looked down. As Bingham presented his own resolutions, which would have blocked any binding instructions to Senator Benton, he must often have gazed at the portrait, placed there at his urging. If he wondered what the man within the portrait thought, he had the opportunity to find out the following spring and summer. As if bearing out Bingham's suggestion that the people should decide the issue, Benton took his appeal to all Missourians. In the course of his campaign the venerable senator would voice aloud his approval of Bingham's legislative efforts.

Just two months after the passage of the Jackson Resolutions, Thomas Hart Benton returned from Washington to make his appeal to the people.[43] In a letter to Missourians early in May and in a speech at the capitol later that month, Benton attacked the Jackson Resolutions and announced his intentions to canvass the state to garner support for his position. Asserting that the Jackson Resolutions did not represent the will of the people, he stated that he would not obey them, preferring to let the people decide whether they would support him or replace him in the Senate. Throughout the summer he campaigned vigorously, focusing particularly on slave counties, the stronghold of his enemies. In Columbia, he shared the platform with the Democratic governor, Austin King, who had signed the resolutions into law. In a dramatic reversal, King declared a change of heart and proclaimed his fervent support for Benton's position. After the appearance in Columbia, Bingham's friend Rollins wrote to Benton, applauding his views on slavery and stating that Benton would go down in history as one of America's great

senators.[44] Other Whigs, like Switzler and Abiel Leonard, also found themselves drawn toward Benton.

The most dramatic moment of the canvass and the moment when Benton specifically praised Bingham's report opposing the Jackson Resolutions occurred late in the summer at Fayette, the home town of Claiborne Jackson and the stronghold of anti-Benton sentiment. There, on a hot September day, Benton appeared in the Chapel of Central College, not far from the town square. Ignoring threats against his life and facing weapons freely brandished in the audience, the distinguished senator spoke for more than three hours.[45] Defiantly and openly he directed his remarks to "MY FRIENDS—and in that term I comprehend those who come to hear the truth, and to believe it—none others."[46] Likening the Jackson Resolutions to the Calhoun Resolutions in Congress, he attacked them as leading to nullification, disunion, and ultimately high treason. Their passage, he asserted, was simply "a plot to get me out of the senate, and out of the way of the disunion plotter."[47]

Benton took particular notice of Bingham's report. He described it as a "patriotic report" that declared " 'that the people of Missouri love the Union, and are in favor of maintaining it at all hazards.' "[48] He deplored the rejection of the Bingham Resolutions and criticized quite harshly the refusal of the house even to print them. He ended, calling for the repudiation of the Jackson Resolutions "as a disgrace to the State."

In the spring and summer of 1849, then, the Jackson Resolutions hung like a pall over the state of Missouri. Not only were they the subject of political debate, they were also an almost daily topic in state newspapers. Small wonder then that the issue of slavery should have attached itself to one of the first works Bingham exhibited after the close of the General Assembly in March. *The Country Politician* was more than a simple political genre scene. For Bingham and for politically astute Missourians, it had latent associations with the whole saga of the Bingham Resolutions.

The Country Politician, 1849

Bingham's second documented political picture, *The Country Politician* (fig. 35) painted sometime before June 1849 and exhibited in both Cincinnati and New York, contrasted dramatically with the crowded and complicated *Stump Orator*.[49] A simple interior, with bare wooden walls and a clean-swept floor, encloses three figures seated around a stove while a fourth reads notices on the wall to the left. In the center of the painting, Bingham has grouped the seated men in a loose pyramidal arrangement, anchored by a dark pot-bellied stove slightly off center. The stove's triangular belly com-

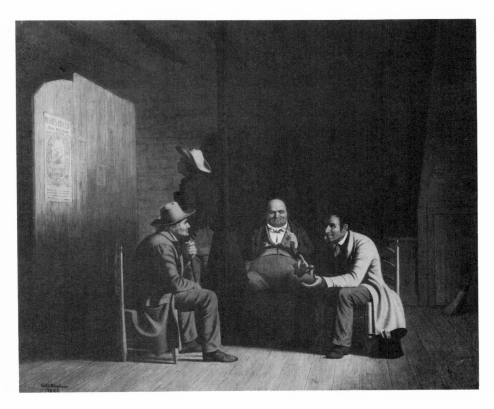

35 The Country Politician, *1849, oil on canvas, 20 × 24 in. The Fine Arts Museums of San Francisco, San Francisco. Gift of Mr. and Mrs. John D. Rockefeller 3d.*

ically echoes the shape of the rotund and balding central figure, while its vertical flue leads the viewer's eye to the adjacent standing figure who turns away from the group to contemplate notices posted on a wall, including a poster for Mabie's Circus. All four figures are bound within a larger triangular shape, rising from the seated figure on the right through the head of the balding man to the central cloak on the back wall, then descending through the standing figure to the back of the old man on the left. The direct and classical stability of the composition matches the spare and uncluttered setting. Even the circus poster and other items are neatly aligned with the wooden slats of the wall on which they are posted.

Bingham's painting arrived at the Art-Union only five years after the exhibition of J. G. Clonney's *The Political Argument,* showing politicians in a country bar.[50] And Bingham's work certainly owed a thematic debt to it or to others like it. Formally, however, it was more closely related to a painting by William Sidney Mount, *The Long Story,* as Bloch surmised on the basis of

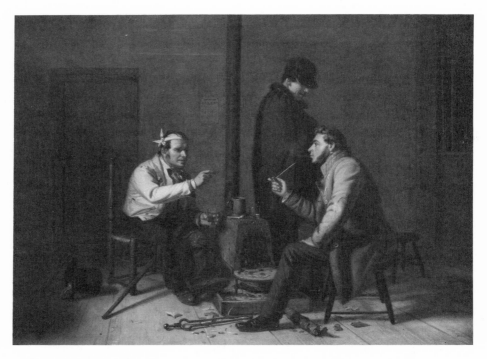

36 *William Sidney Mount,* The Long Story, *1837, oil on canvas. In the Collection of The Corcoran Gallery of Art, Washington, D.C. Museum purchase: Gallery Fund.*

description long before the rediscovery of Bingham's painting (fig. 36).[51] In 1842 that painting had appeared as a print in *The Gift,* an annual Christmas volume of stories and poems that Bingham knew and even copied from.[52] In *The Country Politician,* he essentially borrowed Mount's setting and reversed the figural grouping around the central stove, adding only one figure.

Yet the striking affinities between the two make the differences all the more notable. Bingham quite deliberately cleaned up his composition—he straightened up the top hat that spilled forth its contents in Mount's work, he included only one fire tool, which he placed in its proper location beside the stove, and he even swept up the mess of ashes and wood chips in the foreground. To make a point of what he had done, he left a broom neatly propped up on the right side of the painting, its transparent paint clearly indicating that the broom was a deliberate addition at the end. Years later he would use a similar metaphor in his description of the political debate in his *Stump Speaking* delivered by "a shrewd clear-headed opponent . . . who will . . . make sophisms fly like cobwebs before a housekeepers broom."[53] The clean swept state of the room, which so contrasted with Mount's untidy

bar, was a fitting setting for sober citizens, Bingham seemed to say. Unlike Mount's actors, Bingham's characters did not drink nor had they just emerged from a fracas.[54] As surely as he acknowledged a debt to Mount in his formal arrangement, he equally surely asserted a different message in the clean sweep of his spare composition. His figures eschew liquor and concentrate on the issues, only one of them distracted from the conversation. While Mount's bandaged narrator would seem to be excitedly recounting the mess he is in, Bingham's earnest politician patiently argues what he hopes is a clean and convincing point.

The first to comment on Bingham's painting was a St. Louis reporter who saw the work in April 1849. Describing its setting as a barroom, the reporter went on: "The jolly old landlord, smoking his pipe, a politician, most earnestly discussing to a very indifferent listening farmer, the Wilmot Proviso, whilst a boy, with his coat-tail turned up to the stove, is reading a show-bill."[55] Bloch and others dismissed this writer's mention of the Wilmot Proviso simply as his own idea and not Bingham's. But, if the reporter saw the work in Bingham's studio, he might well have spoken with the artist about it. And in the months preceding the exhibition of the work, the Wilmot Proviso was very much on Bingham's mind. Less than two months before, in late February, the artist had brought his pro-Union resolutions before the legislature. In early March they had gone down to defeat. If a reporter came away from the artist's studio in April linking the Wilmot Proviso with the small political painting, is it not likely he had heard this association made by the artist?

Here again, as in *The Stump Orator,* Bingham represented political discussion brought to the people—exactly what he had recommended in the Bingham Resolutions. There, he and his committee had suggested that the serious issue of slavery in the territories be left to "the wisdom, intelligence and patriotism of the people of the entire Union." Bingham also may well have been thinking of Benton's forthcoming appeal to the people, news of which had reached Rollins—and probably Bingham—as early as February 1849.[56] In the painting Bingham may well have been anticipating the kinds of discussion he knew the appeal would elicit.

Bingham did not make explicit references to the slavery issue in the painting, but in the circus poster he did comment on distractions from the political process. The fellow to the left turns his back on the conversation, absorbed in reading notices on the wall. The only decipherable one, and by far the largest, is a poster for Mabie's Circus, the "showbill" noted by the St. Louis reporter. Most scholars have interpreted the poster simply as an indication of a Missouri locale, since Mabie's Circus performed in the central

37 *Anonymous,* Advertisement for Mabie's Circus, *wood engraving in the* Columbia Missouri Statesman, *29 August 1851. (Photo: author)*

part of the state in these years. Indeed, the image of a figure with hoop or rope jumping above a rearing horse matches advertisements for Mabie's published in 1851 in the *Missouri Statesman* (fig. 37).[57]

The poster does set the scene in Missouri, but in the Whig circles Bingham frequented, circuses carried a deeper meaning, particularly in the legislative session that passed the Jackson Resolutions. In August 1848, an outraged letter to the editor in Switzler's *Missouri Statesman* hostilely attacked circuses. Signed by A True Friend of Columbia, the letter cited various articles from the eastern press describing circuses as "'an increasing evil, this travelling death and moral ruin'" and as "'travelling abominations' . . . corrupting the public morals, defrauding the people of every respectable village in every State in the Union of hundreds of dollars annually, and . . . evading all wholesome restraints attempted to be imposed on them."[58] The outraged writer of the letter suggested that the upcoming legislature deal with the matter. Accordingly, soon after the opening of the General Assembly, James Rollins introduced into the senate: "An act authorizing the trustees of the inhabitants of the town of Columbia to tax the owners and man-

agers of menageries and circuses, outside of the limits of said town, and for other purposes."[59] The curious bill passed both houses and was signed into law in March. Inconsequential as it may seem today, the bill, and the letter that prompted it, seem clear indication of what local Whigs thought about circuses. Just as the Whig press criticized circuses and Rollins moved to restrict their activities in 1848–49, so Bingham made a subtle statement in his painting about the power of circuses to draw the minds of men away from serious political discussion. Even this seemingly unimportant detail in *Country Politician,* in 1849, was charged with local political meaning.

Bingham sent the painting to the Western Art Union in Cincinnati, and failing to sell it there, forwarded it to the American Art-Union in New York, where it sold for $200, less than the amounts usually paid for the later riverboat paintings. Perhaps discouraged by its relative lack of success, Bingham waited another two years before again attempting a political painting.

Postscript on Bingham and Benton

Over the next several years Bingham threw himself once more into his career as an artist—actively seeking a consular position abroad, once again undertaking numerous portraits, exhibiting works in Cincinnati, Philadelphia, and New York, and even pursuing new markets by having some of his works engraved. All of this activity took him east for months at a time, away from the intensity of Missouri politics. Nonetheless, he did not give up the battle to repeal the heinous Jackson Resolutions. When he was in the East, he followed the controversy via the newspapers and correspondence with Rollins. When he was in Missouri, he continued to speak out publically. And Thomas Hart Benton remained high in Bingham's esteem. Indeed some time after 1850 Bingham painted the senator's portrait (fig. 38).[60] The artist, with his down-to-earth and ironic sense of humor, must have chuckled more than once at the discomfort in the General Assembly caused by his legacy to the legislators—the full-length portrait of Benton that glowered over the chamber of the house at Bingham's instigation.

Despite a gap in his correspondence with Rollins from 1847 to 1851, it is possible to trace Bingham's continuing convictions about repealing the Jackson Resolutions. After a trip east from July to late September 1849, Bingham returned to portraiture in Columbia and, one presumes, to courting Eliza Thomas, the woman he married early in December. About a month later, Bingham was once more engaged in the political life of central Missouri. A public debate about Benton's appeal found Bingham arguing the affirmative position on the question: "Has a Senator in the Congress of the United States

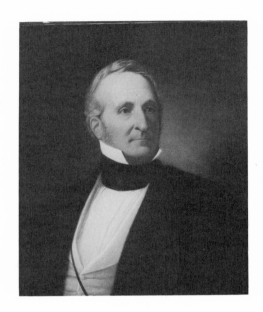

38 Thomas Hart Benton, *after 1850, oil on canvas, 30 × 25 in. Missouri Historical Society, St. Louis. (neg: Por B–136)*

the right to appeal from the instructions of the State Legislature to the People?"[61] The meeting must have been a lively one, and one can imagine Bingham fiercely defending Benton's right to take the issue to the people. Not only in Columbia but elsewhere in Missouri, there was continuing uproar about Benton and his position on the Jackson Resolutions.

After his dramatic and lengthy appeal to the people of Missouri in the summer of 1849, Benton refused to follow the instructions from his state legislature. In the next congressional session he spoke vociferously about his views on the Jackson Resolutions.[62] In prizing his principles above his party, he doomed himself to certain loss of the Senate seat he had held for thirty years. In January 1851, when the state legislature turned to the election of Missouri's senator, they voted him out of the Senate. But not easily. It took forty ballots for a coalition of anti-Benton Democrats and Whigs to elect Henry Geyer, a Whig from St. Louis, as senator.[63]

As forty ballots succeeded one another, the portrait of Benton that had watched over the passage of the Jackson Resolutions once more became an issue (fig. 55). Three days into the balloting, Mr. Benjamin, an anti-Bentonite, "offered a resolution to take down the portrait of Colonel Benton (hung on the right of the Speaker's stand by a resolution of the last Legislature) and that it be not again allowed to come into the capitol without a joint resolution for that purpose."[64] There followed three hours of futile discussion, the resolution finally being declared out of order. Nonetheless, this brief moment clearly demonstrated the power of the image. Bingham's

efforts to have Benton's portrait act as the conscience of the legislature, staring down the Jackson Resolutions, had failed two years earlier. But in 1851 the senator's gaze apparently made the lawmakers trying to vote him out of office so uneasy that they wanted to have the portrait removed. Since the resolution failed, Benton's portrait witnessed his own defeat and remained in the House as a pro-Union conscience.

Bingham, in New York pursuing his career, wrote Rollins that he "was regularly informed by the telegraphic reports of our legislative struggle in the election of a Senator."[65] Dismayed but probably not surprised by the results, Bingham provided a very full account of the history of his thinking on the matter: "While in St. Louis last fall [1850], I was induced to suspect that an intrigue was in progress between some of the Whigs and the *Anties* [anti-Benton forces] to prevent the repeal of the Jackson resolutions and secure the election of Mr. Geyer, or some other whig agreeing with the Anties upon the question of the power of Congress over Slavery in the territories." He decried Geyer's duplicitous playing off of Antis against Whigs, noting that the Whig candidate had published his views on slavery in the territories "just far enough to catch anti-Benton votes" and then afterward had made an effort to placate the Whigs "by telling them that his convictions as to the power of Congress really amount to nothing." Such vacillation outraged Bingham. It certainly was not the way Benton would have acted. "With a frank avowal of our [Whig] principles and a straight forward policy, we can consistently act with all who act with us, and to Benton and his friends I would extend the right hand of fellowship as far as they place themselves on our ground." Bingham still found himself allied not only with like-minded Whigs but also with Benton. Adamantly—and presciently indeed—he concluded: "I trust there will be no bending in such direction again, even should war be the result."

Though Bingham urged Rollins to use his influence to counter the Jackson Resolutions at the next Whig convention, his advice was scarcely necessary. Rollins, at this time, was firmly opposed to the Jackson Resolutions and firmly behind the stand that Senator Benton had taken. So staunch was his position in favor of Benton's views that it got him into trouble late in November 1851 with some anti-Benton Democrats. A Democrat, Lewis W. Robinson, had used the pages of the Jefferson City *Metropolitan* to accuse Rollins of trying in 1849 to deliver enough pro-Union Whig votes to Benton to assure his reelection to the Senate. In the pages of the *Missouri Statesman,* Rollins denied the accusation and then put forth one of his most ardent arguments for the preservation of the Union and his support for Benton. Noting that even a Democratic newspaper had acknowledged that Benton "'occupied

the very ground upon which Bingham and the other whigs stood in the Legis-
lature last winter,'"[66] he praised the long-time senator: "I believe that Mr.
Benton by his opposition to these [Jackson] resolutions, and the influence
which he exerted over the Democratic party in this State, and with the aid of
the Whig party, pressed the life out of nullification and secession here. And
for this I commended him. For such is the value which I place upon the union
of these States that I can scarcely conceive of a cause sufficient to justify
its dissolution." In supporting Benton, Rollins affirmed his conviction to
preserve the Union, thus taking up the chief argument of the Bing-
ham Resolutions.

Bingham followed the fray at this time from St. Louis and wrote to ex-
press his solidarity with Rollins on this issue. "You perceive, by the papers,
that your *friend* Col. Benton is on his way back to the state," Bingham wrote,
predicting that the former senator's presence would give support to all oppo-
nents of the Jackson Resolutions—both Democrat and Whig.

> I am more fully confirmed since I came here, in the opinion which I ex-
> pressed to you, of the propriety of a full and open expression throughout
> the State, of the whig sentiment upon the slavery question. . . . If the
> great mass of whigs throughout the state, will fearlessly express their
> views, as you and Miller have done, and faithfully stand up to them,
> there may be a natural combination of the political elements now in a
> state of fusion, sufficiently powerful to over-ride all opposition, and for-
> ever redeem the State from the equivocal position in which it must re-
> main, so long as the Jackson resolutions remain unrescinded upon the
> Statute-book.[67]

In private to Rollins, then, Bingham implied his admiration for Benton and
urged the rescinding of the Jackson Resolutions, which he felt a coalition of
Whigs and Benton Democrats could effect. In public, he also argued for their
repeal.

In May 1852 he made his feelings about the repeal of the Jackson Reso-
lutions clear to the Whig candidate for governor, James Winston, who had
come to Columbia to seek the advice of the Whig sages there—Rollins,
Switzler, Davis, and Bingham. "In the course of conversation," wrote Bing-
ham, "the subject of the Jackson Resolutions came up. Mr. Winston, having
avowed himself opposed to the principles which they contain, was urged by
Major Rollins, Mr. DAVIS and myself to address a circular to the people of
the State, ADVOCATING THEIR REPEAL."[68] When Winston failed to pub-
lish such a circular, Bingham in effect forced him to make a public state-
ment. In June 1852 the artist published in the Liberty *Weekly Tribune* an

open letter to Winston.[69] Would Winston, if elected, see to the rescinding of the Jackson Resolutions, Bingham asked? And Winston answered yes. The artist-politician knew how to achieve the public statement he wanted. Switzler later would declare: *"Everywhere*—on the street around the 'social board'—before Whigs and Democrats, the propriety of Mr. WINSTON declaring distinctly for 'Repeal' [of the Jackson Resolutions] was urged by Messrs. ROLLINS and BINGHAM."[70] Later in June 1852 Bingham represented his county at the Whig National Convention in Baltimore, supporting first Fillmore and then Scott, but also, one assumes, supporting the pro-Union platform that was settled at the convention.[71]

Throughout this tumultuous period, the portrait of Benton continued to keep watch over the General Assembly. In August 1852 yet another legislative session felt uneasy with Benton's image. At that time the house, still split over the issue of slavery, found itself unable to elect a speaker. One Whig member with tongue in cheek introduced a resolution to have a veil placed over the portrait.[72] Clearly Benton's presence in Missouri was still influential, despite the fact that the legislature had deprived him of his senatorial seat. In the fall of 1852 the *people* of the state returned him to Washington, using the direct election they *could* control for the House. Benton took his seat in the House of Representatives, where he continued to fight for the Union, opposing the Kansas-Nebraska Bill.

At home in Missouri, the Jackson Resolutions remained a thorny issue. Repeatedly in early 1853 most editors of Whig newspapers urged their repeal. When Davis, the editor of the Columbia *Sentinel,* did not, Bingham published a statement about his own meeting with Winston the preceding spring, and he wrote Rollins: "Perhaps it would be well to remind him [Davis] that this certificate owes its existence to his own threatened development of 'A piece of private history in regard to the Jackson Resolutions.'"[73] Finally, in March, the moment seemed ripe to reintroduce the issue of the Jackson Resolutions in the General Assembly. That body had just considered and then rejected resolutions from a proslavery convention in Nashville "asserting the constitutional right of secession."[74] Undoubtedly heartened by the legislature's anti-Southern position, a Benton Democrat decided to force the issue of the Jackson Resolutions. Presenting "a resolution to affirm the Jackson Resolutions . . . [he] announced that a vote to table would be a repudiation of the resolutions. . . . It was something of a legislative maneuver, but [when the legislature voted to table] the Benton men claimed a victory." After this Benton and Bingham with his Whig cronies could sigh with relief that the issue had apparently quieted down.[75] In early 1853 Bingham boldly referred to himself and Rollins as Bentonites.[76]

Small wonder then that in that same year the two friends corresponded with each other about a painting honoring the venerable senator from Missouri. Rollins had suggested Benton as a subject to Bingham who quickly seized on the idea.

> I have quite a serious notion to follow your suggestion, and make old *Bullion appealing to the people of Missouri* the subject of a future picture. That passage in the commencement of his speech at Fayette, in which he designates the friends whom he came to address, as those only who had *heads to perceive and hearts to feel the truth,* would afford, I think, the best point of time for pictorial representation, as the action which accompanied it, and gave it such emphasis, would display his fine portly figure to the very best advantage, and also tell with most happy effect in the faces of the audience.[77]

Four years after the fact, then, Bingham wanted to return to this high point of Benton's appeal, to the speech in the Chapel of Central College at Fayette. Remembering almost exactly Benton's opening words, the artist must have also remembered the implication of those words. At Fayette, the stronghold of Claiborne Jackson, Benton had faced an armed audience to launch an attack on Jackson's Resolutions, the same resolutions that Bingham, the politician, had fought in the legislature. The picture thus was highly personal for the artist, and he went on to make this clear to Rollins. "The subject possesses an additional recommendation to me, from the fact, that I could introduce into it the portraits of many of my friends who were present upon the occasion, and by a license, which painters, as well as poets can take, I could make others present in the pictures, who were not present in fact." Here Bingham baldly acknowledged his desire to insert portraits into his political pictures, a point often challenged by art historians. Alluding to Albertian principles, Bingham found this picture an opportunity to explore a variety of emotions on the faces of those who were there and those Bingham thought should have been there.

The most interesting aspects—and the most revealing about Bingham's own political views—are his remarks about the destination of the painting. "I think an engraving from such a work would sell," he wrote to Rollins, "and if painted on a large scale it would be well suited for a place either in the Capitol or University of our State." The artist's audacity here was unparalleled. To suggest that a scene castigating the Jackson Resolutions should be placed in the state capitol in the winter of 1853 bordered on the foolhardy. The legislative session of 1852–53 had seen stormy controversy over those very resolutions, slavery, and disunion, and more trouble seemed

39 Stump Speaker, ca. 1847, drawing, 10⅛ × 6¹³/₁₆ in. On loan to the Nelson-Atkins Museum of Art, Kansas City. Lent by the People of Missouri. Acquired through the generosity of the Friends of Albrecht Art Museum, St. Joseph.

forthcoming in 1854.[78] Even the suggestion that the picture might be hung in the university was fraught with political overtones, since the university was the setting, as well, for a controversy over slavery—the pro-Union president, John Hiram Lathrop, having been ousted by Claiborne Jackson's forces and replaced by a pro-slavery man, James Shannon, and a stacked proslavery board of curators.[79] As in the case of the Benton portrait in 1849, once again Bingham seemed to want a painting to act as a conscientious reminder—whether to statesmen or university officials—of the right way to resolve the state's and the nation's problems.

The idea of such a polemical painting was new and appealed enormously to Whigs in the central part of the state. Switzler was apparently so taken with it that he announced Bingham's proposal with great glee: "We also understand that Mr. BINGHAM has some idea of painting a picture (to be engraved) of COL. BENTON making his appeal to the people of Missouri. Only think of it! Old Bullion on the rostrum, with ATCHISON, LOWRY, JACKSON, BOWLIN, PHELPS, LAMB *et id omne genus,* constituting a portion of his hearers! That, we take it, would be a selling picture."[80] Switzler envisioned an array of Democrats, including Claiborne Jackson himself, along with Missouri's congressmen, undoubtedly angry or long-faced over the venerable senator's attack on the Jackson Resolutions and their stand on slavery.

Although the artist never executed the painting, one might muse generally about its composition. Bingham mentioned the project to Rollins immediately after a lengthy discussion of his *County Canvass,* also known as *Stump Speaking* (fig. 46). That painting, to be discussed in the next chapter, showed a politician addressing a crowd gathered beneath the spreading branches of a large tree. The orator, in three-quarter profile on the left, gesticulated to the crowd before him below the speaker's stand. Bingham undoubtedly envisioned a similar composition for his painting of Benton's Fayette speech—with one difference. The Fayette speech took place in a college chapel, not out of doors. Even though he never executed the painting, he may well have made some studies. Barbara Groseclose has rightly associated one of Bingham's drawings with the projected painting (fig. 39), a study of a portly orator in shirt sleeves speaking from a stand before the bough of a tree.[81] The distinctive nose, the thinning hairline, the chubby body—all seem to belong to the senator as Bingham had represented him (fig. 38). The outdoor setting of the drawing, however, raises some questions. Had Bingham originally thought of placing a thinly disguised portrait of Benton in his *County Canvass?* Or had he planned to place the Fayette speech in an outdoor setting?

The very conception of this painting was profoundly important for Bing-

ham. A clear testament to his admiration for Benton's views on the slavery issue, the picture also would have celebrated one particular speech in which the senator had specifically lauded Bingham's own stand on the issue. The artist's plan thus had much to say about his own political stance four years earlier and revealed how tenaciously he had held to those beliefs. Just as the Benton painting was intimately tied to his own current views on politics, so, too, were the paintings in his election series.

5

Free People and Free Institutions
The Election Series

It is hard to explain the place filled by political concerns in the life of an American. To take a hand in the government of society and to talk about it is his most important business and, so to say, the only pleasure he knows.

—A. de Tocqueville, Democracy
 in America

In 1852 when George Caleb Bingham wrote to his engraver in Philadelphia about the first of his election pictures, he expressed his desire that *County Election* should be "as *national* as possible—applicable alike to every Section of the Union, and illustrative of the manners of a free people and free institutions" (figs. 40, 43, 45).[1] These goals informed as well, the other two paintings of the electoral process that also appeared as prints— *The County Canvass,* also known as *Stump Speaking* (fig. 46), and *Verdict of the People* (figs. 47, 49).[2] That Bingham chose to diffuse these compositions as prints demonstrated that he wanted his works to reach the widest possible audience and to carry a message about the free institutions of America across the nation.

It is not at all surprising that Bingham should have turned in the early 1850s to scenes of the political process, nor that there should have been a wide audience for them in America. With the consolidation of the two-party system in the late 1830s and the Whig victory in 1840, America had become a country obsessed with politics. Indeed, from 1840 to 1860 politics were a dominant concern in American life, as they were in Bingham's own life.[3] Following the Log Cabin Campaign of 1840, both parties vied in their appeal to the common man. Stump speeches became the centerpiece of partisan gatherings, and gifted orators held audiences spellbound for hours. Posters, slogans and songs, bandannas and other memorabilia proliferated. Apart from major campaign rallies, citizens debated and discussed politics—in lecture series, in debating clubs, on the pages of numerous partisan newspapers. High voter turnout was the rule with more than 75 percent of eligible citizens voting in presidential elections from 1840 to 1870, more than 65 percent in congressional ones in the same period.

120

40 The County Election *(2), 1852, oil on canvas, 38 × 52 in. From the Art Collection of The Boatmen's National Bank of St. Louis, St. Louis.*

Bingham and his close friends in central Missouri took part in this political fervor. The artist's numerous speeches at Whig rallies, along with his political posters for William Henry Harrison and Henry Clay, had given him the opportunity to express partisan views. His own campaigns for the legislature had allowed him to air his views and then to act on them once he attained a seat in the state house of representatives. As outspoken as Bingham the public servant was, he was also articulate in private. His letters to Rollins clearly manifested the degree to which politics occupied his thoughts. There was hardly one that did not address an issue of concern to both of them and to their beloved Whig party. In this intimate correspondence with Rollins, Bingham bared his political soul, sometimes joking about the foibles of the electorate, but more often fervently expressing his idealistic views about liberty, the Constitution, and the duties of citizens. In the early 1850s Bingham made these public and visible. His election series overtly portrayed his idealistic conception of the free workings of democracy in a free society. Yet as serious as his overriding message was, he also allowed some of the jokes about politics that he shared with Rollins to surface in a few details in these three paintings.

As much as Bingham intended his series of prints to reflect the electoral

process throughout the nation and thus to appeal to all Americans, the paintings were rooted in Missouri and in particular issues that concerned him there. When he began *County Election* in 1851, only two years out of the state legislature, he was still taking a stand against the extension of slavery in the territories and writing and speaking about rescinding the Jackson Resolutions. Those concerns continued to occupy him as he finished *County Election* in 1852 and then painted the rest of the series—*The County Canvass* or *Stump Speaking* in 1853–54 and *Verdict of the People* in 1854–55. It is hardly surprising that they did. In Missouri the proslavery Jackson Resolutions dominated politics in the legislature, splitting that body into proslavery and pro-Union factions that cut across party lines. The new allegiances wreaked havoc with such routine business as electing a speaker of the house and with such momentous tasks as electing a Senator. After thirty years in Washington, Thomas Hart Benton lost his seat in the Senate, thanks to the Jackson Resolutions. Even before this loss, in 1849, Bingham had already allied with Benton and with like-minded Whigs on the need to appeal to the people to rescind those resolutions. In the early 1850s, as he began painting the series, he continued to strive for repeal as he worked on *County Election* in 1851–52 and then on *Stump Speaking* in 1853–54. He alluded directly to the "Will of the People" in the first painting and indirectly to the seriousness of an appeal to the people in the second, even as he contemplated at this time a historical image of one of Benton's most famous speeches during his appeal.

When he came to the third painting in the triad, *Verdict of the People,* in 1854–55, Bingham still thought in terms of a Missouri locale and Missouri issues. But by then those issues had become national ones. The Kansas-Nebraska Bill had focused the attention of the nation on slavery, particularly in the Kansas territory just to the west of Missouri. Painting this one work away from home in Philadelphia, Bingham gave free rein to his Whig independence of mind. He introduced into this work, albeit subtly, a point of view that differed somewhat from those of his close political cronies in Missouri. An antislavery bias, probably heightened by his residency in Philadelphia, lay behind Bingham's third painting, even as the issue of Kansas' entry into the Union as a free state informed most of the artist's letters home to Rollins in this period. Finally, after the election series was complete, Bingham returned to Missouri from the East. The travesty of the election process in Kansas in 1855, as squatter sovereignty played itself out, spurred Bingham to conceive another work, *March of the 'Border Ruffians,'* which would have been a despondent coda to the idealistic optimism of the earlier works.

The political content of these election paintings has concerned every

scholar who has written about them, and specialized studies have examined the ways Bingham's Whig ideology surfaced in this series.[4] In the 1970s scholars argued that the artist's sardonically humorous approach was a manifestation of what they perceived as a Whig anti-populist bias. Westervelt believed that some of Bingham's characters in *County Election* "made a mockery" of the election process, and he related the artist's loss of a seat in the General Assembly to what he felt were Bingham's "serious misgivings about the introduction of universal manhood suffrage, with its equalitarian impact on American life."[5] Groseclose felt that Bingham "had poked fun" at both his own party and the Democrats, and she raised questions about connections with Benton's loss of his seat in the Senate.[6] More recently, Husch countered the anti-populist interpretation of *County Election* with an argument that the picture was a manifestation of Whig faith in the will of the people.[7] And finally, Groseclose has tempered her earlier interpretation of Bingham's election series, arguing that he was ambivalent, caught between his realism as a historian and his idealism as a politician.[8]

It is time now to examine even more closely the relation between the election series and Bingham's own political writings and to consider even more fully everything the artist and his friend Rollins wrote about the works and their audience. Bingham could share a joke or two about the paintings with his inner circle of friends like Rollins, but that did not mar his seriousness of purpose as he sold subscriptions for the prints or attempted to exhibit and sell the triad of paintings. The audiences he envisioned and cultivated were not elitist ones that wanted to see a disdainful indictment of the electoral process. He desired to sell the prints throughout the nation and wanted them to be "applicable alike to every Section of the Union, and illustrative of the manners of a free people and free institutions." Exhibiting the three paintings in Washington in 1860, he wanted to sell them "to the Library Committee of Congress,"[9] not only to earn money but also to place his representation of "free people and free institutions" before the eyes of national leaders. So important were these pictures to him that, when he failed to sell them to Congress, he lent them to the Mercantile Library Association in St. Louis, the site of meetings of the State Convention that decided Missouri's position on the Union and that determined Missouri's governance during the early days of the Civil War. He wrote the secretary of the library that these three were "his most elaborate and valuable paintings," and he only parted with them in 1865.[10]

The artist's attachment to those works and his determination to disseminate them throughout the nation, through engravings or exhibitions in important places, set this political series apart from his earlier single paintings

of political subjects. While planning or working on the series, Bingham indicated time and again how important and topical these three paintings were to him. They were rooted in the current political scene—more than once he spoke of including portraits of local political figures or alluded to the defeat of a specific political rival or identified the specific location of the scene. Yet beyond their topical allusions, they were "applicable alike to every Section of the Union." Salted with down-to-earth and humorous details like the drunk being dragged in to vote, the works presented a panorama of human nature. Yet Bingham did not intend the pictures as a Whig indictment of the electoral process. Even though the first two paintings contained Whig symbols and a Whig newspaper, Bingham did not intend to make mockery of the whole process. It was liberty, that most prized of Whig principles, that Bingham thought he had embodied in the series. Echoing his own definition of Whigs as "freemen," he was unequivocal that his election series showed "the manners of a free people and free institutions."

But this is jumping ahead of the genesis of the series. It is important to remember that Bingham did not come to the series all at once. Instead he began with a smaller and less ambitious painting of the political process that then led him to the more monumental series.

Canvassing for a Vote or *Candidate Electioneering*, 1852

As discussed in the preceding chapter, Bingham had come to political paintings slowly—first, in 1847 with *Stump Orator* and then in 1849 with *The Country Politician*. The first of these was ideated soon after his ouster from the legislature, a work at once a jab at his Democratic opponents and an idealistic plea for an appeal to the people. The second, flirting with a subtle message, alluded to the seriousness of politics even as it criticized distractions from earnest discussion. Bingham's messages in both of these were subtle, covert, and readable in Missouri among those who knew him. When the paintings went on view at the Art-Union in New York, some of their subtle meaning went unnoticed. Instead the New York audience responded directly, and not entirely favorably, to the formal qualities of the works. The second one, however, attracted the attention of a publishing firm in New York, who approached Bingham to commission a similar work for an engraving. The dealer Goupil had earlier reproduced *In a Quandary* (figs. 30, 41), a work commissioned specifically for publication as a close reworking of *Raftsmen Playing Cards*.[11] Now in the spring of 1851, Goupil engaged the artist "to paint another for them in the course of the summer."[12] This was *Canvassing for a Vote* (fig. 42), which the firm ordered as a variant of Bingham's earlier *Country Politician*.[13] The patronage of Goupil opened Bing-

41 *Claude Régnier, after Bingham,* In a Quandary, *1852, lithograph, 14¾ × 18¾ in. State Historical Society of Missouri, Columbia.*

ham's eyes to the potential profit in engravings, as well as to the opportunity for the wide diffusion of his work.

Bingham began *Canvassing for a Vote* in the spring of 1851 and intended to complete it during the summer in Missouri. He undoubtedly sketched out his composition before leaving New York for Missouri, as he later wrote Goupil that he hoped "you will find it much improved by *time,* and the additional touches it has received since you saw it."[14] Nonetheless, it was not until October that a reviewer saw it in Bingham's studio in Columbia.[15] And it was even later—after the end of January 1852—that Bingham forwarded the finished canvas to the publishing firm in New York. Signing the work, he also dated it assertively: 1852.

As has long been noted, *Canvassing for a Vote* is *The Country Politician* moved outdoors (fig. 35).[16] The same eager candidate on the right expostulates to the same rotund gentleman in the center, while a slightly younger figure listens on the left. Though Bingham has distanced the figure with his back turned and added another standing figure, he essentially retained the stable triangular grouping of the earlier work. But the effect is very different. The group is skewed on a slight diagonal, echoing the diagonal drives into space of the sidewalk and the brick building, which some

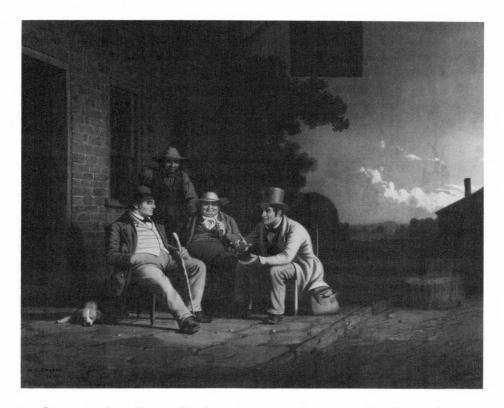

42 Canvassing for a Vote *or* Candidate Electioneering, *1851–52, oil on canvas, 25⅛ × 30³/₁₆ in. Nelson-Atkins Museum of Art, Kansas City, Missouri. Nelson Fund.*

have likened to the tavern in Arrow Rock. No longer constricted by planar interior space, the figures breathe, and the viewer's eye can pause on the sleeping dog in the foreground before sweeping back to the cabin and landscape in the distance. The bold eagle on the signboard is perhaps the only overt indication aside from the title that politics are under discussion.

Just as *The Country Politician* depended on Mount's *The Long Story* (fig. 36), so too did this work. But there were affinities as well with the outdoor settings of William Hogarth's *Canvassing for Votes* and Sir David Wilkie's *Chelsea Pensioners,* which set up a similar diagonally recessive space.[17] Another work cited by Bloch, *Soliciting for a Vote* by R. W. Buss, was undoubtedly in Bingham's visual memory, appearing as it had in an issue of *The Gift* that the artist had consulted.[18] However, although the subject was similar, Buss's work was compositionally so unlike *The Country Politician* and *Canvassing* as to obviate any direct formal dependence. Connec-

tions with humbler sources include the telling compositional affinity that Groseclose noted with a Whig campaign print for William Henry Harrison entitled *Log Cabin Campaign,* in which figures sat before a building sporting a signboard with Harrison Hotel emblazoned on it (fig. 4).[19] Even if Bingham were aware of this particular antecedent, he may also have deliberately chosen the eagle to echo the banners of other political campaigns, such as Henry Clay's in 1844. These connections with the humbler imagery of Whig propaganda cannot be ignored in a work by an artist who was also an avid Whig politician and had himself painted campaign images.

There is little else in the painting to indicate a partisan position. Groseclose commented on two "subtle details that could be said to reveal the artist's political attitude"—the juxtaposition of the horse's posterior with the politician and the presence of the sleeping dog.[20] The canine she interpreted as "Bingham's commentary on the volatile issues of the 1852 election (as in 'let sleeping dogs lie') or its drowsy state may mirror Bingham's perception of the voters' enthusiasm." Since the work was begun in the spring of 1851 and finished in January 1852, it is more likely that any reference to a political concern would be to one in 1851. The major issue late that year was the rescinding of the Jackson Resolutions, and once more it was Thomas Hart Benton who made a vociferous appeal. In December 1851 an open letter from the former senator demanded a repudiation of the Jackson Resolutions and also of the vote that had ousted him from the Senate.[21] Unwilling to have his voice stilled, Benton spoke forth. Might the sleeping dog in Bingham's painting, finished in January 1852, be a subtle comment on Benton? Just two years later, John Beauchamp Jones of Arrow Rock published in his *Life and Adventures of a Country Merchant* an anecdote about Benton and a dog that may well have been in circulation when Bingham painted his picture. The Arrow Rock author described how Benton came to speak in a small town, where he first stopped on the stoop of the local hotel. Hearing a story about a dead dog, Benton "compared his own case to it. He said that when the 'Jackson Resolutions' were adopted in the legislature, his enemies, the 'Softs' and the 'Rottens' believed he was a dead dog; but when they got to their homes, they found him alive and kicking."[22] Given Bingham's admiration for Benton and his own connections with Arrow Rock, such a subtle reference in the painting may not seem surprising.

When Bingham began *Canvassing for a Vote,* then, he reiterated an earlier composition in response to the demands of his publishing firm. As he worked, however, he surely began to understand how wide an audience he would reach with his print. It was then that Bingham began to contemplate a larger painting of the election process.[23]

County Election, 1851–1852

There are three versions of *County Election:* the original painting begun in August 1851 and finished by February 1852 (fig. 43), the copy executed between August and October 1852 (fig. 40), and the engraving by John Sartain finished by the late fall 1853 (fig. 45). All three show a crowded voting scene, set on the main street of a town in front of an open porch. The provenance of both paintings is clearly traceable, leading most scholars to agree on which is the original, and which the copy. Nonetheless, there are details in the original that are missing in the copy and the print, and there are additions in both the painted copy and the engraving that are missing in the original version. All these must be considered in any analysis of Bingham's thinking about the work.

Even before he finished *Canvassing for a Vote*, Bingham began the original *County Election* in August 1851 and, according to his own testimony, worked on it steadily in Columbia until his departure for St. Louis early in November.[24] The unfinished painting accompanied him and elicited a good deal of interest as he worked toward completing it. By December his friend Edward Bates in St. Louis had suggested that it was a work worthy of engraving. By the end of January the artist took up the suggestion, writing to Goupil about the project, while Rollins took it upon himself to contact the Art-Union about publication.

Not since *Stump Orator* had Bingham undertaken such an ambitious and highly populated picture. Beneath a banner proclaiming "The Will of the People the Supreme Law," a large crowd assembled in front of a large porch where citizens voted orally, having sworn that they had not voted in any other location. All the critics who wrote about the painting were struck by the number and variety of types assembled at the polling place. The serious voters engaging in debate or reading a newspaper were there cheek by jowl with a drunk being carried in to vote and a bandaged fellow slumped over and still stunned after a fight. Young and old were assembled, with the very center of the canvas occupied by a stooped and wizened old man who had already cast his vote. On the steps nearby a hopeful candidate doffed his hat ingratiatingly to a prospective voter, who turned his back to a figure appearing to toss a coin. Bingham interwove his figures to lead the viewer from the black man alongside a cider barrel on the far left across the crowd and up the steps. On the right subordinate groups also moved the eye inward toward the center, from the seated pugilist and newspaper readers to the three standing debaters, and finally to the man bending over another seated on the stairs. The figure moving in with his right arm raised at the left, the man bending over the seated scribe, the triad of debaters—all resembled

43 The County Election *(1), 1851–52, oil on canvas, 35⅞ × 48¾ in. St. Louis Art Museum, St. Louis. Museum purchase.*

figural groupings by Raphael, transforming the crowd into a latter day *School of Athens.*[25] Beyond the figures the main street of town stretched off past buildings identified as a Grocery and the Union Hotel in both the copy and the print. This strong diagonal recession, as has long been noted, generally recalled baroque compositional principles and, more specifically, Hogarth's print of *Canvassing for Votes,* where buildings on the right, some of them bearing sign boards, stretched off amid trees toward a faint but still visible church steeple in the distance.

The comparison with Hogarth is apt, for Bingham later identified his works with those of the English artist. Asserting that American art "rank[ed] with the most successful efforts of European Artists," Bingham likened Darley, Mount, and himself to Hogarth and Wilkie.[26] Indeed the influence of Hogarth's *Canvassing for Votes* and *The Polling* is manifest in Bingham's election series.[27] The table with a drinker at one side and the candidate proffering tickets to a voter, seen in Hogarth's *Canvassing,* reappeared in Bingham's painting. Hogarth's *Polling* provided Bingham with the setting of a columned porch with banners, the scene of a man swearing on a Bible, and the episode of a disabled citizen being carried in to vote. Even if Bingham sub-

stituted a drunk for Hogarth's battered man in that episode, he did place the man with a bandaged head elsewhere in his painting. Yet for all its debts to Hogarth, *County Election* was different. Hogarth had clearly marked his works as satirical by placing a riot in *Canvassing* and a broken down carriage of state in *Polling.* No such overt evidence of satire appeared in Bingham's work.

Instead, Bingham the realist faced the fact that the electorate was made up of all sorts. Alongside the drunks hauled in to vote or hungover after a brawl, who recalled Hogarth's voters, Bingham placed thoughtful citizens poring over newspapers and debating the issues. If he showed a candidate unctuously proffering a ticket to a voter, as Hogarth had, Bingham made it clear that the voter would not be swayed. Groseclose has made much of the figure tossing a coin in the first version (fig. 43), which she interpreted as a reference either to the whim of the vote, or even worse, to bribery.[28] Yet that figure and his companion nearby did not appear in the second version of the painting nor in the print (figs. 40, 45).[29] The picture contained clear allusions to the Whig party—in the cider barrel on the left and in the title of the newspaper on the right, the *Missouri Republican* in the painted copy and the *National Intelligencer* in the print. Yet Bingham the Whig was not raising questions about the validity of the will of the people.[30] In *County Election* serious figures far outnumbered the louts. More figures were engaged in discussion or reading newspapers than were drunk or battered. Indeed, in their discussions of the painting, Bingham and Rollins stressed its serious overriding message.

The inscription "The Will of the People the Supreme Law" is a key to interpreting the work. The will of the people was a democratic concept dear to the hearts of politicians of both parties in America. Lying at the core of the American political process, the elective franchise allowed the expression of the popular will. Though some historians have asserted that the Whigs were political elitists,[31] others have acknowledged that after 1840 the Whigs had to accept "the emerging democratic ethos."[32] Nonetheless, Whigs had long recognized that the Democrats used the idea of the popular will for their own purposes, giving lip service to it while often acting in opposition to it. Only three years earlier Switzler had published a Whig interpretation of certain Democratic slogans. In his "Locofoco Dictionary" the will of the people was defined as "veto and ditto."[33] Though undoubtedly referring to the repeated vetoes of the River and Harbor Bill, the Whig editor jabbed at the tyranny of an executive who overrode the voice of the people as expressed in Congress. For true Whigs, Switzler implied, the will of the people had other meanings. Far from being a "Jacksonian motto" antithetical to

Bingham, the inscription celebrated what Whigs felt was the core of American political life.[34] For Bingham particularly, the phrase had a special relevance. It was a reverberation and an echo of his own political beliefs—as stated early in his political career in 1840 and again at the time of his contested election in 1847, and as implied in his support of Senator Benton's appeals to the people in 1849 and again in 1851, at the time Bingham was working on the painting. As a Whig Bingham believed in the free expression of free men's minds, and he decried party organization and party manipulations. In 1840 when Bingham had criticized Van Buren's tyranny in demanding votes along party lines, he reminded his audience that "strict obedience to the will of the people, is by all acknowledged to constitute the vital principle of a republic."[35] In 1846, Bingham believed the Democratic control of the state legislature—not the will of the people—had led to his loss of his contested seat. It was the legislature, too, that had defeated Thomas Hart Benton as senator, not the people. When *The County Election* was painted in 1851, this scene of the *people* voting under a banner celebrating the will of the people had immediate meaning for Bingham.

Reverberations of his own contested election abounded in the painting. Many have thought that some of the figures portrayed alluded to the protagonists of that election. Indeed, the St. Louis reporter who saw it in December 1851 remarked that he recognized "'most unmistakably an old County Court Judge, of the interior.'"[36] Dr. Oscar Potter, one of Bingham's models, who lived in Arrow Rock between 1844 and 1860,[37] added fuel to the fire, claiming to be portrayed in the painting and identifying the glad-handling candidate as E. D. Sappington, the judge taking oaths as ex-governor M. M. Marmaduke, Sappington's brother-in-law, and the thoughtful man writing or sketching at the foot of the steps as Bingham.[38] Even if one cannot easily verify the identifications today, one can see that the judge is decidedly rotund, even as Bingham described Marmaduke. In the speech defending his seat, the artist likened the ex-governor to "that celebrated hero, John Falstaff, (whom in obesity of person he so much resembles)."[39] In that same speech, Bingham dramatically accused Marmaduke of wagering on the Sappington-Bingham election: "upon the evening of the election, . . . he [Marmaduke] was . . . flourishing a fifty dollar bill, challenging, in the windy language of the genuine bragadocio a bet to that amount upon the results of the election!"[40] Bingham's decision to place a coin tosser just beneath the judge in the first version, then, may have been quite deliberate, to spark interest among the locals even as it criticized Marmaduke's bet. Equally deliberate was the omission of that same coin tosser in the print intended to carry a broader and less local message to a larger audience in America.

If all the figures were not recognizable locals, they were familiar types. One of those, the old man who has just cast his vote, Bingham may well have intended as an oblique allusion to his own contested election. In the preliminary drawing, this figure proudly sported an unmistakable '76 on the crown of his hat, clearly identifying him as a veteran of the revolution, one who had taken up arms against a tyrannical government (fig. 44).[41] Ideologically Whig in 1776, he was still Whig at midcentury—after all, Whig campaign buttons from the early days of the party referred to the principles of '76.[42] But beyond identifying him as a Whig, the inscription on his hat may also have referred to his military service. In 1847 Bingham had argued that one of his contested voters had earned the vote through military service. He proposed that foreign-born John Murphy, who had fought in the War of 1812, "the old weather-beaten soldier, is entitled to all the rights and privileges belonging to a native born citizen of this country of his adoption."[43] In his painting of 1851, Bingham may have at first intended a subtle visual argument of the same point—that a veteran of '76, an "old weather-beaten soldier," by virtue of his service to the country, was fully entitled to the vote.

Another vignette summed up Bingham's political philosophy, recalling as it did his assertion that "whigs are freemen, and not like [the Democrats] bound to model their thoughts to correspond with the wishes of a master."[44] This was the encounter between the hat-doffing politician and the citizen in shirtsleeves on the steps. Nothing could better express that citizen's intention to vote as he sees fit than his stolid refusal to take the proffered ticket and to remove his own hat. As unimportant as this latter gesture may seem, it might well have derived from Bingham's close reading of the text accompanying the print, *Soliciting a Vote,* in *The Gift* annual of 1836.[45] The engraving showed an aristocrat seeking the vote of an artisan who not only refused to stand up but also made a point of refusing to remove his hat. The text accompanying the engraving made much of these pictorial indications that the artisan would vote as he saw fit—just as the citizen in Bingham's painting would.

If all these details alluded to Bingham's own experiences in politics and to his own political views, the open, outdoor setting of the painting carried a larger message. For the artist-politician, universal suffrage, with all its faults, took place in the open and was preferable by far to the partisan manipulations behind the closed doors of the legislature. The banner overhead then gave voice to what the scene and the setting suggested. It was a clear statement of Bingham's own political credo, and it echoed the sentiments—and even the words of one of the speeches—of Bingham in this period.

The will of the people was the principal theme of Bingham's speech defending his contested seat in the legislature in 1847.[46] Since selective quota-

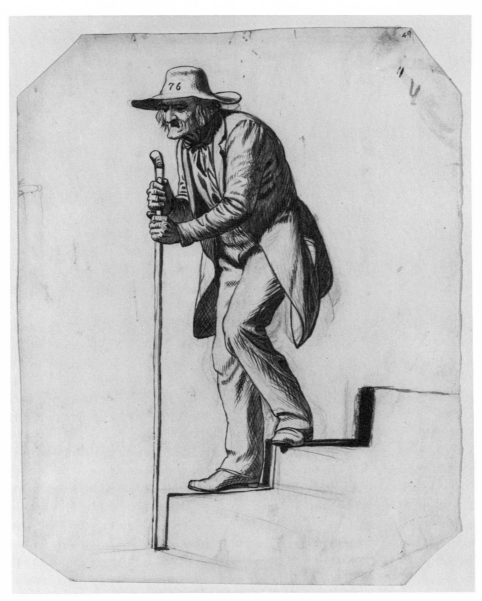

44 Veteran of '76, *1851–52, drawing, 11⅝ × 9 in. On loan to the St. Louis Art Museum, St. Louis. Lent by the People of Missouri.*

tions from that speech have bolstered arguments about Bingham's Whig disdain of the electoral process, it is necessary to examine the whole speech to argue just the opposite. Bingham began the speech with an account of his campaign and its aftermath. Likening himself to David against the Goliath of the Saline County Democrats, he described the imbalance in the campaign

with Sappington, ex-governor Marmaduke, and a host of other Locofocos arrayed against him. "Sustained by the consciousness of a good cause," he fought the dominant party and won.

But it was not, Bingham claimed, a personal victory. He told his fellow legislators it was "the *people* [who] rallied to my rescue, and notwithstanding the fearful odds against me, I conquered in *their* strength, and came off victorious" (emphasis added). It was the people who had elected him, and it was the people, he argued, who should decide the contested election. But his Democratic opponent had refused to resubmit the issue to the people, so the legislature ultimately had to decide. With remarkable irony, Bingham, the Whig, here took a strongly democratic position. To the Democratically controlled legislature, Bingham presented the most democratic of arguments: his impassioned defense of his seat arose not from personal interests but from the duty he felt to those who had elected him to defend "*their* rights [to be represented by the person they had elected] to the very last extremity." But having adopted a democratic position, he went on to criticize the party that opposed him.

In the same speech, Bingham contrasted Sappington's view of the electoral process with his own. Sappington and his cronies, Bingham alleged, had money riding on the election. Bingham claimed, perhaps disingenuously, to be disillusioned that a man like Sappington "would be willing to prostitute that holy safeguard of freedom, the *ballot-box,* to a level with the card, dice, or rolette table." For Bingham the ballot box was the sacred container of the will of the people. And he made that point in the first version of his painting by juxtaposing the single-minded voter who would not be swayed and the coin-tossing wagerer literally and figuratively beneath him.

Further on in his speech Bingham used a phrase almost exactly like the motto in the painting. "I am, sir, a Republican, a Democrat, in the true and legitimate sense of those terms, being governed by that principle which argues us to submit with due deference to *the omnipotence of the popular will*" (emphasis added). For Bingham, the will of the people was all powerful, the will of the people *was* the supreme law. Though the Democratically controlled legislature ousted him in 1847, the people returned him there in 1848.

Not only had an appeal to the people been personally significant for Bingham and his campaigns of 1846 and 1848, it was a concept that dominated Missouri politics from 1849 on, when once again the will of the legislature was pitted against the will of the people. The proslavery Jackson Resolutions, passed behind the closed doors of the General Assembly, provoked the drama in which Bingham, author of the countering Bingham Resolutions,

had such a vested interest. In his own resolutions, Bingham had argued that the matter of slavery in the territories should be left to the people of the entire Union speaking through their representatives in Congress. And he continued to believe that the people should decide the issue.

In late 1851, as the artist Bingham was working on his painted paean to free elections, the politician Bingham wrote tellingly about the issues that might be decided there. Late in November 1851, Bingham made it clear to Rollins how important the ballot box could be in helping to rescind the Jackson Resolutions. "I am more fully confirmed since I came here, in the opinion which I expressed to you, of the propriety of a full and open expression throughout the State, of the whig sentiment upon the slavery question. The differences of opinion that really exist, will then be clearly seen, and certain politicians may be able to discover that an abstraction may prove a 'two edged sword' and be as potent in keeping men out of office, as in placing them in." [47]

The artist-politician here was advocating that all Whig candidates make clear their stand on slavery—that Congress did have the power to legislate on the issue in the territories, a view he had set forth in the Bingham Resolutions. The people could then express their will at the polls. If enough Whigs could "fearlessly express their views . . . and faithfully stand up to them," as Rollins had done, voters might elect enough pro-Union members to the legislature that the state might be able "forever [to] redeem the State from the equivocal position in which it must remain, so long as the Jackson resolutions remain unrescinded." Benton's imminent return to the state, he wrote Rollins in that same letter, would surely scatter the opponents and stir up the issue once more.

In mid-December Benton once more thundered forth about the supremacy of the will of the people over and above the decisions of the legislature. Still stinging from the Missouri legislature's failure to reelect him as senator, Benton returned to Missouri from Washington. Arriving in St. Louis just a few weeks after Bingham moved there with his still unfinished canvas of *The County Election,* Benton went public with his intentions. He published an open letter in the pages of the St. Louis *Missouri Republican* attacking the decisions of the Missouri General Assembly. He demanded a repudiation of the Jackson Resolutions, a repudiation of the principle contained therein that Congress had no right to legislate on slavery in the territories, and as well a repudiation of the Democratic votes in the state general assembly that had replaced him as senator with the Whig Geyer. He was willing, he said, to acknowledge that the state could instruct its congressmen. But only if the instructions were " 'according to the will of the people' not according to leg-

islative 'sovereignty.'"[48] Just as Bingham was putting the finishing touches on his painting in St. Louis, Benton was in the same city, declaring his faith in the will of the people.

The inscription in *The County Election,* then, was neither Whig nor Democrat, but rather a statement of a principle that had guided Bingham in his own battles to retain his seat in the legislature, as well as in his formulation of Missouri's official position on slavery. It was also a principle that Thomas Hart Benton voiced in his direct and open appeal to Missourians. The phrase Bingham inserted in his painting—The Will of the People the Supreme Law—thus reverberated with issues in the contemporary political scene in Missouri. Indeed it may well have been his own quite personal version of the Missouri state motto: *Salus Populi Suprema Lex,* the welfare of the people the supreme law. The painting, then, far from being an indictment of universal suffrage, asserted that the ballot box was the repository of freedom where the will of the people could best manifest itself. Popular elections held out of doors were preferable by far to decisions reached behind the closed doors of the legislature—and *County Election* demonstrated this.

The Print

As soon as the picture was finished, Bingham's friends rallied around him to urge the publication of the painting.[49] As they did so, they and the artist himself spoke out on the political significance of the work. Rollins was so enthusiastic about the painting that he wrote, early in January 1852, to the director of the American Art-Union to urge its publication as a print.[50] Effusively praising the work, he noted that "It is preeminently a *National* painting, for it presents just such a scene, as you would meet with on the Aroostook in Maine, or in the City of New York, or on the Rio Grande in Texas, on an election day." Rollins enthusiastically described the various types Bingham had included—"the Courtier, the politician, the labourer, the sturdy farmer, the *bully* at the poles, the beer-seller, the *bruised* pugilist, and even the boys playing 'mumble the peg'"—but he then went on to an interpretation. "But this is not the point of view in which its excellence is to be regarded. The elective franchise is the very cornerstone, upon which rests our governmental superstructure and as illustrative of our free institutions, the power and influence which the ballot box exerts over our happiness as a people, the subject of this painting was most happily chosen, and executed with wonderful skill by its gifted author."

Rollins went on to say that the work "would be admired alike by an exquisite connoisseur in the arts, the most enlightened Statesman, and the

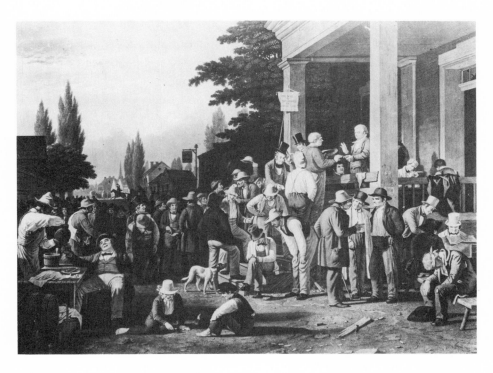

45 *John Sartain, after Bingham,* The County Election, *1854, engraving, 26⅝ ×
32⅝ in. State Historical Society of Missouri, Columbia.*

most ignorant voter." This avid Whig clearly did not ignore the range of po-
litical knowledge and experience in those who were represented in the
painting or in those who would look at the print. He envisioned a varied au-
dience that would comprise those who collected and admired art, those who
had dedicated their lives to politics and statesmanship, and those who voted
but without giving much thought to the issues. But rather than heaping
ridicule on a democratic process that allowed everyone to vote, sober or
drunk, informed or ignorant, he exalted instead "the elective franchise . . .
the very corner stone, upon which rests our governmental superstructure,"
which he saw as the real subject of the painting.

When Bingham turned his attention to the reproduction of the painting
later in 1852, he too argued that its overriding message was about the people
and institutions of a democracy. His instructions to Sartain, his engraver, are
worth quoting here, for they reveal an artist who wanted the print to rise
above local interests to carry a more national message (fig. 45). Specifying
changes he wanted the engraver to make, he wrote: "The title of the news-
paper in the extreme right hand corner of the picture, I wish you to change,

so as to have in print 'The National Intelligencer' instead of 'Missouri Republican.' There will then be nothing left to mar the *general* character of the work, which I design to be as *national* as possible—applicable alike to every Section of the Union, and illustrative of the manners of a free people and free institutions. As far as you may have an opportunity of doing so, you will much favour me by inculcating the idea of Nationality in reference to the subject."[51] His elimination of the coin tosser in the print removed yet another local reference as it bolstered the positive meaning of the scene.

Another change in the print also demands notice. Having left the sign blank in the first version of the painting, Bingham identified one of the buildings in the print as the Union Hotel. In 1851–52 this allusion to the Union by an artist who advocated the Union above all cannot be coincidental. In this composition for widespread distribution, Bingham suggested that, through free institutions, free men who voted their conscience would assure the preservation of the Union.

Bingham also had Sartain add a few notices on the porch support, as he had done in the copy. One of these was a tongue-in-cheek advertisement that began with the legible words "On Sale" and ended with a very legible signature "G. C. Bingham."[52] Nonetheless, if Bingham's sense of humor surfaced in this notice and in a few of the voters, his chief goal in the print was to disseminate an image "applicable alike to every Section of the Union," expressing the liberty of men free to exercise their rights as citizens by voting.

The print as published, then, extended beyond overtly partisan and local references to matters of general and national principle. This celebration of universal suffrage was an argument against the tyranny of corruptible partisan legislatures, against those who would prostitute the ballot box to the level of gambling. At the same time it was an assertion that the people with all their human foibles and failings should be the ones to decide important issues—from the contest between Sappington and Bingham to the state's position on slavery to the election of all their representatives. Even as Bingham began to tour the state with the copy in order to drum up subscriptions for the print, the people proved that they could express their will, and they returned Thomas Hart Benton to Washington in an election they could directly control, the one for the House of Representatives.

Press responses to Bingham's painting as he toured the south for subscriptions in 1853 showed that his celebration of the American electoral process was not lost on his audience. In New Orleans, the *Daily Picayune* remarked that Bingham was " 'to the Western what Mount is to the Eastern States, as a delineator of national customs and manners.' "[53] In Louisville, the press spoke warmly about the work, the *Daily Courier* noting that " 'the subject has the full dignity and interest requisite for a great historical paint-

ing.'"[54] A reporter for the *Daily Times* in Louisville was impressed by the various types of people: "sturdy old farmers who have come to town with a grave sense of their responsibility as citizens . . . how serious and honest and sensible they look, as they gravely discuss the affairs of the country, and the questions of the day! . . . That very complaisant, officious and lawyer-looking personage . . . you will know him at once as a candidate by his excessive politeness and his universal intimacy. . . . There is a group of quiet and intelligent gentlemen sitting under the eaves of the house, reading the newspaper."[55] Alongside the serious voters, the reporter also noted the man recovering from a fight, the drunk being hauled in to vote, and the man imbibing on the left. So taken was he with the picture that he praised "the extraordinary resources of the artist, who was able, with a brush and a little oil, to so completely mirror nature." Responses were favorable, too, in the Lexington press.

But there was one curmudgeon there signing himself Public Weal who wrote a letter to the editor arguing that the picture "'defamed one of the most valuable of our political institutions.'"[56] The painting, he went on, "'is not only a slander on the present, but places weapons in the hands of the enemies of the Republics, to injure them and defame us to the latest ages.'" Accusing Bingham of having represented election day in a slave state, he noted that "'the Judge, candidates and voters, are a reproach to any precinct or county. . . . the voters, as represented, are miserable loafers; one is placed in a large arm chair, a negro filling his glass, and he too drunk to rise.'" Times were bad, wrote this indignant citizen, but one must keep trying to improve and not give in to the dark view presented in this picture. This particular citizen certainly found Bingham's work offensive and urged others not to buy the prints of it. However, compared to the favorable remarks by all the Kentucky reporters who commented on the serious and intelligent voters outnumbering the battered and the drunk, this voice of protest stands alone. Bingham managed to garner more than a hundred subscriptions in Kentucky. Most of the audience for the print appreciated the way the artist had achieved what he set out to, a record of the American people exercising their rights as citizens.

When Bingham went east to the Whig convention in Baltimore in June, he took the painting with him and displayed it for the delegates to see. Soon thereafter he engaged Sartain in Philadelphia as his engraver. During the summer of 1852, he painted a copy to take with him on tour the following spring to drum up subscriptions for the print—in Missouri, in New Orleans, and then in Kentucky (fig. 40).[57] While on tour, he sold the picture to Robert Ward of Louisville. When he returned to Philadelphia later in the summer of

1853 to supervise the completion of the plate, perhaps with Sartain's encouragement, he began another election painting. At this time he may already have been contemplating a series.

The County Canvass or *Stump Speaking,* 1853–1854

By early November 1853, Bingham apparently had begun to formulate the idea of a series of election paintings when he wrote to Rollins to announce that he had begun "my companion to the 'County Election'—the 'County Canvass.'"[58] By February the artist had finished the work, placing his signature and the date 1854 on a log in the lower left foreground (fig. 46). At this time he had plans to exhibit it in Washington.[59] Since the work was slightly larger than *County Election,* it is not clear if Bingham intended to exhibit the two together. What is clear, however, is that by April 1854 he had arranged to have Goupil engrave the *County Canvass* in the same dimensions as the print of the *County Election,* thereby establishing their pendant relationship. By the time Goupil published the print in Paris in 1856, the title was changed to *Stump Speaking.*

The painting was a reprise of Bingham's earlier *Stump Orator* (fig. 34), as its second title might indicate, but it was more ambitious and more complicated. Daringly, the artist turned the speaker's stand on a diagonal to the viewer and spread before the stand two semicircular groups of figures, a smaller oval one of seated or recumbent figures nestled within a larger semicircular one reaching across the whole canvas. Just as the artist strove for a more complicated composition than in the earlier *Stump Orator,* so too he sought to introduce a variety of figures, including children and dogs, as he had in the pendant *County Election.* Bingham also avoided the isocephaly of his earlier work by introducing a standing man just right of center to close the smaller oval group in the foreground and at the same time lead one's eyes to the middleground. The darkness of his curved back mimicked and pointed upward to two figures on a watermelon cart silhouetted in the distance against the glowing sky. Above the scene a massive tree spread its branches over the group closest to the speaker's stand, while the curving distant hills more gently echoed the seated figures stretching across the canvas to the right. On the left the light-clad speaker shone forth against the darkness of the tree, while on the right, in what must have been a deliberate reversal, the dark forms of the figures on the watermelon cart, the barn, and two figures to the right were silhouetted against a light sky.

The work resembled *County Election* in its local allusions, set as it was "in the vicinity of a mill, (Kit Bullard's perhaps)," as Bingham wrote to Rollins.[60] Just as he localized the scene, so he may have included portraits, as

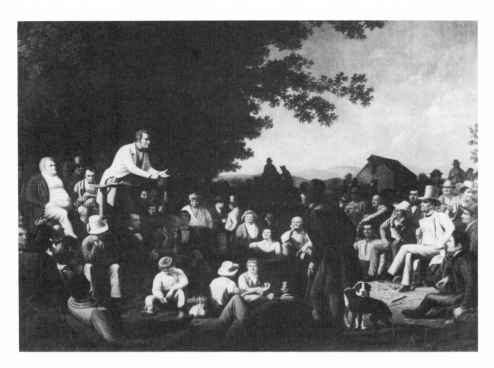

46 Stump Speaking *or* The County Canvass, *1853–54, oil on canvas, 42½ × 58 in. From the Art Collection of The Boatmen's National Bank of St. Louis, St. Louis.*

he had done in the earlier work. For this work, too, Bingham's model Oscar Potter identified figures tied to the election campaigns of 1846 and 1848—Sappington as the speaker, Marmaduke backing him up on the podium, and Bingham making notes or a sketch while waiting to speak.[61] Indeed resemblances to the figures similarly identified in *County Election* would seem to support Potter's observations.

About this painting Bingham spoke more fulsomely than about either of the other two. His interpretation to Rollins, written in December 1853, bore witness to the jesting humor about politics that he and his friend obviously shared. In describing the crowd, Bingham wrote: "*The gathering of the sovereigns* is much larger than I had counted upon. A new head is continually popping up and demanding a place in the crowd, and as I am a thorough democrat, it gives me pleasure to accomodate them all. The consequence, of this impertinence on one side and indulgence on the other, is, that instead of the select company which my plan first embraced, I have an audience that would be no discredit to the most populous precinct of Buncomb."[62] With tongue in cheek, the artist-politician shared a joke with his friend, asserting that Whigs like themselves who believed in democracy had to accept any

and all who came forward in the political process, though he might have preferred a more "select company." At the same time he hinted to Rollins that the speech might be one full of bunkum.[63] The two friends could clearly share a joke about the work.

Nonetheless, if the humorist was at work in this letter, so too was the idealist. Describing the politicians to Rollins, he showed a greater seriousness. "In my orator I have endeavored to personify a wiry politician, grown gray in the pursuit of office and the service of party. His influence upon the crowd is quite manifest, but I have placed behind him a shrewd clear headed opponent, who is busy taking notes, and who will, when his time comes, make sophisms fly like cobwebs before the housekeepers broom."[64] Though Bingham could jest about his "democratic" crowd, he nonetheless acknowledged the seriousness of the debate in which the politicians were engaged, a debate put forth to the people. Bingham was, after all, painting an appeal to the people, a reiteration of his earlier *Stump Orator,* which had spoken so clearly to that issue. That he associated his later composition, at least subconsciously, with an appeal to the people, he had already demonstrated in a letter to Rollins the preceding month. Just after mentioning his *County Canvass* in that letter, he brought up his intention to paint Benton's appeal to the people. As noted in the preceding chapter, the two images were conjoined in his mind.

Just a few months after its completion, the artist wrote to Rollins that he had sold the copyright of the work to Goupil, and soon thereafter the painting must have gone off to the engraver.[65] By this time however, Bingham seems to have been caught up with the idea of a series. In the same letter to Rollins, the artist announced his intention to begin a third work, which he later wrote was intended to "'cap the clymax'" of the series.[66]

Verdict of the People, 1854–1855

The third work in Bingham's election series completed the cycle thematically and compositionally (fig. 47). After the scenes of campaigning and voting, this one represented the announcement of the election returns. Begun in the spring of 1854, the work was finished the following spring and, in the ensuing fall and winter, exhibited in Jefferson City, St. Louis, and Louisville.[67] Some time after 1855 Bingham made a copy, about half the size of the original, which remained in his collection until his death (fig. 48).[68] Like the other two in the series, this one portrayed the principles of representative government with some humorous touches added. Yet it also contained subtle references to the specific issues of slavery that rocked the nation at this time.

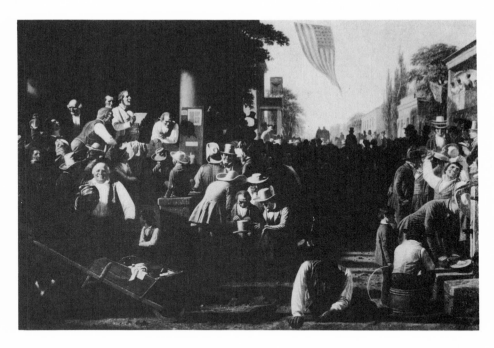

47 The Verdict of the People *(1), 1854–55, oil on canvas, 46 × 65 in. From the Art Collection of The Boatmen's National Bank of St. Louis, St. Louis.*

Larger than the other two, the first version of the painting nonetheless echoed their formal principles. Compositionally it was almost a reversal of *County Election* with a major colonnaded building and leafy tree in the foreground occupying half of the surface and contrasting with open sky and smaller buildings receding diagonally into the distance (figs. 40, 43, 45). From right to left a crowd of figures stretched horizontally across a city street toward the center. There a highlighted seated group formed the base of a diagonal rising to focus on the speaker announcing the results, that diagonal echoed pointedly in the line of the wheelbarrow in the lower left foreground. The watermelon stand at the lower right was a pendant to the cider stand in the earlier work, the slumped figure an exact reversal of one of the children playing mumble the peg, the central seated group an amplified repetition of the pair at the foot of the stairs. In both works a hotel signboard stood out against the sky, and a store was clearly identified. If *Verdict* was compositionally quite closely related to *County Election,* it was similar in its treatment of light to *Stump Speaking* (fig. 46), with a spotlighted figural group on the left contrasting with silhouetted figures on the right. Bingham's sense of humor surfaced in this work as it had in the other two. He took delight in contrasting riant faces with downcast ones, and he quite deliberately

questioned the honesty of the teller with pencil behind his ear who cast a very caricatural shadow on the notice board. Memories of Hogarth's print of *The Polling* were also there in the compositional placement of the building and in the man waving a paper with the results on it.

Iconographically, this work was allied to the other two paintings. Like the earlier two, this one presented the democratic process in action, as a St. Louis reporter clearly recognized. "The genius of the artist has transferred to the canvas a principle in our Government—the exercise of the elective franchise—and submission by the people to the will of the majority is colored true to the requirements of the constitution, and the instincts of our people."[69] Yet, in contrast with the earlier two, this one carried pointed messages about specific political issues in the mid-1850s.

Bingham himself alluded to those issues when he interpreted the painting to his friend Rollins in April 1854. "I intend it to be a representation of the scene that takes place at the close of an exciting political contest, just when the final result of the ballot is proclaimed from the stand of the judges. The subject will doubtless strike you as one well calculated to furnish that contrast and variety of expression which confers the chief value upon pictures of this class. I might very properly introduce into it some of those comically long faces which were seen about Fayette when our friend Claib was so genteelly whipped, last summer."[70] Just as Bingham talked about introducing specific portraits or localities into the earlier political paintings, here too he mentioned a particular moment—the defeat of a specific political figure, his long-term foe, Claiborne Fox Jackson.

The preceding August, Jackson, a Democrat, and John Lindley, a Whig, had run in the third congressional district for the seat left vacant by the death of Jonathan Miller. Lindley had won, to the surprise of many, and Bingham wrote Rollins that he wanted to refer to that election in his painting. Bingham here could not let pass a subtle reminder of the defeat of Jackson, author of the Jackson Resolutions, which his own resolutions had countered in 1849.

The painting was more, however, than simply an allusion to the defeat of the proslavery Jackson in 1853. It overtly and covertly alluded to political issues current in 1854–55, when he was painting the picture. As in *County Election,* a banner hanging in the upper right corner bore a legible inscription that provided a key to one of the issues in the painting. Upheld by a group of women on a balcony, the banner proclaimed: "Freedom for Virtue [Re]striction for Vice."[71] Once more in this triad of paintings celebrating "the manners of a free people and free institutions," freedom surfaced as an issue.

But what was the meaning of this slogan? Almost certainly it had to do with temperance, for one of the key arguments of the prohibition movement linked temperance with freedom.[72] In 1835, a book by George W. Wells, *The*

Cause of Temperance, The Cause of Liberty, set forth such an argument. A drunk was not free because he was a slave to alcohol. To be free a person had to control and curb his appetites. Virtue then was abstinence, indulgence was vice. And the banner blatantly called for virtue. That this issue should surface in 1854–55 is hardly surprising. After the passage of the Maine Law in 1851 making the state dry, temperance had swept the nation, with many states following suit between 1852 and 1855.[73] Such a banner in a painting of 1854 then was topical. That women upheld it alluded to the female temperance societies that had grown up alongside the Sons of Temperance.[74]

There were reasons that temperance should interest Bingham in this context. He himself was a teetotaler,[75] and his friend Switzler was the Worthy Patriarch of Columbia's rather large chapter of the Sons of Temperance.[76] Moreover, the Whigs leaned toward embracing a temperance stand, though they never made it a part of their platform.[77] The issue had reached Missouri by 1854, but Missouri did not go dry.[78] Here was an issue that burned hotter in other states of the Union, including Pennsylvania, where Bingham was then residing. A liquor law was before the Pennsylvania state legislature in the winter of 1854–55, and the topic was current in the Pennsylvania press.[79] Ever alert to political issues, Bingham may well have included a reference to temperance because it was of such interest in the East at the time. But there were other reasons as well.

In the 1850s the temperance movement became associated with the antislavery cause. For decades in the East, intemperance and slavery had been linked together, as in Herman Humphrey's *Parallel Between Intemperance and the Slave Trade* of 1828.[80] Not only were the two immoral, they were also impingements on freedom. In the early 1850s, with the agitation that led to the Kansas-Nebraska Act, the Free-Soilers took up this cry. Late in 1854, the Rev. James T. Henry wrote to Daniel Ullmann of New York: "'Temperance and Freedom are as inseperably connected as Intemperance and Slavery.'"[81] Was the introduction of this allusion to temperance in Bingham's painting a subtle way he could take a stand on the issue of slavery in the territories?

This issue was one, after all, that had concerned Bingham as a legislator in 1848 and that continued to occupy him in this period. The issue of slavery in the territories, vehement and virulent since the later 1840s, came to a head early in 1854 with the introduction of Stephen Douglas's Kansas-Nebraska Bill in the Senate. That bill in effect nullified the Missouri Compromise's banning of slavery in the northern territories and instead introduced the principle of squatter sovereignty, which allowed voters in the territories to decide the issue. In the Bingham Resolutions of 1849, Bingham had advocated leav-

ing the issue to the people of the *entire* union, pointedly rejecting the Jackson Resolutions' view that the people in the territories should decide. Some five years later, Bingham still opposed popular sovereignty in the territories. Writing from Philadelphia on 1 February 1854, less than a month after the introduction of the Kansas-Nebraska Bill into the Senate, Bingham proclaimed his vehement opposition to it. Predicting to Rollins "warm times politically next summer," Bingham stated, "Douglass's infamous Nebraska bill will cause the partially smothered fires to break out with greater violence than ever. Such is the peculiar state of parties at Washington that there is reason to fear that it will pass."[82] Writing from the East, Bingham's views may well have been fanned by those of Easterners around him. But presumably he also thought the free institution of the ballot box should not be used to expand the institution of slavery, which he found a grievous moral wrong.

Later in the spring when the artist first formulated his plans for *Verdict*, the Kansas-Nebraska Bill was still on his mind and probably already linked with the painting. In fact, in a letter to Rollins, his lengthy description of the proposed painting immediately preceded a diatribe against the Kansas-Nebraska Bill, a diatribe that at the same time showed his distance from his local cronies. "I fear that you are all at least half committed in favour of Douglass's Nebraska bill. 'Old Bullion' turns out to be the only man of *full stature* in our entire congressional delegation, and if I resided in his district I would take great pleasure in voting for him in opposition to any whig who sacrifices right to expediency. I have not heard an expression of your views on the subject, but I do not suppose that they differ very materially from my own."[83] The close association of the description of the painting with Bingham's views on the dreaded bill surely indicated that, from the outset, Bingham thought of *Verdict* not only as a general illustration of the elective franchise but also as a way he could subtly address the particular issue of slavery in the territories.

The banner that raised the issues of freedom and temperance, by implication, also raised questions about slavery and intemperance. As if to underline this subtle message, Bingham placed two figures in the foreground who carried meaning. A riant black man pushing a wheelbarrow headed straight toward a drunk man slumped over in the road. The former surely recalled figures of blacks in the earlier two election paintings, one serving cider in *County Election* and the other presiding over a watermelon wagon in *Stump Speaking*. With his inclusion of these active figures, Bingham may have been acknowledging that there were some free blacks in Missouri who engaged in commerce.[84] But the prominence of the latter demands an explanation deeper than the mere insertion of a picturesque drunkard.

The pose of the figure depended unmistakably on a classical statue, per-

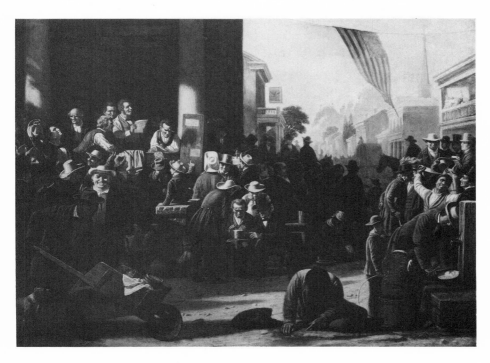

48 The Verdict of the People *(2), after 1855, oil on canvas, 22¾ × 30⁵⁄₁₆ in. Courtesy of The R. W. Norton Art Gallery, Shreveport, Louisiana.*

haps among those antique casts Bingham had collected in 1838 in Philadelphia. The figure in the painting was a modern version of the *Dying Gaul,* the pathetic captive of the Romans with rope around his neck.[85] Placed directly beneath the American flag, Bingham's quotation of the dying slave may well have been intended to make a statement about enslavement to alcohol, even as he also alluded to slavery in America. In the second version of *Verdict of the People,* the seated black mother and child placed under the flag in the middle ground echoed an antislavery stance, even as their posture, like one in some latter day Rest on the Flight into Egypt, alluded to escape from tyranny (fig. 48).

If Bingham alluded poignantly and very subtly to the plight of slaves in his figure modeled on the *Dying Gaul,* he came out strongly and clearly against slavery in a series of articles completed in the winter of 1855–56. "You are aware," he wrote to Rollins in June 1856, "that I commenced a review of Shannons pamphlets upon slavery last winter, in the Statesman. I commenced the task in conformity with the wishes of Col Switzler. The fourth number, however, which I handed to the Col did not make its appearance."[86] Never before traced in the literature on Bingham, these three ar-

ticles appeared in Switzler's paper in January and February 1856. They were a systematic attempt to refute arguments put forth by James Shannon, then president of the University of Missouri, in his *Philosophy on Slavery* and in a speech at the proslavery convention in Lexington in the summer of 1855.[87] In three essays, Bingham rebutted Shannon's moral, economic, and biblical arguments. Though the second two presented complicated and quite specific answers to Shannon's texts, the first took a broad position against slavery.

Bingham's stand against slavery was a moral one tied quite tightly to the issue of the Union. "There could not be a question presented," he wrote, "more fearfully adapted to the overthrow of our national confederacy than that of slavery. Sectional in its nature, and out of harmony with those principles of equality, which lie at the foundation of our great political structure, it is the very instrument upon which ambitious *traitors* would most likely unite to accomplish the fell purpose of disunion."[88] For him, slavery was the gravest threat to the union. It was also the most serious moral wrong. To anyone who had "imbibed the principles of American Independence, slavery cannot appear otherwise than wrong in its origin." Statesmen of both South and North, like Washington, Jefferson, Clay, and others, deemed it "a great social and political evil in continuance." And they "looked forward to the period, in which . . . our country would be relieved from the admitted and multiplied evils of negro slavery." The position he took in the pages of the *Missouri Statesman* was bold for this period, and his outspokenness may have led Switzler to withhold the last of four articles from print. Bingham's stand here was unequivocal and staunch—slavery was wrong from the beginning, a social and political evil that threatened the Union and had to end.

Bingham's feelings about slavery, expressed so clearly in the winter of 1855–56, had surfaced subtly in his *Verdict of the People* completed just a few months earlier (figs. 47, 49). His residency in Philadelphia while he worked on the painting may have separated him enough from his political allies in Missouri that he could take this stance. Pennsylvania also provided him with the vehicle to make his point in a very subtle way, in an allusion to temperance, then a major issue in that state. But on his return to Missouri Bingham was able to maintain his staunch position against slavery.

Verdict of the People completed Bingham's election series. As soon as he finished the painting, he began to see to its publication as a print. Immediately he sent it to Goupil in New York. When the company apparently refused the proposition, the artist reclaimed the painting and began touring with it, inviting subscriptions to the print, which he planned to publish himself. His search for an engraver in Paris the following year, 1856, came to naught. Ultimately the work was lithographed in Düsseldorf, where the

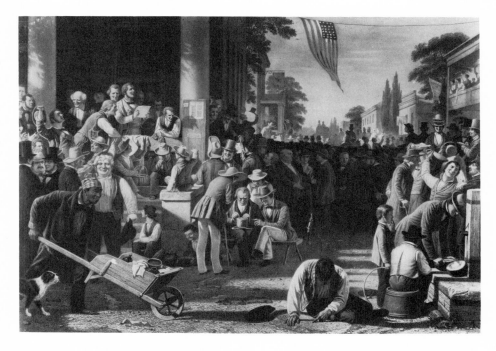

49. *Anonymous, after Bingham,* The Verdict of the People, *1858–59, lithograph, 25⅝ × 35⅝ in. Former collection of Ruth Rollins Westfall. (Photo: State Historical Society of Missouri, Columbia)*

artist lived for two periods from late 1856 to 1859, but only two proofs were pulled.[89]

When he returned to the States early in 1859, he presumably gave one of the two proofs to Rollins. In that print, the inscription on the banner differed from the one in the painting (fig. 49). It is possible that the German lithographers simply did not understand the inscription, but the second part of it makes one suspect that Bingham personalized this print for his friend. The inscription in the print reads: FREEDOM/FOR/FARTUE/ . . . SROLLI/ FOR/ . . . ION. The first phrase might well have been a misreading by the lithographer in Düsseldorf. But the second part may have been a bit of subtle flattery for his friend. If one reads it [JAMES] S ROLLI[NS] for [UN]ION, it clearly alluded to Rollins' quest for office, as it aligned him with the Union. Rollins ran for the Senate in 1855 and 1856, for governor in 1857, and for Congress in 1860.[90] In each of the campaigns, he came out strongly in favor of the Union and against secession.[91] Bingham apparently acknowledged his friend's stance in the inscription in the print.

The Election Series

Because the artist was never able to publish more than two proofs of *Verdict of the People,* the unity of the series is difficult to discern. Nonetheless, if one imagines the three prints hung side by side, one can discover a unified triptych in theme and composition. The prints, unlike the paintings, were all of similar size. Aligning them left to right—*Stump Speaking, County Election,* and *Verdict of the People*—one can read the whole election process from campaigning to voting to the election results. Formally too there is a unity. Reading from left to right, the line of vision begins at the orator in the upper left of *Stump Speaking* and then descends across the heads of the crowd to enter the second image at the lower left corner. Passing from the purveyor of cider and his seated client, the eye moves across the voters and then up the stairs to the moment of the vote. From there, the line of vision moves easily to the figures announcing the results in the third image, diagonally down the steps and across the crowd, finally to come to rest at the right where figures in the street and the balcony of women above conclude the composition.

The unity of the triad of prints would have underscored Bingham's intentions to present a picture of the "manners of a free people and free institutions." At the same time, knowing the dates and circumstances of their production, one can also read in the three the political journey that Bingham made from 1847 to 1855, a journey from an idealistic Whig faith in the electoral process to a strident fight for the Union both in and out of the state legislature. In the course of that journey, Bingham moved from faithful adherence to the Whig party to a realization that shared ideals about the Union could bind him not only to like-minded Whigs but also to Benton and his Democratic followers and ultimately to the radical Republicans. Though chronologically second in the series, *Stump Speaking* recalled quite directly the *Stump Orator,* which Bingham painted in 1847 as an affirmation of his Whig belief in the popular vote. In *County Election,* painted in 1851–52, the artist's subtle allusions to the Union reflected his stand on slavery, made manifest in 1849 in the Bingham Resolutions. By 1854 when he painted *Verdict,* his views against slavery and for the Union had hardened in face of the Kansas-Nebraska Bill. And in this last image Bingham subtly alluded to the freedom he hoped would come.

Though Bingham never renounced the principles of the Whig party, he found himself hard pressed to support it as it foundered on the shoals of sectionalism. One of his last speeches at a Whig convention, in December 1855, asserted allegiance to Whig ideals but at the same time foresaw new political alliances. Bingham threw his support to the resolution of Odon Guitar

that "expressed unswerving devotion to the principles of the Whig party, and stated that although he might be called upon to act with some new organization he could never surrender his devotion to Whig principles."[92] However, the following year, in June 1856, Bingham declared a shift in his political allegiance: "A storm of popular fury, surpassing even that which succeeded the immediate passage of the Nebraska bill is darkening the Northern horizon. . . . I myself have gone clear over to the black Republicans, so far as their creed is indicated by the proceedings at Pittsburg."[93] Here Bingham allied himself with the Republican party, which had gathered in Pittsburgh to affirm its commitment to control slavery in the territories and, in particular, to see Kansas admitted as a free state. Later that year the artist-politician declared unequivocally that the Republicans were his party.[94]

Yet Bingham did not vote in the election of 1856. In September, he had set sail with his family for Europe with a commission from the state legislature for two full-length portraits. Along with these official commissions, Bingham carried the idea for a series of paintings on "squatter sovereignty." This new series would have been his despondent coda to the election pictures. He intended the first work in his projected series to present the election process turned on its head. Though never executed, this work is crucial for a complete understanding of Bingham's political thinking in those tumultuous days before the Civil War.

March of the 'Border Ruffians,' 1856

On the eve of his departure for Europe, Bingham wrote to Rollins about "a new series of pictures illustrative of 'Squatter Sovreignty' as practically exhibited under the workings of the Kansas-Nebraska bill."[95] His fulminations about Douglas' bill, already mentioned above, had grown more bitter as he saw its disastrous effects in western Missouri and Kansas in 1855 and 1856. Knowing he could publish and diffuse such works as prints, the idea of a clear visual statement of his views on the whole issue began to crystallize. The first work he planned was the *March of the 'Border Ruffians,'* and he assured his friend Rollins that he would "take pains to give those infamous expeditions of organized rowdyism all those odious features which truth and justice shall warrant." He went on to request from Rollins certain items that would help in the planning of the picture: images of the principal figures involved and government records of the affairs in Kansas. "I will want a portrait of Col Samuel Young, of the big negro that played the violin, and of a certain methodist parson. As I design to give this trio the most conspicuous position upon the canvass, cannot you manage to forward them to me. . . . I wish you also to forward to me all the documents in relation to these affairs in Kansas, the

evidence taken by the congressional committee &c." From his requests, one may begin to reconstruct the subject of his first proposed painting, for Sam Young and music-making blacks figured in one of the key incidents in the tumultuous aftermath of the passage of the Kansas-Nebraska Bill.

The territory of Kansas was the first to feel the effects of that bill.[96] Passed in May 1854, it in effect overthrew the Missouri Compromise and left the decision about slavery to the people living in the territories. They would themselves decide the issue under the principle of "squatter" or "popular sovereignty." Bingham had placed himself against this principle in his Bingham Resolutions, and he was right to have done so. The working out of popular sovereignty became a nightmare in Kansas. Since voting determined everything, the state became a battleground between pro- and antislavery parties. The New England Emigrant Aid Society sent antislavery settlers to establish residence in Kansas. To counter these voices in the elections for the territorial legislature, proslavery forces from western Missouri, known as "border ruffians," entered the state to vote illegally. In the course of 1855 all the elements of civil war surfaced there—a fraudulently elected proslavery legislature, a countering Free State convention that passed a resolution known as the Topeka Constitution prohibiting slavery, subsequent elections of an antislavery legislature and governor in early 1856, and armed conflict between the two factions, with the Missouri border ruffians bolstering the proslavery forces. The skirmishes culminated in an attack on Lawrence, Kansas, on 21 May 1855, when the border ruffians sacked the town, burned the Free State Hotel, and destroyed the Free State presses there. In immediate reprisal John Brown led the Pottawatomie massacre on 24 and 25 May. Despite the governor's warning to desist, guerrilla warfare continued through the year.

When Bingham requested information about the Kansas affairs in August 1856, he specifically asked for the Congressional Report that had issued forth only weeks earlier.[97] This was the investigation of the situation in Kansas conducted by a select committee of the House. Among its conclusions, the majority of the committee felt that the elections had been "carried by organized invasion from the State of Missouri," that the alleged legislature had been illegally constituted, and that the Topeka Constitution "embodies the will of a majority of the people."[98] The committee also felt that no fair election could be held, in the present circumstances, without a careful census, a firm voting law, impartial judges, and federal troops at each election site. The lengthy publication included not only the majority and minority reports but also the committee's journal, the complete testimony they had heard, and census rolls and poll books.

It is the testimony that permits the identification of the scene Bingham

envisaged for his *March of the 'Border Ruffians.'* It was a moment in the
first elections of the territorial legislature held 30 March 1855, when a large
contingent of Missourians crossed the border to vote illegally in Kansas. It
was Col. Samuel Young who led Missourians into the First District of Kansas
to vote in the town of Lawrence. According to the report, about a thousand
men "came in wagons (of which there were over 100) and on horseback . . .
armed with guns, rifles, pistols and bowie-knives; and had tents, music, and
flags with them."[99] The evening before the election, they assembled at a
camp ground to hear speeches by Young and Claiborne Jackson who was
also there. One eyewitness described how a "company from one of the
camp-fires came, headed by music; a man beating a drum came in."[100] Yet
another witness noted that there was "a *darkey* who drummed for them,
and one who carried a flag."[101] On the day of the election, groups paraded
into Lawrence, the first one led by Young. He was also one of the first to vote,
and according to several testimonies, when asked if he intended to live in
Kansas, he responded that it was none of the poll judge's business. "After his
vote was received, Col. Young got up on the window-sill, and announced to
the crowd that he had been permitted to vote, and they could all come up
and vote. He told the judges that there was no use in swearing the others, as
they would all swear as he had done."[102] At this travesty of the election pro-
cess, one of the judges immediately resigned.

Surely Bingham intended to represent in his picture Sam Young's con-
tingent of illegal Missouri voters approaching the polls in Lawrence. His spe-
cific mention of Young and the black musician echoed the testimony of those
present at that election. With Young, the black violinist, and "a certain
methodist parson" (possibly Shannon) as the central focus, one might imag-
ine the trio leading a group of men to the polls. Flags, like those carried by
the "border ruffians" inscribed "'Clay county boys,' &c," would have left
little doubt of the residency of these voters.[103]

Though the painting was never executed, the artist continued to think
about it and the issues of slavery in Kansas throughout his stay in Europe. In
almost every letter to his friend Rollins, Bingham commented on the situa-
tion in Kansas. In December 1856: "The advocates of Slavery extension may
have the good sense to perceive that there is an extent to which they may be
carried in behalf of their especial interest which will rouse in fierce opposi-
tion the entire north."[104] The following June: "Kansas, in spite of the stupen-
dous rascality to secure it to Slavery, will go, *as it should go,* for freedom."[105]
And in October 1857: "I trust that the people of that Territory are now
strong enough to fight themselves right, if not permitted to vote." In the very
same paragraph, the artist mentioned the series: "I have not yet abandoned

my purpose of doing justice in the way of Art, to our *far famed* 'border ruffians,' and would like you to send me, enclosed in a letter, the most graphic account, extant of one of their most conspicuous forays." [106]

After the election series that set forth Bingham's belief in the free expression of the will of the people, the *March of the 'Border Ruffians'* would have shown a charade of that principle. Whether his trio was simply marching toward the voting place or actually shown at the polls, their actions implied an approval of fraudulent voting, something that Bingham had disapproved from his first contested election to the present. The travesty of the election process in Kansas to secure the protection of slavery flew in the face of all Bingham's principles. And his painting would have been his way of assuring that future generations remembered the charade that had gone on, a presage of his later history painting, *Order No. 11.* In its own way, *March of the 'Border Ruffians'* would have been the pessimistic conclusion of the election series, recalling the scenes of riverboat wrecks that had concluded Bingham's earlier ebullient series of paintings documenting American commerce and development.

Despite his fervor, the painting and the series never materialized. In Düsseldorf Bingham found himself occupied with more traditional political images, the official portraits commissioned by the state government. Ironically it was in Europe that he executed what had been the dream of his artist-politician's life in America—governmental commissions for works to adorn America's public buildings. When he returned with the portraits, he made the most overtly propagandistic use of them. He wanted the works that the state legislature itself had commissioned to affect the issue of slavery and Union, not among the people but among the legislators of the state General Assembly.

6

Bingham and Union
Governmental
Commissions
and State Portraits

But I will . . . say a word on the effect
of art on national feeling. Some one
has said, give me the writing of the
songs of a country, and you may make
its laws. I had almost said, give me the
control of the art *of a country, and*
you may have the management of its
administrations. . . . Pictures *are more*
powerful than speeches. . . . *Let the*
statues of the signers of the Declaration
of Independence line Pennsylvania
Avenue, and he who walks between them
to the Capitol will be a better man and
a patriot.

—*Remarks of Mr. J. T. Headley, Annual*
Meeting of the American Art-Union, 1845

In the 1850s Bingham pursued his career as an artist on two fronts. If the election pictures were his major occupation in the first half of the 1850s, official state portraits were his chief concern in the second—and indeed into the 1860s. Up until 1855, Bingham acted as an independent and entrepreneurial agent. Intent on furthering his career as an artist, he undertook and executed the innovative election paintings on his own, financing and arranging for their reproduction, and then traversing the country to exhibit them and market the prints. After 1855, he became the recipient of state patronage, something he had long desired and long sought. He was able to compose official works that would take their rank with other state portraits. He received substantial stipends for his work, albeit occasionally with some bureaucratic hassles, and then he had the pleasure of placing the paintings on public display in the halls of the legislature where he himself had served. If the nature of his production in the two halves of the decade was different, so too was his message. Early in the decade, when the nation was seeking a political solution to its very grave problems, Bingham's election series made a broad appeal to a wide number of people to cherish and preserve the institutions that were the very cornerstone of American government. Later in the decade, as the country moved inexorably toward war, his state portraits became vehicles to carry the artist's quite specific political admonitions to

155

legislators who had to decide the course the state would take in the crisis that shook the nation.

Bingham had desired state patronage from the moment he determined to become more than a local Missouri portraitist. An ambitious man, he knew that public commissions were the surest way to join the ranks of nationally known artists like Trumbull and Vanderlyn. Such commissions also paid well and reliably. Moreover, in the political arena Bingham knew that he had a decided advantage. His friendship with leading politicians and his own first-hand experience in government at least pushed doors ajar for him. He had tested the waters in 1840 after the success of his banner of William Henry Harrison, when he solicited Rollins' help to obtain a commission for copies of portraits of statesmen to decorate the Missouri state house.[1] He had come closer in 1845, when he almost received a commission for a historical picture from the state legislature. But with the patronage of the Art-Union and national recognition stemming from the publication of *The Jolly Flatboatmen,* he relinquished, for a time, his quest for government patronage.

Only in 1853, as Bingham discovered the rigors of a tour to sell engravings after his election series, did his thoughts turn once more to the advantages of a governmental commission for a full-length portrait. On tour in Kentucky with his election painting in July 1853, Bingham approached some legislators in Frankfort about the possibility of his painting a portrait of Henry Clay for the state capitol in Frankfort.[2] It was a logical choice, as the Farmer of Ashland had been one of the most eminent Kentuckians in American politics. Logical, too, for Bingham, as he had already painted monumental images of Clay on his Whig banners in 1844. Although his plans came to naught, the spark was struck.

In the coming months, on more than one occasion, he wrote from New York to raise the issue of a public commission with Rollins, who was then a serious contender for the Whig nomination for Congress. With characteristic good humor, Bingham joshed with his friend, promising him support so that Rollins could further the artist's chance for a national commission in Washington. "If you should be the candidate in the congressional race in your district," Bingham wrote good-naturedly in February 1854, "you must take good care to be elected, as the great picture for the rotunda will depend on it."[3] Bingham's appetite for such a choice commission as a history painting for the Rotunda of the Capitol had been whetted during his early stay in Washington, when Congress charged four different artists to continue Trumbull's historical series. By 1853, with the prospect of an advocate in the nation's capital, Bingham may even have begun to imagine what his own contribution could be—a western scene on the order of his own *Daniel Boone*

Escorting Settlers Through the Cumberland Gap of 1851 (fig. 21).[4] Indeed, the mere mention of the Rotunda brought the Boone painting to the artist's mind, and he went on in the very next sentence to ask Rollins to inquire about the raffle of the picture then being held in St. Louis.[5] Bingham's jovial directness with Rollins continued through April. But nothing came of it, as Rollins failed to win the Whig nomination for the House in the spring of 1854 or for the Senate in January 1855.

Rollins' return to the state legislature, however, proved a boon for the artist. Early in 1855, Bingham asked Rollins once again about the possibility of painting something for the state capitol, this time explicitly suggesting "the emigration of Boone." "If you are not ripe for such a work of art as the emigration of Boone upon a large scale would be, a full length portrait of Washington might do for a beginning. Were I to receive a commission from the state for such a work I would be ambitious to render it *superior* to that which graces the Hall of Representatives at Washington. I should like to present the 'Father of his Country,' connected with some historical incident in a manner which would rival the far famed picture by Leutze."[6] Now that Rollins was actually in office as a representative in the state General Assembly, in January 1855 Bingham abandoned his joking stance and made a quite specific proposal. Suggesting the Boone picture as a serious possibility, he also contemplated something on the order of Leutze's great *Washington Crossing the Delaware,* leaving open the commission of a full-length portrait. Writing from Philadelphia, he probably had no way of knowing that a bill for a public commission had already appeared before the state senate. He was close to realizing a life-long dream.

Portraits of George Washington and Thomas Jefferson, 1855–1858

The story of Bingham's first commission from the legislature reveals much about the artist's ambitions, as well as about his ideas of what official state portraiture should be. Rollins, long an advocate of the artist, here played a major role in furthering his friend's cause. The legislative record indicates that there may have been some partisan finagling when the commissions first came up in the General Assembly in 1855. Nonetheless, when the paintings of Washington and Jefferson arrived in the capitol in 1859, they were greeted with bipartisan acclaim and immediately won the artist another similar commission (figs. 50, 51). Destroyed by fire in 1911, the portraits are known only dimly, through descriptions and photographs.

The legislative session that approved the first two portraits was a stormy one, which played itself out in small in the two commissions. The 1854 elec-

tions had created a General Assembly in which no party had a clear majority. The Whigs had a plurality with 60 representatives, while the Democrats were split into two factions, with 43 Bentonites and 57 anti-Bentonites. The election of a senator was the chief business of the session, but ballot succeeded ballot as the parties stubbornly continued to vote for their own candidates. Finally after more than 40 ballots the General Assembly declared a stalemate, and the senate seat remained vacant until 1857.[7] It was just during the period of balloting for senator that the bills for the portraits of Washington and then Jefferson came up. In the senate these two bills brought together legislators of all three factions, but the house saw unanimity only on the Washington portrait.

Bingham wrote his letter to Rollins about painting a portrait of Washington on 12 January 1855, just nine days after the Missouri senate first asked the Ways and Means Committee to consider commissioning such a portrait to hang in the senate chambers.[8] That request had arisen at the instigation of a Whig senator, Mr. Carson, just the day before balloting began for senator. The Ways and Means Committee considered the proposal during a week of legislative action that made clear that there was little chance for unanimity on the election of a senator. Within only one week, on 10 January 1855, the bipartisan committee had decided that it was "eminently right and expedient" for the state to commission a portrait of Washington.[9] They presented a bill arguing that such a picture, hung "together with a copy of [Washington's] farewell address to his countrymen," would be an "expression of our love, admiration and veneration for the memory and character of him who was 'first in peace, first in war, and first in the hearts of his countrymen,' and our estimation as Americans of the sentiments and principles embodied in his farewell address." The speed with which they reported back to the senate and their agreement to recommend such a bill spoke subtly of the need for the General Assembly to rise above party lines at a time when it was unable to do so in the matter of the election of a senator. The senate passed the bill quickly, and it went on to the house, where it was referred to a select committee of three that represented all three factions.[10] Since the bill named no specific artist, it was fortunate for Bingham that his friends James Rollins and Frank Blair were on the committee. If the portrait of Washington encountered no difficulty in the house, not so with the portrait of Jefferson.

Such was the success of the bill commissioning the Washington portrait in the senate that the senators almost immediately instructed the Ways and Means Committee to consider proposing a similar portrait of Thomas Jefferson.[11] In mid-February they came back to the senate with a bill for a portrait of Thomas Jefferson to be accompanied by "a copy of the Declaration and

the names of its Signers," and the bill passed.[12] The house, however, balked at this second portrait. At the instigation of Louis Bogy, an anti-Bentonite from St. Genevieve, the house speedily voted it down late in February.[13] Able to accept a portrait of the Father of his Country, the house with no clear party majority was unable to approve the portrait of Jefferson. The whole matter remained unsettled and was carried over to the following fall.

Nonetheless, with at least one commission approved, some of Bingham's advocates were swift to act. As soon as the Washington commission was introduced in the senate in January 1855, W. F. Switzler put forth the artist's name on the pages of the *Missouri Statesman:* "GEORGE C. BINGHAM, Missouri's own distinguished artist, is the man for the work."[14] When the General Assembly adjourned in the spring, however, it had not arrived at a decision on the artist for the portraits. Hence, in November, when the adjourned session of the General Assembly began to meet again, Bingham moved his studio to Jefferson City, undoubtedly hoping to advance his claims for the commission.[15] Painting portraits in the capital, he had opportunities to discuss and promote his aims with the legislators.

In this adjourned session, Rollins became an active advocate for his friend. At the end of the month he orchestrated the passage of a bill in the house for two portraits, with Jefferson's name simply added to Washington's. He also managed to obtain an appropriation of $3,500 for the two paintings.[16] He must have suspected by then that he could win the commission for Bingham. Within a month Rollins had managed to secure a position on the joint legislative committee to select an artist, along with fellow house members Frank P. Blair and John Locke Hardeman from Bingham's own Saline County.[17] Together they used their influence to award the commission to Bingham. Years later Bingham wrote Rollins: "Rannels Blow & Co. [state senators from St. Louis] would have given the commission for the portraits to some eastern daub, had you not overpowered them by the House portion of the Committee."[18] It was Rollins who finally drew up the bill for the two pictures, specifying the fee and the terms of the contract.[19] By the end of 1855, then, Rollins had overcome resistance to the portrait of Jefferson in the house, and Bingham was on his way to painting his first two state portraits.

As pleased as he must have been to receive recognition as an official and formal portraitist, he did not begin the works immediately. At the same time as he was seeking the legislative contract, he also was formulating plans for a trip to Paris, first in 1855 and then more seriously in 1856.[20] It was a dream the artist had long cherished. As early as 1849 he had enlisted Rollins' help in attempting to secure a consulship in Europe.[21] Nonetheless, in 1856, it may have been the commission that pushed him finally to realize his dream. The financial security of the $3,500 fee awarded at the end of the year un-

doubtedly helped. He may also have found it fitting to undertake these large-scale and formal works in Europe, in touch with the kind of official art he hoped to emulate.

The two portraits were the largest and most important commissions the artist had undertaken in his life. Aware of their importance, Bingham must have given a good deal of thought to their design. Before embarking for Europe, he executed copies of Gilbert Stuart's bust portraits of Jefferson and Washington, the former in Governor Coles' collection in Philadelphia, the latter in the Boston Atheneum.[22] But, for the full composition, he also must have considered other American state portraits. He certainly recalled the official portraits he had offered to copy in Washington almost twenty years before—John Vanderlyn's *Washington,* Ary Scheffer's *Lafayette* (fig. 10), and Gilbert Stuart's *Jefferson*.[23] He knew well the full-length portrait of Thomas Hart Benton that he had arranged to have hung in the Missouri house of representatives in 1849. One can also imagine him perusing full-length images he saw in the East before embarking for Europe. In the Atheneum in Boston were two works by Chester Harding, portraits of Chief Justice John Marshall and Daniel Webster which showed the men standing beside desks in interior settings.[24] In Philadelphia Bingham could also have renewed his acquaintance with Gilbert Stuart's Lansdowne *Washington* or John Neagle's *Henry Clay* (fig. 8). His European sojourn must have simply reinforced the visual memories he brought with him. The images he created took their place comfortably in the tradition of American state portraiture.

Once in Europe, work on the portraits occupied him during the next two years. He began the portrait of Washington first, undertaking a small model in Paris as a study for the full-scale work he executed in Düsseldorf.[25] Upon its completion, in the fall of 1857, he began work on the Jefferson, which he completed in the spring of 1858. Undoubtedly thinking of the two as pendants, Bingham posed the two statesmen beside desks in cavernous interiors. The figures seem to have been almost life-size on canvases that must have been quite large, judging from photographs in situ.[26] These indistinct photos—the one of Washington only here rediscovered—and a few comments Bingham himself made about the works allow only limited interpretation.

Bingham placed his Washington alongside a rug-covered table topped with some half-dozen books, following the tradition established by Gilbert Stuart's Lansdowne portrait and continued by John Vanderlyn (fig. 50). The diagonal placement of the table and the receding tiled floor conspired with prominent lighting in the foreground to suggest an ample room. Washington struck a pose almost exactly like that of Neagle's *Henry Clay* (fig. 8), which had earlier probably inspired the artist's Howard County banner. Turning to

50 George Washington, *1856–57, oil on canvas. Destroyed by fire, originally in the Capitol, Jefferson City. (Photo: State Historical Society of Missouri, Columbia)*

the left with his right foot extended, the Father of his Country extended both hands to the right. Yet rather than gesturing toward objects, as Clay had done, Washington firmly rested his left hand atop a book. Unfortunately, the titles of the books are not legible, nor did Bingham leave any indication on this matter. The dramatic pose, the rug-covered desk, the books and tiled floor—all linked the image with such a host of earlier official portraits that an effort to establish specific sources seems pointless.

Following on the heels of the Washington portrait, the image of Jefferson (figs. 51, 52) presented Bingham with the challenge of balance and contrast. At first, after finishing the small study of Washington standing, Bingham conceived the idea of a contrast—"Jefferson in a sitting posture surrounded by his library and other accessories, indicating his character both as Statesman and Philosopher."[27] This idea doubtless derived from Gilbert Stuart's Doggett portrait of Jefferson, a work, widely circulated in prints, that showed the great statesman seated at a desk engaged in work. However, upon completion of the full-scale portrait of Washington, Bingham decided differently. Certainly considering scale, he placed Jefferson "in a legislative hall with a roll of paper in his left, and a pen in his right hand, and with one foot elevated upon a step of the small platform immediately in front of the speakers desk."[28] He thus opted to create a balanced pendant to the first.

As he had in the Washington portrait, Bingham presented Jefferson alongside a desk in an ample room. Yet he balanced the two works by reversing Jefferson's posture, the receding diagonal of the tiled floor and even the direction of light. Conscious of the need for variety, he altered several elements—the pose, the desk, even the pattern of the tiled floor. In color too he sought contrast, as he wrote to Rollins from Germany:

> His [Jefferson's] well known personal singularity in regard to costume has given me some little advantage in aid of the picturesque. In conversation with his old and intimate friend Gov. Coles, I learned that when he did not wear the scarlet vest he sometimes draped himself in a long light reddish brown frock coat reaching almost to his ancles. . . . His object in useing so much red in his apparal appears to have been to counteract the effect of a similar hue in his hair. Availing myself of these facts of dress, I am enabled to make his portrait, in some respects, a complete contrast to that of Washington and to avoid the repetition in it of any thing contained in the latter.[29]

One might surmise from these remarks that Bingham established a color contrast between the two, perhaps using a more traditional dark blue or black for Washington's garb.

51 Thomas Jefferson, *1857–58, oil on canvas. Destroyed by fire, originally in Capitol, Jefferson City. (Photo: State Historical Society of Missouri, Columbia)*

As with the Washington, Bingham certainly thought of other portraits of Jefferson when he designed his own. Even if he had heard about Jefferson's long red coat from Governor Coles, his decision to use it may reflect some knowledge of Thomas Sully's West Point *Jefferson* of 1821, who was also like Bingham's figure holding a scroll of paper in his left hand.[30] In combination with the quill pen, the scroll certainly designated Jefferson as the author of the Declaration of Independence, a copy of which the Missouri legislators wanted to display near the portrait. In these two attributes Bingham's version recalled the noted statue of Jefferson with the Declaration by David d'Angers that U. P. Levy had presented to Congress by 1846.[31]

Bingham's commission from Missouri was a new challenge for him, calling upon him to emulate formal portraitists of the past. The general pose of a statesman standing at a desk had a long tradition in America. One must also remember that Bingham had painted full-length portraits on his own political banners. In short, by the time Bingham arrived in Europe, he was well acquainted with an American variant of the traditions of state portraiture in Europe. With such works already in his visual memory, Bingham would have found little to surprise him in the European state portraits he must have seen in the Louvre and in Düsseldorf. He thus moved with apparent ease into state portraiture.

As soon as Bingham completed the portraits of Washington and Jefferson, he began to see to their framing in Düsseldorf. However, the idea of shipping them across the Atlantic worried him, as he wrote to Rollins in a fulsome letter in July 1858.[32] He was even more concerned that the paintings be carefully unpacked in Jefferson City, varnished correctly, and hung "so as to receive the light properly." He therefore decided to return to the United States, "so that I can attend to these matters myself."

Not only was Bingham anxious about the safety of his first major state portraits, he also was interested in garnering other official commissions in America, either in Missouri or in Washington. In the same letter to Rollins, Bingham went on at length about a large appropriation made for art in the Library of the Capitol. He knew that Leutze was going to compete for a commission, and he himself wanted to "enter the list of competitors. . . . As there is yet no work of Art in the Capitol, properly illustrative of the history of the West, it seems to me that a western artist with a western subject should receive especial consideration." What he had in mind was a picture of the emigration of Boone, like the one he had painted earlier.

Before his return to Missouri, then, he stopped in Washington to push his candidacy. He arrived in time for the second annual meeting of the National Art Association at the Smithsonian. There, not disinterestedly, he offered a resolution for the participation of artists in an art committee to award

52 Thomas Jefferson *and* Henry Clay *in Senate Chamber, Capitol, Jefferson City, ca. 1900. Destroyed by fire. (Photo: State Historical Society of Missouri, Columbia)*

commissions. He concluded his speech with an impassioned plea that the federal government should recognize "that the capabilities of American art are fully adequate to the proper illustrations of American history."[33] In arguing that American artists should undertake American subjects, he subtly put himself forward as a candidate. However, no commission was forthcoming in Washington, so he returned to more predictable patrons in Missouri.

Portraits of Henry Clay and Andrew Jackson, 1859–1861

Even before he completed the portraits of Washington and Jefferson, Bingham had conceived the idea of executing two others of another pair of eminent statesmen, Henry Clay and Andrew Jackson. In March 1858, Bingham wrote to Rollins about his idea, suggesting "Perhaps the Legislature if in a good humor, may be induced, when these are seen in their places, to give me an order for a full length of Gen Jackson, on the back of which, one for Clay will not come amiss."[34] Later in the summer, he wondered "If my presence in Jefferson City this coming winter would be likely to increase the

chances of obtaining a commission for portraits of Jackson and Clay."[35] Consequently, when he returned from Europe to deliver the first set of portraits, he stayed on in Jefferson City, perhaps encouraged by his friend Rollins. But the election of 1858 had changed the character of the General Assembly. Proslavery Democrats dominated the legislature, overwhelming the Opposition party that consisted of old time Whigs like Rollins, Bentonites, Know Nothings, and a few outspokenly antislavery advocates who followed Frank Blair.[36] Despite the constitution of the General Assembly, Bingham felt his chances might be good for another commission. He installed the portrait of Jefferson late in January 1859, and the one of Washington just a few weeks later.[37]

His advocates in the legislature were enthusiastic in their praise, for the first time referring to him as "the American artist," rather than the Missouri artist, and declaring their pride "to recognize him as our fellow-citizen."[38] Partisan bickering arose only over the issue of paying Bingham for framing the Washington and Jefferson portraits, but even that issue was ultimately resolved in the artist's favor.[39] Moreover, the week after the portrait of Washington was hung, the senate and house passed "an act authorizing George Caleb Bingham to paint a military equestrian portrait of Andrew Jackson and a full length portrait of Henry Clay."[40] Bingham may have been correct to feel that the Democratic legislature would jump at the chance of honoring Jackson and therefore would accept Clay. The bill went through the legislature rapidly together with an appropriation to help the Mt. Vernon Association purchase Washington's home.[41]

As the first commission had paired a Federalist with a Democrat, the second also joined members of opposite parties, a Democrat and a Whig. When Bingham first mentioned the project to Rollins, he jocularly speculated that the Democratically controlled legislature would most certainly approve a portrait of Jackson and then might be able to stomach one of Clay. When the decision was made, popular opinion applauded the wisdom of the choice. A reporter for the *Missouri Statesman,* perhaps Switzler himself, wrote: "With these four portraits in the Capitol, the two most important eras in our country's history will be handsomely illustrated, for with the names of Washington and Jefferson, and Clay and Jackson, are associated all that is to be admired in patriotism—all that is wise in council—all that is eloquent in statesmanship—and all that is brave and heroic in the field."[42] In this instance, journalistic enthusiasm for the portraits was unbounded, seeming to transcend party lines. Nonetheless, nothing could smooth over the very real partisan differences on the issue of slavery then dividing the legislature as well as the country.

Once again Bingham took leave of the issues facing the country. In May

1859 Bingham returned to Europe with commissions for three major por-
traits—the two from the state and one of Baron von Humboldt from the
Mercantile Library Association in St. Louis.[43] He probably intended to com-
plete all three in Düsseldorf, but his father-in-law's death called him home.
In his relatively short stay abroad, then, he began only the portrait of the
great German scholar. Only on his return to the United States did his
thoughts turn to the state commissions.

Finding the equestrian portrait "by far the most difficult work of the
two,"[44] he turned his attention first to the image of Jackson, executing it be-
tween January and September 1860. As he had done for the other two, he
first painted a study of the general's head, copied from a painting by Thomas
Sully in the collection of Captain Samuel Lee in Washington.[45] While in the
nation's capital he probably also looked with care at the great equestrian
statue of Jackson by Clark Mills, erected in 1853. Indeed, Bingham acknowl-
edged his rivalry with the American sculptor. "My portrait of Jackson will be
pronounced by connoiseurs and the public, immeasurably superior to any
similar work in the United States, the great Statue at Washington, by Clark
Mills, not excepted."[46] But, if he was aware of the statue, he also studied
equine anatomy from life, as he told Rollins, through the window of his stu-
dio in Independence, where he had moved with his wife Eliza in the middle
of 1860.[47]

Since no photographs of the Jackson portrait exist, one must rely on a few
descriptions of the painting written by contemporaries. The first was a favor-
able report by a local journalist, the second an attack by Senator James T. V.
Thompson. Writing when the portrait was first hung, a reporter in Jefferson
City noted: "The old hero, represented as mounted on a charger, waving
his hat, and cheering his army on to victory."[48] Thompson added a little
more information along with stinging criticism. "In this picture the horse has
stopped, and Jackson is looking back on the enemy . . . [with] a red cloak
flying about him."[49] Attacking Bingham's "equine aesthetics," Thompson
went on to describe the horse with "a little slim neck" and "a foreleg [that]
looks as if it had been lying out on the prairie for six months and the wolves
had been gnawing at it." The senator's criticism suggests that the horse might
well have been rearing. "Now if this battle [of New Orleans] took place on
level ground, as it is said to have been, the horse don't stand on the ground at
all." The accounts by both the Jefferson City reporter and Senator Thompson
hint at Bingham's possible sources.

The portrait, representing the hero at the Battle of New Orleans, cer-
tainly fell into the category of historical portraiture, its composition linked to
great equestrian portraits of the past from Titian onward. That Bingham
sought to represent action would seem confirmed by the journalist's account.

And both the newspaper description and Senator Thompson's remarks make one suspect that Bingham had some knowledge of Jacques-Louis David's well-known portrait of *Napoleon,* where the dramatic diagonal of red cloak formed a foil for the white horse rearing diagonally up an incline.[50]

Having worked on the equestrian portrait for some eight months, he returned to a more familiar format and moved more rapidly on the full-length image of Clay (figs. 52, 53, 54), painting it with some interruptions between October and December of 1860.[51] He made no mention to Rollins of preliminary studies, perhaps deeming these unnecessary given his own earlier portraits of Clay.[52] Indeed, the memory of his own banners seemed to determine some aspects of the portrait, even as the artist apparently sought to make the image compatible with his earlier two he had painted for the state house.

The image of Clay bore some resemblances to the earlier ones. The figure, about two thirds the height of the canvas, stood slightly to the left of center within an ample space defined by octagonal tiles of the floor. Like Bingham's own Jefferson, the great Kentuckian held a paper in his hand as he stood alongside a desk. But the clearer photograph of Clay also reveals differences. In contrast with the pensively poised Jefferson, the orator Clay threw his left arm out in a bold gesture toward the right background. There a pile of books and papers lay before a balustrade and an archway that opened onto an architectural panorama. Immediately visible were the profiles of two statues set before a colonnaded building. Further in the distance a heroic male figure atop a pedestal near an arched passage closed the picture. The floor, the sculpture, and the neoclassical perspective certainly recalled Morse's *Lafayette* as the posture, costume, and gesture of the left hand recalled Neagle's *Clay* (fig. 8). But there were also echoes of Bingham's earlier political banners. The still life of books and papers recalled a similar assortment of papers and objects lying at the base of the marble pedestal in the Harrison banner of 1840. The statesman's posture echoed the figure of Clay in the Howard County banner of 1844. Even the architectural vista recalled that same banner that had also shown "the capital and other national buildings" with Clay.[53] The statues in the painting are so indistinct that they are hard to identify, though the female figure carrying scales could be a figure of Justice. In conceiving this painting, then, Bingham thought back not only to earlier formal portraits in America and elsewhere but also to his own images of statesmen, on banners and canvas.

In these portraits, however, the task for Bingham was not simply a formal one. The message was also important. Later, when he used these portraits as an excuse to make a pro-Union speech, he quite calculatedly discussed his preparations for painting them. "During my efforts to embody, in the enduring forms of Art, the national idea of the two illustrious citizens,

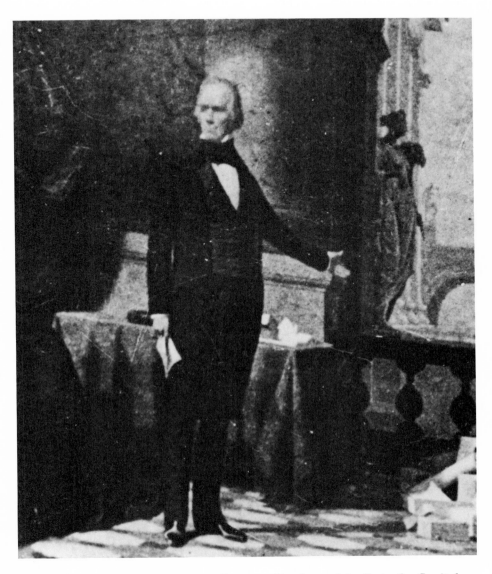

53 Henry Clay, *1860, oil on canvas. Destroyed by fire, originally in the Capitol, Jefferson City. (Photo: State Historical Society of Missouri, Columbia)*

who stood forth so pre-eminently the representatives of this GREAT AMERICAN NATION, I had pondered over the record of their sayings and doings, that I might understand and properly appreciate their services and virtues, and thus be enabled worthily to discharge the duty with which I had been intrusted." [54] Remembering perhaps by heart the words and deeds of his great Whig hero Clay, Bingham also had pored over the military exploits and political speeches of the Democrat Jackson. Speaking to a predominantly pro-

54 Henry Clay *in Senate Chamber, Capitol, Jefferson City, ca. 1900. Destroyed by fire. (Photo: State Historical Society of Missouri, Columbia)*

slavery Democratic audience, Bingham was able to use Jackson's own words to argue against the very policies the Democrats were trying to adopt.

The portraits of Jackson and Clay thus became more than mere complements to the earlier images Bingham had hung in the state capitol. Bingham endowed them with quite specific political meaning when he delivered them to the capitol early in 1861. There was good reason to do so.

The Union that Bingham had so avidly advocated and supported since 1848 was in crisis. All through 1860 rumors of secession and war were rumbling. None other than Bingham's arch enemy on the slavery issue, the secessionist Claiborne Fox Jackson, had been elected governor. In his inaugural address just a few weeks before the presentation of the portraits, Jackson had advocated that Missouri throw her lot with the South and had urged a state convention to decide the issue of secession. In the very days of the installation of the portraits, the state legislature was considering the convention that the governor hoped would propel Missouri out of the Union and into the Confederacy. Consequently, when Bingham presented the portraits to the legislature, he took special care to assure that their message and his own views would not be lost on the lawmakers. He deliberately chose to install them on the anniversary of the Battle of New Orleans, Jackson's great defeat of the British. When called upon to give an impromptu speech at their hanging, the artist eagerly seized the opportunity to make clear his own views on secession, views he claimed to be trying to express in the two portraits.

In presenting the paintings "on the anniversary of one of the most glorious days in the history of our nation," Bingham wrote, he had hoped to elicit "feelings of patriotism, fraternity, and Union, rather than of discord, anger and hate. . . . I really forgot, during the temporary excitement of the hour and the occasion, that there was any North or any South. I thought only of the glorious empire of Freedom—its statesmen, heroes, poets, and philosophers—its mighty rivers—its teeming commerce—its flourishing manufactures—its arts and science—and the national emblem which waves over all." [55] He extolled the unity symbolized in the field of stars on the flag and pointedly alluded to the dangers of secession, describing "the revolting character which would be *mine* if *I* should conspire to rend [the stars] asunder and quench them in eternal night." Bingham here took his cue from the words and deeds of the two great statesmen he had painted, but he also returned to Whig themes he had illustrated in his banners for Harrison and Clay—rivers, commerce, manufacturing, arts and sciences. Nonetheless, he went beyond unity through economic progress to a defense of the Union that transcended parties.

In his earlier Whig days, Bingham had abhorred the tyranny of a Jacksonian executive. Now, in 1860, he could laud that same president who had taken such a strong stand against secession during the nullification crisis of the 1830s. In the great crisis of slavery Jackson had become a national figure who had dared counter the threats of secession in the 1830s. Bingham turned to this national figure and chose to quote extensively from Jackson's farewell address: "'In order to maintain the Union unimpaired it is absolutely necessary that the laws passed by the constitutional authorities should be faithfully executed in every part of the country, and that every good citizen should at all times stand ready to put down, with the combined force of the nation, every attempt at unlawful resistance, under whatever pretext it may be made, or whatever shape it may assume.'" Cleverly, then, Bingham expressed his own views on the preservation of the Union through the words of the great hero of the Battle of New Orleans, the great Democrat whom many Democrats in the General Assembly had idolized. After lauding Jackson, Bingham went on to deliver his own personal views on secession, disunion, and the current situation in South Carolina.

Not surprisingly, given Bingham's clever and calculated use of Jackson's own words, the presentation of the portraits turned into a vituperative partisan fray, according to the press: "Everything would have passed off pleasantly had it not been for an act of indiscretion on the part of Mr. BINGHAM, who availed himself of the opportunity to make a violent coercion speech. The speech had the effect of arousing the angry feelings of nearly all those present, and at one time the excitement rose so high that serious consequences were apprehended."[56]

Lieutentant Governor Reynolds, not present for Bingham's speech, appeared later in the day to admonish the artist. And Bingham responded, taking the platform once more with apparently even more heated remarks. In his afternoon speech, his own angry views surfaced as he went on to discuss the illegality of secession and to accuse the lieutenant governor of treason. Returning to the Jackson Resolutions of 1848, fathered by the man who was governor at that very moment, he spoke of the partisan manipulations that had led to their passage and of the subsequent failure of state officials fully to represent the view stated in the countering Bingham Resolutions. Thirteen years after the defeat of his own resolutions, he still felt just as strongly about the importance of the Union, as he remembered with rancor the fact that the Democratic clerk had never published his own words as part of the permanent record of the government. At the end of his speech, foreseeing bitter and dangerous war, Bingham vowed that his devotion to peace would undoubtedly draw him into war if war came. What began as a simple dedication ceremony thus ended in political furor.

Once Bingham had explicated the portraits, they became vehicles of pro-Union sentiment. In the week that followed, there was angry debate in the senate about whether to accept and pay for them.[57] Aware of this controversy and understandably miffed by it, the artist began to think of taking the two pictures on tour for profit. So agitated was he by the entire sequence of events that he even considered making pro-Union speeches to accompany the exhibition of the pictures.[58] He was confident that their message would appeal to Union supporters. As he noted to Rollins, he could "take them to Springfield and then come in direct and favorable contact with Lincoln, and if I chose to part with them I would have no difficulty, I think, under present circumstances in selling them to the Legislature of his State."[59] Despite the furor, however, the bill to appropriate funds for Bingham finally passed the legislature on 16 January. Bingham then went ahead with his plans for exhibiting the works, obtaining permission to remove them under the pretense of having them framed.[60]

Even after the artist and the portraits had left Jefferson City, secessionist leaders continued to rail against them. When the governor approved payment to Bingham, he did so begrudgingly, affixing his signature to the terse sentence: "I have this day approved and signed a joint resolution to pay George C. Bingham for certain services."[61] There was no praise for his "faithful execution" like that extended to the first set of portraits, no mention of the names of Clay or of Jackson, the great foe of nullification. The lieutenant governor, more outspoken and more condescending, made his views known in the leading St. Louis paper:

'Traitors' to Lincoln's government will do him [Bingham] no harm. Hancock, Adams and the other 'traitors' of 1776 permitted the loyalist painter, Copley, to pursue his profession in Boston unmolested, and even patronized [him], during our war of the Revolution, and the 'Missouri artist' will certainly not receive less consideration from the 'rebels' of today than Lord Lyndhurst's Tory father received from those of the last century. But in order to facilitate this course, let him consider whether he should not begin in time to disclaim everything which looks to the contingency of his levying war against the State which has so liberally patronized him, or which even seems to be 'adhering to its *enemies,* giving *them* aid and *comfort.*'[62]

Bingham's conduct had clearly outraged Lieutenant Governor Reynolds who covertly threatened that state patronage might cease if the artist did not desist in his attacks on the secessionist policies Reynolds hoped the state would embrace. But Bingham's portraits by now were charged with pro-Union sentiment. Later in the month, in debates over Missouri's stand on the

pro-Union Crittenden Resolutions, state senators who favored secession continued to associate Bingham's portrait of Jackson with support for the Union, calling it "a burlesque and the laughing stock of the Legislature and the people of Missouri." [63]

Even before the General Assembly approved payment to the artist, Bingham took refuge in St. Louis, where pro-Union friends awaited him. "Mr. Bingham is no less wedded to his glorious art than he is to the Union," asserted the *Daily Missouri Republican,* welcoming him like a hero returned from battle.[64] Within a few weeks, he had the pictures in St. Louis, apparently determined to capitalize on their charged political meaning. In the western part of the state, Judge Thompson wrote his stinging critique of them and published it in *The Liberty Tribune,* perhaps attempting to block their exposition. But by early February the artist had them hung in the Small Hall of the Mercantile Library Association, where his portrait of von Humboldt resided.[65] The advertisement for the paintings left little doubt as to the political meaning of the two works. Under the bold banner of Jackson's own words, "The Union it *Must* be Preserved," the names of JACKSON and CLAY attracted attention to the exhibition of the portraits.[66] And they played a central role in the celebration of Washington's Birthday at the Mercantile Library.[67]

Bingham's decision to exhibit his pictures at the Mercantile Library in St. Louis must have flown in the face of his secessionist antagonists. Here was the artist-politician daring to place his works in a hall that had just hosted the National Union Convention to elect a Union slate for the state convention on the secession issue.[68] Less than a month later, on 4 March, the day of Lincoln's inauguration, the hall in the Mercantile Library became the setting for that state convention, which would decide in favor of the Union by the end of the month. It was fitting that Bingham's portraits should have graced the building where that decision was made later in March 1861.[69] The portraits eventually returned to the state house, sometime later in 1861, but the bitter memory of their meaning hung over them, casting a pall on Bingham's reputation as official portraitist for the state. Two years later, when the legislature voted another commission, they hesitated some time before bestowing it on the Missouri artist. But before that happened, the Civil War swept over the nation, the state, and the artist.

The Onset of the Civil War

"Art is far below every thing else in such times as these," lamented Bingham in June 1861, less than four months after he exhibited his portraits of Jackson and Clay in the Mercantile Library in St. Louis.[70] The brave words

that had advertised those paintings—"The Union it *Must* be Preserved"—
had propelled the nation into war. And Bingham saw his own state torn be-
tween secessionists and unionists whose minds were certainly on matters
other than art. Staunch supporter of the Union that he was, Bingham could
not simply watch the events unroll but soon became an active participant.
Eventually his first-hand experiences surfaced in the paintings he executed
soon after the war ended.

Events occurred rapidly in the spring of 1861 to catapult Missouri into
war, particularly in the months after Bingham exhibited his portraits in
St. Louis in February.[71] By the end of March the state convention, meeting in
the Mercantile Library Hall, had decided in favor of remaining in the Union,
undoubtedly to the displeasure of the secessionist governor, Claiborne Jack-
son. On 17 April, five days after the firing on Sumter, Jackson refused Presi-
dent Lincoln's request that he muster Missouri troops to serve the Union. In-
stead, two days later, he convened a special session of the General Assembly
to organize the state militia. By 6 May a military camp had opened near
St. Louis ostensibly to "attain greater efficiency in organization and military
drill."[72] But its name, Camp Jackson after the governor and the names of its
principal streets, Davis and Beauregard after major Confederate leaders,
raised doubts about the real purpose of the encampment. Were the state
troops about to seize the United States Arsenal at St. Louis in order to con-
trol the state? Captain Nathaniel Lyon of the United States Army, com-
mander of the arsenal, thought so, and he had for weeks been working to
remove arms from the arsenal.[73] On 10 May, he led United States troops to
seize Camp Jackson, assisted by Generals Frank P. Blair and Franz Sigel.
The surrender was peaceful, and some 800 troops, who chose not to take an
oath of loyalty to the Constitution, were made prisoners. On the march back
to St. Louis, some civilian casualties occurred when the crowd fired on the
United States troops. The war had begun in Missouri!

Reaction was immediate. Newspaper editors deplored Lyon's action and
the ensuing fatalities. Jackson, then in Jefferson City, fearing an attack by
United States troops, called an emergency session of the legislature after
ordering the demolition of a railroad bridge from St. Louis. A resolution pro-
testing Lyon's action passed unanimously and was sent to President Lincoln
and the governors of all the states.[74] Simultaneously with the emergency ses-
sion of the General Assembly, General Harney, commandant of the Depart-
ment of the West, issued statements assuring his intentions to keep peace
but at the same time approving the capture of Camp Jackson.[75] In the follow-
ing weeks, Harney and Lyon met with Claiborne Jackson and Sterling Price,
the commander of the state militia, in a futile attempt to maintain peace. By
the middle of June, Lyon had mustered troops to take possession of Jeffer-

son City, from which Claiborne Jackson and other legislators fled.[76] By the end of July, the state convention declared the chief offices of state vacant and chose Hamilton Gamble as governor, Willard Hall as lieutenant governor, and Mordecai Oliver as secretary of state.[77]

Bingham followed all these developments with avid interest from Kansas City, where he had moved to be near his in-laws. He apparently felt that the seizure of Camp Jackson was justified: "The developments which immediately followed the surrender of Camp Jackson in the shape of stolen munitions, allied with the significant names by which the avenues of the camp were designated, can leave no doubt upon any mind of the damnable treachery of our Governor and his infamous satelites."[78] Though Bingham deplored the fatalities that occurred after the camp's seizure, he blamed them on "the arch plotters who, secure in their closets, have incited this groundless rebellion." Harney's intention to keep the peace reassured the artist, indeed confirmed him in his views about the "wisdom and practicability of Coercion. [Harney's] emphatic declaration that 'the *Supreme Law* shall be enforced' has the ring of old Hickory in it, and the general belief that he may be drawn upon for what he promises operates as an amasing quietus upon the frothy agitators who are so constantly spilling the last drop of their blood rather than succumb to the constitutional rule of their country. The fact is governments are for purposes of coercion alone, those who are willing to do right need no laws to impel them to the performance of duty."[79] Early in June, however, Bingham was not so optimistic about the peace that Harney would bring. Alarmed that secessionists were amassing arms in his part of the state and even preparing to open a munitions factory, he wrote to warn Gen. Frank Blair in St. Louis.[80] He also informed Rollins, then congressman-elect, of the problem and went on to say that he would willingly head a company of volunteers, if it were permitted.[81] "Poor Claib and poor Price! their career began in honor, but prosecuted in hypocracy, has at length terminated in infamy!" lamented Bingham in another letter to Rollins.[82] By this time Jackson had fled the capital and was effectively powerless, though he continued to act as a governor in exile.[83]

By the end of June, Bingham was named captain of Company C in Colonel Van Horn's Battalion in Kansas City. Guided by loyalty to his country in entering the military, he nonetheless felt ill-suited for the career and beseeched Rollins to procure a consulship for him as soon as possible.[84] By the beginning of the next year, Bingham had taken another job, but not abroad as a consul.

Instead he was actively involved once more in the state government. Early in January 1862, Governor Hamilton Gamble named him state treasurer, an "appointee . . . known to the whole State as a man of spotless repu-

tation."[85] Bingham replaced A. W. Morrison, who had refused to take the loyalty oath instituted in December 1861. In office until 1865, Bingham was an insider when the next governmental commission for a portrait arose in 1863.

Portrait of General Lyon, 1863–1867

As 1863 began, the provisional government was running relatively smoothly. Both St. Louisans and lawmakers in the central part of the state were clear in their support of the Union, over against the staunch and still numerous advocates of the Confederacy in the western and southwestern regions. Just as the officers of the provisional government were loyal to the Union, so too was the General Assembly. However, the lawmakers were grappling with the issue of when and how to emancipate the slaves. The major issue of the election of 1862 had been emancipation, and the voters of the state had made clear their approval of some form thereof. The Radicals who favored immediate emancipation had swept St. Louis, but the central part of the state remained more conservative, favoring gradual emancipation. That division characterized the General Assembly. The lawmakers found it next to impossible to reach a decision on the election of senators. And though legislators agreed on the need for federal financial assistance to carry out emancipation in the state, they could not agree on how it would be effected. The legislative session was at a stalemate.[86]

Just as it had done when faced with the impossibility of electing a senator in 1855, the General Assembly in 1863 decided it *could* unite on another issue. Though they could not agree on how to achieve emancipation or on the election of two senators, they did agree on the necessity of ending slavery in some way and on the importance of the Union. The legislators felt that the time was apt to honor those who had promoted the Union cause, an extraordinary move in a state still torn by civil war.

In January, the house moved to honor the memory of General Nathaniel Lyon, now considered the hero of Camp Jackson, who had fallen at the battle of Wilson's Creek in August 1861. The reaction of outrage that had immediately followed the taking of Camp Jackson had turned to pride, as the subsequent history of the war had demonstrated the rightness of Lyon's action. There was a plan afoot in the senate to create a new county named for the general. A joint session of the General Assembly was to hear a eulogy of Lyon.[87] And, on 23 January, a special committee of the house presented a resolution "that the Secretary of State be authorized to contract with an artist of established reputation for an equestrian portrait of General Lyon, similar to the portrait of General Jackson in the senate chamber, at a cost of

55 Gen. Nathaniel Lyon *by Bingham and* Thomas Hart Benton *by an unknown artist, House Chamber, Capitol, Jefferson City, ca. 1900. Destroyed by fire. (Photo: State Historical Society of Missouri, Columbia)*

a sum not exceeding $2,500." [88] Perhaps because of wartime stringencies, the General Assembly insisted that the fee be collected by subscriptions, some to come from the legislators themselves.

The bill eventually passed both house and senate, but not without considerable debate. As soon as the resolution was on the floor, Bingham's friends in the house put his name forth as the artist, noting that "his services, in behalf of his country, well entitled him to the appointment." [89] But opposition was immediate and vicious, calling Bingham "a botch of an artist" and classifying his paintings as "an insult to the State" and "daubs placed in the Capitol." When the bill finally passed, it named no specific artist but instructed the secretary of state "to award the contract . . . to the artist exhibiting the highest merit." [90]

Behind the General Assembly's refusal to write Bingham's name into the bill was ferocious political opposition. The Radical faction in the General Assembly that favored immediate emancipation opposed selecting Bingham and carried enough weight that they were able to prevent it. Bingham remained notably silent on the issue, but his wife did not. [91] Eliza Bingham de-

scribed her husband's opponents as "radicals" who were angry at her husband's "expose of Jennison and his misdoings in this state."[92] She referred, of course, to Bingham's attack the preceding year on a Union colonel, notorious for his injust disregard of human life and property. Stationed in Kansas, Charles Jennison had led numerous raids into Missouri to attack Confederate sympathizers there. Writing from the state treasurer's office, Bingham had assembled evidence which he published in local newspapers and distributed in pamphlet form to members of Congress in Washington in an effort to have Jennison removed from his position. Whether because of Bingham's efforts or not, Jennison was transferred away from Kansas.

The Radicals in the General Assembly apparently took Bingham's attack on Jennison as an assault on a Union officer who had done his best to wage war against the proslavery south. They may have interpreted this stance as a proslavery position, though Bingham's anger had been motivated by the injustices perpetrated on civilians by the military. In fact Bingham advocated emancipation, but he was not ready to move as rapidly as the Radicals wanted. He feared that their ardor might well drive more conservative thinkers from the state. Favoring gradual emancipation, Bingham felt the Radicals' demand for "immediate liberation" might "render Emancipation upon any proper plan impossible, and thus perpetuate slavery in our State for all time."[93] Some wind of his views on the issue may well have reached the ears of the Radicals, and they marshaled to prevent Bingham's obtaining the commission for Lyon's portrait.

The arguments mounted against Bingham, however, attacked his work as an artist and did not mention his views on emancipation. "Assail [Bingham's] reputation as a man they cannot," wrote Bingham's wife, "but they think doubtless to do him infinite harm by their criticisms of him as an artist and would literally pick his works to pieces with their hands if they had the power, as they think they now do with their tongues—A bill has been introduced here this winter to give Mr. Bingham another picture to paint, but he will not get it if the radicals can keep him from it."[94] In spite of the fact that some of the quarrel reported by the press was between central Missourians for Bingham and St. Louisans against, the artist's wife was convinced that the Radicals wanted to prevent her husband from obtaining the commission.

The story of the commission, however, hints at an interesting artistic competition of which only the barest outlines can be sketched. One part of the story has to do with the funding of the portrait, accomplished almost entirely through subscriptions made by the legislators themselves and by an apparently sizable group of St. Louisans.[95] The other part of the story concerns a competition among artists for the commission. Mordecai Oliver, secretary of state, pursued both goals in St. Louis, arriving there late in May just

a few weeks after a gala celebration of the second anniversary of Lyon's seizure of Camp Jackson. The *Daily Missouri Republican* announced that he was there not only to garner subscriptions for the portrait but also to invite all interested artists to deposit their work in the Mercantile Library Hall.[96]

Since Lyon's death, there had been considerable interest in representations of the general. Already in the house debate, two names of artists had been put forth—Ferdinand Boyle and Theodore Kauffmann, both of St. Louis. Kauffmann had been so bold as to propose to the house that he paint a historical work, the *Death of General Lyon,* for the same price and of the same size as mentioned in the resolution.[97] These two artists were undoubtedly interested in the commission. But so were others. Soon after Oliver's arrival in St. Louis, Spore's Emporium exhibited a large painting of *The Death of General Lyon* by Levin and Mulligan, photographs of which were published and sold by Pettes and Leathe.[98] At the end of July, Oliver returned to St. Louis to award the commission on the basis of works displayed at the Mercantile Library and in the art store of Pettes and Leathe.[99]

Unfortunately the *Republican* did not carry any further account of the competition, so one can only surmise what works were on display. Levin and Mulligan's *Death of General Lyon* must have been one of the entries. Boyle and Kauffmann probably also competed. But who were the others? Bingham, well represented in the Mercantile Library by his portraits of Von Humboldt and the Washingtons and by his election series and his *Jolly Flatboatmen in Port* of 1857, may have been too busy to add another painting. But, if he did, might it not have been the small study showing Lyon setting forth from St. Louis with Frank Blair to capture Camp Jackson?[100] An attempt at history painting, this double equestrian portrait seems to have been closely modeled on Charles Wimar's painting of Sigel, Fremont, and Blandowski, as Bloch has suggested.[101] Both presented the pair of heroes turned out to face the viewer as they sat stiffly erect on steeds of contrasting colors. In the small work, Bingham's portrait of Lyon bore a strong resemblance to G. E. Perine's half-length portrait of the general, published widely by 1862.[102] Whether Oliver was persuaded by the works displayed or by his close working relationship with the artist in Jefferson City, he awarded Bingham the contract on 1 August 1863.[103]

Apparently overwhelmed by duties of state, Bingham did not turn to this commission until two years later, toward the end of 1865 when he left the treasurer's office. Then in November he presented to the General Assembly the photograph of a small study of the portrait.[104] The final version was finished and installed in the senate chamber by late February 1867. Even though the secretary of state, Francis Rodman, tried to obtain an additional $2,500 for Bingham, with Rollins helping as usual, the General Assembly ap

56 Gen Nathaniel Lyon, *1867, oil on canvas. Destroyed by fire, originally in Capitol, Jefferson City. (Photo: State Historical Society of Missouri, Columbia)*

proved only an appropriation to bring the sum collected in subscriptions up to $3,000.[105]

As with the portraits of Jefferson and Clay, all that remains of the Lyon portrait is a photograph (figs. 55, 56) and brief descriptions in the press. The general, mounted on a light-colored horse, turned to face the spectator, waving his hat, as Bingham's Jackson had done. Situated apparently on high ground, Lyon's bold silhouette and the almost exaggerated curves of the horse's neck, rump, and tail stood out against a misty background. The horse was not rearing but had been reined in. Bingham may well have chosen to represent the hero at the Battle of Wilson's Creek, just moments before his death, as the *Liberty Tribune* suggested.[106] Indeed the picture coincided

with an account of the battle, based on official reports, that William Switzler later wrote. In the disarray and confusion at the outset of the encounter, Lyon was hit as he tried to rally troops. Wounded in the leg, his horse shot out from under him, he nonetheless took another horse, "which he mounted, and, swinging his hat in the air, called to the troops nearest him to follow." [107] This was how an illustrator for *Harper's Weekly* portrayed Lyon in his final battle, and Bingham may well have known the woodcut.[108] Lyon's pause on horseback, his bold gesture, the smoky background, even the hint of a creek or river between the horse's legs—all could allude to this moment though the artist may simply have wanted to show the general in a pose common to one leading a charge.

 Once again Bingham had to undertake an equestrian portrait. Since the legislative resolution called for a work similar to the portrait of Jackson, Bingham cannot have failed to remember his earlier work. But, given his interest in variation and contrast, he changed the second one. In Lyon's portrait there was no flashy cloak, no hint at a rise in the ground—features present in Jackson's portrait. Bingham must have considered other sources as well. The Perine portrait of Lyon almost certainly provided the general's features and may well have inspired the near frontal presentation. The *Harper's* illustration may well have inspired the outflung arm and hat, as well as the reined-in head of the horse. And any number of models could have influenced the somewhat awkward posture of the horse—with one foreleg planted, the other bent high, and two back legs exaggeratedly bent. The photograph does not allow further comment. One can conclude, however, that Bingham seemed more at ease, more in control of the full-length standing portrait, a type with which he had had some experience earlier in life. The three full-length portraits he had painted for the legislature—Washington, Jefferson, and Clay—seem less forced, less stylized, less awkwardly handled than the equestrian portrait where the artist's admitted difficulties with equine anatomy were all too evident.

When Bingham finally realized the dream of his life and obtained commissions from the government, he created traditional official portraits. The four great statesmen embodied American patriotic values. Just as the choice of which heroes to present was predictable—Federalist and Democrat, Democrat and Whig—so too was the form Bingham used. His full-length images of Washington, Jefferson, and Clay allied comfortably with those by Gilbert Stuart, John Vanderlyn, and others on the east coast. And his equestrian portrait of Lyon (and probably also the one of Jackson) also followed tradition, even if somewhat awkwardly. Iconographically, as well as formally, the portraits presented no innovations.

Bingham, however, certainly used the portraits of Clay and Jackson to carry quite specific political messages, and he may have felt this about all of the portraits. By the time his Washington and Jefferson were installed in 1859, they stood not only as founding fathers. Hung with the Farewell Address and the Declaration of Independence presented nearby, they also were advocates of union. They acted in a way somewhat similar to the undertaking of the Washington monument and the preservation of Mount Vernon in that period. All were patriotic endeavors designed to inspire loyalty and to pull the whole nation together. But by the time Bingham completed his Jackson and Clay, early in 1861, he went beyond a general message of patriotic unity. As explicated in his speeches, the portraits spoke vividly of the importance of avoiding secession, of supporting the Union, of overcoming partisan feelings to preserve the nation. In the state capitol at Jefferson City and on tour in St. Louis, the message in Jackson's own words—"The Union it *Must* Be Preserved!"—boomed forth from them, particularly from the equestrian portrait. Lyon's portrait too carried meanings beyond the obvious eulogy of a military hero. Commissioned when the state was still riven by civil war, the portrait symbolized the provisional government's loyalty to the Union. By the time the portrait was installed in 1867, the rightness of that loyalty had been clearly demonstrated and the portrait thus was less electrically charged. Nonetheless, Lyon also epitomized the military leader true to his calling, bravely charging ahead on a smoke-filled battlefield to defend a just cause. In Bingham's depiction, he was quite a different type from the anti-heroes of the war, the Union generals who had pillaged and burned, who had hated and disregarded human life and property, who had been and were to be the targets of the artist's pen, brush, and engraver's burin.

7

Bingham and Liberty
Order Number 11

GENERAL ORDERS *No. 11*

*Head Quarters District of the Border,
Kansas City, Mo., August 25, 1863
I. All persons living in Jackson, Cass
and Bates Counties, Missouri, and in
that part of Vernon included in this
District, . . . are hereby ordered to
remove from their present places of
residence within fifteen days from the
date hereof.*

*Those who, within that time, establish
their loyalty to the satisfaction of the
commanding officer of the military
station nearest their present places of
residence . . . will be permitted to
remove to any military station in this
District, or to any part of the State of
Kansas except the Counties on the
eastern border of the State. All others
shall remove out of this District.
Officers commanding companies and
detachments serving in the counties
named will see that this Paragraph is
promptly obeyed.*

*II. All grain and hay in the field or under
shelter, in the districts from which the
inhabitants are required to remove,
within reach of military stations . . . will
be taken to such stations and turned over
to the proper officers there. . . . All grain
and hay . . . not convenient to such
stations, will be destroyed. . . .*

By order of Brig. General EWING

When Bingham presented his portraits of Jackson and Clay to the Missouri General Assembly in January 1861, he summarized his own political philosophy even as he foretold the wreckage of the future. In that speech the artist-politician reflected on political issues closest to him throughout his life—the preservation of the Union, the responsibility of government to reflect the will of the people, the protection of life, liberty and property, and the encouragement of development. As he recapitulated ideals dear to him in the past, he presciently foresaw the civil war that would threaten those ideals.

Toward the end of his speech Bingham conjured up a nightmarish vision of death and destruction.

> I live within three-quarters of a mile of the extreme border of our State. Bombs from an enemy in Kansas can demolish my dwelling, and in half an hour's time, made a waste of all the property I own in the world.
>
> As the war which must follow dissolution will be waged in my peculiar locality with all that rancorous hate which years of crimination and re-crimination have necessarily produced, I shall be forced to participate in it, devoted, as I am to the pursuits of peace, or ingloriously desert my country in the hour of her peril. My property will be destroyed, my life may be sacrificed, my wife become a widow and my children orphans.[1]

Living as he did on the border in Independence, Bingham foresaw personal tragedy. He envisioned his own death, the destruction of his property, the dissolution of his family. In Bingham's eyes, the revolution had been fought to guarantee life, liberty, and property. Civil war would take all that away. In his speech Bingham, like some far-sighted prophet, uncannily suggested that the time for abstract debate on the issues was ending, that war was literally about to come home to him.

This was not the first time that Bingham had had premonitions of what war might bring. The passage of the Kansas-Nebraska Bill in 1854 for him conjured up a vision of "a storm . . . now brewing in the north which will sweep onward with a fury, which no human force can withstand."[2] As the consequences of that bill worked themselves out in Kansas, Bingham witnessed first-hand the ravages of the Border Wars. Having hoped for a peaceful resolution at the polls, he was appalled at the travesty of the election process that those wars had brought, and he thought for some time of recording the whole sordid episode in his *March of the 'Border Ruffians.'* Fearing war, yet ever naively believing in the political process, he continued to think that war might be avoided. At the dawn of the 1860s he made an impassioned case for the Union before the state legislators who were to decide

whether Missouri would secede or not. Though the state remained in the Union, the conflict he had foreseen erupted.

Within a few months of Bingham's speech before the General Assembly, a war within a war broke out.[3] From the spring of 1861 on, the border areas of Kansas and Missouri virtually sizzled with turmoil, fueled by memories of the ferocious Border Wars between proslavery Missourians and pro-Union Kansans. War gave the Kansans official uniforms and titles. Soon Union troops led by former Kansas raiders, now known as Jayhawkers or Redlegs, spilled over the border to attack secessionists in Missouri. So outrageous was their conduct that it "'turned against us many thousands who were formerly Union men,'"[4] as the military commander of Missouri, General Halleck, reported to Washington. Swiftly, retaliatory forces marshaled in Missouri under the leadership of William Quantrill and William Anderson. Harrying and attacking Union troops, these irregular guerrillas also burnt bridges, ambushed trains, and disrupted steamboat traffic on the Missouri. Elusive as the wind, they defied any attempts to put them down and escaped the counterattacks of frustrated Union officers from Kansas.

From the first Bingham witnessed the early actions of the Kansas Jayhawkers. As soon as war came, Bingham joined the Union cause as he had predicted he would. By the end of June 1861, he was captain of Company C in the Battalion organized under Major Robert T. Van Horn, then mayor of Kansas City.[5] Within weeks, he saw action. But he was dismayed at the depredations of Kansans against Missourians. Particularly shocking to Bingham was the virulent plundering undertaken by Captain Charles Jennison and his Jayhawkers, whom Major Van Horn employed as an advance guard on an expedition against secessionist troops in Harrisonville.[6] Jennison had been chief among the raiders of the Border Wars and now "cloaked with the implied or actual authority of the United States," his plundering and looting went on, as if sanctioned by the federal government.[7] It was this rampage that Bingham witnessed in the summer and indeed throughout 1861.

Early in 1862, when Bingham joined the provisional government in Jefferson City as state treasurer, he found Missouri's leaders already stirred up about Jennison's actions.[8] Governor Hamilton Gamble had written an indignant letter of protest to General Halleck, then in command of the Department of Missouri. Rollins, in Washington as a member of Congress, had been in touch with Secretary of War Stanton. He had also apparently asked his friend Bingham for an eyewitness account of Jennison's misdoings.

Indeed, the first letter Bingham sent to Rollins in Washington from the state treasurer's office dealt with the matter.[9] Though Bingham had "not yet had time to comply with your request in reference to an expose of Jennison," he detailed for his friend some of the brutality he had witnessed. Almost

shamefacedly he confessed that he could no longer make excuses that the
state government was unaware of Jennison's actions. He urged a prompt trial
and punishment, saying "it would do more for the Union cause in the west-
ern portion of our State than the presence of a Union army. It would be *right*
as a matter of Justice to the scoundrel, and an economical aid in weakening
and destroying rebellion." He encouraged Rollins to urge Congress to form
an investigating committee. Within three weeks he forwarded a full account
of Jennison's horrors, giving Rollins permission to have it published in some
eastern newspaper.[10]

Three months later in May 1862, this account became the basis of a
three-columned letter to the editor of the *Daily Missouri Republican*.[11] Re-
futing an article praising Jennison in the *Democrat,* Bingham recounted in
great detail the horrors that officer had visited on the western part of the
state. The account bristled with his personal experiences. He began with the
raid on Harrisonville in June 1861, which he felt "inaugurated that infernal
system of predatory warfare which has since desolated the fairest portion of
our State." On that occasion, troops "were permitted to invade the sanctity
of private dwellings, and to break open the stores of the merchants of the
place, whose goods they transported in large quantities, to the State of Kan-
sas." After Jennison's commission as a Union officer in September 1861, Bing-
ham alleged, he "turned his attention exclusively to rapine and arson." In
Independence, the artist chronicled two murders and robberies of such
items as watches, jewelry, silk dresses, and quilts. Jennison's men had even
threatened him—"On a subsequent occasion, one of his rascals twice pre-
sented a pistol at my own breast." Maintaining that Jennison had been the
"most deadly, as well as the most treacherous foe" of the Union cause, Bing-
ham publically urged a prompt trial.

In an important section of his exposé, Bingham met in advance the criti-
cism he felt would come his way. After all he was a man who had served in
the Union army and who was presently part of the Constitutional Union gov-
ernment of the state. What business had such a man in attacking an officer
of the Union? In order to avoid the casual dismissal of his inflammatory let-
ter, Bingham summed up his position on the whole issue:

> I have no old prejudice against this man. It is well known that I
> warmly sympathized with the people of Kansas, against citizens of my
> own State, in the "border ruffian" warfare of '56. Nor can it be affirmed
> that I am an ultra pro-slavery man, since I have all my life held to the
> principles of our old Whig leader upon this vexed question. My position
> in relation to the Rebellion is equally well known. I foresaw its approach
> for years, and denounced those who were wickedly conspiring to bring

it upon our country. When at length it came I was not found occupying a neutral position between it and my Government, but prompted alike by my feelings and judgment, I united with my few neighbors, alike loyal to the old flag, and took up arms in its defense.[12]

In this statement he asserted that his attack on Jennison was not personal but based on larger matters of principle. He reminded his readers of views he had long made public. During the crisis of the Border Wars he had decried the insult to the electoral process wreaked by Missourians and had supported the people of Kansas. He had stated on many occasions his view that Kansas should enter the Union as a free state. He had published a series of articles asserting that slavery was wrong and should be ended, as Henry Clay wanted, through gradual emancipation. And as the specter of conflict drew nearer, he had spoken out against war but had asserted that if it came, loyal citizens should serve and serve honorably, as he had done. Jennison's acts had gone beyond propriety. For Bingham the horrors of war must not take precedence over the preservation of civilian rights.

Not content with simply airing his views in St. Louis, he published them in a pamphlet which he distributed to the president, the cabinet, and every member of Congress.[13] Later in the spring of 1862, Jennison was arrested and removed from the western border. But still the conflict raged in that part of the state. William Quantrill, chief of the pro-Confederate Missourian irregular forces, kept up a relentless series of border raids into Kansas, which the Jayhawkers answered. Military leaders like General Ben Loan, commander of the Northwest Military District of Missouri, called for martial law. By June 1863 Bingham was convinced that, in addition to encouraging the Kansans' retaliatory raids, Loan intended to organize a group to "overthrow . . . our provisional government."[14] Bingham's letter warning Gamble of the supposed plot made clear his firm belief that civilian government was preferable to arbitrary martial law.

The unruly situation in Missouri, however, called for firm action of some sort.[15] The government Bingham served as treasurer was a provisional one, appointed by a state convention, not elected. He and his fellow officers ran the state as best they could from Jefferson City, but they lacked any authority over the Union officers who supervised the various districts of the state. The governor did claim authority over the two branches of the state militia that helped control the guerrillas. But neither the Gamble government nor the Union commanders found much success in reining in Quantrill, Anderson, and their irregular guerrillas. By the spring of 1863 their activities were so uncontrolled that General Schofield, the Union commander of Missouri, created two new military districts in the western part of the state.

Over one of these—the District of the Border—he placed a brigadier general named Thomas Ewing.

Ewing, brother-in-law of William Sherman and one-time chief justice of the supreme court of Kansas, had lived through the Border Wars and seemed determined to put down the guerrilla forces by any means he could. Recognizing that these irregulars needed support at home, Ewing decided to go after their women. From April to August he rounded up their wives, mothers, and sisters, detaining them on charges of sheltering and abetting guerrillas. Unable to confine all his prisoners in official jails, Ewing commandeered houses from the local citizenry. In one of these he locked up eleven women, including two sisters of Bloody Bill Anderson, Quantrill's right-hand man. Within days the building collapsed. When the rubble was cleared away, five women were dead, and most of the rest were injured. Two notices on the back pages of the Kansas City newspaper tersely recounted the episode and simply noted that the building belonged to George Caleb Bingham.[16]

Little did the reporters realize what calamities the collapse of the building would bring. These women had been rounded up in a desperate Union attempt to discourage marauding guerrilla raids by their brothers, sons, and husbands. Ironically the tragedy that befell them did nothing but encourage the most vicious of the guerrillas' retaliatory attacks at Lawrence, Kansas. And the Lawrence Massacre in turn provoked the harshest of Union military laws, Order No. 11, which led to the depopulation of the border areas between Missouri and Kansas.

Bingham was outraged at the whole sorry incident in Kansas City. That it was his own building that had crushed the women made his indignation about military atrocities take on a deeper, personal meaning. His was an individual rancor buoyed by larger principles. When Ewing transformed the artist's studio into a prison, he did so without informing the owner, according to Mattie Lykins, who later became Bingham's third wife.[17] To make matters worse, Lykins asserted, Union troops had apparently altered the structure of the building and thus had weakened it to such an extent that there had been premonitions of its collapse, allowing the Union guards to escape uninjured. The whole episode seemed confirmation of the evils of martial rule. There was the arbitrary seizure of property, unrestrained damage to that property, and then the uncalled-for death of innocent civilians.

Though Bingham's response did not come immediately, official reaction was swift, as the authorities tried to sort out responsibility for the disaster. Within three days, Ewing, undaunted by the tragedy, promulgated Order No. 10, which expelled the wives and children of known guerrillas from his district.[18] In response, the guerrillas promised retaliation, flamed into a fury

as they were by Bill Anderson, whose sisters had been prisoners inside the collapsed building. Within a week, Quantrill and Anderson organized what later became known as the Lawrence Massacre, an attack on the longtime center of Free Staters in Kansas and home to Senator Jim Lane. Killing, burning, and looting from dawn to nine in the morning, the guerrillas left Lawrence with 185 buildings destroyed and more than 150 men dead. Senator Lane saved himself but could not protect his house, which was looted and burned. Not one of the raiders suffered injury.[19] Mrs. Lykins, visiting in Lawrence at the time, witnessed the pillaging and saw a neighbor killed before her eyes. She ended her eyewitness account of these events with an unequivocal statement: "we are forced to the conclusion that beyond a doubt the falling of the building in which the wives and sisters of some of Quantrells' men were incarcerated, led to the Lawrence Massacre."[20] Indeed, as the guerrillas marauded, their cries made clear their motives: "'*Remember the murdered women of Kansas City!*'"[21]

So evil begat evil, as both sides remembered the women of Kansas City. The local and national press raised an outcry, publishing images of the raid that recalled paintings of the Rape of the Sabines or the Massacre of the Innocents (figs. 62, 63).[22] Angry Kansans, responding to the cries of Jim Lane, demanded an invasion of Missouri. Pro-Union Missourians angrily accused Hamilton Gamble of aiding the guerrillas.

On 25 August, just four days after the Lawrence Massacre, the by then desperate Ewing took a final and extreme step: he ordered the depopulation of the entire border area under his command. His Order No. 11 was unforgiving.[23] It called for the immediate dispersal of all citizens living beyond a one mile radius of Union military posts in the border counties—Jackson, Cass, Bates, and half of Vernon. It promised confiscation or destruction of all hay or grain left standing after fifteen days. An exodus began, with elderly men, women, and children forced to leave their homes. The Union troops enforcing the order felt no remorse in looting the empty houses, nor did they flinch when the fires they set to crops spread to the vacated dwellings. Within two weeks the area was a desolate ruin, isolated smoking chimneys the only reminder of the population that had once lived there.

This scenario, recalling so vividly the raids by Jennison that Bingham himself had witnessed, finally prompted the artist to act. He joined his voice to those demanding that the order be rescinded, among them Lt. Gov. Willard Hall, who discussed the matter in person with General Schofield.[24] Bingham himself went to Kansas City, "having been drawn thither by the hope that I would be able to have it [the order] rescinded or at least modified."[25] But whether he actually interviewed Schofield or Ewing about the matter, as so many authors assert, remains undocumented.

What is clear is that Bingham did contact Ewing in the fall of 1863 about his own destroyed house, but the substance of the discussion seems to have been reparations. Confiding in his friend Rollins in December 1863, he wrote:

> I will be glad if you can inform me as to the probability of our getting pay for the building ocupied by order of Gen Ewing as a prison, and destroyed while thus ocupied, by the act of his soldiers in removing columns which caused it to fall.
>
> I have the affidavits of good intelligent and Loyal citizens clearly establishing the fact, but Gen Ewing would only Certify that the building was ocupied as a military prison by his order, and while thus ocupied fell.
>
> Had I been a Kansas horse thief he would have certified to all the facts, *proof of which I laid before him* [emphasis added], or he would have ordered his Quarter master to pay me, but he was not capable of doing justice to an honest Missourian. He certainly excels in meanness all his Kansas predecessors.[26]

If he pled with Ewing for recompense, he gave no indication elsewhere in his writings that he begged either Ewing or General Schofield to rescind Order No. 11. In fact, there is only one source for such a meeting between Bingham and Schofield, published in a newspaper some fourteen years after the event. Dramatically, the reporter recounted the confrontation between the two men, ending with the artist's heated promise: "'If God spares my life, with pen and pencil, I will make this order infamous in history.'"[27] Writing in 1877, the Kansas City newspaperman had the advantage of hindsight. He knew that Bingham had devoted years of his life to painting the scene no less than two times, to diffusing it through engravings, to vindicating his work in newspapers and pamphlets. Yet the reporter did not fully understand that the artist was motivated by more than just moral outrage at the failure of government to protect its citizens' rights. Beneath Bingham's pique lay an intensely personal reaction, a bitter resentment that Ewing had confiscated his own house, but more to the point, that the collapse of that house had killed innocent women and had led to the Lawrence Massacre and then on to the disastrous consequences of Order No. 11 in the western part of the state. Yet, however great his animus toward Ewing, Bingham did not turn immediately to canvas. It was two years before he undertook his history painting.

The Painting

As outraged as Bingham was at the events in western Missouri, he could not spill his anger immediately onto canvas. State finances demanded his at-

tention as state treasurer in Jefferson City until the end of the war. Only late
in 1865 did he return to his studio in Independence and begin once more to
paint. One of the works on his mind was the portrait of General Lyon, for
which he had received a contract in August 1863 (fig. 56). Ever mindful of his
responsibilities he began work on that commission. But his contractual obli-
gation could not blot out the memory of Order No. 11. As he started the Lyon
portrait, he also undertook a painting of the hated order (fig. 57).[28] Through
the next year he must have worked on the two large canvases side by side,
dividing his time between a hero and a villain of the Union Army. By Febru-
ary 1867 he had finished the Lyon portrait, and sometime before the end of
1868 he completed the other work.[29]

If the story of the Lyon portrait came to an end with its installation in
the state house in February 1867, the saga of *Order No. 11* only began when
the artist applied his finishing touches. In 1869, Bingham set about publiciz-
ing his work by sending photographs of it to various newspapers in the state.
At the same time he decided to have the work engraved (fig. 64) by John
Sartain in Philadelphia, to whom he sent a photograph and some studies.[30]
By the following spring, he had executed a second painting (fig. 58) to exhibit
as he tried to drum up subscriptions for the print.[31] The first version, on
strips of canvas laid on wood, remained in the artist's collection until his
death and is now in the Cincinnati Art Museum (fig. 57). The second version,
painted on a tablecloth, went to Rollins and Col. R. B. Price, in exchange
for their subsidy of the engraving. It descended in Rollins' family until it
was sold to the State Historical Society of Missouri, Columbia, where it
now hangs.

The work has had several titles, all of them engendered by the sweeping
one Bingham registered when he copyrighted the painting late in 1869:
"Civil War: as realised in the Desolation of Border Counties of Missouri dur-
ing the operation of 'General Order No. 11,' issued by Brigadier General
Ewing, from his Head Quarters, Kansas City, August 25, 1863."[32] When Bing-
ham first sent out photographs to the press in the summer of 1869, his title
was *Civil War,* though some of the newspapers insistently used the title
Order No. 11.[33] Two years later the artist called the painting *The War of
Desolation* in his published vindication of the work.[34] In 1872, however, at
Rollins' suggestion, he changed the title of the print to *Martial Law,* perhaps
because the earlier titles seemed too general.[35] Nonetheless, despite the
broad intentions of these early titles, the work was best known as *Order
No. 11,* a designation that was widely diffused in Bingham's lifetime.[36]

An even more apt title might be *The Effects of Order No. 11,* for the
painting presents a scene of eviction and exodus on the Missouri border just
twenty-three miles from Lexington. Highlit in the foreground is a stark con-

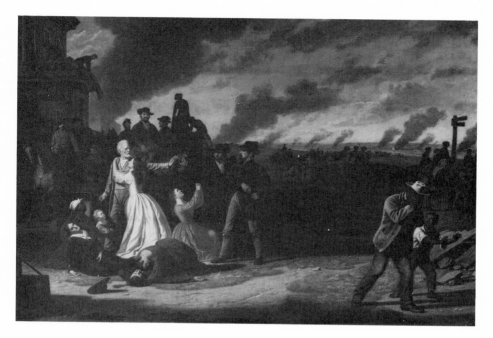

57 Martial Law *or* Order No 11 *(1), 1865–68, oil on canvas, 55½ × 77½ in. Cincinnati Art Museum, Cincinnati. The Edwin and Virginia Irwin Memorial.*

58 Martial Law *or* Order No. 11 *(2), ca. 1869–70, oil on linen, 56 × 78 in. State Historical Society of Missouri, Columbia.*

frontation between a Union officer intent on enforcing the order and a venerable Missourian adamant in his protest. Bingham's narrative intent is clear in the dramatic lighting and bold gestures he used. A handbill circulated at the exhibition of the painting summarized the drama taking place.

> The principal group in the foreground of the picture, chiefly consists of a venerable patriarch and his family, who have just been ejected from their dwelling, which is about to be committed to the flames.
>
> A daughter clings to the defiant form of the old man, imploring him to temper his language so as not to incur the vengeance of the brutal assassin, who, in the act of drawing a pistol, threatens him in front. Another daughter is on her knees before this wretch, vainly endeavoring to awaken some emotion of humanity in his callous breast. A married son lies weltering in his blood, his young wife bending in agony over his lifeless body. His murderer is seen in the scowling ruffian near by with a discharged pistol in his hand. The aged mother has fallen in a swoon, and is supported in the arms of a faithful negro woman. A negro man retires weeping from the scene, accompanied by a negro lad, whose face bears the unmistakable marks of fright and horror.
>
> Immediately in the rear of the outraged family the mirmidons of Kansas, aided by their criminal allies in Federal uniform, are busily engaged in the work of pillage.[37]

In thus describing the scene, the handbill made clear just what dramatic message Bingham intended the chief actors in his painting to convey. The family displaced from its home was an extended one that included the three blacks in the picture. Those who threatened and bullied them were the Kansas Jayhawkers, abetted by federal troops.

All the family would join the desolate train of women and children following the signpost to Lexington. That town, outside the counties designated for depopulation, was on the Missouri River. Bingham later wrote that he himself had witnessed the miserable plight of these dispossessed people. "Bare-footed and bare-headed women and children . . . were exposed to the heat of an August sun and compelled to struggle through the dust on foot. All their means of transportation had been seized by their spoilers, except an occasional dilapidated cart or an old superannuated horse. . . . They crowded by hundreds upon the banks of the Missouri river, and were indebted to the charity of benevolent steamboat captains for transportation to places of safety."[38] Bingham's specific mention of Lexington, then, called attention to the place his brutalized band would go to seek refuge and transport toward the central part of the state.

In the painting, Bingham also called upon his first-hand experience of even earlier outrages by Jennison and his Union troops. The defiant encounter between the patriarch and the Union officer about to draw his pistol recalls the moments when Bingham himself had had a pistol at his breast. The looting going on in the middle ground—of household furniture, quilts, paintings, and clocks—echoes the artist's eyewitness accounts of robberies by Jennison's men of "watches, jewelry, shawls . . . blankets, counterpanes, quilts &c" from innocent citizens.[39] And the entire background seems to illustrate the artist's testimony on Jennison's route west, "traced by the ruins of the dwellings of our citizens, which were first pillaged and then burned without discrimination or mercy . . . heaps of ashes, above which the tall chimneys remain in their mute solitude—sad and mournful monuments of the ever to be remembered march of a desolating fiend."[40] So compelling are these echoes of Bingham's earlier attack on Jennison that one may readily understand the artist's first inclination to entitle the work quite broadly and simply, *Civil War.*

Bingham constructed his work, tonally and compositionally, to heighten the drama. Light rakes across the scene from left to right, calling attention to the principal actors in the foreground. Not only does it reveal their gestures and expressions, it also brings out the bright colors in this area, notably the complementary reds and greens that play in the grass, the blood, and the dresses of the women. Bingham thus created a luminous proscenium where dramatic gestures stand out against a somewhat shadowy middle ground. There, figures in more somber tones either plunder or move into exile, some of them simple grey silhouettes against the sky.

If the light moves dramatically from left to right, so, too, does the composition. Before a wooden farmhouse that closes the scene on the left is a pyramidal mass of people, their heavy density descending to a broad expanse of landscape under an open sky. The patriarch's gesture cues a reading from left to right, supported by the direction of light, shadow, and drifting clouds of smoke, by the movement of the exiles, and by the very obvious signpost pointing to Lexington.

Barbara Groseclose's analysis of this painting rightly associated its lighting and melodramatic gestures, its shallow proscenium, and even its heavy-handed application of paint with romantic history painting Bingham had encountered in Düsseldorf, and she mentioned in particular Karl Hübner's *Weavers of Silesia.*[41] Acknowledging Bingham's connections with American traditions, she also drew parallels with the history painting of Benjamin West and John Trumbull, as well as with more nearly contemporary images. Her specific comparison with Confederate propagandist Adalbert Volck's

Valiant Men dat Fight mit der Siegel was telling and certainly suggested the kinds of images Bingham might have absorbed and used as he composed his painting.

Yet, as important as these precedents were, Bingham cast his net more widely as he drew together all his past experiences to create what in many ways was his most complex composition. He reworked elements of his own earlier works. He looked too to the art of the past. As he had done in so many of his other paintings, he quoted figures with charged meanings. Most important for the message of his work, he added references to images that had chronicled the bloody prologue to Order No. 11, notably illustrations of the Lawrence Massacre (figs. 62, 63).

Certainly the general composition of *Order No. 11* derived from his own earlier paintings, like *Verdict of the People* (figs. 47, 49) or *County Election* (figs. 40, 43, 45).[42] The basic construction of these works was similar: a dense pyramid of figures on one side, open recession in the center, and a few foreground figures on the other side. His train of refugees evoked memories of the women and horses in his first history painting, *Daniel Boone Escorting Settlers Through the Cumberland Gap* (fig. 21). And his officers on horseback echoed his equestrian portraits of Lyon and Jackson (fig. 56).

Bingham also followed the pattern he had established in earlier works of drawing on the art of the past in order to make telling quotations that would add meaning to the work. He knew what he was doing, for he acknowledged his debt to Leonardo when he later wrote about *Order No. 11*. "The great Leonardi Divinci, in his immortal painting of the 'Last Supper,' placed the repulsive face of Judas in close proximity to the benign countenance of the Prince of Peace. It is thus that I present virtue and vice in my picture, the brightness and divinity of the former appearing only the more conspicuous as relieved by the dark and satanic features of the latter."[43] Placing the face of the white-haired patriarch below the dark-bearded face of Ewing, Bingham deliberately contrasted good and evil and even subtly suggested that the Union general was a kind of Judas, a traitor to the master he served. So too the painter's other references to the art of the past were full of meaning. Bloch noted the formal parallels:[44] between Masaccio's *Expulsion* (fig. 59) and the blacks on the right; between Fra Bartolommeo's Pitti *Pietà* (fig. 60) and the four figures at the feet of the father; between Greuze's *The Father's Curse* and the central group of father and clinging children; and between the *Apollo Belvedere* and the father. The kneeling woman, one might also note, is reminiscent of a female saint sketched twice by the artist (fig. 61) that probably derived from a Titianesque *Noli Me Tangere*.[45]

These are not, however, solely formal quotations included as proper

59 *Masaccio,* The Expulsion, *fresco, Brancacci Chapel, S. Maria del Carmine, Florence. (Photo: Alinari/Art Resource)*

components of a history painting. The adoption of poses from religious art gave a ritual and universal significance to the figures. The death of a particular son throbbed with the pathos of the death of the one Son. The heartfelt entreaty not to touch passed, in an ironic reversal, from kneeling woman to standing man. The expulsion of a specific family and their entourage paralleled humankind's original loss of paradise. Here, as in his earlier works, Bingham used his quotations to enrich the meaning and import of his work.

60 *Fra Bartolommeo, Pietà, oil on panel, 59⅞ × 76¹³/₁₆ in. Pitti Palace, Florence. (Photo: Alinari/Art Resource)*

But he also made a few references to popular images of the Lawrence Massacre, as if to tie the order specifically to its immediate cause. The house with porch closing the composition on the left and the drifting clouds of smoke recalled the illustration in *Harper's Weekly* of "The Destruction of the City of Lawrence, Kansas" (fig. 62).[46] Even more telling connections linked Bingham's painting with "The War in Kansas" in *Frank Leslie's Illustrated Newspaper* (fig. 63). The popular magazine showed a woman kneeling with hands clasped together over the foreshortened body of a man with outflung arms—surely anticipations of Bingham's pleading woman and his sprawling foreshortened corpse. Just as Bingham's borrowings from the old masters were deliberate and had meaning, so too did these allusions to the representations of the incident that precipitated Order No. 11.

No single work inspired Bingham's *Order No. 11*. It was an ambitious summation of the artist's past experiences. It also marked an important step in his career. With this work he at last realized his ambition to be a history painter, a role to which he had aspired all his adult life.

61 Kneeling Woman, *drawing, 12⅛ × 8⅞ in. State Historical Society of Missouri, Columbia.*

62 *Anonymous,* The Destruction of the City of Lawrence, Kansas, *from* Harper's Weekly, *5 September 1863, p. 564. Beinecke Rare Book and Manuscript Library, Yale University.*

Bingham clearly understood that his work was a major history painting. In defending his choice of subject matter, he wrote quite directly that he had enlisted "art . . . [as] the most efficient handmaid of history" to perpetuate one of the sorriest incidents of the Civil War.[47] Several times before Bingham had come close to history painting: in 1845 with the failed commission from the state government for *Andrew Jackson Before the Court in New Orleans;* in 1853 with his proposed painting of *Old Bullion Making His Appeal to the People;* and again in 1856 with the series he contemplated on the Border Wars between Missouri and Kansas. The subject of the first one— the subordination of the military to civilian authority—was an antitype of *Order No. 11,* of great appeal to the artist even if the topic came from the state legislature. The latter two works, however, were the artist's own ideas and his aims were polemical—in the first instance, to defend the right of a senator to resist the state legislature's instructions and to appeal to the people and, in the second, to record and protest an absurd travesty of the election process in a neighboring territory. None of these works was executed, however. Only once had Bingham actually carried out a work that qualified as a history painting—the work he referred to as the *Emigration of Daniel Boone* of 1851.[48] He had made efforts to diffuse the work as a print

63 *Anonymous,* The War in Kansas, *from* Frank Leslie's Illustrated Newspaper, *12 September 1863, p. 389. Yale University Library.*

and later in his life had suggested that subject as a fitting one to decorate the state house in Jefferson City. Despite these attempts, the Boone painting had not won him recognition as a history painter. Nonetheless, when juxtaposed with *Order No. 11,* it does provide a counterpoint against which one can judge the profound changes the artist's thought underwent between the early 1850s and the postwar period.

The Boone picture had been an enthusiastic paean to the families who moved west to set down roots, to found settlements, to cultivate the land, to raise and educate their children—in short, to establish civilization. By the time Bingham turned to history painting again in 1865, his outlook had changed, as he watched the havoc that war had wreaked. The optimistic subject matter of the Boone painting yielded to despair in *Order No. 11.* For Bingham that painting was a postwar jeremiad—in it all the hopes of a developing America had come to naught. Citizens who, like Boone, had settled, cultivated the land, and established communities, now found their civil rights transgressed by an arbitrary military order. Their fundamental

rights—to life, liberty, and property—all were turned upside down. Where life had been, now there was death. Where liberty had reigned, now there was banishment. Where property had been secure, now there was looting. The arbitrary and tyrannical arm of the military had slapped democratic principles full in the face.

If the iconographic allusion to the *Flight into Egypt* in Bingham's *Daniel Boone* suggested families seeking refuge and safety, the later allusions in *Order No. 11* hinted at the failure of that safe haven—death in Bingham's secular *Pietà,* banishment in the secular *Expulsion.* That Bingham intended this meaning is evident not only in the formal elements of the painting but also in what he later wrote about the work.

The Meaning of *Order No. 11*

The dedication of the engraving of *Order No. 11* left no doubt about Bingham's purposes: "Dedicated to 'The Friends of Civil Liberty' by the publishers" (fig. 64). In every essay he wrote about the work, the artist reiterated this theme of civil liberty. From the outset the work was the butt of criticism, and Bingham took pen in hand to defend it, writing letters to newspaper editors and a pamphlet, *An Address to the People,* to explain the meanings he intended. Bingham had served in the Union army, he had held office in the Constitutional Union provisional government of Missouri, and he had opposed slavery and advocated gradual emancipation. His essays on *Order No. 11* reminded his critics of his political positions. The painting was not an attack on the Union army, nor was it a defense of slavery. The work was plainly and simply about the rights of citizens, in short about liberty.

Bingham considered his work a history painting with a didactic purpose. In the pamphlet he wrote defending his work, his opening sentence confirmed this: "Art being the most efficient hand-maid of history, in its power to perpetuate a record of events with a clearness second only to that which springs from actual observation, I sometime since became impressed with the conviction, that, as one of its professors, I could not find a nobler employment for my pencil, than in giving to the future, through its delineations, truthful representations of extraordinary transactions indicative of the character of the military rule which oppressed and impoverished large numbers of the best citizens of our State during our late sectional war."[49] Truthful representations, yes, but with the artist's moral position explicitly rendered.

That moral position was firm: the work was as much a critique of arbitrary military power as it was an impassioned defense of liberty. He intended the painting to "keep alive popular indignation. . . . May the American people never forget that hatred of tyranny is but another name for the

64 *John Sartain, after Bingham,* Martial Law, *1872, engraving, 25⅝ × 35⅝ in. State Historical Society of Missouri, Columbia.*

love of Liberty, and that when it perishes, free institutions must perish with it." [50] The old Whig values of Union and liberty were Bingham's muses, both for his painting and for his essays in its defense.

The earliest criticism of the work was launched from the pulpit, in a Thanksgiving Day sermon by Rev. R. S. Johnson. The artist's rebuttal, printed in at least two newspapers, contained enough quotations from the homily to reconstruct its principal line of argument. The minister accused Bingham of casting aspersions on Kansans and on the Union army, and he suggested that the painting was intended as some kind of slavery propaganda. Johnson was outraged at "the impression which the Artist *meant* to convey, that of an unjustifiable outrage by the people of Kansas upon the people of Missouri" in retaliation for the efforts of some Missouri citizens who in the "'palmiest days of slave propagandism deliberately strove, by unparalleled violence, to plant slavery upon a scattered, defenseless, unwilling people.'" [51] Referring, of course, to the Border Wars, Johnson remained bitter about the efforts of Missourians to see that Kansas entered the Union as a slave state. After assuring the pastor that he had intended no such impression, Bingham went on to state that "the band of scoundrels who are truthfully represented . . . are no more the people of Kansas than were the

'Border Ruffians' the Great Commonwealth of Missouri." The evildoers of both states did not represent the majority of citizens. In a very subtle slur at Ewing, the artist admitted that Kansas had her share of villains, as "I have reason to know to my cost, as my own family residence was demolished by them in the perpetration of a most brutal and atrocious murder." Nonetheless, said Bingham, though some of the principals might have come from Kansas, every state had its share of scoundrels.

A few months later the art critic of the *Democrat* joined his voice to Reverend Johnson's, both of them accusing Bingham of having created an image sympathetic to those rebelling against the federal government. To Johnson Bingham adamantly denied that the picture had anything to do with slavery propagandism, asserting that "these facts of history, such as I have presented on my canvas, have no necessary connexion with the sale of negroes by Yankees, or their purchase by Southerners."[52] To the critic, Bingham maintained that the victims were not "'rebels of that region,'" as that critic had asserted, but rather "the honest and thrifty cultivators of the land, standing where they had a right to stand, at their own homes, and where the Government was bound, in honor and justice, to protect them in all their rights of person and property."[53] The accusation that the picture was a proslavery document arose undoubtedly from Bingham's presentation of a family with three black servants. In this period, many might have seen this presentation as Bingham's identification of the family as Confederate sympathizers. But the artist steadfastly refused to identify his chief protagonists as rebels, and he came back to the issue in his vindication written in 1872. For him they were "anything but rebels, in any legal or proper sense of the term."[54] Admitting that these people were slave holders, Bingham argued nonetheless that they had nothing to gain by allying with the secessionists, for then they would lose the efficacy of the fugitive slave law. Despite their ownership of slaves, these people were citizens loyal to the federal constitution. "The great mass of these residents possessed all those virtues which usually characterise an agricultural people. It was well known that they were strongly attached to the Federal Union, as established by the Constitution. Early in 1861, they cast an overwhelming vote against secession, and after the war began, their young and ablebodied men volunteered in numbers, more than sufficient to supply their full quota of troops to the Federal Army."[55]

The people he represented then were loyal to the Union. Unlike the squatters whom Bingham so disliked, these people cultivated the land. They had sent representatives to the state convention of 1861 who had voted against secession. And they had sent young men to serve in the federal army. What the artist wanted above all to drive home was the obscenity of "a gov-

ernment waging a war of desolation against a large population living in obe-
dience to its laws, and supplying its armies with troops and subsistence."[56]
Far from being slavery propaganda, the painting showed loyal citizens with
servants whom Bingham described as faithful, all being expelled from their
homes and forced to undertake an exodus.

The unnamed critic and Reverend Johnson also attacked what they
viewed as Bingham's slur on the Union army. Johnson thought Bingham had
"'given undue prominence to outrages perpetrated by Union soldiers, omit-
ting those perpetrated by rebels for which they were a just retaliation, thus
making a false impression, discreditable to the Union cause and its friends,
which the entire truth, if stated would not permit.'"[57] The other critic took
offense at the artist's slur on the Union army, his presentation of "'Union
military men' as 'brutal, repulsive, soulless beings.'"[58] At this accusation the
artist came on with full force. "I was myself a Union soldier, as was every
male member of my family capable of bearing arms, and would, therefore,
be the last man to libel a class, either with pen or pencil, who were my com-
rades in arms—the honest, the brave, the patriotic defenders of the consti-
tutional government of our fathers in its time of need and peril." The main
actors of the scene were no Union military men, asserted Bingham, but "the
'Red Legs' of Kansas and their equally demoniac associates." If he had in-
cluded men in Union uniforms, this was to indicate that Union soldiers had
abetted the Kansas Jayhawkers.

Bingham the realist simply wanted to make clear whom he considered
to be the true friends of the Union. The soldiers who had enforced Order
No. 11 had "perpetrated their crimes in the garb both of soldiers and citi-
zens, and literally adhering to the truth, I have thus presented them upon my
canvas."[59] They were enemies of the Constitution, because they had not up-
held its principles. "Only those who have endeavored, alike against rebellion
and usurpation, to maintain that constitution inviolate, and the reserved
rights of the States and of the people as stipulated therein, are entitled to
rank as the friends of the Union; *while those who have set it aside, as-
sumed authority incompatible therewith, and trampled upon the rights of
the States and of the people, cannot be considered other than its enemies.
And these only* . . . has it been my purpose to aid in consigning to a justly
infamous immortality."[60]

The lesson of his painting then was rooted in the Constitution. For Bing-
ham the work demonstrated "that the tendencies of Military power are
anti-republican and despotic, and that to preserve Liberty and secure its
blessings, the supremacy of Civil Authority must be carefully maintained."[61]
Paraphrasing the preamble to the Constitution, he made clear the underly-

ing meaning of the painting. He was outraged that Union officers, who had sworn to uphold the Constitution, had instead ignored its most fundamental principles. The people of the border counties, depopulated by Order No. 11, had earlier demonstrated that they were friends of the Union, sending pro-Union candidates to the state convention and serving in the Union army. "Devoted to the Union, as existing by the Constitution, and living within a State, equally true to the Federal Government, none can say that they were not entitled to all the protection which its power and its laws could afford."[62] Instead they had had to leave their homes, to witness the pillaging of their property, and in some cases to face death. Bingham continued his sentence in the pamphlet and referred to Judas, just as he had done formally in the painting—"that they did not receive this [protection], stands as melancholy proof, that there was a treason, basking in high official favor at the Federal Capital, far more Judas-like than that which centered at Richmond." Certain federal officials had allowed the enactment of this hated order that took away from citizens their most basic constitutional rights.

Order No. 11 in Bingham's eyes was a picture about liberty, for which the revolution had been fought, whose blessings the Constitution ensured. For Bingham, the preservation of the Union was the preservation of the Constitution whose preamble he paraphrased. What he chose to represent in *Order No. 11,* then, was a travesty of liberty, an obscene abrogation of constitutional rights by military despotism. Life was not safe, and civilian resistance prompted murder. Liberty was disregarded, and banishment ensued. Property was threatened, there only to be looted or destroyed. The injustice was all the greater because enacted by Union soldiers who had promised to uphold the Constitution and to secure its rights to all people. To convey his serious and didactic purpose, Bingham deliberately referred to other charged images. What treachery was there like the betrayal of Judas? What sorrow like the mourning over the death of Christ? What fate worse than the Expulsion from Paradise?

For all its pessimism, Bingham's message in *Order No. 11* was a logical development of his earlier political views. As a Whig in the expansionist '40s and '50s, he had espoused with Rollins and others economic development, the protection and preservation of property, the full utilization of resources. His faith in the democratic process, in the elective franchise, in the free institutions guaranteed by the Constitution had surfaced in his political service, as well as in his paintings and writings of that period. When the war came, he joined with other Constitutional Unionists to govern Missouri, the very name of their party a declaration of the dual foundation of their beliefs. His attack on Jennison in 1862 was a foreshadowing of his attack on Ewing.

In fact, he felt that Ewing's "merciless and infamous edict was but the con-
summation of the policy inaugurated by the notorious Col. Jennison." [63] After
the war, as he painted *Order No. 11,* Bingham continued to be agitated
about the encroachment of the military on civilian life, as he attacked the
state militia called together by the Radical governor who then ruled the
state. Indeed in the second half of the 1860s Bingham's political views con-
tinued to affect his work, as he responded to the domination of the Radical
party in the state.

Bingham and the Radicals

The elections of 1864 ousted the provisional government that Bingham
had served and put into office the Radical party, which had grown in strength
since 1862.[64] Bound together by their desire for immediate emancipation
and their impatience with the provisional government's wish to move slowly,
the Radicals had flailed away at Governor Gamble and his entourage in the
course of 1863. At the time of the Lawrence Massacre, the Radical press had
accused Gamble of deliberately abetting Quantrill, and the following month
the Radical convention denounced his government. With Gamble's death at
the beginning of 1864, the Radicals swung into action to assure their victory
in the state elections in the fall. Even more important than their control of
the offices of the state government and the General Assembly was the suc-
cess of their proposal to call a new constitutional convention.

The Convention of 1865, dominated by party leader Charles D. Drake
and the Radicals, flew in the face of what the preceding provisional gov-
ernment—and Bingham as part of it—had stood for. Dealing first with the
question of emancipation, the convention then went on to draft a new state
constitution. The provision in that document that most offended the con-
servatives was the so-called "Iron Clad Oath," a test oath demanded of all
voters, all candidates for office, all lawyers, jurors, corporation officials,
teachers, and ministers. Whereas the loyalty oath of 1861 had been in-
clusive, designed to grant amnesty to those who had been unsure of their
fealty in the early days of the war, this oath of 1865 was exclusive, designed
to disenfranchise all those who had "committed any one of eighty-six differ-
ent acts of supposed disloyalty against the state and the Union." [65] Pushed by
Charles Drake, the oath soon became known among conservatives as "The
Code of Draco." Opposition to the new constitution was high, and men such
as Edward Bates, then attorney general in Washington, Switzler, and Rollins
campaigned against it. Despite such efforts the state constitution passed by a
little more than a thousand votes.

When Bingham began *Order No. 11* late in 1865, then, state politics were in turmoil, and the following year saw the formation of a new political party and new realignments. In 1866 the Conservative Union party formed as an opposition party, joining together such old time Whigs as Rollins, Switzler, and Bingham with former Benton Democrats like Frank Blair, who undertook a robust campaign for the Senate seat. Chief among the targets of the Conservative Union Party was the "Iron Clad Oath," and Frank Blair soon initiated a test case against it that eventually went to the Supreme Court. In the course of the spring and summer, however, the Conservatives also became alarmed at the state militia that Radical Governor Thomas C. Fletcher called up. Though Fletcher maintained that he had gathered the militia to control violence in the western part of the state, many of the Conservatives felt that his purpose was to control the forthcoming fall elections.[66]

Bingham found himself unable to stay out of the fray and by June his name was in circulation for Congress.[67] Throughout the hot days of summer he took to the stump, appearing at picnics, at rallies, and at the state Conservative convention.[68] His speeches were as fiery and as informed as ever. At the courthouse in Liberty, for example, he spoke "in the advocacy of the doctrines of the great conservative party, and in opposition to the destructive policy of the radical party. His review of the *acts* of the radical party was scathing. . . . Mr. Bingham is a fine speaker, and is thoroughly posted on the political history of the country, and the head that butts up against him will run against a sawyer."[69] In his speeches Bingham spoke out particularly against the loyalty oath and the state militia.

His vehemence against the state militia was quite clearly an extension of his antipathy to Union military atrocities during the Civil War undoubtedly on his mind as he worked on the canvas of *Order No. 11*. In early July 1866, when the state Conservative Convention considered a resolution calling for the dissolution of the militia, Bingham supported the motion. In a vigorous speech he decried the recent appearance of the militia in his home county on the occasion of a visit by Governor Fletcher. Bingham was particularly appalled that "a militia organization which had been sanctioned by [the Governor] . . . [was] headed by an appointee, hailing not from the State of Missouri, but from the State of Kansas—a man who had distinguished himself in our State during the war, not as a Union soldier, but who has distinguished himself among that other class, who are distinguished as rogues murderers and house-burners—as men who, during the late civil strife, placed all law and order, and truth, and justice, beneath their feet."[70] As the artist attacked the illegality of Governor Fletcher's state militia in peacetime, he also quite clearly recalled the atrocities of Jennison and Ewing during the Civil War. His attack on the state militia then reflected the concerns he was paint-

ing at the time in *Order No. 11*. So too his dismay with the test oath led him to another propagandistic painting.

Although *Major Dean in Jail* was a smaller work than *Order No. 11*, it nonetheless allowed Bingham to vent his anger at the Radicals over the matter of the test oath (fig. 65). In the early summer of 1866, as he labored over the initial composition for *Order No. 11*, he took a break to create this politically charged image. Much smaller and far less complex than his large history painting, this one also took as its subject a contemporary event, the incarceration of a Baptist minister who refused to take an oath of loyalty to the government.[71] Major Dean had served in the Union army as a chaplain, aiding civilians and soldiers, Confederates and Unionists alike. When the war ended, he resumed his life as a minister with no intention of taking the loyalty oath demanded by the state constitution of 1865 that Charles D. Drake had masterminded with the Radical Republicans. When Dean was jailed in Independence for his refusal, he became the subject of a work by his fellow citizen, George C. Bingham.

Today the image is known only through a photograph touched with paint, a process unique in Bingham's oeuvre that calls for some explanation.[72] Contemporaneous newspaper accounts in July 1866 were unequivocal that Bingham's image of Dean was a painting that "will be the most popular of his brush."[73] These articles in newspapers in Independence, Liberty, Columbia, and St. Louis went on to note that the picture would be photographed "and sold from one end of the land to the other, the proceeds of the sale to the benefit of the Methodist and Baptist churches."[74] It seems entirely possible that the surviving image of Major Dean is one of those photographs touched with paint to make it resemble the original. Since the work, today in the possession of William Jewell College, originally belonged to Robert S. Thomas, Bingham's second father-in-law, the artist might well have colored the photograph for him.[75]

The image showed Major Dean sitting quietly in a cell, reading in the bare stream of light coming from a barred window nearby. The starkness of the cell echoed in the blank walls and the meticulous floor tiles whose grid matched the bars on the window. Only a blanket and the rumpled Baptist newspaper broke the horizontal and vertical rhythms of the scene. Like some latter day St. Jerome in his Study, Parson Dean took comfort in the book, presumably a Bible, which he perused.

Conservative newspapers across the state that carried accounts of the work were eager to interpret its meaning for Missourians, still reeling from the Civil War and its aftermath. The Columbia *Missouri Statesman*, quoting the *St. Louis Dispatch*, noted that the painting would serve to "illustrate to

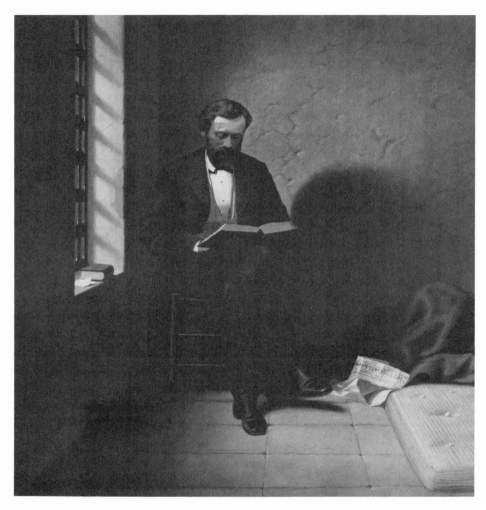

65 Major Dean in Jail, *1866, oil over photograph, 14½ × 14¼ in. William Jewell College, Liberty, Missouri.*

future generations an ignoble period of our State's history, and to be a memento of the reign of Radicalism."[76] The *Independence Sentinel,* as quoted in the Liberty *Tribune,* went further: "It will be a picture that every family should possess, and it should bear the name of 'Missouri under the Radical rule in the middle of the nineteenth century.' We suggest that upon the back of each picture [i.e., photograph], there will be the likeness of Charles D. Drake and the devil, if it be not too much of a disgrace to his satanic majesty to put him in such bad company."[77] Clearly contemporaneous journalists recognized that Bingham's image spoke out, however quietly, against the Radicals and the constitution of 1865.

The image also voiced sentiments that Bingham himself enunciated in his own political speeches. He gave such a speech less than a week after the notices of the painting appeared. Speaking before the Conservative Union convention, he addressed the issue of the Radicals' conception of law:

> What do these men mean when they say law? You who understand that science, and regard Blackstone as your great preceptor, know that he lays down as a fundamental principle that there is nothing in all legislation that is law, that does not rest for its foundation upon the true principles of right and of justice. Nothing is law which does not accord with the law of the Kingdom of Heaven. But these Radicals regard that as law which emanates, not from that source, but a source the very opposite. They do not regard that as a law which condemns roguery, house burning and murder, and all these things which are calculated to lead men astray. *The highest crime in their catalogue is the crime of preaching the Gospel of Jesus Christ.* (Applause) Not the will of Heaven, but the will and rule of Hell means to be their law. (emphasis added)[78]

In this instance, the sentiments Bingham voiced in his speech against the Radicals were as strong as those voiced in newspapers about his picture of Major Dean. There can be little doubt about the polemical intent of his work. Nonetheless, his efforts to diffuse this image in photographs rather than engravings seem to have assured that its impact on history would be minimal. Such was not the case with *Order No. 11,* which continued to preoccupy the artist until his death and to exert an influence on politics as well.

The Aftermath of *Order No. 11*

In his defense of the painting, Bingham stated quite specifically that *Order No. 11* was a protest against the arbitrary tyranny of military rule and a demonstration of "the important lesson that Constitutions and Laws, however carefully framed, are no guarantees of the rights of a people when their public affairs are committed to the hands of unworthy and treacherous agents."[79] As general as this statement was, Bingham's protest was also a quite particular attack against General Thomas Ewing, in part prompted by his own personal dealings with the author of the infamous order. Though Bingham's image early on evoked, in the Missouri press, both positive and negative reactions to its display of Union military atrocities, it soon began to elicit quite specific and intense feelings against Ewing, particularly among his political opponents in Ohio. There the image was seen as a weapon to be used in political campaigns against Ewing, a fact that Bingham acknowledged but did not push immediately. Many years later, however, when

Ewing tried to clear his name as he entered the Ohio Congressional race, Bingham entered the fray. Even if he had not first conceived the painting as propaganda against Ewing, in 1877 the artist seems to have fostered the propagandistic value of his image. In the last two years of his life, Bingham hounded Ewing, using his pen and his engravings in the battle. As he became obsessed with the issue, it became clear that his anger against Ewing was intensely personal and deep-rooted. Its basis, perhaps beneath the level of consciousness, lay in the general's confiscation of the artist's Kansas City home, its use as a military prison, and its destruction that had caused the death of several civilian women.

Bingham first acknowledged his awareness of the propagandistic value of his image in 1871, when the print was being engraved. He wrote to Rollins, almost as an aside in an already newsy letter: "By the way I see that Ewing has been defeated in his aspirations in Ohio. Some months since a portion of the Ohio delegation in Congress applied to me to know if they could procure, and upon what terms, 250 copies of our print to be used in defeating his nomination."[80] Apparently gratified, the artist sent them a photograph, since the prints were not yet available. In July, he expressed the hope that the prints would be ready by fall as they would "likely sell best during the heat of the approaching presidential campaign."[81] But he wrote nothing further to Rollins about the matter in his other letters of 1871, except to mention once that he suspected Ewing of persuading Sartain to delay the production of the print.[82]

From 1872 to 1876 the issue of Ewing dropped from Bingham's correspondence. In the first half of that period he was much more concerned with local politics, with exhibiting his works, and with the faltering economy that failed to support the sales of his engraving.[83] From 1874 on he took an increasingly active role in politics, serving on the Kansas City Board of Police Commissioners in 1874,[84] and as adjutant general of the state of Missouri from 1875–76.[85] In addition his name came up as Democratic candidate for governor in 1872 and 1876 and for Congress in 1874.[86]

Only when Ewing raised the issue late in 1877, as he entered the Ohio Congressional race, did Bingham return to *Order No. 11*. This time, however, he did so with a vengeance. It can hardly be coincidence that he was, at the same time, reliving the whole incident of Ewing's seizure of his house, as he prepared to press his own war claims in Washington. Early in 1877 Ewing saw to the publication of a letter he had requested from General Schofield. The letter defended Ewing, maintaining that Order No. 11 was a military necessity and "was an act of wisdom, courage and humanity, by which the lives of hundreds of innocent people were saved and a disgraceful conflict brought to a summary close."[87] Bingham lost no time in sending a long letter

to the *Missouri Republican's* editor, who inflammatorily entitled the article, "A Scorcher—Gen. Bingham on Order No. 11—Schofield and Ewing Hauled over a Bed of Hot Coals—A Review of One of the Greatest Outrages in Military History."[88] Bolstering his letter with an endorsement from senators and representatives from the counties affected by Ewing's edict, Bingham replied point by point to Schofield. Ewing may have promulgated the order to gain political support in war-torn Kansas, said Bingham in conclusion, but he must now find it politically to his disadvantage in Ohio.

Despite this renewed outcry in 1877, Ewing won a seat in the House of Representatives in Washington. But Bingham followed him there. In 1878 he went to the capital to pursue his "old claim for the destruction of our house in this city [Kansas City] by Gen. Ewing," as he wrote to Rollins.[89] While there, an editorial in the Washington *Sentinel* brought Ewing once more to public notice. Bingham took pen in hand and wrote a long article attacking the representative from Ohio. Significantly—and for the first time publically—Bingham linked the destruction of his house in Kansas City with Order No. 11.

Meticulously and in great detail, Bingham recounted Ewing's arrest and confinement of female prisoners in Kansas City. Without identifying himself as the owner of the house, he described at length the women's treatment in the prison and their death. He went on to place the blame on Ewing:

> The fact that no inquiry was instituted by General Ewing . . . and that no soldier was arrested, tried or punished . . . renders it impossible for him to escape responsibility therefor, and also for tragedies resulting therefrom, in the death of hundreds of Union soldiers and citizens of Missouri, as well as the brutal massacre which immediately followed in the State of Kansas. It is well known that when the notorious Quantrel, at the head of his band of desperadoes, entered the city of Lawrence, dealing death to the surprised and affrighted inhabitants, the appeal of his victims for quarter were answered by the fearful cry, '*Remember the murdered women of Kansas City!*'[90]

The incident in Kansas City became the initial blast in a veritable cannonade of events: the Lawrence Massacre, the issuing of Order No. 11, and the depopulation and desolation of Missouri's border counties.

In this attack, Bingham was determined to ruin Ewing, as a series of unpublished letters quite vividly reveals. To the Speaker of the House, who was "delighted with his [Ewing's] exposure," the artist gave a print of *Order No. 11* to hang in his office in the Capitol.[91] Bingham seemed to exult that the "day of retribution for Gen. Tom Ewing has arrived."[92] In another letter he proclaimed: "I am told that these exposures will finish him in the House of

Representatives, and that they will make me many influential friends therein, especially from Ohio and Pennsylvania."[93] His fury amounted to obsession. Rollins was worried, apparently writing to calm his friend down.[94]

There was good reason to worry. Not only was Bingham's attack on Ewing entwined with his war claims, it was even more gravely tangled up in the rupture of his own family. The artist's principal concern in all these unpublished letters was not Ewing, but Rollins Bingham, his youngest son and James Rollins' namesake. After the death of his mother, the sixteen-year old had taken a violent dislike to Mattie Lykins, a friend of his father's whom Bingham would eventually marry. Attacking her in letters and in person, Rollins also wrote apparently venomous letters to his father declaring his hatred not only of Mrs. Lykins but also of Bingham. Every page of the artist's almost daily correspondence with his friend Rollins in this period shouts of anguish. The letters are obsessive, repeating information, ruminating and returning to his son's accusations, quoting at length passages from his correspondence with Mrs. Lykins. Above all, Bingham repeatedly sought his friend's advice and support.

And Rollins answered. Never in the forty-year correspondence was there so much evidence of such manifest concern. Bingham's comments in his own letters clearly indicate that Rollins urged caution and restraint. Rollins also conveyed to his friend a sympathetic understanding of the particularly difficult period Bingham was going through. The artist, in Washington to press claims for his destroyed house, found his own household on the brink of destruction. Concerned with the death of the female prisoners, he was desperately afraid of losing his son or Mrs. Lykins, whom he intended to marry. Paralyzed into inaction in the face of his son's rebellion, he could take action only against Ewing. How much of this psychological displacement his friend Rollins understood is not clear. What is crystalline is that Rollins urged his friend on more than one occasion to cease his pursuit of Ewing. Finally, on 10 April, Bingham wrote quite simply: "The Ewing controversy has passed."[95] As the storm clouds of Order No. 11 dissipated, so too did the family dispute. By the end of the summer, Bingham and Mattie Lykins had married and were living in apparent tranquility with son Rollins in Kansas City.

Yet, once more before he died, Bingham jousted with Ewing. In June 1879, the Kansas City papers carried the news that Thomas Ewing was the Democratic candidate for governor of Ohio. Even before any controversy erupted, the *Daily Mail* noted: "Order No. 11 is beginning to boom in Republican organs and in Democratic papers of the Tilden persuasion: The *Globe-Democrat* predicts that Gen. Bingham will find a grand market for

his great painting among the Ohio Republicans."[96] Bingham's ears stood up, but not at the prospect of selling his print.

Once more the old war-horse took pen in hand to protest the political career of someone he thought had so egregiously violated the Constitution. In a short but vituperative letter, Bingham criticized Ewing and suggested that Democratic banners should present him on a horse "driving before him terror-stricken mothers, grandmothers, matrons and maidens, with all the sick and decrepid of their sex, all of whom he deemed more worthy of his flashing blade than men in arms who could give as well as receive blows."[97] When his attack in the Kansas City *Daily Mail* evoked a response from former Missouri Governor B. Gratz Brown in St. Louis, Bingham shifted the argument to the pages of the *Post-Dispatch*. He responded to Brown's arguments in a long letter and received another missive from the former governor. Within a week, however, the artist-politician was dead. But his voice was not quite stilled. His son Rollins found among his papers a lengthy response to Brown's final letter that was published a few weeks after the artist's death.[98] In the end, then, his article entitled "Voice from the Grave" gave Bingham the last word on this subject that had dogged him since the August day when his own house collapsed on the women prisoners of war in Kansas City.

Epilogue
The Empty Studio

In late March 1893 an auction took place in Kansas City at the art store of W. W. Findlay. On the auction block that Saturday were paintings by George Caleb Bingham, a collection that represented his life work. Most of the works had been in his studio at the time of his death in July 1879 and had remained in his family until his third wife's death in late 1890. Just a few years later the collection was sold and the proceeds distributed to an ex-Confederate Soldiers Home in Higginsville, a charity that both Bingham and his third wife had supported in their lifetimes.[1]

Among the works auctioned off that day at Findlay's Store was a penetrating self-portrait, painted around 1877 (fig. 66).[2] Staring directly out of the canvas, the artist paused as he interrupted the drawing he was making on a tablet steadied by his left hand. His skin had aged since his early self-portrait (fig. 1), but his dark hair, broad brow, and distinctive features remained the same. What was new about this portrait was that he here presented himself unmistakably as an artist. So intense was Bingham's stare that the viewer must have felt—and indeed still feels—almost like the sitter for one of the artist's portraits.

Outwardly in this portrait Bingham presented himself as an eye and a hand, but his lined face and his gaze suggested the presence of something deeper. Behind the broad brow was a creative mind, a mind that thought as much about the purposes and meanings of art as about its form, a mind that placed art in an integral relationship with history and society. In the same decade that saw the creation of the portrait, Bingham elaborated on these ideas on several occasions—in a letter advising James Rollins on a speech his friend was to give, in an essay defending *Order No. 11,* and in a lecture at the University of Missouri when he became professor of art there in 1878.[3] Having reached his sixties, it was as if he was taking stock of

216

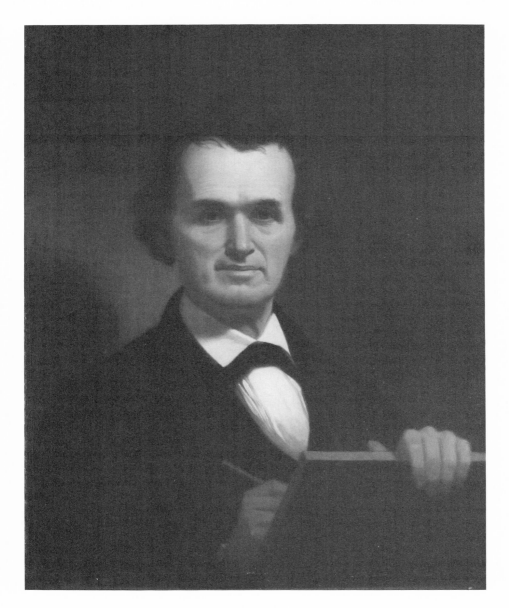

66 *Self-Portrait, ca. 1877, oil on canvas, 27¹/₁₆ × 22¹/₁₆ in. On loan to the Nelson-Atkins Museum of Art, Kansas City. Lent by the Kansas City Public Library.*

his life, of his career as an artist, and of the larger significance of art. In 1871 Bingham wrote that art was "the crowning chaplet of the most advanced civilization . . . that . . . will fulfil its proper mission upon our continent in the production of monuments which will rival in excellence all that human genius has been able to accomplish elsewhere."[4] He likened himself to

Michelangelo in his belief that art had as its primary goal the imitation of nature, but Bingham believed that art was more than simply a mirror of the world, even more than the expression of the beautiful. For Bingham the history painter, art was also "the most efficient hand-maid of history, in its power to perpetuate a record of events with a clearness second only to that which springs from actual observation."[5] Indeed, its chief utility for Bingham lay in this sphere. "Much that is of great importance in the history of the world would be lost if it were not for Art," he wrote. "Great empires which have arisen, flourished and disappeared, are now chiefly known by their imperishable records of Art. It is indeed the chief agent in securing national immortality."[6] Complacently looking out of his late self-portrait, Bingham portrayed himself as one who had worked to attain that goal in his major works. When he wrote to Rollins in 1871 about the principal figures in American art, he self-confidently placed himself alongside William Sidney Mount as one of the nation's two important genre painters. Mount's *Bargaining for a Horse* and his own *Jolly Flatboatmen* and *County Election,* he wrote, "assure us that our social and political characteristics as daily and annually exhibited will not be lost in the lapse of time for want of an Art record rendering them full justice."[7] Looking back on his life as an artist, Bingham was confident that he had left an important legacy for future generations in America. Certain of his paintings, he felt, had recorded the social and political face of his fellow Americans, while others had testified to important events in the history of his country.

These major works formed the core of the collection that Bingham amassed and kept in his studio until his death. A microcosm of his life's work, that collection revealed much about the works he had especially prized in his career.[8] There were portraits of his family and friends. Of course, James Sidney Rollins was there, the closest of his friends throughout his life. The artist's family was there, too—his second wife Eliza, their son Rollins, and his third wife Mattie, all in single portraits.[9] Not only had the artist surrounded himself with his closest friends and relatives, there were also portraits of a Mr. and Mrs. McCoy, reminders that portraits had been the principal source of his artist's income. There was also a portrait of Frank P. Blair, Jr., probably a study for, and certainly a reminder of, the full-length image that Blair's friends had ordered in 1870.[10] Several landscapes and rural scenes recalled those he had sent early to the American Art-Union and then later to the Western Art-Union. And there were two paintings of women probably inspired by the works of other artists—*The Palm-Leaf Shade,* which was a variation after a work by Sully, and *Bathing Girl,* which was one of the artist's few studies of the female nude.[11] If these stood as testaments to the various types of paintings Bingham had undertaken in his life-

67 The Jolly Flatboatmen *(2), 1877–78, oil on canvas, 26 × 36¼ in. Daniel J. Terra Collection. Terra Museum of American Art, Chicago.*

time, the others represented the highlights of his career. Many of them were works that had gained him a national reputation, reaching a broad audience across America in the form of engravings.

A second version of *The Jolly Flatboatmen* (fig. 67), which the artist had finished in 1878, was a nostalgic recapitulation of the riverboat scene of 1846 that had first brought him to the attention of connoisseurs across America.[12] It was an echo of his early triumph at the American Art-Union, the work they had selected to be engraved for their membership. The general pyramidal composition of the version of 1878 looked back to the earlier one of 1846 (fig. 25), as did the poses of most of the figures. Only the dancer departed from the first *Jolly Flatboatmen,* assuming the lively pose of the Roman drunken satyr that Bingham had used in the *Jolly Flatboatmen in Port* of 1857 (fig. 33). In opting for an asymmetrical pose Bingham may well still have been remembering the criticism launched against the first work in 1847—"In composition, Mr. B. should be aware that the regularity of the pyramid is only suitable to scenes of the utmost beauty and repose; that when motion and action are to be represented . . . proportionate departures must be made from this formal symmetry."[13] Yet as much as this work reflected the two earlier versions of 1846 and 1857, it also differed from them

in ways that suggest that Bingham intended more of a nostalgic evocation not only of his past career but also of bygone days on the river. It is a smaller canvas, and all elements within it have shrunk. The breadth and stability of the earlier boat has given way to a narrower platform for less monumental figures. The prominence of the cargo, evidence of hard work in the earlier one, has disappeared. The later painting seems less a celebration of actual trade on the river than an evocation of life on the river long gone. In fact, the reporter for *The Kansas City Star* described the boat as "an old time Missouri river flatboat."[14] By 1878 when Bingham completed the picture, the railroads dominated trade in a way they had not when the earlier river scenes first appeared. In his old age, the artist was no longer immersed in discussion about internal improvements and may well have wanted this work as a reminder of his earliest success.

If only one work represented the host of river scenes he had produced in the 1840s and early 1850s, such was not the case with the election series. All three of the election pictures hung in Findlay's store—engravings of *Stump Speaking* and *County Election* (fig. 45), and a second version of *Verdict of the People* (fig. 48), designated as *Results of the Election* in the newspaper account of the auction.[15] This last painting, like the second *Jolly Flatboatmen* was much smaller than its model. Painted at some undetermined date after 1855, it nonetheless moralized more strongly on the issue of slavery, placing a black woman bending over her child in close proximity with the figure alluding to *The Dying Gaul.* This more direct witness of the artist's stand on slavery replaced the indirect temperance banner of the earlier work. Also new in the picture was a church steeple silhouetted against the sky in the upper right, which replaced the tall trees in the earlier work. Much larger than the miniscule steeple in Bingham's *County Election,* it stood out alongside the American flag with a prominence that suggested a more direct moral message than that carried in the first version of the painting.

Reminders of Bingham's desire for governmental commissions were also there in his collection—an engraving of *The Emigration of Boone* (fig. 22) and a painting of *Washington Crossing the Delaware* (fig. 68).[16] These represented the commissions for great historical works that the artist had discussed repeatedly with Rollins but never obtained. As late as 1876 Bingham still doggedly persisted in seeking such a commission in Washington.[17] But his attempts had begun much earlier. In the early 1850s he had jocularly supported Rollins' bid for Congress, noting that a commission for the Rotunda of the Capitol might result from his friend's election.[18] In the later 1850s he had succeeded only in obtaining commissions in Missouri for state portraits when he had preferred to offer an "emigration of Boone" or "the 'Father of his Country,' connected with some historical incident, in a manner

68 Washington Crossing the Delaware, *1856–71, oil on canvas, 36¼ × 57¼ in. The Chrysler Museum, Norfolk, Virginia. Gift of Walter P. Chrysler, Jr., in Honor of Walter P. Chrysler, Sr.*

that would rival the far famed picture of Leutze."[19] His competition with Leutze had led him, soon after his plea to Rollins in March 1856, to begin *Washington Crossing the Delaware.* But the work remained unfinished for well over a decade. Only in the winter of 1871–72 did he complete it, undoubtedly encouraged that the engraver Sartain was "quite anxious" to make a print of the work. The Philadelphian thought the work would sell well, deeming it "far superior to Leuitzes picture of the same subject."[20]

In taking up the subject of *Washington Crossing the Delaware,* then, Bingham admitted his rivalry with Leutze, as he recalled his own earlier river scenes. His canvas, like Leutze's, was a great horizontal composition with figures struggling against the ice-clogged river. Yet Bingham did not adopt the earlier solution of having the boat move boldly across the picture surface. As in his earlier riverboat pictures, he placed the boat in the center facing the viewer with a pyramidal group of figures rising to the head of an equestrian Washington, silhouetted against the light sky. If the boat moved downstream as his earlier ones had, it was like them too in its form. Bingham here transported a Missouri boat like the one in *Boatmen on the Missouri* (fig. 26) to the icy waters of the Delaware. As in *Lighter* (fig. 23), he hung straps carelessly over the edge of the boat. But there the similarities with his own works and with Leutze's ended. Bingham's historical picture

teemed with figures and with boats. Rather than concentrating only on Washington's craft, Bingham jammed the boats of the other troops into the work. Busy pattern filled the composition with the crossing diagonals of oars below and jagged punctuations of bayonets and heads at the horizon. Since he began the work in 1856, his congested canvas followed on the heels of his election series, in which he had also dealt with throngs of people. Though not nearly so successful as his own earlier riverboat compositions, this work did embody Bingham's yearnings to be a history painter and represented that genre in his own personal collection.

So, too, did *Order No. 11,* though that work had associations for Bingham far more personal than the painting of Washington. The version on sale in Kansas City was the original painted between 1865 and 1868. It stood as a vivid reminder of the tragedy that had begun with the collapse of the artist's own house on the women held prisoner by Union forces in Kansas City. Both this painting and the copy Bingham had kept in his collection until 1878 were silent but powerful presences before his eyes in the 1870s undoubtedly goading him into action in that decade.[21] It was then that he pressed his war claim in Washington. It was then that he entered his last vituperative letter-writing campaign against Thomas Ewing, which ceased only upon his death. Of great personal import for the artist, *Order No. 11* also stood in his collection as his most powerful statement about the importance of civil liberty.

Finally, there was a small reminder of Bingham's brief tenure as president of the Kansas City Board of Police Commissioners in 1874.[22] This was *The Puzzled Witness,* completed late in 1874, which showed an interrogation in the interior of a county courtroom.[23] Critics in St. Louis rhapsodized over the work when it appeared there in Harding's Store in November 1874, likening it to the best character pieces of Sir David Wilkie.[24] A small work, it remained in Bingham's own collection as his last genre study and an echo of the time he had spent seeing to the prohibition of gambling in the city and of drinking on Sunday.[25]

At Bingham's death, however, there were several works that were not in the studio, works that he had contemplated, talked about, but never realized. These would have brought full circle his involvement in the artistic and political life of his own Missouri. One was a joint project that James Rollins had suggested to Bingham—an illustrated history of Missouri with text presumably by Rollins and pictures by the Missouri artist. The idea came up at the end of 1871 as Bingham was finishing his historical painting of Washington and at the same time concluding work on the engraving of *Order No. 11.* "Your suggestion as to a history of our State with illustrations, as the result of our joint labors strikes my fancy, as does also the suggestion of the great Historical Picture illustrative of some important event connected with that his-

tory."[26] Bingham was clearly enthusiastic about both plans, but nothing came of either. Nonetheless, once more before he died, he did have the opportunity to realize his dream of hanging a monumental history painting in the state house in Jefferson City.

Toward the end of 1876 Bingham returned to the subject designated in that first commission from the state government thirty-one years earlier in 1845—*Andrew Jackson Before the Court in New Orleans*. Retiring from the post of adjutant general for the state, the artist looked forward to returning to his paintbrushes, there expecting to "find much greater comfort than attends the discharge of the thankless duties of a public office."[27] Rather than occupying himself solely with portraits, he preferred to take up once again "our often talked of picture of Jacksons submission to the Civil Court at New Orleans." In returning to this subject, proposed and then defeated in the General Assembly in 1845, he continued to brandish the issue of the supremacy of civil authority over the military that had concerned him in *Order No. 11*. But he was not simply picking up an old idea that had been rattling around in his mind for thirty years, not simply aiming to recapture the commission that had been denied him in 1845. His was a timely decision prompted by his own strong reactions to President Grant's use of federal troops in South Carolina, Louisiana, and Florida following the national elections on 7 November 1876.[28]

Early in December Bingham made his reactions known to his friend Rollins.

The wisdom and statesmanship of Gen. Wade Hampton, I think will yet secure him the gubernatorial chair of South Carolinia to which he has been fairly elected, in spite of Chamberlin and Grant and his army to the contrary. I give myself less concern than has been usual with me about these matters, trusting that Providence, at the proper time, will overrule for good the wrongs which are perpetrated by dishonest rulers. A civil war on the question of the presidency would be a terrible calamity. It is evidently Grants policy to involve the country in such an evil, but I trust that it is equally the policy of the Democracy, as headed by Tilden, to fail him in his efforts, as with the exercise of proper discretion they have the power to do.[29]

Just a month after the presidential election, the country still did not have a duly elected president, with returns contested in Oregon, South Carolina, Florida, and Louisiana, and federal troops sent in to the three southern states to maintain order. As in Louisiana, so also in South Carolina two men claimed the governorship. In South Carolina they were the Democrat Wade

Hampton and the Republican Daniel Chamberlain, who had served since 1874. Only the presence of federal troops sent in by Grant kept Chamberlain in the governor's mansion. And it was this dominance of military over civil authority that riled Bingham. Characteristically he turned to painting to express his profoundly political sense of the world.

A few weeks after his letter to Rollins, Bingham made his motivations clear in an announcement to the Jefferson City *People's Tribune.* The artist informed the newspaper that as soon as he finished his job as adjutant general he intended to undertake two monumental historical pictures.

> One will represent the supremacy of the civil over military authority *under Democratic rule and Democratic interpretation of the constitution* as exemplified in the case of General JACKSON at New Orleans, surrounded by a victorious army cheerfully submitting to the judgment of the court and *promptly* paying the fine imposed on him. [The other will represent the supremacy of the military over civil authority] as exemplified in the official conduct of President GRANT in sending troops into the Southern States to make and unmake Governors and establish and overthrow legislative bodies at his own will and pleasure.[30]

The canvases were to be larger than *Order No. 11,* "and the subjects," the reporter averred, "are such as will bring out the full talent of Missouri's great artist." In stressing the Democratic roots of Jackson, the Jefferson City paper obliquely criticized the Republican party with Grant at its head.

Bingham, the inveterate political idealist, was not, however, renouncing the Whig views he had earlier held about the tyranny of Jackson's presidency. In showing Jackson humbled before the court and in criticizing Grant's abrogation of power, he continued to rail against a tyrannical executive and thus held firm to his earlier beliefs. Everyone in central Missouri knew that the Old Whigs had become New Democrats, carrying their independent ideology with them.[31] The next month, when Bingham took rooms for a studio in the Thespian Hall in Boonville, the local newspaper left no doubt about the artist's intentions in choosing the two subjects. The paintings would show "how General Jackson gave way to the civil authorities in New Orleans, and how President Grant usurps his authority and places the military over the civilian."[32] Dismayed by what Bingham saw as Grant's usurpation of authority, he set out once more to record for posterity what he saw as nefarious political wrongdoings.

As irate as he was over the turmoil shaking the nation, Bingham also was thinking about his life-long dream of hanging historical paintings in government buildings. As he contemplated the paintings, he urged his friend Rollins to write an article on the proposed plans hoping that it would "draw

public attention to the matter, and perhaps pave the way for a commission from our Legislature or from Congress if the Democrats get control of that branch of our government." [33]

Three months later, the day after Rutherford B. Hayes was inaugurated president with the promise of withdrawing all federal troops from the south, the Missouri General Assembly saw the introduction of a bill to commission a historical painting from Bingham. [34] Shying away from direct criticism of former President Grant, the house opted instead to consider a bill commissioning Bingham for a single painting of Jackson illustrating "one of the grandest principles that underlies the fabric of our government—the subordination of the military to the civil power." [35] Although the lawmakers did not seek a pictorial indictment of Grant, their agitation about the imposition of martial law in the south surfaced in the preamble to the resolution brought before the house.

"WHEREAS, the strict subordination of the military to the civil authority of our country is a most vital principle, the perpetual maintenance of which is absolutely essential to the preservation of our Democratic institutions and

WHEREAS, the frequent interference of the Federal Executive with the civil affairs of States of this Union by the intervention of arbitrary military power, supported as such intervention has been by a large and influential political party, and by a large portion of the public press of the country, is calculated to weaken in the minds of the rising generation, that due regard for the essential principles of popular liberty by which alone they can become the safe custodians of our free institutions, and

WHEREAS, the teachings and examples of imperialism, and their influence upon the minds of the youth of our country, can best be counteracted by holding up to their view, in the graphic and enduring forms of art, the noble and self-abnegating examples of the illustrious statesmen and heroes whose names adorn the past and early history of our republic, therefore be it

RESOLVED . . . to commission General George C. Bingham, the distinguished artist of Missouri, for a historical painting . . . [of] Andrew Jackson . . . bowing in deferential submission to the judgment of a civil court of Louisiana . . . setting an example which so long as it shall be remembered and cherished by the American people, will secure the perpetuation of their republic, alike from military usurpation from within and invasion from without. [36]

Beneath the legal language of the resolution, and especially in the second clause, lay an attack on the Republican party, on President Grant,

and on the use of military force that the legislators felt had interfered with civil liberties.

The issue clearly was charged politically, as other commissions to Bingham had been, and there was a good deal of discussion in the house. Memories of other pointedly political paintings by Bingham reemerged and entered the discussion. According to one Kansas City reporter, "An unreconstructed confederate, with moss on his back, said he would agree to give General Bingham the commission on a *proviso* that the picture of General Nathaniel Lyon be removed from the hall of representatives."[37] Despite this brief flurry of opposition, the resolution passed. Yet as lofty as its wording was, the lawmakers were not ready to commit themselves wholeheartedly to it. An amendment was added to the effect that the state would not be obliged to accept the painting, if it were found deficient in any way.

The commission that Bingham had set out to obtain late in 1876 had come to pass. Here was his opportunity at last to paint a monumental historical picture, to hang it in the halls of the state capitol, and to make a major statement about the subordination of military to civil authority. Toward the end of his life Bingham was about to undertake the commission he had come within a few votes of winning more than thirty years earlier.

However, the amendment rankled the artist, and he wrote of his dismay to Rollins. "I felt very little interest in the picture Resolution after it was amended. The fact is, it was my purpose not to accept a commission under it if it had passed. I did not consider it any compliment to be commissioned to devote two or three years of my life in painting a picture for my State, with the understanding that the State was not to be bound to pay for it."[38] Understandably miffed that the state he had served so loyally in so many capacities was hedging on becoming his patron, Bingham lamented that he would just as soon sell such a painting to his native state of Virginia, for the first time in his correspondence disassociating himself with his adopted state of Missouri. Yet so great was his disappointment that he gave up the idea of the historical pictures altogether. He would, he told Rollins, continue painting portraits that brought him into contact with more agreeable and "appreciative friends." Thus ended the commission for the painting of Jackson before the court of New Orleans. It would have concluded Bingham's career as an artist who was more than a portraitist just where that career had begun. It would have brought Bingham's artistic and political journeys full circle.

In the two years that followed, Bingham drifted away from the political scene. He became a professor of art at the University of Missouri, he tried to obtain an appointment as commissioner of the Paris Exposition, and he continued to seek claims for damage to his house in Kansas City. In 1878 he re-

married and settled with Mattie Lykins in Kansas City. A few months later he was appointed one of the commissioners for a monument to Robert E. Lee in Richmond.[39]

His last exhibition took place in the spring of 1879 in the English and Art Building of the University of Missouri. There he put on view the works in his studio and, according to the memoirs of Judge North Todd Gentry, he discussed "how he happened to paint many of his pictures."[40] Gentry did not record Bingham's comments, but he did note that the artist had three more paintings in mind, all of them related to life in Missouri—"one to represent a Camp meeting in Missouri, one a County fair in Missouri and one a Circus day in Missouri." As his life drew to a close, Bingham's thoughts turned for a moment away from state commissions for historical paintings and away from the battle with General Ewing that he had recorded in *Order No. 11*. The paintings he proposed would have recorded the face and the faces of Missourians in characteristic pastimes that would not have demanded, as *Order No. 11* had or as the painting of Jackson would have, any visceral political responses from his viewers. Instead his pictures would have reflected the increased sense of community that many scholars found rising in the late 1860s, as Missourians sought to overcome the animosities of the war.[41]

The works on the auction block in Kansas City along with the unexecuted paintings of the last decade of Bingham's life stood as representatives of the vast visual legacy he bequeathed to posterity. He himself thought of his major works as records of the social and political characteristics of his country. His friend Rollins went even further. In introducing Bingham's lecture on art in 1876, Rollins "spoke of the great moral effect of all his works, and wherein a number of them so handsomely illustrated the character and habits of Western life, and others of them illustrated with inimitable skill, the free institutions under which we live."[42] Echoing Bingham's views that art assured national immortality, Rollins declared that his friend's paintings would exist long after the institutions they represented had died. Both Rollins and Bingham recognized the authenticity of the artist's portrayals of American life, and they knew that deep experience in art and politics lay behind them. From the era of western development to the end of Reconstruction, the major paintings by George Caleb Bingham recorded American society as manifest in Missouri and reflected the major political issues of the day. They were the work of a whole person, of a man who wanted to be remembered not just as a painter but "as a public officer, as a writer and even as an artist."[43]

Notes

Introduction

1. "The Festival at Rocheport," *Boon's Lick Times,* 4 July 1840, p. 2, col. 4.
2. C. B. Rollins, ed., "Letters of George Caleb Bingham to James S. Rollins," *Missouri Historical Review,* 33 (1938–39), pp. 368–69, letter of 25 June 1876. Rollins' son published the correspondence of Bingham with his father in two volumes of the *Missouri Historical Review.* The letters from 1837–61 appeared in volume 32 (1937–38), 3–34, 164–202, 340–77, and 484–522, while those from 1862–79 appeared in volume 33 (1938–39), 45–78, 203–29, 349–84, and 499–526, hereafter cited as "Letters" (1937–38) or (1938–39). Rollins' son omitted many letters from the 1870s that had to do with family troubles but also contained valuable information about Bingham's political views. It would seem time now to bring together all of Bingham's writings in a completely edited volume.
3. See evidence in his correspondence with Rollins. On his candidacy for governor, see Rollins, ed., "Letters" (1937–38), 17, letter of 10 March 1847; "Letters" (1938–39), 206–07, letter of 7 Jan. 1872; 357–58, letter of 9 March 1876; 360, letter of 16 March 1876; 364–65, letter of 13 April 1876; 366–67, letter of 26 May 1876; 369–70, letter of 29 June 1876. On his candidacy for Congress, see: "The Right Spirit," *Missouri Statesman,* 5 Oct. 1866, p. 2, col. 2; "Our Candidate for Congress," *Liberty Tribune,* 19 June 1868; "G. C. Bingham," (Jefferson City) *People's Tribune,* 16 Sept. 1874, p. 1, col. 4.
4. Barbara Novak, *American Painting of the Nineteenth Century,* p. 160, made this remark about his letters to Rollins, but the other essays, speeches, and pamphlets also deal primarily with politics.
5. Editorial, *Missouri Statesman,* 23 April 1847, p. 2, col. 3.
6. "Geo. C. Bingham, The Painter," *The Metropolitan,* 17 Aug. 1847, p. 1, col. 2.
7. "Paintings," *St. Louis Republican,* 30 Nov. 1847, p. 2, col. 1.
8. "Paintings," *St. Louis Republican,* 21 April 1847, p. 2, col. 1. A similar view appeared in "Beautiful Paintings," *St. Louis Republican,* 11 Oct. 1850, p. 2, col. 2.
9. "George C. Bingham, The Painter," *The Metropolitan,* from the *New York Express,* 17 August 1847, p. 1, col. 1.
10. "The Gallery—No. 4," *Bulletin of the American Art-Union,* 2 (Oct. 1849), 10.
11. Wayne Craven, "The Grand Manner in Early Nineteenth-Century American Painting: Borrowings from Antiquity, the Renaissance and the Baroque," 43, argues that the efforts of American artists "to transplant the Grand Manner into the United States in the first quarter of the nineteenth century failed completely," and that the second quarter was dominated by landscape and genre painters who "reflected the America that Americans knew and with which they could readily and warmly identify." The American Art-Union played an important role in supporting painters of such distinctively American subjects. See chapter 2.

12. Meyric Rogers, J. B. Musick, and Arthur Pope, *George Caleb Bingham: The Missouri Artist.*

13. For example, see: Oliver Larkin, *Art and Life in America,* pp. 218–20; E. P. Richardson, *Painting in America,* pp. 175–77; Daniel Mendelowitz, *A History of American Art,* pp. 313–17; Alan Gowans, "Painting and Sculpture," pp. 156–68; John Wilmerding, *American Art,* pp. 118–19; Jules D. Prown and Barbara Rose, *American Painting from the Colonial Period to the Present,* pp. 79–80; Novak, *American Painting of the Nineteenth Century,* pp. 152–64; and Joshua C. Taylor, *The Fine Arts in America,* pp. 79–80.

14. Fern Rusk, *George Caleb Bingham: The Missouri Artist;* Albert Christ-Janer, *George Caleb Bingham of Missouri: The Story of an Artist;* John F. McDermott, *George Caleb Bingham: River Portraitist;* E. Maurice Bloch, *George Caleb Bingham: The Evolution of an Artist;* Bloch, *George Caleb Bingham: A Catalogue Raisonné;* Bloch, *The Drawings of George Caleb Bingham;* and Bloch, *The Paintings of George Caleb Bingham.* In 1975, Christ-Janer revised his earlier book and published *George Caleb Bingham: Frontier Painter of Missouri.* More recently an article for a catalog accompanying an exhibition of western art has brought the scholarship of Bingham up to date. See Ron Tyler, "George Caleb Bingham: The Native Talent," pp. 25–49. As this book goes to press, a new catalog for a major exhibition of Bingham's works has brought scholarship on the artist into the 1990s. See Michael E. Shapiro et al., *George Caleb Bingham.* Another work, published in the mid-1950s, which has the character of a vivid historical novel is Lew Larkin, *Bingham, Fighting Artist: The Story of Missouri's Immortal Painter, Patriot, Soldier and Statesman.*

15. Richardson, p. 176; Gowans, p. 216; and Taylor, p. 79.

16. Theodore E. Stebbins, Jr., Carol Troyen, and Trevor J. Fairbrother, *A New World: Masterpieces of American Painting, 1760–1910,* p. 107.

17. "Letters" (1938–39), 73, letter of 19 June 1871. An American historian, John Demos, went so far as to identify Bingham as a social historian, but his reading of the postures and poses of various figures in Bingham's paintings does not take into account what is known about the artist's copying after prints and his use of carefully posed models. See John Demos, "George Caleb Bingham as Social Historian."

18. G. C. Bingham, *An Address to the Public Vindicating a Work of Art Illustrative of the Federal Military Policy in Missouri During the Late Civil War.*

19. See Barbara S. Groseclose, "The 'Missouri Artist' as Historian," in Michael E. Shapiro et al., *George Caleb Bingham,* pp. 53–91; Groseclose, "Politics and American Genre Painting of the Nineteenth Century"; Groseclose, "Painting, Politics and George Caleb Bingham"; Gail E. Husch, "George Caleb Bingham's *The County Election:* Whig Tribute to the Will of the People"; Robert F. Westervelt, "The Whig Painter of Missouri." Other articles on Bingham's art and politics are: Keith L. Bryant, "George Caleb Bingham: The Artist as Whig Politician," *Missouri Historical Review,* 59 (1964–65), 448–63; Albert Castel, "Order No. 11 and the Civil War on the Border"; E. Maurice Bloch, "Art in Politics"; and May Simonds, "Missouri History as Illustrated by George C. Bingham.

Chapter One: Portrait of the Artist as a Young Whig

1. Bingham painted Switzler in 1849 (Bloch, *Paintings,* p. 183, no. 199).
2. *Missouri Statesman,* 19 June 1846, p. 2, col. 4.
3. "Progress of the Campaign," *Boonville Observer,* 24 June 1846, p. 2, col. 2.
4. Bloch, *Paintings,* p. 138, no. 26, with reference to John Cheney's print published in *The Gift: A Christmas and New Year's Present for 1836.* Already in 1836 a contemporaneous journalist discussed this work by Bingham and its source. See "The Fine Arts," from the *St. Louis Bulletin, Jeffersonian Republican,* 2 Jan. 1836, p. 4, col. 2.
5. These were works he had completed in St. Louis for a patron who was going to take them to Louisville. George Caleb Bingham, letter to Sarah Elizabeth Hutchison, 16 Dec. 1835, Bingham Family Papers, 1814–1930, folder 4, Joint Collection University of Missouri Western Historical Manuscript Collection–Columbia and State Historical Society of Missouri Manuscripts. Hereafter cited as "Joint Collection, Columbia."
6. "Letters" (1937–38), 7, letter of 6 May 1837.
7. "The Gallery—No. 4," *Bulletin of the American Art-Union,* 2 (Oct. 1849), 11.
8. George Caleb Bingham, letter to his wife Sarah, 3 June 1838, in Bingham Family Papers, 1814–1930, folder 7, Joint Collection, Columbia.
9. Bloch, *Paintings,* p. 147, no. 58. The review of that exhibition in the *New-York Mirror* discussed a number of specific paintings but failed to comment on Bingham's. See "The Apollo Gallery," *New-York Mirror,* 20 Oct. 1838, p. 135, col. 1 and 27 Oct. 1838, p. 142, col. 3.
10. Bingham painted numerous portraits of his friend from 1834 to 1873. See Bloch, *Paintings,* pp. 133–34, no. 9 of 1834 (private collection); p. 175, no. 172 of ca. 1845 (Baltimore, Mrs. John C. Cooper III); p. 230, no. 371 of 1871 (Columbia, State Historical Society of Missouri); p. 230, no. 372 of 1871 (private collection); and pp. 231–32, no. 377 of 1871–73 (destroyed). Bingham had a portrait of Rollins, undated and now unlocated, in his own collection when he died (Bloch, *Paintings,* p. 247, no. 444).
11. "Letters" (1937–38), 7, letter of 6 May 1837. Bingham made this request of his friend: "if you could procure me subscribers for a dozen portraits at $25 I should be glad to remain with you six or eight weeks."
12. On Rollins, see W. B. Smith, *James Sidney Rollins: A Memoir,* and C. R. Barns, ed., *The Commonwealth of Missouri,* pp. 827–36. On Rollins' newspaper connections, see Minnie Organ, "History of the County Press," 114.
13. "Letters (1937–38), 16, letter of 2 Nov. 1846.
14. On the Whig party in Missouri, see Leota Newhard, "The Beginning of the Whig Party in Missouri, 1824–1840"; Richard P. McCormick, *The Second American Party System,* pp. 304–10; and especially John V. Mering, *The Whig Party in Missouri.*
15. On Benton, see William N. Chambers, *Old Bullion Benton–Senator from the New West,* and Elbert B. Smith, *Magnificent Missourian: The Life of Thomas Hart Benton.*
16. For Whig ideas in general, see Daniel W. Howe, *The Political Culture of the American Whigs,* especially his chapter on Henry Clay, pp. 123–49.

17. Clay first discussed the American System in his speech, "On American Industry, in the House of Representatives, March 30 and 31, 1824." See Daniel Mallory, ed., *The Life and Speeches of Henry Clay,* vol. 1, pp. 440–82.

18. Mering, pp. 52–70, on the social and economic characteristics of Missouri Whigs.

19. "Letters" (1937–38), 7, letter of 6 May 1837.

20. Mering, pp. 142–43, on Doniphan, and pp. 49, 154–59, 204–05 on Leonard. In 1838 Doniphan led a brigade in the Mormon War but refused to obey the Missouri governor's order to execute Joseph Smith.

21. On Harrison's campaign, see Robert G. Gunderson, *The Log Cabin Campaign.* On the Rocheport convention, see Newhard, "The Beginning of the Whig Party," 277–78, and William F. Switzler, *Switzler's Illustrated History of Missouri,* p. 256.

22. For the request from Boone County, see George Caleb Bingham, letter to Thomas Miller, 30 May 1840, in James Sidney Rollins Collection, 1817–1937, folder 6, Joint Collection, Columbia.

23. "Rocheport Convention," *Daily Commercial Bulletin,* 22 June 1840, p. 2, col. 1.

24. The banner was described in two newspapers: "The Festival at Rocheport," *Boon's Lick Times,* 4 July 1840, p. 2, col. 4, and "Rocheport Convention," *Daily Commercial Bulletin,* 22 June 1840, p. 2, cols. 1–2. On the banner, see Bloch, *Paintings,* p. 159, no. 111; Bloch, *Evolution,* p. 74, n. 18; and McDermott, *George Caleb Bingham,* pp. 35–36.

25. "The Festival at Rocheport," p. 2, col. 4, for this and subsequent quotations describing the banner in the next two paragraphs.

26. For the use of this imagery on campaign medals and badges, see Edmund B. Sullivan, *American Political Badges and Medalets, 1789–1892,* pp. 55–79 for the log cabin, and p. 77 for the Battle of the Thames. For log cabins on banners and kerchiefs, see: Herbert R. Collins, *Threads of History: Americana Recorded on Cloth 1775 to the Present,* pp. 88–89, 94–95, 99–105.

27. It should be noted that in 1840 the Whigs had no stated platform, but the Democrats did voice opposition to internal improvements. See Donald Bruce Johnson, *National Party Platforms, 1840–1956,* vol. 1, pp. 1–2. Howe, *Political Culture of the American Whigs,* p. 90, argues that the chief issue that Harrison addressed in the campaign was opposition to a strong executive.

28. George Caleb Bingham, letter to Thomas Miller, 30 May 1840, James Sidney Rollins Collection, 1817–1937, folder 6, Joint Collection, Columbia.

29. "Progress of the Campaign," *Boonville Observer,* 24 June 1846, p. 2, col. 1.

30. Rev. Horace Bushnell, *Barbarism: The First Danger,* p. 27.

31. "Speech of Mr. Bingham, of Saline," *Boon's Lick Times,* 8 August 1849, p. 1, cols. 1–6.

32. Henry Clay, "On the Sub-Treasury Bill, in the Senate of the United States, January 20, 1840," in Mallory, ed., *Life and Speeches,* vol. 2, pp. 384–405.

33. "Speech of Mr. Bingham," p. 1, col. 4. Here Bingham echoed Clay's speech of 20 Jan. 1840: "This so much dreaded union of the purse and the sword will at last be consummated." See Mallory, ed., *Life and Speeches,* vol. 2, p. 405.

34. Clay often cited these same rulers from the past. See, for example, "On the Sem-

inole War, in the House of Representatives, Jan. 17, 1818," in Mallory, ed., *Life and Speeches,* vol. 1, pp. 387–88.

35. "Speech of Mr. Bingham," p. 1, col. 4.
36. "Speech of Mr. Bingham," p. 1, col. 5. For similar arguments by Clay, see Mallory, ed., *Life and Speeches,* vol. 2, pp. 404–05.
37. "Speech of Mr. Bingham," p. 1, cols. 5–6.
38. On Bingham's work, see: E., "Bingham's Copy after Vanderlyn's Ariadne," *Daily National Intelligencer,* 17 Feb. 1841, p. 3, col. 5. On the Rotunda commissions authorized in February 1837, see Glenn Brown, *History of the United States Capitol,* vol. 1, p. 79. Bingham saw the paintings by J. G. Chapman and Robert Weir hung in the Rotunda during his stay in the capital.
39. "Letters," (1937–38), 9, letter of [21] Dec. [1840]. Bingham was referring no doubt to John Vanderlyn's *Washington* hung to the right of the speaker's chair in the House after 1834, to Ary Sheffer's *Lafayette* of 1832 also in the Capitol, and to Gilbert Stuart's Doggett portrait of Jefferson of 1823 in the Library. On the first two, see Charles Fairman, *Art and Artists of the Capitol of the United States of America,* pp. 87–88 and 129. On the Stuart portrait, see Fiske Kimball, "The Life Portraits of Jefferson and Their Replicas."
40. Sarah Bingham, letter to Mary Bingham, 11 Jan. 1841, Bingham Family Papers, 1814–1930, folder 8, Joint Collection, Columbia.
41. "Letters," (1937–38), 10–12, letter of 21 Feb. 1841, for all quotations in the next three paragraphs.
42. For Whig use of personifications and symbols of liberty, see Sullivan, *American Political Badges,* pp. 37–41.
43. Donald B. Cole, *Martin Van Buren and the American Political System,* p. 151, quoting from Van Buren's letter to Thomas Ritchie, 13 Jan. 1827. On Van Buren's ideas about party discipline, see Cole, pp. 127, 151–52, 174.
44. Quoted on a Harrison banner of 1840 and illustrated in Collins, *Threads of History,* p. 91, no. 102. The campaign songs for Henry Clay abounded with exhortations to "freemen" to support the Whig candidate. See John S. Littell, *The Clay Minstrel,* pp. 210–12, "Appeal to Freemen," and pp. 199–201, "Our Candidate," which asserted "Our motto—'Clay and Liberty.'"
45. Letters from December 1842 to February 1843 are addressed to Sarah Bingham in Arrow Rock. See Jane Shaw, letter to Sarah Bingham (13 Dec. 1842) and George Caleb Bingham, letters to Sarah Bingham (17 Jan. 1843 and 21 Feb. 1843), Bingham Family Papers, 1814–1930, folders 10 and 11, Joint Collection, Columbia.
46. George Caleb Bingham, letter to his mother, Mary Bingham, 25 Sept. 1841, Bingham Family Papers, 1814–1930, folder 9, Joint Collection, Columbia.
47. George Caleb Bingham, letter to Sarah Bingham, 28 Nov. 1842, Bingham Family Papers, 1814–1930, folder 10, Joint Collection, Columbia.
48. George Caleb Bingham, letter to Sarah Bingham, 17 Jan. 1843, Bingham Family Papers, 1814–1930, folder 11, Joint Collection, Columbia.
49. A. B. Chambers, editor of the St. Louis *Missouri Republican,* called the Art-Union article "a tolerable correct notice of his rise and the difficulties he has contended with." See A. B. Chambers, letter to Millard Fillmore, 12 Oct. 1850 in

"Letters of Application and Recommendations during the Administrations of James Polk, Zachary Taylor and Millard Fillmore, 1845–1853," in *Official Records of the U.S. Department of State,* Washington, D. C., National Archives, Microfilm Publications M873, Roll 7, frame 505.

50. "The Gallery - No. 4," *Bulletin of the American Art-Union,* 11.

51. For a contemporaneous account of its goals, see "American Art Union Society," *New York Herald,* 21 Dec. 1845, p. 2, col. 4. On the Art-Union, see Maybelle Mann, *The American Art-Union,* and M. B. Cowdrey, *American Academy of Fine Arts and American Art-Union.*

52. "The Gallery—No. 4," *Bulletin of the American Art-Union,* 10, for this and the following quotation.

53. "The Gallery—No. 4," *Bulletin of the American Art-Union,* 11. Some scholars have accepted this explanation of Bingham's turn to river scenes. See, for example, George Ehrlich, "George Caleb Bingham as Ethnographer: A Variant View of His Genre Works," *American Studies,* 41–55. Ehrlich's arguments that Bingham's methods paralleled those of contemporaneous ethnographers are questionable.

54. McDermott, *George Caleb Bingham,* p. 50, and Ron Tyler, "George Caleb Bingham, The Native Talent," p. 25, identify the "paintings . . . in another line" mentioned in the *Daily Missouri Republican,* 4 June 1845, p. 2, as those Bingham sent to the Art-Union that year.

55. See Bloch, *Paintings,* pp. 166–67, nos. 137, 138, 139; Bloch, *Evolution,* pp. 74–79; and McDermott, *George Caleb Bingham,* pp. 46–48.

56. Bloch, *Catalogue,* pp. 46–47, discusses their exhibition and notes that all but one of the banners were destroyed by fire early in the twentieth century.

57. "Letters" (1937–38), 13–14, letter of 23 Sept. 1844, and "The Convention," *Boonville Observer,* 15 Oct. 1844, p. 2, cols. 1–2.

58. Also on the committee were Sinclair Kirtley, who served in the legislature that fall, and William F. Switzler, editor of the Columbia *Missouri Statesman* and a close friend of both Rollins and Bingham. See "Whig Meeting," *Missouri Statesman,* 30 Aug. 1844, p. 2, col. 4.

59. "Letters" (1937–38), 13–14, letter of 23 Sept. 1844.

60. Henry Nash Smith, *Virgin Land: The American West as Symbol and Myth,* pp. 51–58, on the conflicting views of Boone as civilizer or natural man.

61. Leah Lipton, "George Caleb Bingham in the Studio of Chester Harding, Franklin, Mo., 1820."

62. Bloch, *Evolution,* p. 123, n. 149 with reference to a letter from W. Adams to J. S. Rollins, Boonville, Mo., 20 Mar. 1882.

63. "The Convention," p. 2, col. 2.

64. For the attribution to Bingham, see Susan Strickler, "Recent Acquisition: George Caleb Bingham's 'Going to Market.'" See also Bloch, *Paintings,* p. 162, no. 124. Paul N. Perrot, director of the Virginia Museum of Fine Arts, has informed me that "there have been serious questions concerning the authenticity of this work" (letter of 6 Nov. 1989). For the moment I accept Bloch's attribution based on Strickler's presentation of clear evidence that the work was in the collection of Bingham's sister-in-law, Mrs. Mary Piper.

65. John S. Littell, "A Sketch of the Life, Public Services, and Character of Henry

Clay," in Littell, *The Clay Minstrel,* pp. 13, 15–16. Clay's childhood poverty was a topos in his biographies. See, for example, Mallory, ed., *Life and Speeches,* vol. 1, p. 10. For one of Clay's campaign medals in 1844 showing the Mill Boy, see Sullivan, *American Political Badges,* p. 108.

66. Bloch, *Evolution,* p. 79, traced the hat to a painting by Thomas Sully, *The Torn Hat* (Boston, Museum of Fine Arts). But Bingham may also have wanted to allude to a Whig campaign song for Clay, "When This Old Hat Was New," printed in Littell, *The Clay Minstrel,* pp. 326–31. Accompanied by an illustration of a tattered straw hat, the song made the point that Clay had been true to his beliefs throughout his life, in contrast with the more fickle Democrats Van Buren and Buchanan.

67. For eagles on Clay's medals, see Sullivan, *American Political Badges,* pp. 100, 103, 105, 107–08, 110.

68. "The Convention," p. 2, col. 1.

69. Mallory, ed., *Life and Speeches,* vol. 1, p. 478.

70. *The National Clay Almanack . . . 1845.* The cover shows a bust portrait of Clay between images of a ship and a plough. See also medals in Sullivan, *American Political Badges,* pp. 97–99.

71. William Gerdts, "Natural Aristocrats in a Democracy: 1810–1870," p. 38.

72. Collins, *Threads of History,* p. 110, no. 158, for the needlepoint copy and reference to the Sartain print. A poem describing the painting, "Mr. Neagle's Portrait of Henry Clay," appeared in the campaign song book, *The Clay Minstrel,* pp. 365–68. Bingham went to Philadelphia in June 1843 to look at paintings and might well have seen Neagle's original. See Sarah Bingham, letter to Mary Bingham, 24 Aug. 1843, Bingham Family Papers, 1814–1930, folder 12, Joint Collection, Columbia.

73. Merrill Peterson, *The Great Triumvirate: Webster, Clay, and Calhoun,* opp. p. 310 for the identification of Neagle's Clay as Father of the American System. Bingham himself described the banner as showing "Clay as the Statesman with his American System operating in the distance." See "Letters" (1937–38), 13, letter of 23 Sept. 1844.

74. A. J. Herndon to Abiel Leonard, 12 Sept. 1844, Abiel Leonard Collection, 1786–1909, folder 186, Joint Collection, Columbia. Herndon told Leonard that he had gathered subscriptions so that he could pay Bingham $50 (with $25 for framing) or even more since "We *want a first rate* Banner, cost what it may."

75. "Mutilation of Banners," *Boonville Observer,* 15 Oct. 1844, p. 2, col. 3.

76. "The Convention," p. 2, col. 2.

77. Horace Greeley, *Why I Am a Whig,* p. 6. Howe, *Political Culture of American Whigs,* p. 21, cited Greeley and also discussed the larger contrasts between Democratic and Whig views on expansion.

78. *Jefferson Inquirer,* 26 Dec. 1844, p. 3, col. 5. This is the first notice of Bingham's residency in Jefferson City. Since the reporter noted a number of portraits already completed, one might assume the artist arrived near the beginning of the legislative session.

79. Gerdts, "Natural Aristocrats," p. 48, suggests that the Edwards portrait was possibly "a completed study for a lost life-size image."

80. Gerdts, "Natural Aristocrats," p. 47 and fig. 20.

81. Bloch, *Evolution,* p. 186, and Gerdts, "Natural Aristocrats," p. 48. The Edwards portrait, however, lacks both the forward motion and the neoclassical setting of Morse's work. The portrait by Morse belongs to the Art Commission, City of New York.

82. Marian M. Ohman, *The History of Missouri Capitols,* pp. 27–28.

83. Just such a suggestion surfaced in 1845 when the state constitutional convention met. See Ohman, p. 28, and "A Fertile Fancy," *Jefferson Inquirer,* 29 Nov. 1845, p. 2, col. 1.

84. Missouri, General Assembly, *Journal of the Senate of the State of Missouri at the . . . 13th General Assembly* (Jefferson City: Gunn, Hammond and Main, 1845), p. 196, on 21 Jan. 1845.

85. Missouri State Archives, General Assembly, 13th Session, Senate, Bills, folder 11615, Senate bill no. 199, read 13 Feb. and tabled 14 Feb. An earlier version, Senate Bill no. 148, which did not contain the proviso about legislative approval, had been read on 21 Jan. and tabled on 22 Jan. (folder 11598).

86. Missouri, General Assembly, *Journal of the House of Representatives of the State of Missouri at the . . . 13th General Assembly* (Jefferson City: James Lusk, 1845), p. 500. Hamilton Gamble amended the bill to insure approval before payment was made. See "Missouri Legislature," *St. Louis Morning Missouri Republican,* 28 Mar. 1845, p. 2, col. 3.

87. "House of Representatives. Saturday, March 22, 1845," *Jefferson Inquirer,* 27 March 1845, p. 2, col. 3.

88. *Journal of the Senate . . . 13th General Assembly,* pp. 486–88.

89. Tom W. Campbell, *Two Fighters and Two Fines,* pp. 283–312.

90. On the debate, see *Appendix to the Congressional Globe,* May 1842, pp. 373–79; Thomas Hart Benton, *Thirty Years View,* vol. 2, pp. 499–507; and E. A. Linn and N. Sargent, *The Life and Public Services of Dr. Lewis F. Linn,* pp. 303–40.

91. "Remarks of Mr. Dickinson of Tennessee," *Daily National Intelligencer,* 19 Jan. 1844, p. 2, col. 2.

92. James W. Morrow, "A Discourse on the Life and Character of Gen. Andrew Jackson," *Jefferson Inquirer,* 31 July 1845, p. 1, col. 4.

93. Missouri, General Assembly, *Journal of the House of Representatives of the State of Missouri . . . at the 29th General Assembly* (Jefferson City: Regan and Carter, 1877), pp. 574–76; and "Jefferson City," *Daily Journal of Commerce,* 22 March 1877, p. 1, col. 3.

94. Bloch, *Paintings,* p. 272.

95. Twice in his letters, Bingham wrote about the financial necessity of painting portraits. He did so, he said, "to feed and clothe us" and "to make the pot boil." See "Letters" (1937–38), 497, letter of 27 Nov. 1860 and "Letters" (1938–39), 355, letter of 7 June 1874.

96. "Portrait Painting," *St. Louis Morning Missouri Republican,* 4 June 1845, p. 2, col. 2.

Chapter Two: Bingham's Early Vision of the West

1. Bloch, *Paintings,* pp. 172–73, nos. 158, 159, 160, 163. Bloch suggests that *Landscape: Rural Scenery* may be identical with the landscape submitted to the Art-Union.

2. Bloch, *Paintings,* p. 147, no. 58 (*Western Boatmen Ashore*), p. 153, no. 80 (one version of *Tam O'Shanter*), p. 158, nos. 103 through 107 (the five other National Academy paintings of 1840) and p. 162, no. 124 (*Going to Market*). Bingham exhibited the first Tam O'Shanter in St. Louis in 1839. He painted another version of *The Sleeping Child* in 1843–44. See Bloch, *Paintings,* pp. 164–65, no. 132.

3. Bloch, *Paintings,* pp. 172–73. The relevant information on the purchase prices appears in the Minutes of the Committee of Management, vol. 1, 8 Dec. 1845, American Art-Union Papers, New-York Historical Society.

4. "American Art Union," *New York Herald,* 25 Dec. 1847, p. 1, col. 4.

5. For Bryant's speech at the annual meeting of 1845, see "The Art Union," *New York Tribune,* 22 Dec. 1845, p. 1, col. 2. For Jay's speech, see *Transactions of the American Art-Union for the Year 1844* (New York: John Douglas, n.d.), pp. 13–18. For especially lavish praise for American art, see Dr. Bethune's "Remarks on the Opening of the New Gallery," *Bulletin of the American Art-Union,* 2 (Oct. 1849), 7–8.

6. *Transactions of the American Art-Union . . . for the Year 1844,* pp. 7–8. The annual report and the proceedings of the annual meeting were published on pp. 3–19.

7. For the presence of Dutch seventeenth century art in America, see: Henry Nichols Blake Clark, *The Impact of Seventeenth Century Dutch and Flemish Genre Painting on American Genre Painting, 1800–1865,* pp. 42–148.

8. *Transactions of the American Art Union . . . for the Year 1844,* p. 21, no. 49. The painting is in the Manoogian Collection, Detroit. See: Nicolai Cikovsky, Franklin Kelly, and Nancy Rivard Shaw, *American Paintings from the Manoogian Collection,* pp. 86–89.

9. J. F. McDermott, "Charles Deas: Painter of the Frontier," *Art Quarterly,* 13 (1950), 302, quoting *The Broadway Journal,* Dec. 1844. On Deas, see most recently Carol Clark, "Charles Deas," in *American Frontier Life: Early Western Painting and Prints,* pp. 51–77.

10. For *The Indian Guide,* see *Transactions of the American Art-Union for the Year 1845* (New York: Evening Post, n.d.), p. 27, no. 19, and Clark, "Charles Deas," p. 64. On *Death Struggle,* see Clark, "Charles Deas," pp. 65–66. *The Indian Guide* is now lost, while *Death Struggle* is in The Shelburne Museum, Shelburne, Vermont.

11. Clark, "Charles Deas," p. 52. She notes a three-month exhibition beginning in Sept. 1837 and reopenings of the gallery in Jan. 1838 and June 1839. On Catlin, see also George Catlin, *Drawings of the North American Indians;* William H. Truettner, *The Natural Man Observed: A Study of Catlin's Indian Gallery;* Royal B. Hassrick, *The George Catlin Book of American Indians;* and Marjorie Halpin, *Catlin's Indian Gallery: The George Catlin Paintings in the United States National Museum.*

12. F. O. C. Darley, *Scenes in Indian Life.*

13. S. Oetterman, *Das Panorama: Die Geschichte eines Massenmediums* (Frankfurt/Main: Syndicat, 1980), pp. 260–70. See also John F. McDermott, *The Lost Panoramas of the Mississippi.* Bloch, *Paintings,* p. 18, suggests a connection between the panoramas and Bingham's river scenes.

14. "Mammoth Panoramas," *Bulletin of the American Art-Union* 2 (June 1849), 28.

15. McDermott, *Lost Panoramas,* pp. 20–47, 50, and Oetterman, pp. 261–64.

16. McDermott, *Lost Panoramas,* pp. 68–80 on Stockwell, pp. 81–144 on Lewis, pp. 145–60 on Pomarede. On Dickeson, see Perry T. Rathbone, *Mississippi Panorama,* pp. 127–35. See also Oetterman, p. 267 on Stockwell, pp. 266–67 on Lewis, pp. 267–69 on Pomarede, and pp. 269–70 on Dickeson.

17. Barbara Novak, *Nature and Culture,* pp. 20–29.

18. Lewis F. Thomas, and J. C. Wild, *The Valley of the Mississippi Illustrated.*

19. Glenn Brown, *History of the United States Capitol,* vol. 1, p. 79, quoting the resolution of Congress, 23 June 1836.

20. As noted in the first chapter, he had already tried for a commission for state portraits in 1840 and had again come close to a history painting in the spring of 1845. Later in his life, Bingham expressed an interest in painting a picture for the library of the Capitol: "As there is yet no work of Art in the Capitol, properly illustrative of the history of the West, it seems to me that a western artist with a western subject should receive especial consideration." See "Letters" (1937–38), 365, letter of 18 July 1858. One of the subjects awarded by Congressional Committee in 1837 had been *Daniel Boone in the Wilds of Kentucky,* begun by Henry Inman but not finished at the time of his death (W. H. D., "Henry Inman," *Dictionary of American Biography,* vol. 9, p. 482). Bingham twice thought of Boone as a subject appropriate for government buildings. For the State Capitol he even suggested this to Rollins: "What is the chance for a pictorial embellishment for the Capitol? . . . If you are not ripe for such a work of art as the emigration of Boone upon a large scale would be, a full length portrait of Washington might do for a beginning" ("Letters" [1937–38], p. 187, letter of 12 Jan. 1855). Still later he proposed a painting of Boone to sell to Congress ("Letters" [1937–38], 353, letter of 3 June 1857).

21. "Letters" (1937–38), 13, letter of 23 Sept. 1844.

22. Compare, for example, drawings of Osage by George Catlin in Catlin, *Drawings,* figs. 35–41. Catlin noted alongside his fig. 37: "This tribe, like the Pawnees & Konzas, shave the head, and ornament it with the red crest." William H. Goetzmann and William N. Goetzmann, *The West of the Imagination,* p. 122, identify the figure as a Pawnee, but all other scholars describe him as an Osage.

23. Henry Vest Bingham, "The Diary of Henry Vest Bingham," 184. On Clark's museum see also J. F. McDermott, "Museums in Early St. Louis," 129.

24. Henry Vest Bingham, "Diary of Henry Vest Bingham," 52–53 and 183–84.

25. H. L. Conard, *Encyclopedia of the History of Missouri,* vol. 5, p. 476.

26. Thomas L. McKenney and James Hall, *History of the Indian Tribes of North America,* vol. 2, p. 160: "Le soldat du Chene, An Osage Chief."

27. Perry McCandless, *A History of Missouri,* pp. 54–57.

28. For the attribution to Deas, see Clark, "Charles Deas," pp. 55–56 and n. 20, citing William Clark Breckinridge in James Malcolm Breckinridge, *William Clark Breckinridge, His Life, Lineage and Writings* (St. Louis: n.p. 1932).

29. Henry Adams, "A New Interpretation of Bingham's *Fur Traders Descending the Missouri,*" 675.

30. This point is stressed by Glanz, *How the West Was Drawn,* p. 42 and has been reiterated by Adams, "Bingham and His Sources," 515.

31. For a contemporaneous overview of the fur trade, see *The Commerce and Navigation of the Valley of the Mississippi,* pp. 5–6. See also H. M. Chittenden, *The American Fur Trade of the Far West.*

32. Wilson Primm, "Oration," in "Saint Louis Anniversary Celebration," *The Weekly Reveille,* 22 Feb. 1847, p. 1181, col. 2.

33. My reading of the picture differs from that of Vincent Scully, *New World Visions of Household Gods and Sacred Places,* p. 113, who asserts that the half-breed will be "a dead duck when they reach the settlements." It was common for French traders to see that their Indian children were educated. They were not rejected in port. I am grateful to Jay Gitlin for information about the French traders.

34. Adams, "A New Interpretation," 679–80.

35. Charles D. Collins, "A Source for Bingham's *Fur Traders Descending the Missouri,*" 678–81. Collins dates the watercolor to 1840–41, while Clark, "Charles Deas," pp. 68–70, dates both watercolor and oil to 1845. The oil is in the Rokeby Collection, New York, on loan to the Metropolitan Museum of Art. I find Collins' suggestion of Deas' work as a source for Bingham's more convincing than the one put forth by John Maass as reported by Adams ("Bingham and his Sources"). Maass suggested Ludwig Richter's *The Crossing at the Schreckenstein* of 1837 (Dresden, Staatliche Kunstsammlungen, Gemäldegalerie Neue Meister) as a possible source. There are a few superficial similarities but there are notable differences—in the number and scale of figures and in the setting. Showing a ferry boat between two banks of the river, Richter's work would seem to be a distant inheritor of the tradition of Dutch ferry boat paintings by such artists as Jan van Goyen and Esias van de Velde (Peter C. Sutton, *Masters of Seventeenth Century Dutch Landscape Painting,* pp. 321–22 and 499–501, respectively). Moreover, Adams notes that he could find no nineteenth century painter's manual including Richter's work. I also find difficulty with the sources suggested by Stephen C. Behrendt, "Originality and Influence in George Caleb Bingham's Art," 24–38. I am indebted to Professor Howard Lamar for this reference.

36. Bloch, *Evolution,* p. 81 and n. 28.

37. Both compositions by Raphael were widely available in books and individual prints. For the tapestry cartoon, see Richard Cattermole, *The Book of the Cartoons,* pl. 1. J. D. Passavant, *Raphael d'Urbin et son père, Giovanni Santi,* vol. 2, p. 194, lists more than 20 prints after the cartoon or the tapestry. For the print, see Bartsch, *Illustrated Bartsch 26,* 245. For individual prints of the river gods, see Bartsch, 214 (reclining god) and 257 (seated god).

38. Bloch, *Paintings,* pp. 196–97, no. 253. On the pirogue, see Chittenden, *Early Steamboat Navigation,* vol. 1, p. 92. For a model of the pirogue, see Rathbone, *Mississippi Panorama,* p. 208.

39. "The Festival at Rocheport," *Boon's Lick Times,* 4 July 1840, p. 2, col. 3.

40. On the decline of the fur trade in the 1840s, see John E. Sunder, *The Fur Trade on the Upper Missouri, 1840–1865,* pp. 11–18, and Chittenden, *Fur Trade,* vol. 1, pp. 370–74.

41. "Fur Trade of Missouri," *The Weekly Reveille,* 28 Dec. 1846, p. 1115, col. 2.

42. Scholars have variously identified the animal as a fox, a cat, and a bear cub, and at least one scholar has argued that Bingham deliberately left the identity of the animal unclear (John Demos, "George Caleb Bingham: The Artist as Social Historian," p. 228). Trevor Fairbrother quite rightly noted that, in the reworking of this painting, *Trappers' Return* of 1851 (fig. 16), Bingham clearly shows a bear

cub as he equally clearly paints an accurate pirogue with a square stern (Stebbins, Troyen, and Fairbrother, *A New World,* p. 262, n. 3). See also C. K. Wilson, "Bingham's Bear Cub," 154.

43. Thomas and Wild, *Valley of the Mississippi,* p. 75: "The Missouri may be termed the Nile of the New World, for it more nearly resembles that famous stream, than any other river in the Western Hemisphere, and, like the Nile it rises periodically and suddenly, and inundates a larger tract of country." See also George Bingham to Wyatt and Rebecca Bingham, 25 May 1826: "& surely [the Missouri] is the greatest river in the world, except the Nile," Bingham Family Papers, 1814–1930, folder 2, Joint Collection, Columbia.

 Interest in Egypt was high in the early nineteenth century, even in St. Louis. The Mormon leader, Joseph Smith, had brought Egyptian artifacts to St. Louis as early as 1835: a papyrus he published in 1842 and mummies that were later acquired by the St. Louis Museum (John D. Cooney, "Acquisition of the Abbott Collection," 19–20). George Gliddon, an Egyptologist of sorts, lectured on Egypt between 1842 and 1850 along the east coast and as far west as St. Louis, usually using illustrations from I. Rosellini's *I Monumenti dell'Egitto e della Nubia.* Gliddon's own book on Egypt was published in 1844. (See C. R. Williams, "The Place of the New York Historical Society in the Growth of American Interest in Egyptology," and George Gliddon, *Ancient Egypt*). Rosellini's second volume, pl. cxxvii, has a picture of the boat of the dead with a jackal in the prow and a rower in the stern.

44. On the name of the state, see Walter Williams and Floyd Shoemaker, *Missouri Mother of the West,* vol. 1, pp. 3–5. The canoe appeared on the Missouri Loan Office Certificate of 1821 as seen in an example in the Mercantile Money Museum, St. Louis. On the state seal, see Ohman, *History of Missouri Capitols,* p. 105.

45. See for example Hobbema's *Wooded Landscape* of 1667 in R. H. Fuchs, *Dutch Painting* (London: Thames and Hudson, 1978), fig. 114; Saftleven's *Field Before Farm amid Trees: Girl Milking Cow* in F. W. H. Hollstein, *Dutch and Flemish Etchings, Engravings and Woodcuts, c. 1450–1700,* ed. K. G. Boon, vol. 23 (Amsterdam: Van Gendt, 1980), no. 38 on p. 142; Van Scheyndel's *Landscape with Farm and Fisherman* in Hollstein, *Dutch and Flemish Etchings,* vol. 24, no. 10 on p. 254; and Ostade's print in John Burnet, *A Practical Treatise on Painting in Three Parts,* pl. 3, fig. 3.

 Elizabeth Johns, "The 'Missouri Artist' as Artist," in Michael E. Shapiro et al., *George Caleb Bingham,* p. 100, suggests the two landscapes are pendants. She traces *Cottage Scenery* to English sources and suggests that the large tree in *Landscape: Rural Scenery* depends on Asher Durand's *The Solitary Oak* of 1844 (New-York Historical Society).

46. On Allston see William H. Gerdts, and Theodore E. Stebbins, Jr., *"A Man of Genius": The Art of Washington Allston, 1779–1843,* p. 175, fig. 2. Clark, *Impact of Seventeenth-Century Dutch and Flemish Genre Painting,* p. 190, noted Allston's dependence on Dutch examples such as paintings by Teniers. On Art-Union paintings, see: *Transactions of the Apollo Association . . . 1842,* p. 5, no. 5 (W. M. Oddie's *View of an Old Mill at Tappan*) and no. 23 (J. G. Chapman's *View of an Old Mill in Virginia*); *Transactions of the Apollo Association . . . 1843,* pp. 13–14, no. 9 (V. G. Audubon's *Creek Scene*), no. 10 (J. G. Clonney's

Barn Scene), and no. 34 (William Bayley's *Cottage View*); *Transactions of the American Art-Union . . . 1844*, p. 23, no. 78 (J. F. Cropsey's *View in New Jersey—Old Saw Mill*); and *Transactions of the American Art-Union . . . 1845*, pp. 27–28, no. 36 (W. E. Winner's *Cottage Scene*) and no. 60 (J. L. Williams' *The 'Lone Cabin', Susquehanna Scenery*).

47. George Caleb Bingham, letter to Sarah Bingham, 17 Jan. 1843, Bingham Family Papers, 1814–1930, folder 11, Joint Collection, Columbia.

48. "Letters" (1937–38), 13–14, letter of 23 Sept. 1844.

49. "On the Public Lands, in the Senate of the United States, June 20, 1832," Mallory, *Life and Speeches*, vol. 2, p. 62.

50. Bloch, *Paintings*, p. 171, no. 157, in the collection of Julian Headley, New Orleans. Bloch, p. 172, has linked this work with another one, *Emigrant Encampment on the Frontier* (private collection), no. 157a, and suggested that the two may have been "part of a projected series relating to emigration and settlement on the Missouri Frontier." Two later works by Bingham also dealt with families on the frontier: *Captured by Indians*, 1848, St. Louis, St. Louis Art Museum (Bloch, *Paintings*, p. 179, no. 182) and *Halt in the Forest: Emigrants Resting at Night*, 1852, St. Louis, St. Louis Art Museum (Bloch, *Paintings*, p. 200, no. 261). *Captured by Indians*, a nocturne, presents an emigrant woman and child surrounded by three Indian braves at a campfire. This composition, like *Concealed Enemy*, also has debts to one of the frontispieces of Lewis and Wild's *Valley of the Mississippi Illustrated*.

51. Bloch, *Paintings*, pp. 188–89, no. 222.

52. George C. Bingham, letter to the American Art-Union, 19 Nov. 1850, Letters from Artists, vol. 6, American Art-Union Papers, New-York Historical Society. Courtesy of the New-York Historical Society.

53. Two different views of *The Squatters* have been set forth recently. Barbara Groseclose, "The 'Missouri Artist' as Historian," in Michael E. Shapiro et al., *George Caleb Bingham*, pp. 59–62, sees the squatters as "a less positive element" of society, but finds Bingham's sympathetic portrayal of them an indication of their role in settling the West. Johns, "The 'Missouri Artist' as Artist," pp. 112–18, interprets the squatters more positively but does note that their transience caused problems at the election polls, a fact that Bingham himself acknowledged.

54. George C. Bingham, letter to American Art-Union, 19 Nov. 1850.

55. "Speech of Mr. Bingham, of Saline," *Boon's Lick Times*, 8 Aug. 1840, p. 1, col. 3.

56. One other work of 1850 showed a scene of life in an established town. This was *Shooting for the Beef* (Brooklyn, Brooklyn Museum of Art), which presented marksmen vying for the prize of a steer. See Bloch, *Paintings*, pp. 189–90, no. 224.

57. Bloch, *Paintings*, pp. 195–96, no. 251.

58. "Letters" (1937–38), 21, letter of 30 March 1851.

59. "Letters" (1937–38), 187, letter of 12 Jan. 1855 (state Capitol); and 353, letter of 3 June 1857 (Congress), and again, 357, letter of 12 Oct. 1857 (Congress). See above, note 20.

60. "George C. Bingham," *Missouri Statesman*, 23 May 1851, p. 3, col. 1, reprint from *The Missouri Republican*, 13 May 1851.

61. Already in March 1851, Bingham confided to Rollins that he felt his star was set-

ting with the Art-Union. See "Letters" (1937–38), 21, letter of 30 March 1851. Early in 1852 Bingham threatened to sue the Art-Union over what he felt was a personal slur in their bulletin. See George C. Bingham, letter to A. Warner, 1 March 1852, Letters Received, vol. 64, American Art-Union Papers, New-York Historical Society.

On the idea of a raffle, see A Friend of Genius, "Bingham's Splendid Pictures," *Missouri Statesman,* 29 Oct. 1852, p. 2, col. 5.

62. On Bingham's dissatisfaction with the print, see "Letters" (1937–38), 184–85, letter of 29 May 1854. On the print see also Bloch, *Catalogue,* p. 219, and Bloch, *Evolution,* fig. 84. Dwayne Snedeker of the Missouri Historical Society, St. Louis, kindly brought to my attention a daguerreotype in their collection showing an intermediate stage of the painting. This will be published in a forthcoming book on the Society's collection of daguerreotypes.

63. Bloch, *Evolution,* p. 128, for the classical sources of the male figures.

64. Bloch, *Evolution,* p. 120, found Bingham's claim to originality "strange" in light of Ranney's painting, but the subjects are altogether different. On Ranney's work, see Peter Hassrick, *Treasures of the Old West* (New York: Abrams, 1984), pl. 29 on pp. 43, 57. Ranney's painting is in the Gilcrease Institute of American Art and History, Tulsa.

65. "George C. Bingham," *Missouri Statesman,* 23 May 1851, p. 3, col. 1. See also Humphry Marshall, *The History of Kentucky,* vol. 1, pp. 24–25.

66. For example, before 1851, women appeared in: *Going to Market* of 1842 (fig. 6); *Family Life on the Frontier* before 1845; the two landscapes of 1845 (figs. 17, 18); *Captured by Indians* of 1848 (Bloch, *Paintings,* p. 179, no. 182); and *The Squatters* of 1850 (fig. 19).

67. See, for example "Letter to the Editor," *Missouri Statesman,* 12 July 1850, p. 2, col. 4, and "News from the Boone Emigrants," *Missouri Statesman,* 23 Aug. 1850, p. 2, col. 4.

68. Howe, pp. 21 and 42, explores the differences between Whigs and Democrats on this issue, noting that the Democrats favored territorial acquisition in order to expand agriculture while the Whigs favored improvements for land already settled.

Chapter 3: Of Snags and Whigs

1. This chapter is an expansion of my article: "George Caleb Bingham's 'Lighter Relieving a Steamboat Aground,'" *Smithsonian Studies in American Art,* 2 (Spring 1988), 17–31.

2. Bloch, *Paintings,* pp. 176–77, no. 174, where he cites American Art-Union Papers, Letters Received, vol. 6, "Memorandum of pictures to be recommended for purchase," 29 May 1846, and Minutes of the Committee of Management, 6 July 1846, New-York Historical Society. These sources indicate that Bingham submitted the painting by 29 May 1846, and the Art-Union resolved to purchase it for $100 on 6 July 1846. The Minutes of the Executive Committee, vol. 1, 24 July 1846, American Art-Union Papers, indicate that Bingham was to receive payment on 1 Oct. 1846.

3. Bloch, *Paintings,* p. 176, no. 175, notes its purchase on 9 Oct. 1846, for $290. The

Minutes of the Executive Committee, vol. 1, American Art-Union Papers, New-York Historical Society, show the following: resolution to purchase for an undecided amount (9 Oct. 1846); decision to engrave (19 Nov. 1846); and payment of $290 (1 Feb. 1847). The Art-Union announced the decision to engrave "The Jolly Flatboatmen, by Bingham, and the Sybil by Huntington" on 18 Dec. 1846 ("Eighth Annual Distribution of Prizes by the American Art-Union," *New York Herald,* 20 Dec. 1846, p. 2, col. 4). At the same time, the Art-Union renamed the work.

4. It should be noted that the first title the Art-Union bestowed was *The Jolly Flatboatman,* though the plural title, *The Jolly Flatboatmen,* has since become the accepted one. For accuracy, I here use the singular, but will use the plural elsewhere in the book.

5. Bloch, *Paintings,* pp. 177–78, nos. 179 and 180. The Art-Union approved the purchase of *Raftsmen* on 9 Oct. 1847 for $300. See Minutes of the Executive Committee, vol. 1, 9 Oct. 1847, American Art-Union Papers, New-York Historical Society.

6. Timothy Flint, *History and Geography of the Mississippi Valley,* and Washington Irving, *Astoria.*

7. William T. Porter, *The Big Bear of Arkansas and Other Sketches.*

8. Roger Lax and Frederick Smith, *The Great Song Thesaurus,* p. 220, and Patricia P. Havlice, *Popular Song Index,* p. 159. See also Carl Carmer, ed., *Songs of the Rivers of America,* p. 155.

9. *The Commerce and Navigation of the Valley of the Mississippi,* p. 6. See also Chittenden, *Early Steamboat Navigation on the Missouri River,* vol. 1, pp. 90–114. My view contrasts with that of Bloch, *Evolution,* p. 86, who suggested that "the flatboats and the men who operated them were, like the fur traders, fast disappearing in the wake of steamboat traffic." It also differs from that of Michael Shapiro, "The River Paintings," in Michael E. Shapiro et al., *George Caleb Bingham,* p. 153, where he asserts that flatboats "by the 1840s . . . had almost disappeared."

10. "Mr. Deas," *The Literary World,* 1 (1847), 280.

11. "The Fine Arts," *The Literary World,* 1 (1847), 348. On the struggle between civilization and wilderness, see Novak, *Nature and Culture,* pp. 4—10; Leo Marx, *The Machine in the Garden: Technology and the Pastoral Ideal in America,* pp. 226 and 320–24; and Perry Miller, *Errand into the Wilderness,* pp. 204–16. On the American paradise, see Novak, pp. 3–17; Henry Nash Smith, *Virgin Land: The American West as Symbol and Myth,* and R. W. B. Lewis, *The American Adam.*

12. "Paintings," *St. Louis Republican,* 21 April 1847, p. 2, col. 1.

13. "Paintings," *St. Louis Republican,* p. 2, col. 1, for this and the following quotation.

14. "James E. Yeatman," *Dictionary of American Biography* (1936).

15. "Purchased," *Weekly Reveille,* p. 1253, col. 3.

16. "Geo. C. Bingham, The Painter," from *The New York Express, The Metropolitan,* 17 Aug. 1847, p. 1, col. 2, for this and the following quotation.

17. "The Art-Union Pictures," *The Literary World,* 2 (1847), 277, for this and the following quotation.

18. See James T. Callow, *Kindred Spirits: Knickerbocker Writers and American Artists, 1807–1855,* p. 180, for an overview of the controversy.

19. "The Art Union Pictures," *The Literary World,* 2 (1847), 277.

20. "The Fine Arts," *The Literary World,* 1 (1847), 209.

21. J., "To the Committee of Management of the American Art-Union," *The Literary World,* 1 (1847), 348.

22. "Paintings," *St. Louis Republican,* 21 April 1847, p. 2, col. 1.

23. Mitford M. Matthews, ed., *A Dictionary of Americanisms on Historical Principles,* vol. 2, p. 1779. Bingham himself abstained from alcohol. See "Letters" (1937–38), 14–15, letter of 2 Nov. 1846.

24. "Saint Louis Anniversary Celebration," *The Weekly Reveille,* 22 Feb. 1847, p. 1182, col. 1.

25. *Proceedings of the St. Louis Chamber of Commerce in relation to the Improvement of Navigation of the Mississippi,* p. 4.

26. *Memorial of the Citizens of St. Louis Missouri to the Congress of the United States,* title page.

27. *The Commerce and Navigation of the Valley of the Mississippi,* title page.

28. See, for example, *The Commerce and Navigation of the Valley of the Mississippi,* pp. 9–11, estimating a loss of $1,920,000 annually on ships damaged or sunk by snags on the rivers.

29. J. T. Scharf, *History of St. Louis, City and County,* vol. 1, p. 583 on Grimsley, pp. 871–74 on Crow, and vol. 2, p. 1488 on Primm, and vol. 1, p. 676 on the Chicago Convention.

30. "Fur Trade of Missouri," *The Weekly Reveille,* 28 Dec. 1846, p. 1115, col. 3, for contemporaneous praise of the goals of the Mercantile Library.

31. A Whig, "Henry Clay on Internal Improvements," *Missouri Statesman,* 19 April 1844, p. 1, cols. 1–2.

32. John V. Mering, *The Whig Party in Missouri,* p. 148, quoting a letter from John Wilson to George R. Smith, 16 July 1847, in the General George R. Smith Papers, Joint Collection, Columbia.

33. T. W. W., "The Great South-Western Convention at Memphis," *New York Tribune,* 26 Nov. 1845, p. 2, col. 4.

34. *Congressional Globe,* 4 Dec. 1845. See also Lucien Chase, *History of the Polk Administration,* p. 396.

35. *Congressional Globe,* 20 March 1846 (on House passage of bill, 111-90) and 24 July 1846 (on Senate passage, 34-16).

36. Chase, *History of Polk Administration,* p. 396.

37. See, for example, Awful Hull-Ripper, "Proceedings of the Convention of Snags and Sawyers," *The Weekly Reveille,* 4 Jan. 1847, p. 1126, col. 5.

38. Augustus Snag, Esq., "The Harbor," *The Weekly Reveille,* 12 Oct. 1846, p. 1027, cols. 1–2.

39. "The Difference," *The Weekly Tribune,* 17 Oct. 1846, p. 1, col. 4.

40. The arguments set forth here, based on newspaper accounts of 1846–47, run counter to John Mering's assertions that internal improvements did not become a Whig issue until 1848 in Missouri. See Mering, *Whig Party,* pp. 146–48.

41. William Kincaid, "Letter to the Editor," *The Weekly Tribune,* 10 Oct. 1846, p. 2, col. 4.

42. Missouri, General Assembly, *Journal of the House of Representatives of the*

State of Missouri . . . at the 14th General Assembly (Jefferson City: James Lusk, 1847), pp. 19–21.

43. A Looker On, "Letter to the Editor," *The Weekly Tribune,* 28 Nov. 1846, p. 2, col. 4.

44. "Missouri Legislature," *Missouri Statesman,* 25 Dec. 1846, p. 2, col. 4, reporting the events of 18 Dec. For the introduction of the River and Harbor Bill on 17 Dec. 1846, see *Congressional Globe,* 17 Dec. 1846.

45. "Whig Meeting at the Capitol," *The Weekly Tribune,* 6 March 1847, p. 1, col. 4. Immediately after the meeting Rollins sent a letter to Robert Miller, editor of the Liberty *Weekly Tribune,* urging him to publish the resolution "and raise a *shout* over the doctrines contained in the resolutions. The question of internal improvements is to occupy a large place in the canvass of 1848, and the Whigs should take occasion early, even now, to go in advance on this great subject" (James S. Rollins, letter to Robert Miller, 20 Feb. 1847, Alvord Collection, Joint Collection, Columbia).

46. "Letters" (1937–38), 17, letter of 10 March 1847 for all the quotations in this paragraph.

47. "The Festival at Rocheport," *Boon's Lick Times,* 4 July 1840, p. 2, col. 4.

48. A. J. Herndon, letter to Abiel Leonard, 12 Sept. 1844, Abiel Leonard Collection, 1786–1909, folder 186, Joint Collection, Columbia.

49. As noted in the preceding chapter, this is the way Thomas Allen described them in his speech recorded in "Fur Trade of Missouri," *The Weekly Reveille,* 28 Dec. 1846, p. 1115, col. 2. Henry Adams, "A New Interpretation of Bingham's *Fur Traders Descending the Missouri,*" without citing Allen, nonetheless, argued that the Claudian landscape in the painting also carried connotations of civilization.

50. "Speech of Mr. Bingham, of Saline," *Boon's Lick Times,* 8 Aug. 1840, p. 1, col. 3.

51. Marcantonio's print was widely diffused (Bartsch, 245), and there was even a small print showing only the seated river god (Bartsch, 257). The Sistine Ceiling had also been reproduced in prints and books. See, for example, R. Duppa, *The Life of Michel Angelo Buonarroti,* pl. III.

52. "St. Louis Anniversary Celebration," *The Weekly Reveille,* 22 Feb. 1847, p. 1182, col. 1.

53. *The Commerce and Navigation of the Valley of the Mississippi,* p. 6, reports more than four thousand keel and flatboats in 1847.

54. Flint, *History and Geography of the Mississippi Valley,* vol. 1, pp. 152–53.

55. In this chapter, the interpretation of the pictures as showing evidence of labor differs from those who maintain that the pictures simply present leisure scenes. See, for example Stebbins, Troyen, and Fairbrother, *A New World,* p. 107; Jules D. Prown and Barbara Rose, *American Painting from the Colonial Period to the Present,* p. 80; J. T. Flexner, *That Wilder Image,* p. 127; and Alfred Frankenstein, "American Art and American Moods," p. 76.

56. *The Transfiguration* was widely reproduced in numerous prints after the whole and its parts. See Passavant, *Raphael d'Urbin et son père, Giovanni Santi,* vol. 2, pp. 297–98. John Burnet (whose books Bloch suggests that Bingham knew) reproduced Raphael's work in his *A Practical Treatise on Painting in Three Parts,* pl. 6.

The symmetrical pose of the dancing figure was soundly criticized by a New

York reporter for *The Literary World* ("The Art Union Pictures," *The Literary World* 2 [1847], 277). Bingham apparently took these criticisms to heart, for when he reiterated this composition—in *The Jolly Flatboatmen in Port* of 1857 (fig. 33) and *The Jolly Flatboatmen* of 1877/78 (fig. 67)—he adopted an asymmetrical pose based on the Roman statue of the drunken satyr, widely diffused in bronze copies (Bloch, *Evolution,* pp. 93–94).

57. "Morality of Labor," *The Weekly Tribune,* 16 May 1846, p. 1, col. 5.

58. Robert G. Gunderson, *The Log Cabin Campaign,* pp. 75–76. Switzler's *Missouri Statesman* repeatedly used images of a raccoon to accompany his partisan articles during the Clay campaign. All of these images appear in the inside cover of the first volume of the William F. Switzler Scrapbooks, 1844–1896, vol. 1 (1844–1855) in the Joint Collection, Columbia. At the convention nominating Clay in 1844, the Missouri delegation even brought boxes of live raccoons ("Convention Day," *Daily National Intelligencer,* 2 May 1844, p. 3, col. 3). For Clay and a raccoon on a campaign medal, see Edmund B. Sullivan, *American Political Badges and Medalets, 1789–1892,* p. 106. For images of Clay and raccoons on campaign banners and kerchiefs, see H. R. Collins, *Threads of History: Americana Recorded on Cloth, 1775 to the Present,* pp. 119 and 121.

59. Though the Whigs had endorsed the log cabin and hard cider campaign for William Henry Harrison, they were seen as "the party of temperance." See Daniel Howe, *The Political Culture of the American Whigs,* pp. 158–59.

 Raftsmen in particular suggests sources in genre painting different from the sources in Grand Manner art present in the earlier three river paintings. Bloch made comparisons with works by Boilly and Wilkie (*Evolution,* p. 99) but there are affinities as well with a peasant scene by Adrian von Ostade and *Checkerplayers* by James Burnet reproduced in Burnet's *Practical Treatise on Painting,* pl. 3, figs. 2 and 3. The still-life motif of jug and stick leaning against a box, common to Dutch genre scenes, appears in Ostade's work in Burnet's book.

60. *The Weekly Tribune,* 3 Oct. 1846, p. 1, col. 1.

61. Editorial, *Missouri Statesman,* 23 April 1847, p. 2, col. 3.

62. *The Commerce and Navigation of the Valley of the Mississippi,* pp. 1–30.

63. "Chicago Convention," *The Weekly Tribune,* 5 June 1847, p. 2, col. 2.

64. Chase, *History of Polk Administration,* p. 401.

65. VIGILANCE, "The Next Canvass," *Missouri Statesman,* 4 Feb. 1848, p. 3, col. 1.

66. Bloch, *Paintings,* pp. 196–97, nos. 253 and 254.

67. Bloch, *Paintings,* pp. 180–82, 188, 190, 196, and 204. The works showing boatmen ashore are no. 186, *St. Louis Wharf* (location unknown); no. 187, *The Wood Yard* (location unknown); no. 189, *Watching the Cargo* (Columbia, Mo., State Historical Society of Missouri); no. 190, *A Boatman* (location unknown) of 1849; no. 221, *The Wood Boat* (St. Louis, Art Museum), discussed in chapter 2; no. 225, *Mississippi Boatman* (private collection) of 1850; no. 252, *Fishing on the Mississippi* (Kansas City, Nelson-Atkins Museum) of 1851; no. 274, *Watching the Cargo by Night* (Denver, Museum of Western Art); and no. 275, *Western Boatmen Ashore by Night* (Fort Worth, Amon Carter Museum) of 1854.

68. *Bulletin of the American Art-Union,* 2 (Dec. 1849), p. 39, no. 218.

69. The steamboat *Kit Carson* that had serviced the Missouri River in 1848 was burned in a fire that swept the St. Louis wharf in May 1849. See "Tremendous

Conflagration," *Missouri Statesman,* 25 May 1849, in which the *Kit Carson* was valued at $14,000 with a cargo worth $3,000.

70. Bloch, *Paintings,* p. 181, notes that this work was at the Art-Union in New York by 1 Aug. 1849.

71. James Rollins' campaign for governor in 1848 had focused on internal improvements. See Mering, "Political Transition of Rollins," pp. 146–49. For Rollins' platform, see "To the People of Missouri," *The Weekly Tribune,* 19 May 1848, p. 1, cols. 2–6.

72. "To the People of Missouri," *The Weekly Tribune,* 19 May 1848, p. 1, col. 5.

73. "Grand Torchlight Demonstration," *Missouri Statesman,* 1 Dec. 1848, p. 2, col. 6.

74. See "Internal Improvements—Locofocos—A Change of Times Makes Change of Men," *Missouri Statesman,* 16 Nov. 1849, p. 1, col. 3, and "River and Harbor Improvements," *Missouri Statesman,* 11 Jan. 1850, p. 1, col. 6.

75. On the darker side of progress in nineteenth century America, see Marx, *Machine in the Garden,* and Fred Somkin, *Unquiet Eagle: Memory and Desire in the Idea of American Freedom, 1815–1860.*

76. Bloch, *Paintings,* p. 204, suggests the work was painted between February and April 1854 in Philadelphia, along with another nocturne, *Western Boatmen Ashore by Night* (Fort Worth, Amon Carter Museum). See "Letters" (1937–38), 179, letter of 16 April 1854, in which Bingham says he has just completed "two small pictures," without specifying their subjects.

77. See "The Differences," *Missouri Statesman,* 26 March 1852, p. 2, cols. 2–3; "Whig State Convention," *Missouri Statesman,* 30 April 1852, p. 1, cols. 5–7; "Baltimore Whig Convention," *Missouri Statesman,* 25 June 1852, p. 2, col. 4; and "National Whig Platform," *Missouri Statesman,* 2 July 1852. See also Donald B. Johnson, *National Party Platforms, 1840–1956,* vol. 1, p. 20.

78. "River and Harbor Bill," *Missouri Statesman,* 4 Aug. 1854, p. 2, col. 2, and "President's Message—Veto of the River and Harbor Bill," *Missouri Statesman,* 18 Aug. 1854, p. 2, col. 1.

79. "Letters," (1937–38), 353, letter of 3 June 1857.

80. The exception is the second *Jolly Flatboatmen* (fig. 67, Chicago, Terra Museum) of 1877/78 discussed in the final chapter.

81. Bloch, *Paintings,* p. 178, notes that the painting was completed by late Nov. 1847, but Bingham seems to have been planning it since May of 1847. See chapter 4.

Chapter Four: From Snags to Slavery

1. "Letters" (1937–38), 15, letter of 2 Nov. 1846.

2. W. F. S[witzler], "Whigs of Missouri in Council," *Missouri Statesman,* 7 April 1848, p. 2, cols. 1–3.

3. "Democratic State Convention," *Missouri Statesman,* 31 March 1848, p. 2, col. 4.

4. "Whig State Convention," *Missouri Statesman,* 14 April 1848, p. 2, col. 4, gives the Whig resolutions. The fourth and fifth resolutions had to do with internal im-

provements and federal funding thereof, the sixth had to do with education. See also J. B. Crockett, H. R. Gamble, and J. O'Fallon, "To the People of Missouri," *Missouri Statesman,* 12 May 1848, p. 1, cols. 1–4.

5. Numerous accounts of Rollins' speeches appeared in the *Missouri Statesman.* See, for example, "Major Rollins' Speech," 28 April 1848, p. 1, col. 5; "Major Rollins' Speech in Audrain," 29 April 1848, p. 2, col. 2; "Public Speaking," 6 May 1848, p. 2, col. 1; "Major Rollins in the Field," 19 May 1848, p. 2, cols. 3–4; "Gubernatorial Canvass," 26 May 1848, p. 2, cols. 4–5; "Major Rollins in Daviess County," 2 June 1848, p. 2, cols. 5–6; E Pluribus Unum, "Major Rollins' Speech in Livingston County," 9 June 1848, p. 2, col. 5; "Major Rollins' Speech in Linn County," 9 June 1848, p. 2, col. 5; "Rollins and King at Warsaw," 7 July 1848, p. 2, cols. 4–6; "Major Rollins in St. Louis," 25 July 1848, p. 2, col. 3.

6. For an excellent overview of the issue that shook the nation at this time and up to the Civil War, see David M. Potter, *The Impending Crisis, 1848–1861.*

7. "Letters" (1937–38), 11, letter of 21 Feb. 1841.

8. As a young Whig in 1841, Bingham had blasted "Col. Benton and his tools throughout the state, who have made it their business to hunt down every man who possessed independence enough to act without consulting the great 'Solitary and alone'" ("Letters" [1937–38], 12, letter of 21 Feb. 1841). The major biographies of Benton are William N. Chambers, *Old Bullion Benton,* and Elbert B. Smith, *Magnificent Missourian: The Life of Thomas Hart Benton.*

9. Bloch, *Paintings,* pp. 178–79, no. 181. Bloch notes that the work was finished "by late Nov. 1847." I will argue here that it was begun earlier in the year, sometime after May.

10. James C. Kelly, "Landscape and Genre Painting in Tennessee, 1810–1985," *Tennessee Historical Quarterly,* 44 (Summer 1985), 26–27.

11. "Paintings," *St. Louis Daily Missouri Republican,* 30 Nov. 1847, p. 2, col. 1.

12. S. W. Bailey, letter to Abiel Leonard, 5 May 1847, Abiel Leonard Papers, 1803–1947, folder 194, Joint Collection, Columbia.

13. Karl Arndt, *William Hogarth: Der Kupferstich als Moralische Schaubühne,* pls. 39a–39d.

14. "Paintings," p. 2, col. 1.

15. "Contested Election," *Missouri Statesman,* 2 Oct. 1846, p. 3, col. 1. Bingham had painted Sappington (Portland, Ore., Mrs. Lucia N. Skov) in 1844/45 before the two faced each other in the political arena. See Bloch, *Paintings,* pp. 168–69, no. 145.

16. "Contested Election from Saline County—Speech of George C. Bingham," *Missouri Statesman,* 22 Jan. 1847, p. 1, cols. 1–6, and p. 2, cols. 1–3, for quotations in the following two paragraphs.

17. Bingham had painted Marmaduke (St. Louis, Missouri Historical Society) in 1834 at the same time as he painted Marmaduke's parents-in-law, the Sappingtons. See Bloch, *Paintings,* p. 132, no. 5.

18. W. Shields, letter to M. M. Marmaduke, 7 Aug. 1846, Sappington Papers, Missouri Historical Society, St. Louis; and T. H. Harvey, letter to M. M. Marmaduke, 9 Aug. 1846, Sappington Papers, Missouri Historical Society, St. Louis. Harvey wrote: "I have just heard that Steen at this place [Arrow Rock] has never qualified as an American citizen." Mr. Steen was the first of the contested voters Bing-

ham discussed in his speech in his own defense. "Contested Election from Saline County," p. 1, col. 4.

19. A Looker On, "Letter to the Editor," *The Weekly Tribune,* 28 Nov. 1846, p. 2, col. 4.

20. For a smiliar positive reading of Bingham's election series, see chapter 5, and Gail E. Husch, "George Caleb Bingham's *The County Election:* Whig Tribute to the Will of the People," *The American Art Journal,* 19, no. 4 (1987), 5–22.

21. "Paintings," p. 2, col. 1.

22. One of Bingham's models, Dr. Oscar Potter, identified specific figures in two later works, *The Stump Orator* and *County Election.* See chapter 5.

23. "Paintings," p. 2, col. 1.

24. "The Fine Arts," *The Literary World,* 3 (1848), 350–51.

25. *Bulletin of the American Art-Union,* 1 (25 Nov. 1848), 29.

26. Mary Bingham, letter to Henry Vest Bingham, Jr., 1 Jan. 1849, Bingham Family Papers, 1814–1930, folder 14, in Joint Collection, Columbia.

27. Bingham declined the nomination in May ("Whig Meeting in Saline," *Missouri Statesman,* 12 May 1848, p. 1, col. 5), then reversed himself in June ("Letter from Marshall," *Missouri Statesman,* 7 July 1848, p. 2, col. 5.

28. "Letter from Marshall," p. 2, col. 5.

29. Missouri, General Assembly, *Journal of the Senate of the State of Missouri at the 15th Session of the General Assembly* (Jefferson City: Hampton Boon, 1848), pp. 41–43.

30. "Debate on the War," *Missouri Statesman,* 9 Feb. 1849, p. 1, col. 5.

31. Missouri, General Assembly, *Journal of the House of Representatives at the First Session of the 15th General Assembly,* p. 278.

32. "Portrait of Thomas H. Benton," *Jefferson Inquirer,* 17 Oct. 1844, p. 2, col. 2, and "Portrait of Col. Benton," *Jefferson Inquirer,* 3 March 1849, p. 3, col. 2. In the introductory comments to "Letters" (1938–39), 526, C. B. Rollins asserts that Bingham painted a portrait of Benton for the capitol, but I have found no corroborating evidence that he did.

33. The image appeared on a $50 bill of the Bank of the State of Missouri as early as 1846. I am grateful to Eric P. Newman and the Eric P. Newman Numismatic Education Society for a photocopy of one of these bills.

34. Bingham had painted Napton (private collection) around 1845 (Bloch, *Paintings,* p. 174, no. 168). Bloch now doubts the attribution to Bingham of a portrait of Jackson (Bloch, *Paintings,* pp. 262–63, no. 517).

35. The Jackson Resolutions appear in entirety in Switzler, *Switzler's Illustrated History of Missouri,* pp. 265–66.

36. Bingham painted Atchison (Columbia Mo., Mr. Jackson Atchison Wright) around 1843/44 (Bloch, *Paintings,* p. 164, no. 130).

37. See, for example, the view voiced in Switzler's newspaper: "Jackson's Resolutions," *Missouri Statesman,* 15 June 1849, p. 2, col. 2: "Rancorous and bitter enmity for Benton was their origin—to get him out of the Senate, and to get one of their members in his place."

38. The resolutions came to the House on Feb. 20. See Missouri, General Assembly, *Journal of the House . . . 15th General Assembly,* p. 352.

39. Groseclose, "Painting, Politics and George Caleb Bingham," 7.

40. A. B. Chambers, letter to G. F. M. Davis, 14 Aug. 1850, in "Letters of Application and Recommendation during the Administrations of James Polk, Zachary Taylor and Millard Fillmore, 1845–58," *Official Records of the U.S. Department of State,* Washington, D. C., National Archives Microfilm Publications, M 873, Roll 7, frame 494.

41. The document is reproduced in its entirety in "Majority Report of the Committee on Federal Relations," *Missouri Statesman,* 16 Mar. 1849, p. 1, col. 4. All the quotations in this and the following two paragraphs come from this source.

42. Potter, *Impending Crisis, 1848–1861,* pp. 57–59.

43. Benton was a long-standing advocate of the voice of the people. In 1824 he had introduced a bill to eliminate the electoral college and give a direct vote to the people in presidential elections. See *Annals of the Congress of the United States, 18th Congress, Dec. 1823–May 1824,* pp. 167–204.

44. James S. Rollins, letter to Thomas Hart Benton, 6 June 1849, James Sidney Rollins Collection, 1817–1937, folder 15, Joint Collection, Columbia.

45. "Colonel Benton's Speech," *Jefferson Inquirer,* 6 Oct. 1849, p. 3, col. 3: "But to appreciate this master effort of the Senator, and to justify its abrupt and daring tone, especially at the beginning, it is necessary to remember . . . the particular circumstances under which the speech was delivered;—a band of armed men present determine to insult and prepared to kill—actually commencing with concerted outrage upon him before he had spoken a word."

46. Benton, *Speech . . . at Fayette,* p. 1.

47. Benton, *Speech . . . at Fayette,* p. 31.

48. Benton, *Speech . . . at Fayette,* pp. 31–32, for this and the following quotation.

49. Bloch, *Paintings,* p. 180, no. 185.

50. *Transactions of the American Art-Union for the Year 1845* (New York: Evening Post, n.d.), p. 29 and no. 90. For an illustration, see Patricia Hills, *The Painters' America: Rural and Urban Life, 1810–1910,* p. 16. The painting is in the New York State Historical Association, Cooperstown, New York.

51. Bloch, *Evolution,* pp. 138–39.

52. *The Gift: A Christmas and New Year's Present for 1842,* opp. p. 99. The work was entitled "The Tough Story." As noted in chapter 1, Bingham had copied the image of Fanny Kemble as Beatrice from *The Gift* of 1836.

53. "Letters" (1937–38), 172, letter of 12 Dec. 1853.

54. Accompanying the print of Mount's painting in *The Gift . . . 1842* was a short story, "The Tough Yarn: or the Cause of Jack Robinson's Lameness," by Seba Smith, pp. 99–114. That story stressed that the two seated figures were indulging in mugs of "flip."

55. "The Missouri Artist," *St. Louis Daily Missouri Republican,* 17 April 1849, p. 2, col. 1.

56. Charles D. Drake, letter to James S. Rollins, 19 Feb. 1849, James Sidney Rollins Collection, 1817–1937, folder 14, Joint Collection, Columbia. The news of Benton's appeal became public late in March. See "Col. Benton Coming!" *Missouri Statesman,* 23 March 1849, p. 2, col. 2.

57. "Circus," *Missouri Statesman,* 29 Aug. 1851, p. 3, col. 4.

58. "Circuses," *Missouri Statesman,* 18 Aug. 1848, p. 2, col. 3.

59. Missouri, General Assembly, *Journal of the Senate . . . 15th General Assembly,* p. 111 (15 Jan. 1849).
60. Bloch, *Paintings,* p. 195, no. 249.
61. "Columbia Lyceum," *Missouri Statesman,* 4 Jan. 1850, p. 2, col. 4.
62. "Col. Benton's Remarks in the Senate," *Missouri Statesman,* 25 Jan. 1850, p. 2, cols. 5–6.
63. Bingham had painted Geyer (Columbia, University of Missouri School of Law) around 1839 (Bloch, *Paintings,* p. 154, no. 85).
64. "Missouri Legislature," *Missouri Statesman,* 17 Jan. 1851, p. 2, col. 5.
65. "Letters" (1937–38), 19–21, letter of 30 March 1851, for all quotations in this paragraph.
66. "Letter from Maj. James S. Rollins," *Missouri Statesman,* 7 Nov. 1851, p. 2, col. 5 for this and the following quotation.
67. "Letters" (1937–38), 22–23, letter of 24 Nov. 1851.
68. "'Jackson Resolutions'—The Sentinel," *Missouri Statesman,* 25 Feb. 1853.
69. "Important Letter from the Whig Candidate for Governor," from the *Boonville Observer, Missouri Statesman,* 11 June 1852, p. 2, col. 2; and "Important Letter from Mr. Winston," *The Weekly Tribune,* 18 June 1852, p. 1, col. 6.
70. "The Sentinel 'Jay-Hawked' on the Jackson Resolutions," *Missouri Statesman,* 18 March 1853, p. 2, col. 2.
71. "Letters" (1937–38), 24, letter of 27 June 1852; and "National Whig Platform," *Missouri Statesman,* 2 July 1852, p. 3, col. 1.
72. Switzler, *Switzler's Illustrated History of Missouri,* p. 276.
73. "Letters" (1937–38), 30, letter of 9 March 1853.
74. Perry McCandless, *A History of Missouri, vol. 2, 1820 to 1860,* p. 258, for this quotation and the following one.
75. "Legislature—Jackson Resolutions," *Missouri Statesman,* 5 March 1853, p. 2, col. 2.
76. "Letters," (1937–38), pp. 28–29, letter of 24 Jan. 1853.
77. "Letters" (1937–38), 167, letter of 7 Nov. 1853 for this quotation and those following in this paragraph and the next.
78. Switzler, *Switzler's Illustrated History of Missouri,* p. 277.
79. In 1852 there had been an acrimonious exchange in the *Missouri Statesman* between Benton and Shannon on the issue of slavery. See "Letter from Honorable Thomas H. Benton," 25 June 1852, p. 3, cols. 3–4; "President Shannon's Reply to Colonel Benton," 2 July 1852, p. 3, cols. 3–4; "Ex-Senator Benton to the People of Missouri," 6 Aug. 1852, p. 4, cols. 1–2; and "President Shannon's Reply," 6 Aug. 1852, p. 4, col. 2.
 Bingham painted both presidents of the university (Bloch, *Paintings,* p. 184, no. 203 of Lathrop, now lost; p. 194, no. 243 of Lathrop [Columbia, State Historical Society of Missouri]; p. 208, no. 288 of Shannon [Columbia, State Historical Society of Missouri]).
80. "The Fine Arts—George C. Bingham," *Missouri Statesman,* 18 Nov. 1853, p. 3, col. 1.
81. Groseclose, "Painting, Politics and George Caleb Bingham," pp. 10, 13.

Chapter Five: Free People and Free Institutions

1. George Caleb Bingham, letter to John Sartain, 4 Oct. 1852, Art and Artists Papers, 1807–1979, Missouri Historical Society, St. Louis. The correspondence between Bingham and Sartain was published by George R. Brooks, "George Caleb Bingham and 'The County Election,'" *Bulletin of the Missouri Historical Society,* 21 (1964), 36–43.
2. Bloch, *Paintings,* pp. 198–200, no. 259 and no. 260, pp. 203–05, no. 273 and no. 276.
3. William Gienapp, "'Politics Seem to Enter Everything': Political Culture in the North, 1840–1860," pp. 15–69.
4. Westervelt, "The Whig Painter of Missouri," 46–53; Groseclose, "Painting, Politics and George Caleb Bingham," 5–19; Groseclose, "Politics and American Genre Painting of the Nineteenth Century," 1210–17; Husch, "George Caleb Bingham's *The County Election:* Whig Tribute to the Will of the People," 5–22; and Groseclose, "The 'Missouri Artist' as Historian," in Shapiro et al., *George Caleb Bingham,* pp. 66–83. Less useful is Bryant, "George Caleb Bingham as a Whig Politician," 448–63.
5. Westervelt, "Whig Painter," 46 and 48.
6. Groseclose, "Painting, Politics and Bingham," 8 and 14.
7. Husch, "Bingham's *The County Election,*" especially 18.
8. Groseclose, "The 'Missouri Artist' as Historian," especially pp. 82–83.
9. "Letters" (1937–38), 494, letter of 9 Jan. 1860.
10. George Caleb Bingham, letter to Jonathan Dyer, 20 March 1862, in Mercantile Library, *Constitution of the St. Louis Lyceum,* microfilm roll 1. In this letter Bingham suggested that he had offered to donate the election series to the library and was miffed that the board had not accepted his offer. For the exhibition of two of the paintings in Philadelphia and St. Louis in 1860 and for their sale in 1865, see Bloch, *Paintings,* pp. 198–200, 203–05.
11. Bloch, *Paintings,* p. 197, no. 254.
12. "Letters" (1937–38), 21, letter of 30 March 1851.
13. Bloch, *Paintings,* p. 198, no. 256.
14. George C. Bingham, letter to Messers Goupil & Co., 31 Jan. 1852, collection M. Knoedler and Co., New York.
15. "New Works of Art by Bingham," *Missouri Statesman,* 31 Oct. 1851, p. 2, col. 4.
16. Bloch, *Evolution,* p. 156.
17. E. D. H. Johnson, *Paintings of the British Social Scene* (New York: Rizzoli, 1986), fig. 15, *An Election: Canvassing for Votes,* c. 1754, and fig. 99, *Chelsea Pensioners,* 1822. Both works circulated as prints. See Arndt, *William Hogarth: Der Kupferstich als moralische Schaubühne,* pl. 39b, and William J. Chiego, *Sir David Wilkie of Scotland (1785–1841),* p. 192.
18. *The Gift: A Christmas and New Year's Present for 1836,* pl. opp. p. 88. As noted in chapter 1, Bingham had copied the frontispiece of that book.
19. Groseclose, "Painting, Politics and Bingham," 8 and figs. 3 and 4.
20. Groseclose, "Politics and American Genre Painting," 1212 for this and the following quotation.
21. Chambers, *Old Bullion Benton,* p. 383.

22. J. B. Jones, *Life and Adventures of a Country Merchant,* p. 107. The book was first published in 1854.

23. McDermott, *George Caleb Bingham,* p. 91, thinks: "Without doubt it was working on that masterly study of one facet of the political scene, *Canvassing for a Vote,* that stirred Bingham to undertake *County Election* . . . , that made him rush from an electioneering to an election itself."

24. Bloch, *Paintings,* pp. 198–99.

25. John Wilmerding, *American Art,* p. 119, suggests affinities with Claude, Poussin, Hogarth, Wilkie, and Raphael.

26. "Letters" (1938–39), 72–73, letter of 19 June 1871.

27. Arndt, *William Hogarth,* pl. 39b (*Canvassing*) and pl. 39c (*Polling*).

28. Groseclose, "Painting, Politics and Bingham," 8; and Groseclose, "The 'Missouri Artist' as Historian," pp. 77–78.

29. The coin tosser appears to have been painted in after the work was finished, as the line of the fence behind him is clearly visible through the paint of his collar.

30. Groseclose, "The 'Missouri Artist' as Historian," p. 78, raised such questions. My interpretation is closer to Husch, "George Caleb Bingham's *The County Election,*" 18.

31. See Thomas Brown, Introduction in *Politics and Statesmanship,* p. 2, for a review of theories. See also Mering, *Whig Party,* p. 70, for his view on the elitism of the Missouri Whigs.

32. Gienapp, "'Politics Seem to Enter Everything,'" p. 38, citing Edward Everett who "insisted, when it came to upholding popular government, 'we are all democrats.'"

33. "Locofoco Dictionary," *Missouri Statesman,* 6 Oct. 1848, p. 1, col. 3.

34. Groseclose, "Painting, Politics and Bingham," 8; and Groseclose, "The 'Missouri Artist' as Historian," p. 78, where she characterized the inscription as having a Jacksonian tone.

35. "Speech of Mr. Bingham, of Saline," *Boon's Lick Times,* 8 Aug. 1840, p. 1, cols. 5–6.

36. McDermott, *George Caleb Bingham,* p. 92, quoting the St. Louis *Evening Intelligencer* as reprinted in the *Missouri Statesman,* 9 Jan. 1852.

37. Rusk, *Bingham,* pp. 35 and 43. Bingham painted a portrait of Potter in 1848 (St. Louis, Art Museum). See Bloch, *Paintings,* p. 179, no. 183.

38. This information derives from an image of *The County Election* annotated 15 Aug. 1912 by P. E. Spencer of St. Louis based on Dr. Oscar Potter's identifications. Dr. Richard Forry, of the Arrow Rock Historical Site, kindly provided me with photocopies of this annotated image and another of *Stump Speaking.*

39. "Contested Election from Saline County," *Missouri Statesman,* 22 Jan. 1847, p. 1, col. 2.

40. "Contested Election from Saline County," p. 1, col. 2.

41. Bloch, *Drawings of George Caleb Bingham,* fig. 93.

42. Sullivan, *American Political Badges and Medalets, 1789–1892,* pp. 41–43, for Whig buttons inscribed E PLURIBUS UNUM and TRUE WHIGS OF 76 AND 34.

43. "Contested Election from Saline County," p. 2, col. 3.

44. "Letters" (1937–38), 11, letter of 21 Feb. 1841.

45. "Soliciting a Vote," *The Gift . . . for 1836,* pp. 88–89.

46. "Contested Election from Saline County," p. 1, cols. 1–6 and p. 2, cols. 1–3. All the quotes that follow in this and the next three paragraphs come from this source.

47. "Letters" (1937–38), 22–24, letter of 24 Nov. 1851. The quotes that follow in this paragraph derive from this source.

48. Chambers, *Old Bullion Benton*, p. 383.

49. G. C. Bingham, letter to Messrs. Goupil and Co., 31 Jan. 1852, M. Knoedler and Co., New York. "My '*County Election*' has excited more interest than any of my previous productions, and my friends, here, propose to raise a sum which will enable me to publish it, in Superior Style, upon a large scale."

50. James S. Rollins, letter to A. S. Warner, 11 Jan. 1852, American Art-Union Papers, Letters Received, vol. 63, New-York Historical Society for all quotes in this paragraph. Courtesy of the New-York Historical Society.

51. George Caleb Bingham, letter to John Sartain, 4 Oct. 1852, Art and Artists Papers, 1807–1979, Missouri Historical Society, St. Louis.

52. The inscriptions first appear in the fourth proof of the print. The Boatmen's National Bank in St. Louis owns the plate and six different proofs of the print.

53. McDermott, *George Caleb Bingham*, p. 97, quoting the *Daily Picayune*, 18 March 1853.

54. McDermott, *George Caleb Bingham*, p. 99, with quote from the (Louisville) *Daily Courier*, 18 May 1853.

55. McDermott, *George Caleb Bingham*, p. 98, quoting from the (Louisville) *Daily Times*, 6 April 1853 for this and the following quotation.

56. McDermott, *George Caleb Bingham*, pp. 99–100, quoting from the (Lexington) *Kentucky Statesman*, 31 May 1853 for this and the quotations in this paragraph.

57. Bloch, *Paintings*, pp. 199–200, no. 260.

58. "Letters" (1937–38), 166, letter of 7 Nov. 1853.

59. "Letters" (1937–38), 174, letter of 26 Dec. 1853.

60. "Letters" (1937–38), 171, letter of 12 Dec. 1853.

61. See photograph of *Stump Speaking* annotated on 15 Aug. 1912 by P. E. Spencer of St. Louis.

62. "Letters" (1937–38), 171, letter of 12 Dec. 1853.

63. Groseclose, "Painting, Politics and Bingham," 9, explains the origin of the term. "The word, which is today spelled 'Bunkum,' became part of the American political vocabulary as a result of debate on the Missouri Compromise in 1820 when the Congressional representative for that North Carolina district refused to end discussion, droning on and on, as he said, 'for Buncombe.'"

64. "Letters" (1937–38), 171–72, letter of 12 Dec. 1853.

65. "Letters" (1937–38), 178, letter of 16 April 1854.

66. "Letters" (1937–38), 182, letter of 17 May 1854.

67. Bloch, *Paintings*, pp. 204–05, no. 282. See also "Letters" (1937–38), 179 (16 April 1854, his first idea for the painting), 182 (17 May 1854, beginning of the work), 188 (21 June 1855, completion of the painting), and 196 (2 June 1856, exhibition in Louisville).

68. Bloch, *Paintings*, pp. 206–07, no. 282.

69. "Bingham's Painting," *Missouri Republican*, 6 May 1856, p. 2, col. 1.

70. "Letters" (1937–38), 180, letter of 16 April 1854.

71. Groseclose, "Painting, Politics and Bingham," 14, read the inscription "Freedom for [Kans]as." More recently she reinterpreted it as "Freedom for Virtue. Remember the Ladies." See Groseclose, "The 'Missouri Artist' as Historian," p. 80. In one of the two prints, the inscription is different and may have been personalized for Rollins. See below in text.

72. W. J. Rorabaugh, *Alcoholic Republic,* pp. 200–201 and p. 201, n. 12, with reference to George W. Wells, *The Cause of Temperance, The Cause of Liberty.* See also Jed Dannenbaum, *Drunk and Disorder,* pp. 132–34.

73. Ian R. Tyrrell, *Sobering Up,* p. 260. For a contemporary recapitulation, see: "Prohibitory Liquor Law (from New York *Herald*)," *Pennsylvania Telegraph,* 14 April 1855, p. 3, col. 2.

74. Tyrrell, *Sobering Up,* pp. 211–18 and Ruth Bordin, *Woman and Temperance,* p. 5.

75. "Letters" (1937–38), 14, letter of 2 Nov. 1846.

76. "Sons of Temperance," *Missouri Statesman,* 25 Aug. 1848, p. 2, col. 3.

77. See Tyrrell, *Sobering Up,* pp. 261–64; Dannenbaum, *Drunk and Disorder,* p. 91; and William Gienapp, *Origins of the Republican Party, 1852–1856,* pp. 46–47.

78. Jones, *Life and Adventures of a Country Merchant,* p. 118, discusses the Maine Law.

79. See in the (Harrisburg) *Pennsylvania Telegraph:* "Temperance Legislation," 20 Jan. 1855, p. 2, col. 1; "The Sunday Liquor Law," 21 Feb. 1855, p. 2, col. 3; "Progress of Prohibition," 10 Mar. 1855, p. 2, col. 5; "The New Liquor Bill," 14 April 1855, p. 1, col. 1; and "Liquor Law Passed," 14 April 1855, p. 2, col. 6.

80. Cited by Rorabaugh, *Alcoholic Republic,* p. 215. The work was published in Amherst, Mass., 1828.

81. Gienapp, *Origins,* p. 47, citing the Ullmann papers, New-York Historical Society.

82. "Letters" (1937–38), 177, letter of 1 Feb. 1854.

83. "Letters" (1937–38), 180, letter of 16 April 1854.

84. McCandless, *History of Missouri,* p. 58 for the state's restrictive laws and for statistics on free blacks, pp. 65–66 for an analysis of the free black population in St. Louis.

85. Bloch, *Evolution,* p. 166, was the first to note this, without pushing further the implications of the source. W. H. Goetzmann and W. N. Goetzmann, *The West of the Imagination,* pp. 78–79, noted the debt to *The Dying Gaul* but read this figure as black when he is white and interpreted the black man with the wheelbarrow as a woman.

86. "Letters" (1937–38), 196, letter of 2 June 1856.

87. R., "President Shannon and His Discourses upon the Subject of Slavery," *Missouri Statesman:* "Number I," 18 Jan. 1856, p. 2, cols. 5–6; "Number II," 25 Jan. 1856, p. 2, cols. 1–2; "Number III," 8 Feb. 1856, p. 2, cols. 1–2. For Shannon's speech at the Lexington Convention, see "State Pro-Slavery Convention," *Missouri Statesman,* 29 June 1855, p. 2, col. 4; and "Pres. Shannon's Pro-Slavery Speech," *Missouri Statesman,* 6 July 1855, p. 2, col. 3.

88. R., "Pres. Shannon and His Discourses, Number I," 18 Jan. 1856, p. 2, col. 5, for this and following quotations in this paragraph. Bingham had owned a few slaves in the early 1850s, but by 1856 when he published these essays with their strong

stand against slavery, he no longer had slaves. See Paul Nagel, "The Man and His Times," in Michael E. Shapiro et al., *George Caleb Bingham,* pp. 40–41.

89. Bloch, *Evolution,* pp. 163–64, noting a reference to the Düsseldorf printing in *The Crayon,* 5 (Oct. 1858), 292, doubts that the work was produced by Goupil in 1869, as C. B. Rollins had suggested. For Bingham's earlier offer to Goupil and his subsequent touring of the painting, see "Letters" (1937–38), 188, letter of 21 June 1855 and 196, letter of 2 June 1856.

90. For an overview, see Mering, "Political Transition of James S. Rollins," 219–22.

91. Mering, "Political Transition of James S. Rollins," 221. Rollins stood strong on the Union but hedged on the issue of slavery.

92. An American, "Whig Meeting at the Capitol," *Missouri Statesman,* 14 Dec. 1855, p. 1, cols. 6–7.

93. "Letters" (1937–38), 195, letter of 2 June 1856.

94. "Letters" (1937–38), 348, letter of 14 Dec. 1856. At one point Bingham had said he might support the Know-Nothings in Missouri in order to oust the Democrats there ("Letters" [1937–38] 195, letter of 2 June 1856: "in Missouri I might support the American ticket as the surest mode of weakening the party which sustains the most unholy administration with which our country has ever been cursed.") On the Republican convention in Pittsburgh, see R. J. Bartlett, *John C. Frémont and the Republican Party,* pp. 10–11.

95. "Letters" (1937–38), 201, letter of 10 Aug. 1856 for this and all quotations in this paragraph.

96. For an overview of this period, see: Richard S. Brownlee, *Gray Ghosts of the Confederacy,* pp. 5–9.

97. "House Report no. 200: Kansas Affairs" in *Reports of Committees of the House of Representatives . . . 34th Congress, 1855–56* (Washington: Cornelius Wendell, 1856). The report was presented to the House on 2 July 1856 when it was ordered printed.

98. "House Report no. 200," p. 67.

99. "House Report no. 200," p. 10.

100. "Testimony of Norman Allen," in "House Report no. 200," p. 124.

101. "Testimony of Lyman Allen," in "House Report no. 200," p. 137.

102. "House Report no. 200," p. 11.

103. "Testimony of Dr. John Doy," in "House Report no. 200," p. 159.

104. "Letters" (1937–38), 349, letter of 14 Dec. 1856.

105. "Letters" (1937–38), 354, letter of 3 June 1857.

106. "Letters" (1937–38), 357, letter of 12 Oct. 1857.

Chapter Six: Bingham and Union

1. "Letters" (1937–38), 9, letter of [21] Dec. [1840].

2. "Letters" (1937–38), 32, letter of 5 July 1853.

3. "Letters" (1937–38), 178, letter of 1 Feb. 1854. The earliest mention came in a letter of 12 Dec. 1853 ("Letters" [1937–38], 172).

4. Bloch, *Paintings,* pp. 195–96, no. 251.

5. "Letters" (1937–38), 178, letter of 1 Feb. 1854. ("the great picture in the rotunda

may depend upon it. While you are in St. Louis, see how the Boone raffle is getting on.")

6. "Letters" (1937–38), 187, letter of 12 Jan. 1855.

7. McCandless, *History of Missouri,* pp. 267–68, and Missouri, General Assembly, *Journal of the Senate . . . at the 1st Session of the 18th General Assembly* (Jefferson City: James Lusk, 1855), pp. 48, 54–55, 58–60, 62–64, 70–74, 76, 130–36, 138, 146–47, 149–50, 202.

8. *Journal of the Senate . . . 18th General Assembly,* p. 43 on 3 Jan. 1855.

9. Ibid., p. 66 on 10 Jan. 1855 for this and the following quotation in this paragraph.

10. Missouri, General Assembly, *Journal of the House of Representatives . . . at the 18th General Assembly* (Jefferson City: James Lusk, 1855), p. 97 on 12 Jan. and p. 188 on 27 Jan. 1855.

11. *Journal of the Senate . . . 18th General Assembly,* p. 78 on 15 Jan. 1855.

12. Ibid., p. 204 on 13 Feb. 1855.

13. Ibid., p. 358 on 22 Feb. 1855.

14. "Missouri Legislature," *Missouri Statesman,* 19 Jan. 1855, p. 2, col. 2.

15. "George C. Bingham, Esq.," from the *Jefferson Inquirer, Missouri Statesman,* 23 Nov. 1855, p. 3, col. 4.

16. Missouri, General Assembly, *Journal of the House . . . at the Adjourned Session of the 18th General Assembly* (Jefferson City: James Lusk, 1855), p. 147, on 27 Nov. 1855; and "Missouri Legislature," *Missouri Statesman,* 7 Dec. 1855, p. 3, col. 4, reporting legislative action for 27 Nov.

17. Missouri, General Assembly, *Journal of the Senate . . . at the Adjourned Session of the 18th General Assembly* (Jefferson City: James Lusk, 1855), p. 197 on 8 Dec. 1855.

18. "Letters" (1937–38), 371, letter of 1 March 1859.

19. "Letters" (1937–38), 365, letter of 18 July 1858; and 369, letter of 21 Feb. 1859.

20. "Letters" (1937–38), 191, letter of 21 June 1855.

21. J. S. Rollins, letter to the secretary of state, 19 March 1849, in "Letters of Application and Recommendations during the Administrations of James Polk, Zachary Taylor and Millard Fillmore, 1845–1853," in *Official Records of the U.S. Department of State,* Washington, D.C., National Archives, Microfilm Publications M873, Roll 7, frame 476–77. This letter is the first in the file of recommendations for Bingham as consul that date between 19 March 1848 and 1 May 1851. See also Jonathan Miller, letter to James S. Rollins, 15 Oct. 1851, James Sidney Rollins Collection, 1817–1937, folder 17, Joint Collection, Columbia.

22. "Letters" (1937–38), 197, letter of 29 July 1856. The study of Jefferson is now in the State Historical Society of Missouri, Columbia. One of the portraits of Washington is in the Mercantile Library Association, St. Louis. See Bloch, *Paintings,* pp. 208–09, no. 289 (Jefferson) and no. 290 (Washington).

23. "Letters" (1937–38), 9–10, letter of [21] Dec. [1840].

24. Leah Lipton, *A Truthful Likeness,* pp. 76–77 and 114–15.

25. "Letters" (1937–38), 344, letter of 4 Nov. 1856.

26. In a letter of 4 Nov. 1856 ("Letters" [1937–38], 344), Bingham stated that he had "ordered a large canvass, 8 by 12 feet, for the portrait of Washington." When prepared and stretched, the "full length of 'The Father of his Country' [stood] up

six feet and a half in my studio." ("Letters," [1937–38], 348, letter of 14 Dec. 1856).

27. "Letters" (1937–38), 344, letter of 4 Nov. 1856.
28. "Letters" (1937–38), 359–60, letter of 8 March 1858.
29. "Letters" (1937–38), 360, letter of 8 March 1858.
30. Garry Wills, *Cincinnatus,* p. 168 and pl. 48.
31. Reproduced in *The United States Magazine and Democratic Review,* 18 (1846), 3.
32. "Letters" (1937–38), 364–65, letter of 18 July 1858 for quotations in this paragraph and the following one.
33. Bloch, *Paintings,* p. 21, citing *Proceedings of the 2d Convention of the National Art Association, held at the Smithsonian Institution,* Jan. 12, 13, 14, 1859, p. 8.
34. "Letters" (1937–38), 363, letter of 8 March 1858.
35. "Letters" (1937–38), 364, letter of 18 July 1858.
36. McCandless, *History of Missouri,* pp. 283–86.
37. "Letters" (1937–38), 367, letter of 23 Jan. 1859.
38. Missouri, General Assembly, *Journal of the Senate . . . at the 1st Session of the 20th General Assembly* (Jefferson City: Corwin, 1859), p. 230 on 11 Feb. 1859.
39. "Letters" (1937–38), 368–72, letters of 19 Feb., 21 Feb., 1 March, and 13 March 1859; and *Journal of the Senate . . . 20th General Assembly,* p. 375 on 4 March, p. 432 on 9 March, p. 458 on 10 March, and p. 486 on 12 March.
40. *Journal of the Senate . . . 20th General Assembly,* p. 241 on 14 Feb. 1859; and Missouri, General Assembly, *Journal of the House of Representatives . . . at the 1st Session of the 20th General Assembly* (Jefferson City: Corwin, 1859), p. 293 on 17 Feb. 1859.
41. *Journal of the Senate . . . 20th General Assembly,* pp. 264–65 on 18–19 Feb. 1859. "Patriotic," from the *Jefferson Examiner, Missouri Statesman,* 25 Feb. 1859, p. 4, col. 2, noted that Mr. Johnson introduced an appropriation of $2,000 for the Mt. Vernon Association, referring "'to the erection of the splendid portrait of WASHINGTON today, in the Senate chamber, as a suitable occasion'" to present such a bill.
42. "Geo. C. Bingham," from the *Missouri Statesman, The Weekly Tribune,* 18 March 1859, p. 1, col. 5.
43. Bloch, *Paintings,* p. 217, no. 321. See also *14th Annual Report of the Board of Directors of the St. Louis Mercantile Library Association* (St. Louis: Missouri Democrat Office, 1860), p. 25. Bingham delivered the painting in April 1860 and received payment for it in two installments, $600 in Oct. 1860 and $600 in April 1861. See *15th Annual Report of the Board of Directors of the St. Louis Mercantile Library Association* (St. Louis: Geo. Knapp, 1861), pp. 20–21; *Minute Book 1859,* Mercantile Library, Constitution of the St. Louis Lyceum, microfilm roll no. 1, entries for 2 Feb. 1860, 1 May 1860, and 29 Dec. 1860; and *Treasurer's Journal, 1846–1873,* Mercantile Library, St. Louis, p. 229, entry for 28 April 1860.
44. "Letters" (1937–38), 495, letter of 15 Sept. 1860.
45. "Letters" (1937–38), 494, letter of 9 Jan. 1860. Lee was the brother-in-law of Frank P. Blair of St. Louis.

46. "Letters" (1937–38), 495, letter of 15 Sept. 1860.
47. "Letters" (1937–38), 495, letter of 15 Sept. 1860.
48. "Celebration of the Eight of January," *Weekly Jefferson Inquirer,* 12 Jan. 1861, p. 4, col. 6.
49. "Senator Thompson on the Fine Arts," *The Weekly Tribune,* 1 Feb. 1861, p. 1, col. 3, for this and quotations following in this paragraph.
50. William Gerdts, "Natural Aristocrats in a Democracy," p. 28, notes that Daniel Fanshaw's review of an exhibition at the National Academy of Design in 1827 cited David's portrait as an example of "historical or poetic" portraiture.
51. "Letters" (1937–38), 497 and 504, letters of 27 Nov. and 9 Dec. 1860.
52. A writer for the *Missouri Statesman* had earlier noted: "Mr. Clay, he [Bingham] knew personally, and painted several fine portraits of him, one of them in our town, and said to be a most accurate and splendid likeness of this great statesman." See "Geo. C. Bingham," from the *Missouri Statesman, The Weekly Tribune,* 18 March 1859, p. 1, col. 5.
53. "The Convention," *The Boonville Observer,* 15 Oct. 1844, p. 2, col. 1.
54. "Letter from G. C. Bingham," *Daily Missouri Republican,* 14 Jan. 1861, p. 3, col. 3. Bingham sent this very full account of his speech to Nathaniel Paschall, editor of the St. Louis paper to express, as he wrote to Rollins, "a full exposition of my sentiments and views as they were delivered, and the motives which induced me to give them utterance." See "Letters" (1937–38), 505, letter of 12 Jan. 1861.
55. "Letter from G. C. Bingham," p. 3, col. 3, for all quotations in this and the next two paragraphs.
56. "From Jefferson City," *Daily Missouri Republican,* 9 Jan. 1861, p. 2, col. 2.
57. Missouri, General Assembly, *Journal of the Senate . . . at the 1st Session of the 21st General Assembly* (Jefferson City: Cheeney, 1861), pp. 65–66 on 9 Jan.; pp. 72–74 on 12 Jan.; pp. 87–89 on 16 Jan.
58. "Letters" (1937–38), 507, letter of 12 Jan. 1861.
59. "Letters" (1937–38), 506, letter of 12 Jan. 1861.
60. *Journal of the Senate . . . 21st General Assembly,* pp. 101–02 on 19 Jan. 1861.
61. *Journal of the Senate . . . 21st General Assembly,* p. 104.
62. "Letter from Lieutenant Governor Reynolds," *Daily Missouri Republican,* 18 Jan. 1861, p. 2, col. 3.
63. "Missouri Legislature," *Daily Missouri Republican,* 27 Jan. 1861, p. 3, cols. 2–3.
64. "Bingham, the Artist," *Daily Missouri Republican,* 17 Jan. 1861, p. 3, col. 8.
65. "Exhibition of Paintings," *Daily Missouri Republican,* 12 Feb. 1861, p. 3, col. 6.
66. Advertisement, *Daily Missouri Republican,* 12 Feb. 1861, p. 3, col. 9.
67. "Celebration of Washington's Birthday," *Daily Missouri Republican,* 22 Feb. 1861, p. 3, col. 7.
68. "Proceedings of the National Union Convention," *Daily Missouri Republican,* 4 Feb. 1861, p. 2, col. 2.
69. "Missouri State Convention," *Daily Missouri Republican,* 24 March 1861, p. 2, cols. 4–6.
70. "Letters" (1937–38), 517, letter of 5 June 1861.
71. For an overview of the period, see James M. McPherson, *Battle Cry of Freedom,* pp. 290–93. For greater detail on Missouri in the early years of the Civil War, see

Switzler, *Switzler's Illustrated History of Missouri,* pp. 303–443; and W. E. Parrish, *Turbulent Partnership.*

72. Switzler, *Switzler's Illustrated History,* p. 349.
73. Parrish, *Turbulent Partnership,* pp. 15–24.
74. Switzler, *Switzler's Illustrated History,* pp. 316–17.
75. Parrish, *Turbulent Partnership,* p. 25.
76. Ibid., pp. 26–32.
77. Switzler, *Switzler's Illustrated History,* pp. 333–34.
78. "Letters" (1937–38), 515, letter of 16 May 1861.
79. "Letters" (1937–38), 515–16, letter of 16 May 1861.
80. James Peckham, *General Nathaniel Lyon and Missouri in 1861,* p. 218, in which Bingham's letter is quoted.
81. "Letters" (1937–38), 516–17, letter of 5 June 1861.
82. "Letters" (1937–38), 521–33, letter of 29 June 1861.
83. Parrish, *Turbulent Partnership,* pp. 34–35.
84. "Letters" (1937–38), 521, letter of 29 June 1861.
85. "State Treasurer," *Daily Missouri Republican,* 6 Jan. 1862, p. 2, col. 1.
86. Parrish, *Turbulent Partnership,* pp. 136–38.
87. Published in Missouri, General Assembly, *Journal of the House of Representatives . . . at the 1st Session of the 22nd General Assembly* (Jefferson City: n.p., 1863), pp. 276–85.
88. "Special Dispatch to the Republican," *Daily Missouri Republican,* 24 Jan. 1863, p. 3, col. 4. See also Missouri, General Assembly, *Journal of the Senate . . . at the 1st Session of the 22nd General Assembly* (Jefferson City: n.p., 1863), pp. 271, 294, 303, 345, 355, 366; and *Journal of the House . . . 22nd General Assembly,* pp. 145–46, 157, 303, 414, 437, 463, 498.
89. "Special Dispatch to the Republican," p. 3, cols. 4–5 for this and the quotations in the next sentence.
90. "Missouri Legislature," *Daily Missouri Republican,* 18 Feb. 1863, p. 3, col. 1.
91. Eliza Bingham's letter to her sister of 7 Feb. 1863 is quoted extensively by Rusk, pp. 80–81.
92. Rusk, *Bingham,* pp. 80–81, quoting Eliza Bingham's letter to her sister, 7 Feb. 1863.
93. "Letters" (1938–39), 60, letter of 16 Feb. 1863.
94. Rusk, *Bingham,* p. 81, quoting letter of 7 Feb. 1863.
95. There was a resolution in 1863 that each member of the Legislature contribute $5 (*Journal of the House . . . 22nd General Assembly,* p. 303, on 17 Feb. 1863). On the subscriptions and on the sum raised in St. Louis, see: "Missouri Legislature," *Daily Missouri Republican,* 27 Nov. 1865, p. 1, col. 4. A report of the subscriptions is in Missouri, General Assembly, *Appendix to the House Journal of the Adjourned Session of the 23rd General Assembly* (Jefferson City: Emory S. Foster, 1865–66), pp. 855–56.
96. "Portrait of General Lyon," *Daily Missouri Republican,* 30 May 1863, p. 2, col. 2.
97. *Journal of the House . . . 22nd General Assembly,* p. 157, on 26 Jan. 1863.
98. "Death of General Lyon," *Daily Missouri Republican,* 19 June 1863, p. 3, col. 4. See other articles in the *Daily Missouri Republican:* "Work of Art," 19 April 1863, p. 1, col. 2; "Art Publication," 30 April 1863, p. 2, col. 1; "Death of General Lyon," 9 May 1863, p. 2, col. 1.

99. "Important to Artists," *Daily Missouri Republican,* 27 July 1863, p. 2, col. 2.

100. Bloch, *Paintings,* p. 221, no. 338. The work is in the collection of Mrs. Arnold A. Willcox, Bethesda, Md.

101. Bloch, *Evolution,* p. 214 and fig. 161. The work is in the collection of Mrs. Edwin H. Conrades, St. Louis.

102. See, for example, Ashbel Woodward, *Life of General Nathaniel Lyon,* frontispiece.

103. Copy of contract published in *Appendix to the House Journal of the Adjourned Session of the 23rd General Assembly,* p. 857.

104. *Appendix to the House Journal of the Adjourned Session of the 23rd General Assembly,* pp. 856–57, prints a letter from Bingham dated 24 Nov. 1865: "I have the canvas now ready, and have completed a small study to be used as my guide in the large picture. I inclose you a small photograph of this study, which please show to Jamieson and Johnson of St. Louis, and other friends of the work."

105. Missouri, General Assembly, *Journal of the House of Representatives of the State of Missouri at the 24th General Assembly* (Jefferson City: Emory Foster, 1867), pp. 432–33 on 27 Feb. 1867, p. 659 on 12 March 1867); Missouri, General Assembly, *Journal of the Senate of the State of Missouri at the 24th General Assembly* (Jefferson City: Emory Foster, 1867), p. 304 on 28 Feb. 1867, p. 423 on 11 March 1867.

106. *The Weekly Tribune,* 8 March 1867, p. 2, col. 1: The picture "represents Gen. Lyon at the Battle of Wilson Creek leading his men in to action, riding his favorite dapple grey, which was killed under him in the fight."

107. Switzler, *Switzler's Illustrated History,* p. 382.

108. *Harper's Weekly,* 31 Aug. 1861, cover on p. 545.

Chapter Seven: Bingham and Liberty

1. "Letter from G. C. Bingham," *Daily Missouri Republican,* 14 Jan. 1861, p. 3, col. 4.

2. "Letters" (1937–38), 185, letter of 29 May 1854.

3. For this period in Missouri history, see Brownlee, *Gray Ghosts of the Confederacy.*

4. Brownlee, *Gray Ghosts,* p. 49, citing U.S. War Department, *The War of Rebellion: A Compilation of the Official Records of the Union and Confederate Armies,* series 1, vol. 8, pp. 818–19.

5. "Letters" (1937–38), 520, letter of 29 June 1861.

6. G. C. Bingham, letter in "Jennison—His Raids in Missouri—His Murders, Robberies and Houseburnings," *Daily Missouri Republican,* 8 May 1862, p. 2, col. 1; Brownlee, *Gray Ghosts,* pp. 43–44.

7. Brownlee, *Gray Ghosts,* p. 10; see also pp. 40–41. Jennison had first commanded a local military unit early in 1861. In September he took command of the Seventh Kansas Volunteer Cavalry as a Lieutenant Colonel. It was this unit that became known as Jennison's Jayhawkers.

8. Brownlee, *Gray Ghosts,* p. 48.

9. "Letters" (1938–39), 46, letter of 22 Jan. 1862, for all the quotations in this paragraph.

52. "Reply of G. C. Bingham, Esq.," p. 1, col. 6.
53. "'Civil War'—A Stinging Letter from the Artist," p. 1, col. 2.
54. Bingham, *An Address to the Public,* p. 9.
55. "Bingham's Great Picture MARTIAL LAW," handbill.
56. "Bingham's Great Picture MARTIAL LAW," handbill.
57. Bingham, *An Address to the Public,* p. 4.
58. "'Civil War'—A Stinging Letter from the Artist," p. 1, col. 2, for all the quotations in this paragraph.
59. Bingham, *An Address to the Public,* p. 7.
60. Bingham, *An Address to the Public,* p. 8.
61. "Reply of G. C. Bingham Esq.", p. 1, col. 6.
62. Bingham, *An Address to the Public,* p. 10 for this and quotations following in this paragraph.
63. "Gen. Bingham's Letter," *St. Louis Post-Dispatch,* 26 June 1879, p. 3, col. 2.
64. On this period in Missouri history, see Parrish, "Reconstruction Politics in Missouri, 1865–1870," pp. 1–36. Also Parrish, *Missouri under Radical Rule, 1865–1870.*
65. Parrish, *Radical Rule,* p. 27.
66. Ibid., pp. 89–94.
67. "Candidates for Congress," *The Liberty Tribune,* 1 June 1866, p. 4, col. 2. Bingham eventually withdrew his name in the fall. See "Congressional Convention," *The Liberty Tribune,* 24 Aug. 1866, p. 2, col. 4, and "The Right Spirit," *Missouri Statesman,* 5 Oct. 1866, p. 2, col. 2.
68. "Grand Picnic of Clay County," *The Liberty Tribune,* 15 June 1866, p. 3, col. 1; notice, *The Liberty Tribune,* 29 June 1866, p. 2, col. 1; and "Phelps' Resolutions," *People's Tribune,* 11 July 1866, p. 3, cols. 4–5.
69. Notice, *The Liberty Tribune,* 29 June 1866, p. 2, col. 1.
70. "Phelps' Resolutions," p. 3, cols. 4–5. During the summer Bingham made other speeches against the militia which he alluded to in a letter to Rollins the following spring. See "Letters" (1938–39), 63, letter of 26 March 1867: "In some of my speeches last summer I denounced the Governor in pretty strong terms but he provoked it by tormenting us with his lawless and rogueish Militia."
71. Thomas S. Barclay, "The Test Oath for the Clergy in Missouri," discusses the oath as it affected the clergy, of whom some thirty-six were indicted.
72. Bloch, *Paintings,* pp. 223–24, no. 345, noted that the work at William Jewell College was a photograph touched with oil paint, correcting his earlier misimpression that this particular work was an oil painting (Bloch, *Catalogue,* p. 125).
73. "The Parson in His Cell," from the *Independence Sentinel, The Liberty Tribune,* 6 July 1866, p. 1, col. 3.
74. "The Preacher in His Cell," from the *St. Louis Dispatch, Missouri Statesman,* 6 July 1866, p. 3, col. 3. This article and the one in the preceding footnote refer to accounts in the *Independence Sentinel* and the *Independence Messenger.*
75. Robert S. Thomas was the first president of William Jewell College, a Baptist institution. The work descended in the family to Thomas' grandson William E. Thomas, whose widow donated it to the college. See *Report of the President of William Jewell College to Board of Trustees* (Liberty: William Jewell College,

1 Oct. 1940), p. 4. On the condition of the piece, see Ross E. Taggart, letter to Susan Pogany, Senior Curator, William Nelson Gallery of Art, 10 Feb. 1972: "Mr. Roth [James Roth, conservator, Nelson-Atkins Museum] and I have carefully examined the picture, the basis of which is a photograph. . . . It is not possible to tell if the painting was done by Bingham or not. On the other hand, there is nothing that is inconsistent with Bingham's technique. However, the lack of color makes it difficult to attribute."

76. "The Preacher in His Cell," p. 3, col. 3.
77. "The Parson in His Cell," p. 1, col. 3.
78. "Phelps' Resolutions," p. 3, col. 4.
79. Bingham, *An Address to the Public,* p. 14.
80. "Letters" (1938–39), 70, letter of 4 June 1871.
81. "Letters" (1938–39), 75, letter of 1 July 1871.
82. "Letters" (1938–39), 203, letter of 9 Dec. 1871.
83. See letters of 28 Sept., 29 Oct., and 14 Dec. 1873 in "Letters" (1938–39), 228–29, 349–52.
84. "Letters" (1938–39), 354–55, letters of 26 May and 7 June 1874.
85. *Biennial Report of the Adjutant General Acting Paymaster of Missouri for the Year 1875–76.*
86. On his candidacy for Congress, see "G. C. Bingham," *People's Tribune,* 16 Sept. 1874, p. 1, col. 4; and "Capt. Bingham Withdraws," *People's Tribune,* from Kansas City *Times,* 30 Sept. 1874, p. 1, col. 6. On his candidacy for governor, see letter of 7 Jan. 1872 and letters of March to May 1876, from Washington ("Letters" [1938–39], 206 and 357–69).
87. "Gen. Ewing's Missouri Order," *Missouri Republican,* 21 Feb. 1877, p. 5, col. 4.
88. *Missouri Republican,* 26 Feb. 1877, p. 5, cols. 3–4.
89. "Letters" (1938–39), 507, letter of 7 Feb. 1878.
90. "More of Brig. Gen. Tom Ewing's Deeds," *Washington Sentinel,* 9 March 1878, p. 1, col. 2.
91. G. C. Bingham, letter to James S. Rollins, 9 March 1878. James Sidney Rollins Collection, 1817–1937, Joint Collection, Columbia.
92. G. C. Bingham, letter to James S. Rollins, 11 March 1878, James Sidney Rollins Collection, 1817–1937, Joint Collection, Columbia.
93. G. C. Bingham, letter to James S. Rollins, undated, after 4 March 1878, James Sidney Rollins Collection, 1817–1937, Joint Collection, Columbia.
94. In letters of 17 and 20 March 1878, Bingham specifically admonished his friend not to worry so much (G. C. Bingham, letters to James S. Rollins, James Sidney Rollins Collection, 1817–1937, Joint Collection, Columbia).
95. G. C. Bingham, letter to James S. Rollins, 10 April 1878, James Sidney Rollins Collection, 1817–1937, Joint Collection, Columbia.
96. Editorial, *The Daily Mail,* 6 June 1879, p. 2, col. 1. See also "The Ohio Ticket" and "Ewing and Rice," *The Daily Mail,* 5 June 1879, p. 2, cols. 1–2.
97. "Order No. 11," *The Daily Mail,* 13 June 1879, p. 2, col. 2.
98. The correspondence in the *St. Louis Post-Dispatch* is as follows: "B. Gratz Brown," 16 June 1879, p. 2, col. 3; "Gen. Bingham's Letter," 26 June 1879, p. 3, cols. 2–3; "That Order No. 11," 28 June 1879, p. 2, cols. 3–4; and "Voice from the Grave," 23 July 1879, p. 2, cols. 4–6.

Epilogue: The Empty Studio

1. "For the Ex-Confederates," *The Kansas City Star,* 18 March 1893, p. 5, cols. 1–2; and "The Bingham Paintings Sold," *The Kansas City Star,* 25 March 1893, p. 1, col. 6. In 1867 Bingham had participated in a fund-raising barbecue for a home for the widows and orphans of the ex-Confederates, as he put it, "to bring about a fraternal feeling in place of the animosities engendered by the war." See "Letters" (1938–39), 64, letter of 10 July 1867. In 1866 his third wife, Mattie Lykins Bingham, had founded a Widow and Orphans Home Society for ex-Confederates, of which she remained president until 1874. See Barns, ed., *Commonwealth of Missouri,* pp. 770–71.

2. Bloch, *Paintings,* p. 240, no. 412.

3. "Letters" (1938–39), 72–74, letter of 19 June 1871; George C. Bingham, *An Address to the Public;* and George C. Bingham, "Art, the Ideal of Art, and the Utility of Art," in McDermott, *George Caleb Bingham,* pp. 394–401.

4. "Letters" (1938–39), 72, letter of 19 June 1871.

5. Bingham, *An Address to the Public,* p. 3.

6. Bingham, "Art, the Ideal of Art, and the Utility of Art," in McDermott, p. 401.

7. "Letters" (1938–39), 73, letter of 19 June 1871.

8. Bingham wrote in Aug. 1878 that he wanted to have his "most valuable pictures" in his studio at Columbia and would like to see them placed in an art gallery at the university once the addition to the Art Building was finished. See "Letters" (1938–39), 513, letter of 25 Aug. 1878.

9. Bloch, *Paintings,* pp. 227, no. 359 (his son, Rollins Bingham), pp. 246–47, no. 440 (Eliza Thomas Bingham?), no. 441 (Mattie Lykins Bingham), and no. 444 (James Sidney Rollins). The painting of Bingham's son is in the collection of Mrs. William C. Branton, Kansas City. The locations of the other portraits are not known.

10. Bloch, *Paintings,* pp. 247, nos. 442–43 (Mr. and Mrs. McCoy) and pp. 229–30, no. 369 (Francis P. Blair). The painting of Blair is in the Brooklyn Museum. The locations of the McCoy portraits are not known.

11. Bloch, *Paintings,* pp. 241, no. 414 (*Palm Leaf Shade*), and p. 245, no. 433 (*Bathing Girl*). The first painting is in the collection of George W. Stier, Lexington, Missouri, while the location of the second is unknown.

12. Bloch, *Paintings,* pp. 240–41, no. 413.

13. "The Art-Union Pictures," *The Literary World,* 2 (23 Oct. 1847), 277.

14. "For the Ex-Confederates," p. 5, col. 2.

15. Bloch, *Paintings,* pp. 206–07, no. 282.

16. Bloch, *Paintings,* pp. 210–11, no. 299.

17. "Letters" (1938–39), 356, letter of 9 March 1876.

18. "Letters" (1937–38), 172 and 178, letters of 12 Dec. 1853 and 1 Feb. 1854.

19. "Letters" (1937–38), 187, letter of 12 Jan. 1855.

20. "Letters" (1938–39), 206, letter of 7 Jan. 1872. The first notice of the beginning of the work appeared in "Washington Crossing the Delaware," *Missouri Statesman,* 14 March 1856, p. 3, col. 4.

21. Bingham gave the copy to Rollins and Col. R. B. Price in 1878 to repay them for their subsidy of the engraving. See Bloch, *Paintings,* p. 225.

22. "Letters" (1938–39), 354 n. 5, letter of 26 May 1874.

23. Bloch, *Paintings,* p. 234, no. 390, and Bloch, *Evolution,* pp. 239–40, who connected it with his career on the Police Board.

24. Bloch, *Evolution,* p. 239, n. 130 (with reference to *Missouri Republican,* 29 Nov. 1874, p. 8) and p. 240, n. 131 (with reference to *Missouri Statesman,* from the *St. Louis Republican,* 11 Dec. 1874, p. 1, col. 5).

25. "Letters" (1938–39), 354–55, letters of 26 May 1874 and 7 June 1874.

26. "Letters" (1938–39), 207, letter of 7 Jan. 1872.

27. "Letters" (1938–39), 378–79, letter of 14 Dec. 1876, for this and the following quotation in this paragraph.

28. For the election crisis of 1876, see Eric Foner, *Reconstruction,* especially pp. 570–82; C. Vann Woodward, *Reunion and Reaction;* and Woodward, *Origins of the New South, 1877–1913.* For a still valuable detailed account of the crisis, see William Archibald Dunning, *Reconstruction Political and Economic, 1865–1877,* pp. 304–41.

29. "Letters" (1938–39), 376–77, letter of 3 Dec. 1876.

30. "Something New," *People's Tribune,* 20 Dec. 1876, p. 2, col. 2, for this and subsequent quotation in this paragraph.

31. "The Old Whig and New Democratic Party," *Missouri Statesman,* 28 Dec. 1877, p. 2, col. 1, where Switzler asserts that there would be no Democratic party in Missouri were it not for Whigs like Rollins, Bingham, Mordecai Oliver, and A. W. Doniphan.

32. *Boonville Weekly Advertiser,* 19 Jan. 1877, p. 4, col. 3.

33. "Letters" (1938–39), 379, letter of 14 Dec. 1876.

34. Missouri, General Assembly, *Journal of the House of Representatives of the 29th General Assembly of the State of Missouri, regular session* (Jefferson City: Regan and Carter, 1877), pp. 458–59 on 6 March 1877.

35. *Journal of the House of Representatives of the 29th General Assembly,* p. 574 on 21 March 1877.

36. "Compliment to General Bingham," *Daily Tribune,* 22 March 1877, p. 1, cols. 4–5, reporting legislative action on 21 March 1877.

37. "Jefferson City," *Daily Journal of Commerce,* 22 March 1877, p. 1, col. 3.

38. "Letters" (1938–39), 380, letter of 18 April 1877.

39. On his later years, see Bloch, *Evolution,* pp. 247–53.

40. Typescript, p. 3, in North Todd Gentry Papers, 1803–1947, folder 15, Joint Collection, Columbia.

41. Parrish, pp. 319–21.

42. "General Bingham's Lecture," *Missouri Statesman,* 7 March 1879, p. 2, col. 3.

43. "Letters" (1938–39), 368–69, letter of 25 June 1876.

Bibliography

Primary Sources: Manuscripts

Historical Society of Pennsylvania, Philadelphia. Letter Press Book, 1869–1871. Harriet Sartain Collection.
———. John Sartain Papers, 1771–1929.
Joint Collection University of Missouri Western Historical Manuscript Collection–Columbia and State Historical Society of Missouri Manuscripts. Abiel Leonard Collection, 1786–1909.
———. Alvord Collection, 1760–1962.
———. Bingham Family Papers, 1814–1930.
———. James Sidney Rollins Collection, 1817–1937.
———. Missouri State Archives.
———. North Todd Gentry Papers, 1803–1947.
———. William F. Switzler Scrapbooks, 1844–1896.
M. Knoedler and Co., New York. George C. Bingham, letter to Messrs. Goupil and Co., 31 Jan. 1855.
Missouri Historical Society, St. Louis. Art and Artists Collection, 1807–1979.
———. Hamilton R. Gamble Papers, 1787–1964.
———. Sappington Family Papers, 1810–1978.
New-York Historical Society, New York City. American Art-Union Papers. Letters from Artists, Letters Received, and Letter Press Book.
Official Records of the United States Department of State, Washington D.C., National Archives. Letters of Application and Recommendations during the Administrations of James Polk, Zachary Taylor, and Millard Fillmore, 1845–1853. Microfilm Publications, M873, Roll 7.
St. Louis Mercantile Library Association, St. Louis. Constitution of the St. Louis Lyceum, Microfilm Roll 1.
———. Minute Book 1859.
———. Treasurer's Journal, 1846–73.

Primary Sources: Newspapers and Periodicals

PERIODICALS
Bulletin of the American Art-Union, 1848–51.
Frank Leslie's Illustrated Newspaper, 1863.
Harper's Weekly, 1863.
The Literary World, 1847–48.
New-York Mirror, 1838.
Transactions of the American Art-Union for the Promotion of the Fine Arts in the United States . . . , 1844–49.

Transactions of the Apollo Association for the Promotion of Fine Arts in the United States . . . , 1840–43.
The United States Magazine and Democratic Review, 1846.

NEWSPAPERS
Boonville, Mo.
 Boonville Observer.
 Boonville Weekly Advertiser.
Columbia, Mo.
 Missouri Intelligencer.
 Missouri Statesman. Published under this title from 1843 through 17 Oct. 1851.
 Thereafter published as *Weekly Missouri Statesman* from 24 Oct. 1851 to
 1860 and as *Columbia Missouri Statesman* from 1861 to April 1905.
Fayette, Mo.
 Boon's Lick Times.
Harrisburg, Pa.
 Pennsylvania Telegraph.
Jefferson City, Mo.
 Daily Tribune.
 Jefferson Inquirer.
 Jeffersonian Republican.
 Metropolitan.
 People's Tribune.
Kansas City, Mo.
 Kansas City Journal of Commerce.
 Kansas City Mail.
 Kansas City Star.
 Kansas City Western Journal of Commerce.
Liberty, Mo.
 Liberty Tribune.
Marshall, Mo.
 Saline County Progress.
New York City, N.Y.
 New York Express.
 New York Herald.
 New York Tribune.
St. Louis, Mo.
 Daily Commercial Bulletin.
 Daily Missouri Republican.
 St. Louis Post-Dispatch.
 Weekly Reveille.
Washington, D.C.
 National Intelligencer.
 Washington Sentinel.

Primary Sources: Books and Pamphlets

Annals of the Congress of the United States, 18th Congress, Dec. 1823–May 1824. Washington: Gales and Seaton, 1856.

Barns, C. R., ed. *The Commonwealth of Missouri.* St. Louis: Bryan, Brand, 1877.

Benton, Thomas H. *Thirty Years View.* 2 vols. New York: Appleton, 1860.

———. *Speech of the Hon. Thos. H. Benton, delivered at Fayette, Howard County, Missouri, on Saturday, the First of September, 1849.* Jefferson City: James Lusk, 1849.

Biennial Report of the Adjutant General Acting Paymaster, State of Missouri, for the Year 1875–76. Jefferson City: Regan and Carty, 1877.

Bingham, George Caleb. *An Address to the Public Vindicating a Work of Art Illustrative of the Federal Military Policy in Missouri during the Late Civil War.* Kansas City: n.p., 1871.

———. "Letters of George Caleb Bingham to James Sidney Rollins." Ed. C. B. Rollins. *Missouri Historical Review,* 32 (1937–38), 3–34, 164–202, 340–77, and 484–522, and *Missouri Historical Review,* 33 (1938–39), 45–78, 203–29, 349–84, and 499–526.

Bingham, Henry Vest. "The Diary of Henry Vest Bingham: The Road West in 1818." Ed. Marie Windell. *Missouri Historical Review,* 40 (1945–46), 21–54, 174–204.

Bingham, Mattie Lykins. "Recollections of Old Times in Kansas City: The Journal of Mattie Lykins Bingham." *Kansas City Genealogist,* 25, nos. 3–4 (1985), 112–17.

Bingham's Great Picture MARTIAL LAW. N.p.: Courier Journal Printing, n.d.

Burnet, John. *A Practical Treatise on Painting in Three Parts.* 2d ed. London: James Carpenter, 1828.

Bushnell, Rev. Horace. *Barbarism: The First Danger.* New York: Home Missionary Society, 1847.

Catlin, George. *Drawings of the North American Indian.* Introd. Peter Hassrick. Garden City, N.Y.: Doubleday, 1984.

Cattermole, Richard. *The Book of the Cartoons.* London: J. Rickerby, 1837.

Chase, Lucien. *History of the Polk Administration.* New York: Putnam, 1850.

The Commerce and Navigation of the Valley of the Mississippi . . . considered with reference to the Improvement by the General Government of the Mississippi River and its principal tributaries. St. Louis: Chambers and Knapp, 1847.

Congressional Globe, 1842 and 1845.

Darley, F. O. C. *Scenes in Indian Life.* Philadelphia: J. R. Colon, [1843].

Duppa, R. *The Life of Michel Angelo Buonarroti.* 2d ed. London: John Murray, 1807.

Flint, Timothy. *History and Geography of the Mississippi Valley.* 2 vols in 1. 2d ed. Cincinnati: E. H. Flint and L. R. Lincoln, 1832.

The Gift: A Christmas and New Year's Present for 1836. Philadelphia: Carey and Hart, 1835.

The Gift: A Christmas and New Year's Present for 1842. Philadelphia: Carey and Hart, 1841.

Gliddon, George. *Ancient Egypt: Her Monuments, Hieroglyphics, History and Archeology.* New York: J. Winchester, 1844.

Greeley, Horace. *Why I Am a Whig.* New York: The Tribune Office, 1851.

"House Report No. 200: Kansas Affairs." In *Reports of Committees of the House of Representatives . . . 34th Congress, 1855–56.* Washington: Cornelius Wendell, 1856.

Irving, Washington. *Astoria.* 2 vols. Philadelphia: Carey, Lea and Blanchard, 1836.

Jones, J. B. *Life and Adventures of a Country Merchant.* Rpt. Philadelphia: J. B. Lippincott, 1877 [1854].

Linn, E. A. and N. Sargent. *The Life and Public Services of Dr. Lewis F. Linn.* New York: Appleton, 1857.

Littell, John S. *The Clay Minstrel: or, National Songster.* 2d ed. New York: Greeley and M'Elrath, 1844.

McKenney, Thomas L., and James Hall. *History of the Indian Tribes of North America.* Vol. 2. Philadelphia: Rice and Clark, 1842.

Mallory, D., ed. *The Life and Speeches of Henry Clay.* 2 vols. 5th ed. New York: Van Amringe and Bixby, 1844.

Marshall, Humphry. *The History of Kentucky.* 2 vols. in 1. 2d ed. Frankfort, Ky.: Geo. S. Robinson, 1824.

Memorial of the Citizens of St. Louis Missouri to the Congress of the United States praying an appropriation for removing obstructions to the navigation of the western rivers, for the improvement of the St. Louis harbor, and for other purposes. St. Louis: Chambers and Knapp, 1844.

Missouri, General Assembly, *Journal of the House of the State of Missouri . . . ,* 1845–77.

———. *Journal of the Senate of the State of Missouri . . . ,* 1845–77.

The National Clay Almanack . . . , 1845. Philadelphia: W. A. Leary, 1844.

Passavant, J. D. *Raphael d'Urbin et son père, Giovanni Santi.* 2 vols. Paris: Renouard, 1860.

Peckham, James. *General Nathaniel Lyon and Missouri in 1861.* New York: American News, 1866.

Porter, William T. *The Big Bear of Arkansas and Other Sketches.* Philadelphia: Carey and Hart, 1845.

Proceedings of the St. Louis Chamber of Commerce in relation to the Improvement of Navigation of the Mississippi River and Its Principal Tributaries and the St. Louis Harbor. St. Louis: Chambers and Knapp, 1842.

Rosellini, I. *I Monumenti dell'Egitto e della Nubia.* Pisa: N. Capurro, 1834.

St. Louis Mercantile Library Association. *Fourteenth Annual Report of the Board of Directors of the St. Louis Mercantile Library Association.* St. Louis: Missouri Democrat Office, 1860.

———. *Fifteenth Annual Report of the Board of Directors of the St. Louis Mercantile Library Association.* St. Louis: Geo. Knapp, 1861.

Thomas, Lewis F., and J. C. Wild. *The Valley of the Mississippi Illustrated.* 1841; reproduction. St. Louis: Joseph Garnier, 1948.

Wells, George W. *The Cause of Temperance, The Cause of Liberty.* Kennebunk, Me.: James K. Remich, 1835.

Woodward, Ashbel. *Life of General Nathaniel Lyon.* Hartford: Case, Lockwood, 1862.

Secondary Sources

Adams, Henry. "A New Interpretation of Bingham's *Fur Traders Descending the Missouri." Art Bulletin,* 65 (1983), 675–80.

———. Letter. "Bingham and His Sources." *Art Bulletin,* 66 (1984), 515.

Arndt, Karl, ed. *William Hogarth: Der Kupferstich als moralische Schaubühne.* Stuttgart: Verlag Gerd Hatje, 1987.

Barclay, Thomas. "The Test Oath for the Clergy in Missouri." *Missouri Historical Review,* 18 (1924), 345–81.

Bartlett, R. J. *John C. Frémont and the Republican Party.* Columbus: Ohio State University Press, 1930.

Bartsch, Adam von. *The Illustrated Bartsch 26 (formerly Volume 14, part 1): The Works of Marcantonio Raimondi and of His School.* Ed. Konrad Oberhuber. New York: Abaris, 1978.

Behrendt, Stephen C. "Originality and Influence in George Caleb Bingham's Art." *Great Plains Quarterly,* 5 (1985), 24–38.

Bloch, E. Maurice. "Art in Politics." *Art in America,* 33 (1945), 93–100.

———. *The Drawings of George Caleb Bingham.* Columbia: Univ. of Missouri Press, 1975.

———. *George Caleb Bingham: A Catalogue Raisonné.* Berkeley: Univ. of California Press, 1967.

———. *George Caleb Bingham: The Evolution of an Artist.* Berkeley: Univ. of California Press, 1967.

———. *The Paintings of George Caleb Bingham.* Columbia: Univ. of Missouri Press, 1986.

Bordin, Ruth. *Woman and Temperance: The Quest for Power and Liberty, 1873–1900.* Philadelphia: Temple Univ. Press, 1981.

Brooks, George R. "George Caleb Bingham and 'The County Election.'" *Missouri Historical Society Bulletin,* 21 (Oct. 1964), 36–43.

Brown, Glenn. *History of the United States Capitol.* 2 vols in 1. 1900 and 1903, rpt. New York: Da Capo, 1970.

Brown, Thomas. *Politics and Statesmanship: Essays on the American Whig Party.* New York: Columbia Univ. Press, 1985.

Brownlee, Richard S. *Gray Ghosts of the Confederacy: Guerrilla Warfare in the West, 1861–1865.* Baton Rouge: Louisiana State Univ. Press, 1958.

Bryant, Keith. "George Caleb Bingham: The Artist as a Whig Politician," *Missouri Historical Review,* 59 (1964–65), 448–63.

Callow, James T. *Kindred Spirits: Knickerbocker Writers and American Artists, 1807–1855.* Chapel Hill: Univ. of North Carolina Press, 1967.

Campbell, Tom W. *Two Fighters and Two Fines.* Little Rock: Pioneer Publishing, 1941.

Carmer, Carl, ed. *Songs of the Rivers of America.* New York: Farrar and Rinehart, 1942.

Castel, Albert. "Order No. 11 and the Civil War on the Border." *Missouri Historical Review,* 54 (1962–63), 357–66.

Chambers, William N. *Old Bullion Benton: Senator from the New West.* Boston: Little, Brown, 1956.

Chiego, William J. *Sir David Wilkie of Scotland (1785–1841).* Raleigh: North Carolina Museum of Art, 1987.

Chittenden, H. M. *The American Fur Trade of the Far West.* Rpt. Stanford: Academic Reprints, 1954 [1902]. Vols. 1 and 2.

———. *Early Steamboat Navigation on the Mississippi River.* Vol. 1. New York, Francis P. Harper, 1903.

Christ-Janer, Albert. *George Caleb Bingham: Frontier Painter of Missouri.* New York: Abrams, [1975].

———. *George Caleb Bingham of Missouri: The Story of an Artist.* New York: Dodd, Mead, 1940.

Cikovsky, Nicolai, Franklin Kelly, and Nancy Rivard Shaw. *American Paintings from the Manoogian Collection.* Washington, National Gallery of Art, 1989.

Clark, Carol. "Charles Deas." *American Frontier Life: Early Western Paintings and Prints.* New York: Abbeville, 1987, pp. 51–77.

Clark, H. Nichols B. *The Impact of Seventeenth Century Dutch and Flemish Genre Painting, 1800–1865.* Diss. University of Delaware 1982. Ann Arbor: Univ. Microfilms, 1987.

Cole, Donald B. *Martin Van Buren and the American Political System.* Princeton: Princeton Univ. Press, 1984.

Collins, Charles D. "A Source for Bingham's *Fur Traders Descending the Missouri.*" *Art Bulletin,* 66 (1984), 678–81.

Collins, Herbert R., *Threads of History: Americana Recorded on Cloth, 1775 to the Present.* Washington: Smithsonian Institution Press, 1979.

Conard, H. L., ed. *Encyclopedia of the History of Missouri.* Vols. 1 and 5. New York: Southern History, 1901.

Cooney, John D. "Acquisition of the Abbott Collection." *Bulletin of the Brooklyn Museum,* 10, no. 3 (1949), 17–23.

Corn, Wanda. "Coming of Age: Historical Scholarship on American Art." *Art Bulletin,* 70 (1988), 199–201.

Cowdrey, M.[ary] B., comp. *American Academy of Fine Arts and American Art-Union.* 2 vols. New York: New-York Historical Society, 1953.

Craven, Wayne. "The Grand Manner in Early Nineteenth-Century American Painting: Borrowings from Antiquity, the Renaissance, and the Baroque." *The American Art Journal,* 11 (1979), 5–43.

Dannenbaum, Jed. *Drunk and Disorder: Temperance Reform in Cincinnati from the Washingtonian Revival to the WCTU.* Urbana: Univ. of Illinois Press, 1984.

Demos, John. "George Caleb Bingham: The Artist as Social Historian." *American Quarterly,* 17 (1965), 218–28.

Dickerson, Philip. *History of the Osage Nation.* Pawhuska, Okla.: n.p., 1906.

Downes, William H. "The Missouri Artist." *The Art Interchange,* 36, no. 6 (1896), 130–32.

Dunning, William Archibald. *Reconstruction Political and Economic, 1865–1877.* Rpt. New York: Harper Torchbooks, 1962 [1907].

Ehrlich, George, "George Caleb Bingham as Ethnographer: A Variant View of His Genre Work." *American Studies,* 19 (Fall 1978), 41–55.

Fairman, Charles. *Art and Artists of the Capitol of the United States of America.* Washington: United States Government Printing Office, 1927.

Flexner, J. T. *That Wilder Image.* New York: Bonanza, 1970.

Frankenstein, Alfred. "American Art and American Moods." *Art in America,* 54 (1966), 76–87.

Foner, Eric. *Reconstruction: America's Unfinished Revolution, 1863–1877.* New York: Harper and Row, 1988.

Fuchs, R. H. *Dutch Painting.* London: Thames and Hudson, 1978.

Gerdts, William H. "Natural Aristocrats in a Democracy: 1810–1870." In *American Portraiture in the Grand Manner, 1720–1920.* Ed. Michael Quick. Los Angeles: Los Angeles County Museum, 1981, pp. 27–60.

Gerdts, William H., and Theodore E. Stebbins, Jr. *"A Man of Genius": The Art of Washington Allston, 1779–1843.* Boston: Museum of Fine Arts, 1979.

Gienapp, William. *The Origins of the Republican Party.* New York: Oxford Univ. Press, 1987.

————. "'Politics Seem to Enter Everything': Political Culture in the North, 1840–1860." In *Essays in American Antebellum Politics, 1840–1860.* Ed. Stephen Maizlish. College Station, Texas: Texas A and M Univ. Press, 1982.

Glanz, Dawn. *How the West Was Drawn: American Art and the Settling of the Frontier.* Ann Arbor: UMI Research Press, 1982.

Goetzmann, William H., and William N. Goetzmann. *The West of the Imagination.* New York: W. W. Norton, 1986.

Gowans, Alan. "Painting and Sculpture." In *The Arts in America: The Nineteenth Century.* New York: Scribner's, 1969, pp. 175–284.

Groseclose, Barbara S. "Painting, Politics and George Caleb Bingham." *The American Art Journal,* 10 (1978), 5–19.

————. "Politics and American Genre Painting of the Nineteenth Century." *Antiques,* 120 (1981), 1210–17.

Gunderson, Robert G. *The Log Cabin Campaign.* Lexington: Univ. of Kentucky Press, 1957.

Halpin, Marjorie. *Catlin's Indian Gallery: The George Catlin Paintings in the United States National Museum.* Washington: Smithsonian Institution Press, 1965.

Hassrick, Peter. *Treasures of the Old West.* New York: Abrams, 1984.

Hassrick, Royal B. *The George Catlin Book of American Indians.* New York: Watson and Guptill, 1977.

Havlice, Patricia P. *Popular Song Index.* Metuchen: Scarecrow, 1975.

Hills, Patricia. *The Painters' America: Rural and Urban Life, 1810–1910.* New York: Praeger, 1974.

Hollstein, F. W. H. *Dutch and Flemish Etchings, Engravings and Woodcuts, c. 1450–1700.* Ed. K. G. Boon, vols. 23 and 24. Amsterdam: Van Gendt, 1980.

Howe, Daniel W. *The Political Culture of the American Whigs.* Chicago: Univ. of Chicago Press, 1979.

Husch, Gail E. "George Caleb Bingham's *The County Election:* Whig Tribute to the Will of the People." *The American Art Journal,* 19, no. 4 (1987), 5–22.

Johnson, E. D. H. *Paintings of the British Social Scene* (New York: Rizzoli, 1986).

Johnson, Donald Bruce, ed. *National Party Platforms: 1840–1956.* Vol. 1. Rev. ed. Urbana: Univ. of Illinois Press, 1978 [1973].

Kelly, James C. "Landscape and Genre Painting in Tennessee, 1810–1985."
Tennessee Historical Quarterly, 44 (Summer 1985), 2–152.

Kimball, Fiske. "The Life Portraits of Jefferson and Their Replicas." *Proceedings of the American Philosophical Society,* 88 (1944), 497–534.

Larkin, Lew. *Bingham, Fighting Artist: The Story of Missouri's Immortal Painter, Patriot, Soldier and Statesman.* St. Louis: State Publishing, [1955].

Larkin, Oliver. *Art and Life in America.* 2d ed. New York: Rinehart, 1950.

Lax, Roger, and Frederick Smith, *The Great Song Thesaurus.* 2d ed. New York: Oxford, 1989.

Lewis, R. W. B. *The American Adam.* Chicago: Univ. of Chicago Press, 1955.

Lipton, Leah. "George Caleb Bingham in the Studio of Chester Harding, Franklin, Mo., 1820." *The American Art Journal,* 16 (1984), 90–91.

———. *A Truthful Likeness: Chester Harding and His Portraits.* Washington: National Portrait Gallery, 1985.

Mann, Maybelle. *The American Art-Union.* Otisville, N.Y.: ALM Assn., 1977.

Marx, Leo. *The Machine in the Garden: Technology and the Pastoral Ideal in America.* New York: Oxford, 1964.

Matthews, Mitford M. *A Dictionary of Americanisms on Historical Principles.* Vol. 1. Chicago: University of Chicago Press, 1951.

McCandless, Perry. *A History of Missouri, Vol. 2, 1820–1860.* Columbia: Univ. of Missouri Press, 1972.

McCormick, Richard P. *The Second American Party System.* Chapel Hill: Univ of North Carolina Press, 1966.

McCurdy, Frances L. *Stump, Bar and Pulpit: Speechmaking of the Missouri Frontier.* Columbia: Univ. of Missouri Press, 1969.

McDermott, John F. "Charles Deas: Painter of the Frontier." *Art Quarterly,* 13 (1950), 293–311.

———. *George Caleb Bingham: River Portraitist.* Norman, Okla.: Univ. of Oklahoma Press, 1959.

———. *The Lost Panoramas of the Mississippi.* Chicago: Univ. of Chicago Press, 1958.

———. "Museums in Early St. Louis." *Missouri Historical Society Bulletin,* 4 (April 1948), 129–38.

McPherson, James M. *Battle Cry of Freedom: The Civil War Era.* New York: Oxford, 1988.

Mendelowitz, Daniel. *A History of American Art.* New York: Holt, Rinehart and Winston, 1960.

Mering, John V. "The Political Transition of James S. Rollins." *Missouri Historical Review,* 53 (1958–59), 217–26.

———. *The Whig Party in Missouri.* Univ. of Missouri Studies, 41. Columbia: Univ. of Missouri Press, 1967.

Miller, Perry. *Errand into the Wilderness.* Cambridge, Mass.: Harvard University Press, 1956.

Newhard, Leota. "The Beginning of the Whig Party in Missouri." *Missouri Historical Review,* 25 (1930–31), 254–80.

Niepman, Ann D. "General Order No. 11 and Border Warfare during the Civil War." *Missouri Historical Review,* 66 (1971–72), 185–210.

Novak, Barbara. *American Painting of the Nineteenth Century.* 2d ed. New York: Harper and Row, 1979.

———. *Nature and Culture: American Landscape Painting, 1825–1875.* New York: Oxford, 1980.

Oetterman, S. *Das Panorama: Die Geschichte eines Massenmediums.* Frankfurt/Main: Syndicat, 1980.

Ohman, Marian. *The History of Missouri Capitols.* Columbia: Univ. of Missouri, Columbia Extension Div., 1982.

Organ, Minnie. "History of the County Press." *Missouri Historical Review,* 4 (1909–10), 111–33, 149–66, and 252–308.

Parrish, William E. *Missouri under Radical Rule, 1865–1870.* Columbia: Univ. of Missouri Press, 1965.

———. "Reconstruction Politics in Missouri, 1865–1870." In *Radicalism, Racism and Party Realignment: The Border States during Reconstruction.* Ed. R. O. Curry. Baltimore: Johns Hopkins Press, 1969, pp. 1–36.

———. *Turbulent Partnership: Missouri and the Union, 1861–1865.* Columbia: Univ. of Missouri Press, 1963.

Penn, Dorothy. "George Caleb Bingham's 'Order No. 11.'" *Missouri Historical Review,* 40 (1945–46), 349–57.

Peterson, Merrill. *The Great Triumvirate: Webster, Clay and Calhoun.* New York: Oxford, 1987.

Potter, David M. *The Impending Crisis, 1848–1861.* New York: Harper and Row, 1976.

Prown, Jules D., and Barbara Rose. *American Painting from the Colonial Period to the Present.* 2d ed. New York: Abrams, 1977.

Rash, Nancy. "George Caleb Bingham's 'Lighter Relieving a Steamboat Aground.'" *Smithsonian Studies in American Art,* 2 (1988), 17–31.

Rathbone, Perry, ed. *Mississippi Panorama.* St. Louis: City Art Museum, 1949.

Richardson, E. P. *Painting in America.* New York: Crowell, 1956.

Rogers, Meyric, J. B. Musick, and Arthur Pope. *George Caleb Bingham: The Missouri Artist.* New York: Museum of Modern Art, 1935.

Rollins, C. B. "Some Recollections of George Caleb Bingham." *Missouri Historical Review,* 20 (1925–26), 463–84.

Rorabaugh, W. J. *The Alcoholic Republic.* New York: Oxford, 1979.

Rusk, Fern. *George Caleb Bingham: The Missouri Artist.* Jefferson City: Hugh Stephens, 1917.

Scharf, J. T. *History of St. Louis, City and County.* 2 vols. Philadelphia: L. H. Everts, 1883.

Scully, Vincent. *New World Visions of Household Gods and Sacred Places.* Boston: Little, Brown, 1988.

Shapiro, Michael E. et al. *George Caleb Bingham.* New York: Abrams, 1990.

Simonds, May. "Missouri History as Illustrated by George Caleb Bingham." *Missouri Historical Review,* 1 (1907), 181–90.

Smith, Elbert B. *Magnificent Missourian: The Life of Thomas Hart Benton.* Philadelphia: Lippincott, 1958.

Smith, Henry Nash. *Virgin Land: The American West as Symbol and Myth.* 2d ed. Cambridge: Harvard University Press, 1970.

Smith, W. B. *James Sidney Rollins: A Memoir.* New York: De Vinne Press, 1891.

Somkin, Fred. *Unquiet Eagle: Memory and Desire in the Idea of American Freedom, 1815–1860.* Ithaca: Cornell Univ. Press, 1967.

Stebbins, Thedore E., Jr., Carol Troyen, and Trevor J. Fairbrother. *A New World: Masterpieces of American Painting, 1760–1910.* Boston: Museum of Fine Arts, 1983.

Strickler, Susan. "Recent Acquisition: George Caleb Bingham's 'Going to Market.'" *Arts in Virginia,* 20, no. 3 (1980), 2–10.

Sullivan, Edmund B. *American Political Badges and Medalets, 1789–1892.* Lawrence, Mass.: Quarterman Publications, 1981.

Sunder, John E. *The Fur Trade on the Upper Missouri, 1840–1865.* Norman, Okla.: Univ. of Oklahoma Press, 1965.

Sutton, Peter C. *Masters of Seventeenth Century Dutch Landscape.* Boston: Museum of Fine Arts, 1987.

Switzler, William F. *Switzler's Illustrated History of Missouri.* St. Louis: C. R. Barns, 1881.

Taylor, Joshua C. *The Fine Arts in America.* Chicago: Univ. of Chicago Press, 1979.

Truettner, William H. *The Natural Man Observed: A Study of Catlin's Indian Gallery.* Washington: Smithsonian Institution Press, 1979.

Tyler, Ron. "George Caleb Bingham, The Native Talent." In *American Frontier Life: Early Western Painting and Prints.* New York: Abbeville, 1987.

Tyrrell, Ian R. *Sobering Up: From Temperance to Prohibition in Antebellum America, 1800–1860.* Westport, Conn.: Greenwood, 1979.

Valcanover, Francesco. *L'opera completa di Tiziano.* Milan: Rizzoli, 1969.

Viles, Jonas. "Old Franklin: A Frontier Town in the Twenties." *Mississippi Valley Historical Review,* 9 (1923), 269–82.

Westervelt, Robert F. "The Whig Painter of Missouri." *The American Art Journal,* 2 (1970), 46–53.

Williams, C. R. "The Place of the New York Historical Society in the Growth of American Interest in Egyptology." *Bulletin of the New-York Historical Society,* 4 (1920), 3–20.

Williams, Walter, and Floyd Shoemaker. *Missouri Mother of the West.* Vol. 1. Chicago: American Historical Society, 1930.

Wilmerding, John. *American Art.* New York: Penguin, 1976.

Wills, Garry. *Cincinnatus: General Washington and the Enlightenment.* New York: Doubleday, 1984.

Wilson, C. K. "Bingham's Bear Cub." *Art Bulletin,* 67 (1985), 154.

Woodward, C. Vann. *Origins of the New South, 1877–1913.* Baton Rouge: Univ. of Louisiana Press, 1951.

———. *Reunion and Reaction: The Compromise of 1877 and the End of Reconstruction.* Boston: Little, Brown, 1951.

Index

Page references in italics indicate illustrations.

Allen, Thomas, 53, 76–77

Allston, Washington, 55

American Art-Union: Bingham's life in *Bulletin* of, 3, 7, 22–23, 64–65; goals of, 23, 42–43, 55–57, 64–65; discontent with Bingham, 61, 73, 241–42n61; and Rollins, 128, 136–37. *See also* Apollo Association and Gallery

—patronage of Bingham by, 11, 39, 218–19; in *1845*, 40, 42–45, 55–57, 63; in *1846–47*, 65–67, 69, 72–73, 80–81; in *1848–49*, 92–93, 100, 107, 111, 124; in *1850*, 58–59; in *1851*, 61

American System: 14, 28, 77; illustrated on Bingham's banners, 7, 17, 27–29. *See also* Clay, Henry; Internal Improvements; Whig ideology

Anderson, William, 186, 189, 190

Apollo Association and Gallery (New York), 12, 40, 42, 52

Apollo Belvedere, 196

Arrow Rock, 19, 21, 22, 56, 126–27

Atchison, David R., 103, 118

Austen, George W., 43

Bailey, S. W., 97, 100

Banvard, John, 44

Bartolommeo, Fra, 196, *198*

Bates, Edward, 128, 207

Benton, Thomas Hart, 9, 13–14, 20, 31, 37, 95, 102, 146; speech at Fayette, 94, 106, 116; portrait of, in state capitol by anonymous artist, 102, 103, 105, 111–13, 115, 160, *178;* appeal to people of Missouri (*1848, 1851*), 105, 109, 127, 135–36; Bingham's portrait of, 111, *112;* and elections in Missouri, 112, 115, 138; Bingham's proposed painting of Benton's appeal, 116–19

Bingham, Clara, 39, 56

Bingham, Eliza Thomas, 64, 111, 167, 178–79, 218

Bingham, George Caleb, as artist: 1, 5–7, 24

—and American Art-Union: 3, 7, 11, 39, 218, 219; in *1845*, 40, 42–45, 55–57, 63; in *1846–47*, 65–67, 69, 72–73, 80–81; in *1848–49*, 92–93, 100, 107, 111, 124; in *1850*, 58–59; in *1851*; 61, 241–42n61

—biography of, in American Art-Union *Bulletin*, 3, 22–23, 64–65

—exhibits work: St. Louis, 7, 23, 67, 69, 109, 123, 142, 174–75, 222, 237n2; New York City, National Academy of Design, 7, 25, 41, 100 (*see also* Bingham, George Caleb, as artist: and American Art-Union; and Apollo Association); Cincinnati, 7, 89, 106, 111; Philadelphia, 111; Washington, D.C., 123; New Orleans, 138, 139; Kentucky, 138–39, 142; Baltimore, 139; Jefferson City, Missouri, 142, 166, 172–73, 174, 180–81; Columbia, Missouri, 227

—desire for government patronage, 8, 19, 32–33, 45, 61, 155–57, 164, 165, 220–21, 225

—as bust portraitist, 11, 22, 32, 39, 217, 218, 226

—and Apollo Association, 12, 40, 42, 52

—and copies after other artists, 19, 108, 160; buffalo paintings, 11, 28–29, 56;

Bingham, George Caleb (*continued*)
Thomas Sully, 11, 108, 167; collection
of prints, drawings, and antique casts,
12, 51
—prices for paintings of, 35, 42, 65, 67,
72, 159, 179, 216, 242–43 n 3
—and history painting, 38, 44–45, 61,
200–201, 222, 224–25
—suggested sources for: 48, 196–97;
classical sculpture, 1, 61, 146–47, 196;
High Renaissance painters, 4, 51, 52,
54, 61, 82, 96, 196; landscapists, 43,
50, 51, 55–57, 61, 62; popular imagery,
182, 196, 198
—and representation of women, 57–58,
62–64, 144–45, 201–02
—question of portraits in his genre
pictures, 97, 100, 116, 118, 124, 131,
141, 196
—compares himself to other artists, 157,
167, 196, 218, 221
—professor of art, 216, 226, 227
Bingham, George Caleb, as author: on
presentation of state portraits, 3, 8,
168–72, 185; on art, 5, 164–65,
216–18, 227; on *Order No. 11*, 8,
202–03; on Independent Treasury Bill,
17–18, 60–61, 81–82; on contested
election, 98–99, 132–34; on Mexican
War, 102; on slavery, 147–48; on
Charles Jennison, 179, 186–88, 195,
206–07; on radicals, 208, 211. *See
also* Bingham Resolutions
Bingham, George Caleb, as politician:
—and Democratic party, 1, 2; Bingham
critical of, 10–11, 14, 17–18, 20–21,
69, 79–80, 86–87, 98–99, 131,
133–35; Bingham allied to, 212,
224–25
—and Whig party, 1, 2, 5, 20, 115, 121,
139; speeches at Whig conventions, 2,
17–18, 60–61, 81–82, 121, 150–51;
and Whig principles, 6, 123, 132, 145,
187, 206; models speeches on William
H. Harrison and Henry Clay, 14, 17, 18,
19, 21, 24; banners for, 15–17, 23–32,
35, 38, 39, 45–47, 57, 77; on Whigs as
free men, 20–21, 99, 124, 131, 132;

and Whig position on Internal
Improvements, 27–29, 76–80, 85–87,
89–91, 94–95; and Whig position on
commerce, 45, 52–53, 60, 68, 81, 82,
171; and Whig position on settlement,
57–58, 64
—and Constitutional Union party, 1, 202,
206
—as candidate and office holder, 2, 20,
208, 212; state representative (*1846*),
2, 9–11, 69, 78–79, 92–93, 97–99,
131; state treasurer, 2, 176–77,
186–87, 191–92; president of Kansas
City Board of Police Commissioners, 2,
212, 222; adjutant general, 2, 212, 223,
224; state representative (*1848*), 93,
94, 101
—on will of the people, 18, 98–99, 102,
104–05, 132, 134, 144; in *County
Election*, 122, 128, 130–31, 136
—and Thomas Hart Benton, 20, 94–95,
101–03, 111–13, 116–19, 121, 127,
131, 150
—on civil over military authority, 36–38,
205–06, 211, 223–26
—on slavery, 92–93, 95, 104, 147–48,
150–51, 153–54, 179, 185, 188, 220.
See also Bingham Resolutions
—and Republican party, 150–51
—and Radical party, 207–11
—and Conservative Union party, 208
Bingham, George Caleb, life of:
—family, 11, 21–22, 39, 64, 100–101,
111, 167, 214–15
—residences: St. Louis, 11, 39, 97;
Philadelphia, 12, 22, 111, 122, 139–40;
Boonville, Missouri, 12, 22, 224; Arrow
Rock, Missouri, 19, 21, 22, 56;
Washington, D.C., 19–22, 164–65;
Petersburg, Virginia, 22; Jefferson City,
Missouri, 22, 32, 35, 38, 165, 166;
Europe, 159–60, 164, 167;
Independence, Missouri, 167, 185, 192
—friendship with James Sidney Rollins:
103, 121–22, 159, 214, 227; and
commissions, 12, 19, 24, 32–33, 45, 61,
156–59, 180, 220–21, 224–25; and
common political ties, 12–13, 19–20,

79–80, 94–95, 114–15, 135, 141–42, 146, 153, 186–87, 206; and discussions about paintings, 116, 128, 130, 136–38, 141–42, 144, 149, 151–52; and joint projects, 192, 212, 222, 223
—seeks consulship, 111, 159, 176
—military service, 176, 186, 188
—his house seized, 189, 191, 215
—attacks Thomas Ewing, 191, 206–07, 211, 213–15
—presses war claims, 212–13, 222, 226
—professor of art, 216, 226, 227
—on art commissions, 226, 227
Bingham, George Caleb, paintings by:
—*Bathing Girl*, 218
—*Boatman*, 246n67
—*Boatmen on the Missouri*, 65, 66, 80–82, *81*, 84, 92, 221
—*Candidate Electioneering. See Canvassing for a Vote*
—*Canvassing for a Vote*, 124–27, *126*
—*Captured by Indians*, 241n50
—*Concealed Enemy*, 5, 38, 40, 42, 44–51, *46*, 59, 67, 68
—*Cottage Scenery*, 40–42, 54–55, *55*, 57
—*Country Politician*, 93–95, 106–11, *107*, 124–25
—*County Canvass. See Stump Speaking*
—*County Election*, 120, *121*, 122, 128–36, *129*, 150; banner in, 122, 128, 130–31; drawing for, 132, *133*; compared to other works, 140, 143, 196
—*Dance on the Flatboat. See Jolly Flatboatmen*
—*Daniel Boone*, on tavern sign, 24
—*Daniel Boone Escorting Settlers through the Cumberland Gap*, 38, 58, 61–64, *62*, 156–57, 196, 200–202
—*Emigrant Encampment on the Frontier*, 241n50
—*Emigration of Daniel Boone. See Daniel Boone Escorting Settlers through the Cumberland Gap*
—*Family Life on the Frontier*, 57–59
—*Fishing on the Mississippi*, 246n67
—*French Trader and His Half-Breed Son. See Fur Traders Descending the Missouri*
—*Fur Traders Descending the Missouri*, 5, 23, 40–42, *41*, 44, 48–54, 59, 65–68, 80, 84, 91
—*Going to Market*, 25, *26*, 41
—*Halt in the Forest: Emigrants Resting at Night*, 241n50
—*In a Quandary*, 88, *88*, 124
—*Jolly Flatboatmen* (1), 67, 72–75, *74*, 82, 84, 91, 219
—*Jolly Flatboatmen* (2), 219–20, *219*
—*Jolly Flatboatmen in Port*, 91–92, *92*, 180, 219
—*Landscape: Rural Scenery*, 40, 41, 54–57, *56*, 59
—*Life on the Mississippi. See Jolly Flatboatmen in Port*
—*Lighter Relieving a Steamboat Aground*, 67, 69–75, *70*, 90–91, 221
—*Lyon and Blair Setting Out for Camp Jackson*, 180
—*Major Dean in Jail* (photograph touched with paint), 7, 209–11, *210*
—*Market Day. See Going to Market*
—*Martial Law. See Order No. 11*
—*Mississippi Boatmen*, 246n67
—*Order No. 11* (1), 7, 38, 154, *193*, 208, 211, 222; form, 192–202; content, 202–07
—*Order No. 11* (2), 192, *193*
—*Palm Leaf Shade*, 218
—*Pennsylvania Farmer*, 41
—*Political Banners*: 2, 54, 65, 80, 121, 168, 171, 215; for William Henry Harrison, 15–17, 52–53; for Henry Clay, 23–32, *25*, 35, 39, 77
—*Portraits*: Benton, Thomas Hart, 111, *112*; Blair, Frank P., Jr., 217; Edwards, John C., 32–35, *33*, 38; Humboldt, Baron von, 167, 174, 180; Rollins, James S., *13*, 217, 231n10; Switzler, W. F., *11*
—*Portraits for state capitol*, 155–56, 166, 182–83; Clay, Henry, 165, *165*, 166, 168–71, *169*, *170*; Jackson, Andrew, 165–68, 174, 196; Jefferson, Thomas, 157–59, 162–64, *163*, *165*;

Bingham, George Caleb (*continued*)
 Lyon, Nathaniel, 7, 177–79, *178,*
 180–82, *181,* 192, 196, 226
—*Puzzled Witness,* 222
—*Raftsmen Playing Cards,* 67, 69–75,
 71, 91, 246n59
—*St. Louis Wharf,* 89
—*Shooting for the Beef,* 241n56
—*Squatters,* 58–61, *59,* 64
—*Stump Orator,* 92, 94–101, *96*
 (daguerreotype), 109, 124, 140, 151
—*Stump Speaking,* 108, 118, 120, 122,
 140–43, *141,* 150
—*Tam O'Shanter,* 41
—*Trappers' Return,* 52, *53,* 88
—*Verdict of the People* (1), 120, 122,
 142–50, *143,* 150, 196
—*Verdict of the People* (2), 142, 147,
 147, 220
—*Washington Crossing the Delaware,*
 220–22, *221*
—*Watching the Cargo,* 89–90, *90*
—*Watching the Cargo by Night,* 90–91,
 91
—*Western Boatmen Ashore,* 12, 40, 42,
 52
—*Western Boatmen Ashore at Night,*
 246n67
—*Woodboat,* 59–61, *60,* 91
—*Woodyard,* 246n67
Bingham, George Caleb, prints and
 drawings by: 7–8, 91, 116, 152, 219,
 221; *Canvassing for a Vote,* 124–25;
 County Election, 136–38, *137,* 220;
 Drawings, *117,* 118, 132, *133,* 196,
 199; Election Series, 7–8, 120,
 123, 150–51; *Emigration of Daniel
 Boone and his Family,* 61–63, *63,* 220;
 In a Quandary, 88, 124, *125; Jolly
 Flatboatmen,* 67, 72, 73, 87, 219;
 Martial Law or *Order No. 11,* 192,
 203, 212, 214–15; *Stump Speaking,*
 140, 142, 220; *Verdict of the People,*
 148–49, *149*
Bingham, George Caleb, proposed
 paintings by: 215, 222–25, 227;
 *Andrew Jackson before Court in New
 Orleans* (*1845*), 35–37, 156, 200;

 *Andrew Jackson before Court in New
 Orleans* (*1877*), 37, 38, 223–26;
 March of the 'Border Ruffians', 122,
 151–54, 185; *Old Bullion Benton
 Appealing to the People,* 95, 116–19,
 122, 142, 200; political banner for
 Boone County, 24, 38, 45–47, 57
Bingham, Henry Vest, 47
Bingham, Horace, 21, 56
Bingham, Mattie Lykins, 189, 190, 214,
 218, 227
Bingham, Newton, 11, 21
Bingham, Rollins, 214–15, 218
Bingham, Sarah Elizabeth Hutchinson,
 11, 21, 56
Bingham Resolutions, 101, 103–05, 109,
 134–35, 145, 150, 172
Blair, Frank P., 158, 159, 166, 175–76,
 180, 208, 218
Blow, Henry, 159
Boats on western rivers, 67, 75–76,
 83–84. *See also* Rivers
Bodmer, Karl, 6
Boone County Banner Committee, 17,
 24, 31, 35
Boone, Daniel: subject on Bingham's
 proposed banner, 24, 45, 47, 62;
 subject of Bingham painting and print,
 38, 58, 61–64, *62, 63,* 156–57, 196,
 200–202; subject for other artists, 62,
 238n20
Boonville, Missouri, 22–24, 29, 224
Border ruffians, 151–52, 187, 204;
 Bingham's proposed painting of, 122,
 151–54, 185. *See also* Border Wars
Border Wars, 185–86, 188–200, 203.
 See also Border ruffians
Bowen, J. T., *16,* 127
Boyle, Ferdinand, 180
Briggs, Charles F., 42–43
Bryant, William Cullen, 40, 42
Burnet, John, 55
Bushnell, Horace, 17
Buss, R. W., 126, 132

Cass, Lewis, 105
Catlin, George, 6, 43, 45, 47
Chamberlain, Daniel, 223, 224

Chambers, A. B., 76, 104

Chapman, J. G., 26, *27*

Chicago Convention of Friends of Western Improvement, 76, 77, 86, 87

Cincinnati, Ohio, 40, 89, 106, 111, 218

Civil War, 174–77, 183, 185–91, 194–95, 198, 200

Clark, William, 47

Clay, Henry: Bingham's banners for, 2, 23–32, *25*, 35, 39, 77; *1844* campaign literature, 9, 25, 27–29; speeches as model for Missouri Whigs, 14, 17–18, 21; Bingham hears speech by, 19; portrayed by other artists, 26, *27*, 29, *30;* and American System, 28–29, 57, 59, 77; Bingham's portrait in state capitol, 165–66, *165*, 168–71, *169, 170*

Clonney, J. G., 107

Coles, Edward, 162, 164

Conservative Union party, 208–10

Constitutional Union party, 187, 188, 202, 206, 207

Darley, F. O. C., 43, 129

David, Jacques-Louis, 168

David d'Angers, Pierre-Jean, 164

Davis, E. Curtis, 114–15

Deas, Charles: 43, 45, 47, 68; *Fur Trader and His Family,* 50–51, *51*

Declaration of Independence, 158–59

Democratic party: Bingham critical of, 10–11, 14, 17–18, 20–21, 69, 79–80, 86–87, 98–99, 131, 133–35; party organization, 13–14, 98–99, 130–31; campaign tactics, 15, 25, 29; in Missouri legislature, 31–32, 35–37, 102, 103, 112–13, 158, 166, 169–71; on Internal Improvements, 69, 77–78, 86–87, 89, 94–95, 101; Bingham allied to, 212, 224–25

Dickeson, M. W., 44

Dickinson, David W., 37

Doniphan, A. W., 15

Doryphoros, 61

Drake, Charles D., 207, 209–10

Düsseldorf, Germany, 91, 148, 160, 167, 195

Dying Gaul, 147, 220

Eaton, Nathaniel, 76–77

Edwards, John C., 32–35, *33*, 38, 78

Ewing, Thomas, 184, 189, 190, 212–15

Fayette, Missouri, 106, 116, 144

Fletcher, Thomas C., 208

Fort, William, 35

Frank Leslie's Illustrated Newspaper, 198, *201*

Fur Trade, 45, 49, 75. *See also* Rivers

Fur Traders: as subject for Bingham, 40–42, *41*, 48–54, 65–68; as subject for Deas, 50–51, *51;* as forerunners of civilization, 53, 54, 80

Gamble, Hamilton: and *1845* painting of Andrew Jackson, 35–36, 38, 236n86; as governor, 176, 186, 190, 207

Gentry, North Todd, 227

Geyer, Henry, 76, 77, 112–13, 135

Goupil and Co., 61, 88, 124–25, 128, 140, 142, 148

Grant, Ulysses S., 223–25

Great Southwestern Convention. *See* Memphis Convention

Greeley, Horace, 31

Greuze, Jean-Baptiste, 196

Grimsley, Thornton, 76

Guitar, Odon, 151

Hall, Willard, 176, 190

Halleck, Henry W., 186

Hampton, Wade, 223, 224

Hardeman, John Locke, 159

Harding, Chester, 24

Harney, William S., 175, 176

Harper's Weekly, 182, 196, 198, *200,* 263n46

Harrison, William Henry: 15, 21; Bingham's banner for, 2, 15–17, 52–54, 80, 121, 168, 171

Harrisonville, Missouri, 186–87

Hayes, Rutherford, 225

Herndon, A. J., 29

Hills, A. Stephen, 34

Hogarth, William, 97, 126, 129, 130, 144

Hübner, Karl, 193

Independent Treasury Bill, 14, 17, 18, 60

Inman, Henry, 238n*20*

Intemperance. *See* Temperance

Internal Improvements: 12, 31, 95; and Bingham's paintings, 29, 89–90; of western rivers, 76–80, 85–86, 94. *See also* American System; Chicago Convention of Friends of Western Improvement; Clay, Henry; Memphis Convention; River and Harbor Bills; Rivers

Jackson, Andrew: 9, 13–14, 36, 170, 172; subject of proposed history painting by Bingham, 35–37, 38, 156, 223–26; Bingham's portrait of in state capitol, 165–68, 174

Jackson, Claiborne Fox: 106, 116, 118, 144; and Bingham's proposed painting of Andrew Jackson, 35–36, 38; sponsors Jackson Resolutions, 103; as governor, 171, 175, 176

Jackson Resolutions, 101, 103–06, 110–16, 127, 134–35, 172

Jason, 61

Jayhawkers, 186, 188, 194, 205

Jefferson, Thomas: Bingham's portrait of in state capitol, 157–59, 162–64, *163, 165*

Jefferson City, Missouri, 22, 32, 34, 35, 165–66

Jennison, Charles, 179, 186, 190

Johnson, R. S., 203–05

Kansas-Nebraska Act and Bill, 115, 122, 145–46, 150–52, 185

Kauffman, Theodore, 180

King, Austin, 101, 105

Kirtley, Sinclair, 35, 234n*58*

Lafayette, Marquis de: portrait by Sheffer, 33–34, *34;* portrait by Morse, 34, 168

Lathrop, John Hiram, 118

Lawrence, Kansas, 152–53

Lawrence Massacre, 189–91, 196, 198, 213, *200, 201*

Leonard, Abiel, 15, 29, 97, 106

Leonardo da Vinci, 196

Leutze, Emanuel, 157, 221

Levin and Mulligan, artists in St. Louis, 180

Lewis, Henry, 44

Lexington, Missouri, 192, 194

Lincoln, Abraham, 173–75

Lindley, John, 144

Linn, Lewis, 36

Loan, Ben, 188

Locofocos. *See* Democratic party

Log Cabin Campaign, 15, *16,* 127. *See also* Harrison, William Henry

Lyon, Nathaniel: 175, 177; Bingham's portrait in state capitol, 7, 177–79, *178,* 180–82, *181,* 192, 196, 226; Bingham's *Lyon and Blair,* 180; *Death of General Lyon* by Levin and Mulligan, 180; Perine's portrait of, 180, 182

Mabie's Circus, 109–10, *110*

Maine Law, 145. *See also* Temperance

Marcantonio Raimondi, 51, 54, 82, *83,* 84

Marmaduke, Meredith Miles, 98, 131, 134, 141

Masaccio, 196, *197*

Memphis Convention, 77, 85

Mercantile Library Association, St. Louis: 6, 38, 72, 77, 180; patron of Bingham, 6, 167; exhibits Bingham's paintings, 123, 174, 175, 180

Mexican War, 77, 101–03

Michelangelo, 82, *84*

Miller, Thomas, 17

Mills, Clark, 167

Morse, Samuel F. B., 34, 168

Mount, William Sidney: press compares Bingham to, 72, 138; *The Long Story,* 107–09, *108,* 126; Bingham compares himself to, 129, 218

Napton, William, 103

National Academy of Design, New York, 25, 68, 100

National Art Association, 164–65

Neagle, John, *30,* 32, 160, 168

Newspaper coverage of Bingham: Whig press in Missouri, 2, 3, 5, 11, 17, 69, 71–72, 86, 87, 96, 97, 100, 109, 114–15, 118, 159, 166; Democratic press in Missouri, 2–3, 204–05; in St. Louis, 3, 39, 68, 70–71, 96–97, 100, 109, 144; in New York City, 3, 72–73, 100, 219; in New Orleans, 138; in Kentucky, 138–39

Oliver, Mordecai, 176, 179, 180

Order No. 11: 184, 189, 190; as subject for Bingham's painting, 7, 38, 154, 192–208, 211, 222. *See also* Ewing, Thomas

Osage Indians, 45, 47

Ostade, Adrian von, 55

Panoramas of rivers, 44, 67

Perine, G. F., 180, 182

Philadelphia, 22, 111, 122, 139–40

Polk, James K., 31, 96; vetoes River and Harbor Bills, 78, 86, 87, 89

Pomarede, Leon, 44

Potter, Oscar, 131, 141

Press. *See* Newspaper coverage of Bingham

Price, Sterling, 175, 176

Primm, Wilson, 49, 76, 77

Quantrill, William, 186, 188

Radical Party in Missouri, 177–79, 207–11. *See also* Drake, Charles D.

Raimondi, Marcantonio. *See* Marcantonio Raimondi

Rannels, Charles, 159

Ranney, William, 62

Raphael, 54, 61, 129; *Miraculous Draught of Fishes,* 51–52, *52; Judgment of Paris, 83,* 84; *Transfiguration,* 84–85, *85*

Régnier, Claude, *63,* 125, *125*

Republican party, 150, 225

Reynolds, Thomas C., 172, 173

River and Harbor Bills, 77–79, 86, 87, 91, 130

Rivers, 54; trade on, 16, 68, 75–77; reports on, 67, 76. *See also* Boats on western rivers; River and Harbor Bills

Rocheport (Missouri) Convention, 15, 17. *See also* Harrison, William Henry; Log Cabin Campaign

Rollins, James Sidney: 12, *13,* 19, 38, 222–23; and Internal Improvements, 2, 79, 89–90, 94, 101, 245 n *45;* and Whig party in Missouri, 12, 15, 20, 24, 79; helps Bingham obtain commissions, 12, 19, 24, 32–33, 45, 61, 156–57, 158–59, 180, 220–21, 224–25; as candidate for office in Missouri, 89, 90, 94, 101, 150; on slavery, 105–06, 113–15; on circuses, 110–11; on Benton, 113–14; and American Art-Union, 128, 136–37; and Jennison, 186–87; and Conservative Union party, 208

St. Louis, 6, 43, 44, 90; Bingham exhibits there, 11, 23, 53, 67, 69, 72, 97, 109, 123, 180; as center of trade, 12, 44, 75–77, 87, 89

Sappington, Erasmus D.: 131, 141; and contested election, 98, 99, 134, 138

Sartain, John, 29, 128, *137,* 137–39, 192, *203,* 212, 221

Schofield, John M., 188, 190, 191, 212–13

Shannon, James, 118, 147–48

Sheffer, Ary, 33–34, *34*

Sigel, Franz, 175, 180

Slavery. *See also* Bingham, George Caleb, as politician: on slavery; Bingham Resolutions; Jackson Resolutions; Kansas-Nebraska Act and Bill; Rollins, James Sidney: on slavery; Temperance; Wilmot Proviso

Smith, John Rowson, 44

Squatter sovereignty, 122, 145–46, 151–52

Stockwell, Samuel, 44

Stringfellow, B. F., 98, 99

Stuart, Gilbert, 160, 182
Sub-Treasury Bill. *See* Independent
 Treasury Bill
Sully, Thomas, 11, 164, 167, 218, 235n66
Switzler, William Franklin: *11,* 13, 145,
 182, 234n58; coverage of Bingham in
 his newspaper, 2, 86–87, 114–15, 118,
 159; author of minority report on
 contested election, 79, 99; political
 views, 94–95, 102, 106, 130, 207; and
 Conservative Union party, 208

Taylor, Zachary, 90
Temperance: 75, 144–45; and
 antislavery movement, 145, 146, 148
Test-oath, 207–09
Thompson, James T. V., 167, 174
Tippecanoe Clubs, 15, 17. *See also*
 Boone County Banner Committee
Topeka Constitution, 152
Trumbull, John, 156, 195

University of Missouri, 6, 38, 117–18

Van Buren, Martin, 9, 13–14, 17–18, 21,
 131
Vanderlyn, John, 19, 160, 182
Volck, Adalbert, 195–96

Washington, D. C., 19–22, 123, 164–65
Washington, George: 160; farewell
 address, 104, 158; Bingham's portrait
 for state capitol, 157–62, *161;* subject
 of Bingham's history painting, 220–22,
 221
West, Benjamin, 195
Western Art-Union. *See* Cincinnati, Ohio
Whig ideology: commerce and economic
 development, 45, 68–69, 85–86;
 settlement, 57, 64; labor, 82, 86;
 temperance, 86, 145; on circuses,
 110–11. *See also* American System;
 Clay, Henry; Internal Improvements
Whig party: 115, 139
—in Missouri, 2, 14, 16; conventions, 15,
 17, 23, 79; and Internal Improvements,
 79, 87, 89–90; and education, 95
Whig symbols, 86, 100, 124, 130, 246n58
Wild, J. C., 44, 47, 48, *48,* 54
Wilkie, Sir David, 126, 129, 222
Wilmot Proviso, 103, 104, 109
Wimar, Charles, 180
Winston, James, 114–15

Yeatman, James, 72, 77, 86–87
Young, Samuel, 151–53